Inside Fashion Design

FOURTH EDITION

Sharon Lee Tate

The Fashion Center
Los Angeles Trade-Technical College

ILLUSTRATED BY
MONA SHAFER EDWARDS

 LONGMAN

An imprint of Addison Wesley Longman, Inc.

New York • Reading, Massachusetts • Menlo Park, California • Harlow, England
Don Mills, Ontario • Sydney • Mexico City • Madrid • Amsterdam

Editor-in-Chief: Priscilla McGeehon
Acquisitions Editor: Donna Erickson
Marketing Manager: John Holdcroft
Project Coordination and Text Design: Electronic Publishing Services Inc., NYC
Cover Illustration: Mona Shafer Edwards
Cover Designer/Manager: Nancy Danahy
Full Service Production Manager: Valerie L. Zaborski
Print Buyer: Denise Sandler
Publishing Services Manager: Al Dorsey
Electronic Page Makeup: Electronic Publishing Services Inc., NYC
Printer and Binder: Courier Companies, Inc.
Cover Printer: Phoenix Color Corps.

Library of Congress Cataloging-in-Publication Data
Tate, Sharon Lee.
 Inside fashion design / Sharon Lee Tate; illustrated by Mona
Shafer Edwards.—4th ed.
 p. cm.
 Includes index.
 ISBN 0-321-01550-9
 1. Costume design. I. Title.
TT507.T38 1998
746.9'2—dc21 97-43402
 CIP

Please visit our website at http://longman.awl.com

ISBN 0-321-01550-9

12345678910—CRW—01009998

Contents

Preface

Designing apparel is an exciting and demanding profession that requires special skills and abilities. The successful designer is usually a skilled sketcher and sometimes a qualified patternmaker and sewer. Leading a team and interpreting fashion trends from the many sources of fashion information for a specific customer are other necessary skills. Finally, above all, the successful designer must create a garment that will sell. To sell, the garment must appeal to a group of customers and be producible at a price competitive with a particular market.

FEATURES

When I wrote the first edition of *Inside Fashion Design*, there were no other books that dealt with the business, art, and craft of fashion design. Two decades later, the scene has changed. First, there are more textbooks available on the basic skills necessary to be a successful designer. Sketching and illustration are covered in my own *The Complete Book of Fashion Illustration* and *The Snap Fashion Sketch Book*. An excellent text on patternmaking, *Patternmaking for Fashion Design* by Helen Armstrong, published by Addison Wesley Longman, is a very complete text on patternmaking.

Technology

The industry has profoundly changed during the last 20 years because of the increasing use of the computer. In the third edition, computerization could be separated from the process and described as an aid to pre-production. In this edition, the role of computer systems has been integrated into every phase of the design and production of a garment. Computer systems and software have gradually become more affordable and user friendly. Technology exists to manage information, design, and control almost every facet of the design and production processes. Manufacturers and contractors vary widely in how systems are used. Contractors often build businesses around a computer application, like grading or

marking or relaying sales information between the retailer and manufacturer using EDI systems. Clearly, the race to organize the vast amounts of information and change required to manage a large apparel company will be increasingly dependent on computer systems. The increasing sophistication of computer applications cannot substitute for the core talent of a designer who can create a garment that will sell. The computer is a tool that speeds up the information-gathering process, sketches and images garments, makes patterns and grades them efficiently, and streamlines the manufacturing process. The idea for a garment and the synthesis of fabric, details, and trim must still originate with the designer.

Patternmakers must understand the traditional skills of draping the fabric on a dress form, creating the pattern pieces, correcting the fit of the garment, and applying grade rules to a pattern to use the computer. Computerized sewing machines still require a skilled operator to manipulate the fabric and construct the garment. This powerful tool will continue to change the way apparel is designed and manufactured. Body scanning and mass customization will appeal to many customers. Fashion change can be accelerated. Inevitably, a certain customer will continue to value unique and individualized handcrafted garments. The future of apparel design and manufacturing is inevitably linked to increasing use of computer systems, and the only certainty is that change will continue to accelerate.

Applications

The fourth edition of *Inside Fashion Design* provides an understanding of how all categories of apparel are created and manufactured. Vocabulary basic to all fashion careers has been linked to illustrations and photographs. The specific talents and skills and how to develop them are the core of this edition. Many important areas that should be studied in greater depth—such as textiles, fashion sketching and patternmaking, and draping—are put into perspective so that the aspiring designer will be able to understand the importance of this additional knowledge as an integral part of the designer's responsibilities. I have tried to explain the business of design, and hopefully the practical skills, resources, and aesthetics described will demystify the design process.

At the end of Chapter Six, a Textile Dictionary provides brief definitions and photographs of many common textiles. This "pictionary" shows what fab-

rics look like and provides specific names so that the new designer can work with textile and fiber salespeople with a working visual and verbal vocabulary. This information is fundamental to every designer/manufacturer/and retail buyers' core of knowledge.

Special Note

Designing apparel is a career in which both men and women can excel. Creativity and skill are the ingredients of success, not the gender of the designer or craftperson. Men and women have equal abilities to function in most occupations in an apparel factory; even the traditional male dominance in the cutting room is disappearing. Thus I have used she/he pronouns interchangeably in the book, with the understanding that both genders can build careers in all areas of manufacturing, designing, and promoting fashion.

ACKNOWLEDGMENTS

I would like to extend many thanks to the following professionals and teachers who helped in the preparation of this edition of *Inside Fashion Design:* Carol Sapos and Inge Broulard for arranging the computer photographs; Shaheen Sadeghi, men's wear merchandiser, for his excellent perspective on the men's wear industry; and Helen Armstrong for her advice on the technical aspects of patternmaking. A great deal of the vision and information on the future of the apparel industry was supplied by the professionals at the Textile/Clothing Technology Corporation, [TC]2 (pronounced TC-squared). Most especially, Joe Off, the Managing Director, who contributed many hours of editing manuscripts, explaining technology advances and the extraordinary research and development in progress at [TC]2. Thanks also to Gloria Carter and Mike Fralix of [TC]2. Special thanks to Peter Tredwin and Mary Fox of Gerber Garment Technology for reviewing technical computer information and providing an array of photographs and forms. Longtime friend, and innovative fashion visionary Bill Glazer contributed images and information from Report West and Snapfashun, his CAD system. Photographs taken by Larry Kastendiek, Kim Tucker, and Susan Lakin illustrate new aspects of the industry. Lisa Millward of La Belle, Robert Walter, the Manuel Collection and Frank Walter Sportswear, and the Fashion Center, Los Angeles Trade-Technical

College provided many of the new photographs. A special thank you to Michael McNamara and Cassandra Durant-Hamm of Cotton, Incorporated for the professional color boards. Fashion and color information from Pat Tunskey was an invaluable addition. Tadashi Shoji, *The California Apparel News,* courtesy of Michele Markman, Joan Martin, Elanore Kennedy of DuPont, Lidz Brothers, Mr. Pleat, John Scott, Shaheen Sadeghi, Kirk Nozaki, and Mari Isono are all photographed to show readers an insider's view of the industry.

In addition, I am most grateful to the many students and teachers, especially Adrienne Zinn, who have reviewed and read this text during the last two decades and have contributed their suggestions on how to improve it. Many editors from Harper and Row, HarperCollins, and now Addison Wesley Longman have also helped to shape the fourth edition and have supported the evolution of the original concept.

Finally, a special thanks to Mona Edwards, who has so faithfully illustrated this text and our many other projects. The saying "A picture is worth a thousand words" has special meaning to me. When I think back on memorable ideas from textbooks on art and design, the word is a poor second to the image. Mona's sketches make my words come alive and hopefully make them easier for you to remember.

I thank each person who has helped make this book a reality. Hopefully it will serve as a tool to help organize the talents of future successful fashion designers.

Sharon Lee Tate

Unit One

The Business of Design

Author and Artist
Partners and Friends

CHAPTER 1
The Apparel Manufacturer

The garment industry is characterized by both small and large manufacturing firms. A business person with a good idea or the ability to sell a product can capitalize on his or her talent and pay subcontractors to complete the manufacturing process. Unlike other manufacturing industries, even the largest apparel manufacturers may not own factories where garments are actually sewn. Most manufacturers use specialized sewing contractors to construct all or part of the garments they produce.

In fact, almost all phases of production, product development, and selling can be contracted to outside firms. This saves the manufacturer from making large investments in plant facilities and machinery. Also, a small apparel firm tends to have more styling flexibility and may be successful because of an innovative product concept. Because the small manufacturer does not have to support a large factory and keep many machines busy, he or she can follow a trend quickly and then pull out as the fashion item saturates the market. Often, small firms specialize in servicing a small group of retailers who want exclusive, more expensive styling or perhaps quicker response.

During the past two decades, many small apparel manufacturers have developed into giants with sales in the millions of dollars. Typically, large firms bring all phases of product development inside, including production, marketing, and distribution. Frequently, these firms have several divisions that produce noncompetitive lines. Some firms produce men's, women's, and children's apparel.

When you have read this chapter, you will understand:

1. The relative advantages of being a large or small manufacturer.

2. The major departments in an apparel manufacturing firm.

3. The differences between contracting and operating a manufacturer-owned factory.

4. How computers are revolutionizing apparel manufacturing.

5. The functions of those manufacturing departments not directly involved in production.

6. The designer's role in garment production.

3

Larger firms have several advantages over smaller firms. Larger manufacturers can buy fabrics before they are offered to the general market because they cut in large volume and order large amounts of yardage well before the season begins. Often, the larger manufacturer has a well-established credit rating that facilitates ordering stock yardage. The design departments can order special colors and prints and occasionally style the fabrics they use if the manufacturer also owns a knitting operation or prints his or her own fabrics.

The large manufacturer faces several disadvantages. Though usually able to control internal operations, the firm must still be flexible enough to design garments that sell. For that reason, the larger firm must not become complacent about its position in the market. Often, a large manufacturer's styling policy will not be flexible because the manufacturer becomes engrossed in improving the production aspects of the business and neglects to change styling rapidly to match consumer demand. When the consumer fails to purchase goods, the inflexible manufacturer will have a great deal of unwanted merchandise in the production pipeline. Retailers charge manufacturers for markdown and promotional allowances and may return merchandise that has not sold. Several seasons of the wrong styles can be disastrous for an apparel producer of any size. Finally, finding the proper executive and sales talent to manage all phases of a large manufacturing organization may be difficult.

DEFINING AN APPAREL MANUFACTURER

If the definition of an apparel manufacturer does not necessarily include sewing garments, what are the important elements that separate a manufacturer from a contractor? An apparel manufacturer:

1. originates the product concept and specifications (though sample patterns and garments may be contracted out)
2. initiates contact with the customer and consummates the selling contract (independent sales representatives may be hired to cover speciality and regional markets)
3. arranges financing and assumes product liability (banks may lend money to manufacturers, and factors [also see page 37] purchase accounts re-

ceivable to provide immediate capital to finance day-to-day business)
4. purchases fabric and findings for product
5. sells and delivers garments to retailer or consumer

MAJOR DEPARTMENTS IN AN APPAREL FIRM

The average apparel firm is divided into three major departments: design, pre-production and production, and merchandising/sales.

1. *The design department* is headed by the designer or merchandiser, who is responsible for producing somewhere between four and six collections of garments per year: fall-winter; holiday (an optional season depending on category of merchandise); cruise-spring; summer; and transitional or early fall. Many progressive manufacturers avoid truly seasonal lines by working with a loose seasonal feeling and constantly adding and subtracting garments.

2. *The production department* is responsible for mass-producing the line in quantity assorted by various sizes and colors and for filling orders placed by retailers. Pre-production refers to preparing the production pattern, grading (changing the size of the pattern), making a marker, and cutting the fabric. Production is constructing the garment, beginning with bundling the pieces together, sewing, finishing, and pressing.

3. *The sales department* markets the line produced by the design department and acts as an intermediary between buyers and the designer. Small firms may combine the design and sales departments, especially if they are a knock-off house specializing in copying current garments that are selling well at a lower price.

The designer participates in the operation of all three departments. Most manufacturers have computerized the business-related departments including fabric ordering, accounts receivable, accounts payable, payroll, and so forth. Many have also purchased computer systems to make and grade (change the size) patterns and markers (called CAD, or computer-aided design). Progressive manufacturers will completely computerize the "front end," adding more CAD systems to design garments and customize textile prints and patterns. CAD and CAM

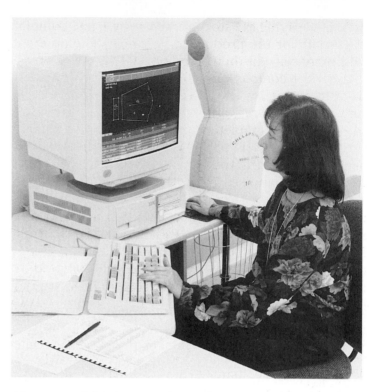

All aspects of the design and manufacturing process are being computerized.

(computer-aided manufacturing, typically cutting) systems enable a company to computerize most of the pre-production processes. Computer software programs such as Gerber's **Product Data Management (PDM)** and Lectra's **Style Manager** allow the manufacturer to manage every step of the design, merchandising, purchasing, sewing, warehousing, and shipping process with direct links to the factory floor and to the retailer.

Computers are also revolutionizing the sewing process. Computerized unit production systems (like the Gerber Mover and the Eton System) transport single units from operator to operator, gathering data pertaining to the sewing process along the way. Bar codes printed on sewing tickets allow the sewing operators to scan a code in the computer that records the exact number of operations completed and the time each operation requires and calculates the sewing efficiency and rate of pay. Calculating the number of operators and time it will take to manufacture large numbers of garments is simplified, and "loading the factory" becomes more efficient.

Orders and shipping, a subdepartment that reports to the sales staff, works between sales and production. This subdepartment was one of the first to be computerized and is responsible for processing

orders, verifying the store's credit rating, and compiling orders for the production manager. The production manager can then work out delivery schedules to meet the completion dates (deadline for shipment to stores) set by the manufacturer and the customers. Sometimes, a buyer will have the "muscle" to override a completion date set by the manufacturer. This buyer is probably important because he or she buys such large quantities of the manufacturer's merchandise. Thus, the manufacturer must honor the buyer's request for an earlier shipping date. Normally, though, the production manager will schedule according to the availability of fabric from the mill, and completion dates will follow automatically from fabric delivery dates. If the completion date is not met, the retailer has the right to cancel the order and refuse delivery of any goods.

A manufacturer should ship merchandise as soon as it is ready to avoid carrying an expensive inventory. The store may wish to delay shipment of goods until the consumer is most likely to purchase them. Garments in a stockroom, for either manufacturer or retailer, are a liability. Both need to sell them to make a profit.

CONTRACTING

Contracting is hiring a factory or service outside the parent business to perform a specific part of the manufacturing process. The range of contracting services offered in an apparel-producing center spans all phases of production and design. Whether operations in a small- to moderate-size firm will be done by a contractor is determined by how much investment capital is available, the talent of the person starting the firm, and the age of the business.

For example, a designer may team up with a person who can supervise the production aspects of a business, and the two may hire a sales organization to represent them in their home market and in the territories. They will pay the salesperson a commission based on the volume of the product sold. The partners can also contract out the pattern work, marking and grading, cutting, and sewing. On the other hand, a good salesperson might contract out everything but the actual selling and shipping of the garments when starting a manufacturing business. This person would have to purchase the fabric and assume responsibility for choosing the styles to make into samples and cut for shipping. Many import firms style the garments and sell and ship them

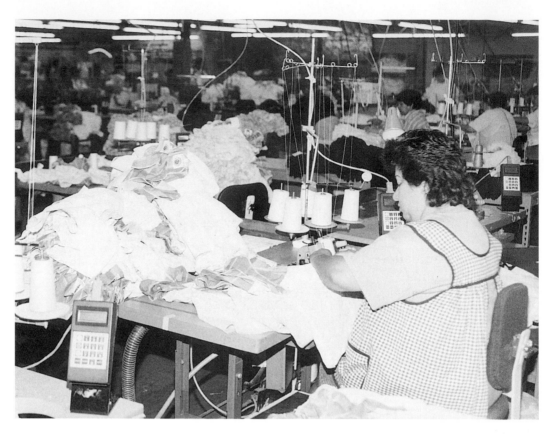

Many companies contract for the sewing portion of the manufacturing process.
Courtesy: Frank Walter Sportswear.

from a warehouse, contracting all manufacturing to foreign factories.

The contractor is generally responsible for completing the agreed-upon work by a specific time. A sewing contractor must make the garments to a previously agreed-upon standard. Because the contractor assumes no responsibility for styles that do not sell, his or her risk is smaller than the manufacturer's.

As a manufacturer matures and gains some working capital, people will be hired to work exclusively for the firm. Especially important is an in-house designer. The company designer is more likely to create a product uniquely in the image of the manufacturer than is a freelance designer who cannot benefit from close contact with the day-to-day operations of the business.

There are both advantages and disadvantages to contracting out work or maintaining an inside shop. To overcome the disadvantages, the manufacturer and the contractor *must* work closely together on the product and allow each other a fair share of the profits. The production person is the contact between the contractor and the manufacturer.

In-House Shop

Advantages

1. Greater quality control of product
2. More accurate scheduling; special jobs more easily handled
3. Less physical movement of goods and personnel
4. Depreciation of facilities and machinery yields tax benefits

Disadvantages

1. Large, fairly consistent payroll to maintain
2. Greater monthly rent, repair, and overhead costs
3. More time and effort devoted to union and employee demands
4. During seasonal slow periods, workers have to be laid off, or an artificial work flow of promotional garments is created
5. Large amounts of capital (money) tied up in machinery and facilities

Contractor

Advantages

1. Great production flexibility when a contractor is hired only as production requires. During the busy season, almost all firms have to contract out some aspect of the sewing operation
2. Some contractors specialize in operations requiring special machines or talents (examples: a pleater, a belt maker). These services are used by most firms at some time
3. A highly paid technician whose work is seasonal, such as a patternmaker or a grader, does not have to be maintained during a period of no work
4. No direct negotiations with labor or unions
5. No capital investment or maintenance necessary
6. Allows a person with a small amount of capital to go into business

Disadvantages

1. Less control over quality of product
2. Delivery and deadlines sometimes missed
3. Communication problems (many contractors speak foreign languages)
4. Extra physical movement of goods, resulting in greater chance of shortage or possible style piracy
5. Manufacturer must ensure that each contractor is in compliance with labor and safety regulations

Labor Issues

Domestic employers must abide by state and federal labor and safety laws and regulations. Compliance issues such as minimum wage, overtime pay, legal immigration status, child-labor laws, and safe working conditions are some of the standards that must be met by contractors and manufacturers alike. In an effort to eliminate the noncompliant employer, the federal Department of Labor, Wage and Standards Division has closed down businesses that violate the law. In addition, when a manufacturer hires a contractor who is violating labor laws, merchandise in the process of construction may be confiscated (second party liability).

This tough enforcement policy is necessary to prevent labor abuses and to provide a level playing field for all legitimate businesses that treat their workers fairly and yet must remain competitive in the global marketplace. Domestic contractors in

many apparel manufacturing hubs have formed coalitions to police themselves. In addition, manufacturers hire compliance firms to validate that their contractors are obeying the labor laws.

Price-conscious retailers may demand an unrealistically low price for a garment, thereby forcing the manufacturer to squeeze the sewing contractor for a price that does not cover the cost of labor and a small profit margin. In order to remain competitive with foreign labor markets, the contractor must implement technology and streamline the production process. The Textile/Clothing Technology Corporation, [TC]2 (pronounced TC-squared), is a national known organization, based in Cary, North Carolina, dedicated to increasing the productivity of sewn-product manufacturing in the United States. [TC]2 provides instruction on all aspects of the manufacturing process, research into new production methods, and Value-Added Coaching® for manufacturers and contractors to increase their profitability.

Foreign Production

Manufacturers may produce merchandise in a foreign country. This is called *offshore* production. The foreign sewing shop receives a sample garment, construction specifications (spec sheet), and a production pattern or marker from the manufacturer. The fabric may be sent to the contractor, who cuts and sews it, returning finished garments to the stateside manufacturer. Another method is to cut the fabric domestically and send the cut pieces abroad to be sewn. There are some advantages to this method because customs rates may be lower. The manufacturer must carefully weigh the advantages of inexpensive labor against shipping costs, customs fees, hidden costs, and the management necessary to coordinate offshore production.

The viability of producing offshore depends on the kind of apparel being manufactured, delivery dates, and the price of the garment. Staple garments, less influenced by fashion, are typically most efficiently sewn by a foreign contractor. The large manufacturer will evaluate each cut and determine whether the garment can be made and delivered by a foreign factory more efficiently than by a local contractor. Distributing the sewing in a variety of factories, both domestic and foreign, is called ***balanced sourcing.***

Counter Sample			**Design Specification**								GGT/GIS
Style:	95JKTPRT										
Division:	WOMEN		Notify:	2848							
Season:	FALL		Approved:	peter chen							
Q'ty:	9,600		Date:	November 10, 1995							
Sizes:	6 - 20		Modified:	November 10, 1995							
Fabric:	90/10 Linen/Cotton		Modified:	3:04 pm							
Description:	Missy fully lined 1 btn closure blazer w/pocket						Page 35	of 43	Identifier:	Basic	

Cat.	Code	Part No./#	Description	Vendor/Item #	Use	Width/Size	UOM	Src	Qty	PR/LF	Adj.Qty
F	GB95-00027	BFCNG380S 2	FUSIBLE COTTON INTERFACING	AMERICAN IF2038	Front/Neck Facing	48"	YD	M	0.1640	2.00%	0.1673
F	GB95-00027	BFCNG380F 2	FUSIBLE COTTON INTERFACING	AMERICAN IF2038	Front/Neck Facing Fusing	48"	YD	D	0.1980	2.00%	0.2020
F	GB95-00365	BSLV382 2	90/10 FALL LINEN/COTTON	TEXTILE SO LC9010	2 PC Sleeves	65"	YD	D	0.3540	3.00%	0.3646
F	GB95-00203	BBK382 2	ELITE 100% ACETATE SATIN	AVERY STF4351	Back Lining	44"	YD	D	0.3460	2.00%	0.3529
F	GB95-00203	BFL382 2	ELITE 100% ACETATE SATIN	AVERY STF4351	Front Lining	44"	YD	D	0.4460	2.00%	0.4549
F	GB95-00365	BBK382S 2	90/10 FALL LINEN/COTTON	TEXTILE SO LC9010	2 PC Back	65"	YD	D	0.2520	3.00%	0.2596
F	GB95-00365	BFA382 2	90/10 FALL LINEN/COTTON	TEXTILE SO LC9010	Jacket Front	65"	YD	D	0.4260	3.00%	0.4388
T	B95-02316	3	BUTTON 36 LIGNE LINE366110227/61	SOMMERS B36610	Button	36 Ligne	EA	M	3.0000	2.00%	3.0600
T	B95-00067	2	SHOULDER PAD 9X5X20 FORM	HOLLINGSWO F1-2	Shoulder Pad	9x5	PR	M	2.0000	2.00%	2.0400
O	OB95-PCDT	1	THREAD PCDTM STOCK	AMERICAN TH456	Thread		YD	M	1.0500	2.00%	1.0710
O	OB95-00105	1	GARMENT COVER 20 X 10	GALEY&LORD GC1265	Garment Bag	20 X 10	EA	M	1.0000	75.0% / 2.00%	1.0200
O	OB95-0105L	1	GARMENT COVER L< 20 X 12	GALEY&LORD GC1266	Garment Bag	20 X 12	EA	M	1.0000	25.0% / 2.00%	1.0200

cbom 14 Aug. 95 Copyright (C) 1990-1995 Gerber Garment Technology, Inc.

Computerized Spec Sheet
The specification (spec) sheet was primarily used when foreign contractors were commissioned to sew garments. Today, computerized spec sheets are used throughout the manufacturing process to guide the contractor in all phases of the manufacturing process. *Courtesy: Gerber Garment Technology, Inc.*

MANUFACTURING A READY-TO-WEAR GARMENT

Let us follow all phases of production of a style that has sold successfully. The job titles and operations described in the following sections are typical of a moderate-size firm. The larger the manufacturer, the more staff members participate in each operation. In a small factory, one person might perform several of the jobs described. Alongside each task, descriptions of how the computer has been integrated into the process illustrates the revolution that has taken place in the last decade.

Plan Cutting and Production
Pre-Production Manager

Pre-production includes all the steps required to get a garment ready to sew. Patternmaking, grading, marker development, ordering fabric and buttons, zippers, and threads (also called *"findings"*), cut-

order planning, bundling, and so forth are steps in pre-production. Large companies manage production through networked computers that join the design departments, the fabric-ordering department, the cutting room, and the production department. Small to moderate-size manufacturers are also purchasing computers to organize the production process. Production management programs begun in the design room are continually updated to reflect modifications that occur as the sample is developed to go into production. The electronic specification (spec) sheet is updated by every department as they order the material and findings and complete all the phases of the manufacturing process.

Computer Software Programs

Compile orders for a specific style and list the style by size, color, and fabric on a cutting ticket.

Cutting Ticket

The number of garments to be cut in each size and color is designated by compiling the individual store orders and counting all the pieces that have been sold. These totals are recorded on the cutting ticket. The cutter lays up the fabric and may slightly alter the number of garments cut, depending on the exact yardage that can be cut from each bolt (also called *piece*) of fabric. Additional garments may be cut to supply reorders and to replace possible damaged garments. The minimum number of pieces to be cut is set by the manufacturer, based upon the kind of garment and the price.

CUTTING TICKET

Style No. 7268 P Date 5/3 19 83

Color	4 / 3	6 / 5	8 / 7	10 / 9	12 / 11	14 / 13	16 / 15	18 / 17	Total
Red Floral Pattern #4959		35	40	40	40	35			190
Actual Cut									
piece 1 – 151 1/2 y.		38	40	40					
piece 2 132 y.					38	35			191
Total		38	40	40	38	35			
Gray Floral Pattern #4959		35	40	40	40	35			190
Actual Cut									
piece 3 153 y.		38	40	40					
piece 4 136 y					39	35			

The Findings Department
All the components of a cut must be ordered, matched with the cut garments, and forwarded to the sewing contractor. When this department fails to coordinate all components of the garment, delays in production are inevitable.
Courtesy: La Belle, California.

Calculate the amount of stock yardage required and check that fabric is in-house and ready for cutting.

Update the cost sheet to reflect cutting-room situations.

Findings Buyer

Orders findings (lining, zippers, thread, seam tape, and so on).

Orders trimmings (buttons, belts, special trims, and so forth).

Checks in items and stores them as they arrive.

Dispatches items, including labels and care instruction labels, to contractors as needed.

Suppliers are going "on line" to provide the findings buyer with an updated listing of resources on the World Wide Web (WWW). As each garment component is ordered and received, the findings buyer in a computerized firm will update the electronic spec sheet.

Stock Yardage Ordering and Receiving
Owner or Production Person

Orders stock yardage. The manufacturer may estimate how much to order before a style has been sold. If a fabric looks like a good seller, the manufacturer will take an early position (place

Stock Yardage
Stock yardage is ordered as early in the season as possible to ensure delivery.
Courtesy: La Belle, California.

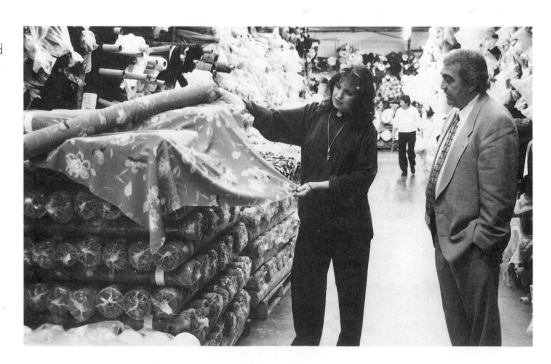

a tentative order) on a given amount of yardage to receive delivery at the proper time. The textile firm may let the purchaser decide on the color or print (assort) at a date nearer the production season. Later assorting prevents errors.

Checks with the mill if delivery is delayed.

Fabric Quality Control

Quality control occurs at several phases of the production process. First, stock yardage is checked for damages by unrolling and inspecting each bolt over a large light table that highlights flaws in the material as the fabric passes over the light source. Damages are marked in the selvage (fabric edge) to alert the cutter to avoid flaws. If the yardage is too badly damaged, the manufacturer will try to return it to the mill.

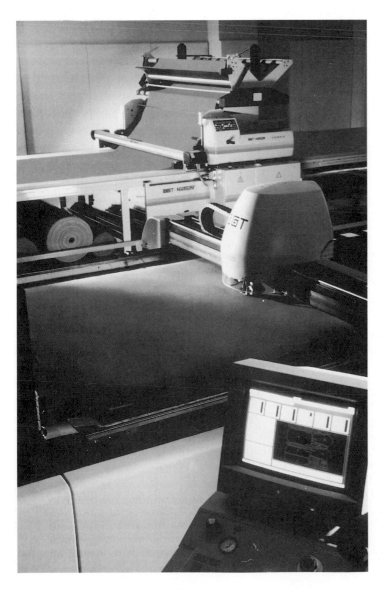

Computer-assisted spreading systems monitor fabric shading and identify flaws in the yardage.
Courtesy: Gerber Garment Technology, Inc.

Shading is the term used to define color variation in piece goods. Shading occurs in piece dyed goods, and the fabric supplier will identify different dye lots in each shipment. Sportswear manufacturers must cut all pieces of an outfit in the same dye lot so that tops match bottoms. Shading can occur randomly in the same bolt of fabric; this makes matching all pieces of a single garment very difficult. Quality control inspectors must evaluate all these factors before cutting the garment.

When this phase of the production process is computerized, each dye lot is logged while fabric is inspected and classified by shade and dye lot, number of yards in each bolt, and other variables that will be used in the cut-order planning process.

Pattern Work
Production Patternmaker

Today, many production patterns are made by hand, but this will change as all phases of pattern development are computerized. The accuracy and speed of computerized pattern stimulates computerization of the pattern process. The skilled patternmaker uses a sample pattern or else creates it from scratch on the computer and corrects it according to the manufacturer's blocks or slopers (basic patterns that fit a typical customer and are used in the development of styles).

The pattern is printed full scale on a specialized plotter, and the production sample is cut, sewn, and fitted. The computer pattern is corrected, and a test

Production Patternmaker

The production patternmaker remakes the designer's pattern into a garment that is simple to construct. The stock garment must also conform to the company's commercial fit.
Courtesy: La Belle, California.

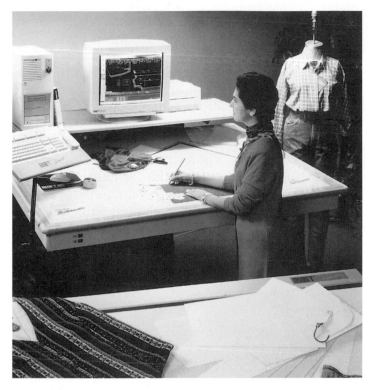

Computerized Patternmaking
The AccuMark Silhouette© is a computerized
pattern development system that combines the skill
of manual pattern design with an automated system.
Patternmakers use tools they are familiar with—paper
and curves. As the work is performed on the tabletop,
it is simultaneously captured by the computer for faster,
more accurate pattern development.
Courtesy: Gerber Garment Technology, Inc.

marker is made to determine the amount of yardage
needed to verify the designer's estimate of material
usage. The pattern pieces may be scanned and posi-
tioned on to the spec sheets and used for reference
as the garment is constructed.

At this stage, the production pattern is simpli-
fied as much as possible to eliminate sewing prob-
lems and waste. The patternmaker works with a
production sample maker who understands all
phases of garment construction. The production
sample maker not only sews the garment but offers
suggestions on how to make the operations as sim-
ple and precise as possible.

Grader

Grading is changing the size of the basic pattern
and scaling it up and down the size range of the gar-
ment. Grading was the first patternmaking function
to be computerized.

The production pattern is graded according to
grade rules established by the manufacturer and
used by the grader or programmed into the com-
puter. Manual grading is time consuming because of
the time it takes to manipulate and cut paper pat-
tern pieces physically. A computer system does this
accurately in a matter of minutes. Additional sav-
ings are made if a style is cut in various fabrics with

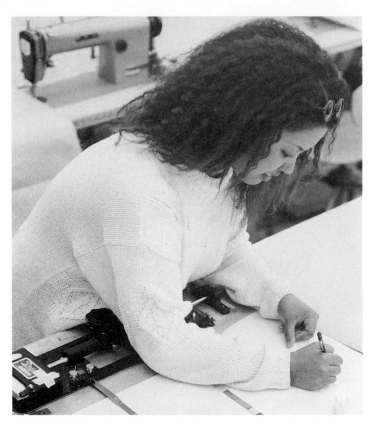

Grading the Pattern
The grader uses a simple machine to move the pattern pieces as she outlines the pieces in the various sizes. Each piece of the production pattern must be graded for each size.

Digitizing the Pattern
Digitizing the pattern translates the paper pattern into a series of codes that input the shape into the computer.

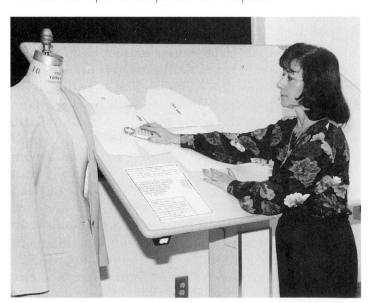

Computerized Grading
Grade rules are input into the system based on the size specifications of the manufacturer. The pattern is quickly graded, and the pieces can be printed out, or the pattern can be used to make a marker and then printed out.
Courtesy: Gerber Garment Technology, Inc.

different shrinkage (the amount the fabric contracts when washed) or stretch factors. These variables can be fed into the system and the patterns automatically alter to compensate for the difference.

Marker Maker

The pattern pieces from all sizes of the garment are arranged and interlocked to save as much fabric as possible during the cutting process. Each fabric component of a garment, the outer fabric, lining, and interlining require different markers. A handmade marker is a roll of paper the same width as the fabric to be cut. The original can be easily and inexpensively replicated if the cut is repeated. The marker may also be reprinted from a computer program in the exact width of the fabric. If the style is cut again in a different width fabric, the computer analyzes all the pattern pieces, compares them to previously made markers, and creates a new efficient marker. Systems producers estimate that a minimum savings of 3 percent on fabric alone is typical for computerized markers, a significant factor because fabric is the most expensive cost element of a garment. A skilled marker maker who is trained to use a computer can make approximately eight markers in the time it took to make one manual

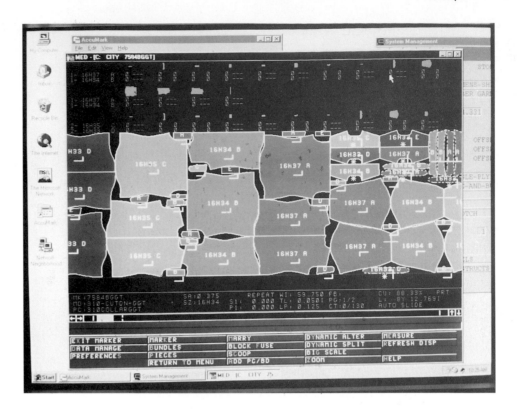

Marker

A marker may be made by outlining each pattern piece on marker paper, but this labor-intensive system has been replaced largely by computer systems that are more accurate and much faster to produce.
Courtesy: Gerber Garment Technology, Inc.

marker. Computerized markers are needed to drive a numerically controlled cutting system.

Spreader

Lays up the cut. The fabric is spread evenly, layer upon layer, according to the size, color, and amount designated on the cutting ticket. *Step spreading* refers to additional layers added to the size ranges that have the most units. Spreaders should double-

Spreading

Fabric is laid on the cutting table in many layers. Cutting costs are lowered when many garments can be cut at the same time.
Courtesy: La Belle, California.

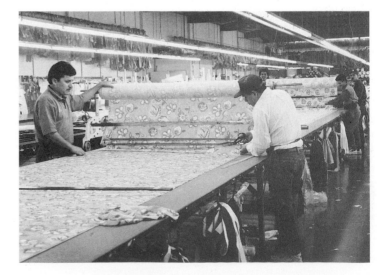

check the quality and shades of the fabric as it is spread.

When spreading for a computerized cutting system, fewer ply of fabric are cut at one time, and more accurate control of sizes and color ranges is possible.

The marker is spread on the stack of fabric when cut manually.

Cutter

In less-automated cutting rooms, the cutter cuts the stack of fabric with a straight- or round-blade cutting machine (a hand-held machine resembling an electric saw). Pattern notches and dart punch holes are made with a drill.

Fabric may be cut by computer-driven automatic cutters. The Gerber cutting system uses a combination of vacuum hold-down plastic cover film and the Gerber Bristle Square cutting surface. These patented systems can cut a single ply (layer) of fabric to a stack 3 inches high under vacuum. The vacuum system works in tandem with the plastic cover film to compress the fabric and secure it firmly in place. The knife that cuts the fabric is automatically resharpened during the cutting process. This method ensures complete accuracy and greater flexibility and allows far more accurate cuts to be made in a shorter time with fewer skilled personnel.

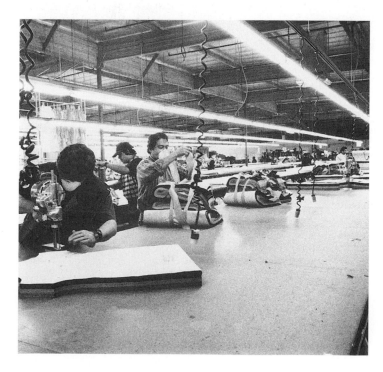

Cutting
The cutter cuts the stack with a blade. Accuracy is critical to the fit of the garments.
Courtesy: La Belle, California.

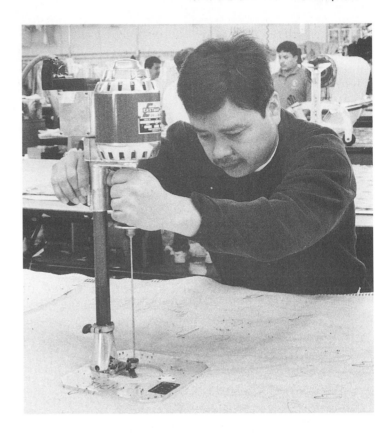

Cutting

The cutter uses a drill to make punch holes that guide
sewers to make darts and place pockets.
Courtesy: La Belle, California.

Automated Cutting

The GERBERcutter® speeds cutting and is more accurate and flexible than conventional hand-
cutting procedures. Plastic film compresses the fabric as it is placed on the air-suction table. The
cutting unit is mounted on the bar and can cut a single piece from the center of a marker or cut the
garment conventionally. The cutter is programed by the AccuMark™ system.
Courtesy: Gerber Garment Technology, Inc.

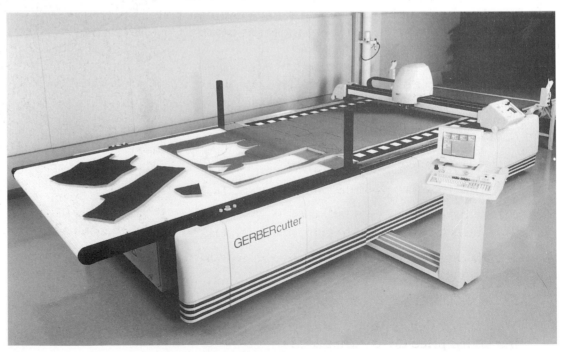

The cutter also edits the cutting ticket to indicate the number of pieces cut from each color and shade. This is especially important when manufacturing coordinated sportswear because tops and bottoms must match.

Bundling
Bundling Worker

Organizes the pieces of each garment. Garments can be bundled according to item, group, or section methods. The construction process for each of these bundling systems is described on page 27.

Update the electronics spec sheet based on number of garments, available trims, and so forth. Logs out each cut and appropriate trimmings to the assigned sewing contractor or in-house factory.

1. Item. All pieces that make up one garment are placed together and sewed by one operator.
2. Group bundle. Ten to 20 garments are put in one bundle that a single operator or a team of operators in a modular system sews.
3. Section work is also called the *progressive bundle system*. An operator works on one area of a garment (shirt collars, cuffs and sleeves, and so forth); other operators construct various components and all the parts are assembled in the final step. A trim that requires special machines can be sent out while work continues in-house on other parts of the garment.
4. Individual garment pieces may be delivered to each sewing station by a computerized delivery system (UPS, or unit production system) that is programed to balance the line, collect payroll data, and reduce through put time.

Recuts any damaged pieces.

Puts the necessary findings with each bundle.

Prints bar-coded sewing tickets, or prepares guidelines for contractor to print sewing tickets.

Attaches production tickets to record sewing operations.

Attaches labels and care instructions.

When provided, retail labels, hang tags, and bar-coded price tickets are added.

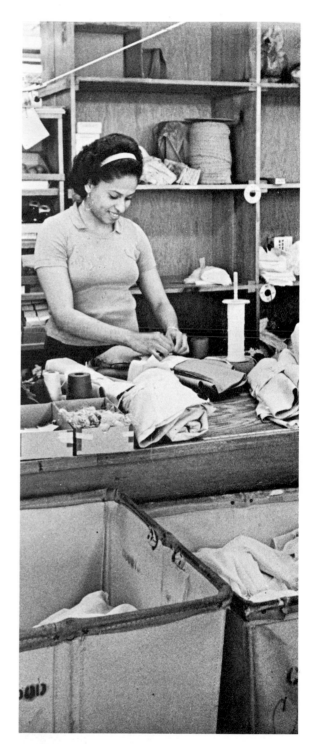

Bundling
As each garment is assembled in a bundle for the sewers, the bundler includes thread, work tickets, zippers, and other findings.

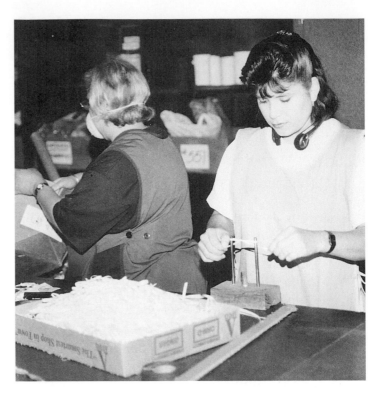

Specialized Trims
The sewing contractor may make special trims in-house that are bundled with each garment or added at a specific stage in the construction.
Courtesy: Frank Walter Sportswear.

Special Trims (not always used)
Contractor Specializing in Trims

Bundling department coordinates trim cuts and accessories made outside the shop and logs them on to the computerized spec sheet as they are sent out and returned.

Does trim work as well as appliqués and pleats. Also included are special finishing treatments such as washing or dying complete garments. The section to be trimmed is separated from the bundle and is reunited with it after the trim is applied.

Construction Operations
Production Manager

The production manager coordinates schedules with pre-production activities and designates the specific factories that will construct each lot or cut (groups of styles cut at the same time). Logs and tracks the lots assigned to contractors. Efficient product management systems are used by large manufacturers and will soon be widespread in industry. The production manager and quality control staff visit factories throughout the production process to deliver findings, check work in progress, determine accurate delivery dates, and trouble-shoot.

Production Manager
A variety of computer programs assist the production manager to load the factory, monitor the work in progress, and manage the sewing process more efficiently.
Courtesy: Frank Walter Sportswear.

Sewing Floor Supervisor

A production sample and spec sheet is sent to the in-house production or the outside contractor. Methods engineering, or analyzing the best method of constructing the garment, and determining the Standard Allowed Minutes (SAMs) is begun. A timed study of the operator constructing the garment evaluates the movements an operator needs to place each piece of the garment under the needle and complete the sewing operation. A value is placed on the time needed to complete the garment, and the sewing cost is calculated. Usually a short run of the garment will be tested by the best operators in a factory to complete the evaluation of the cost of sewing the garment. An operator who is completing the operation in the time established by this method is said to be working at 100 percent efficiency. Operators may take longer to complete an operation than the Standard Allowed Minutes and will receive less pay as a result. Conversely, those working with greater efficiency than the standard will earn more per hour.

Once the price and method of producing the garment is agreed upon, the cut (all the garments in one style that have been cut together), hopefully accompanied by all the findings required to construct the garments, is put into production. The garment components are counted and logged in.

The sewing room management loads the factory, determining the operators most capable of performing each phase of the production process.

Floor Supervisor
The floor supervisor regulates the flow of work through the factory and solves any construction problems that may arise.
Courtesy: Frank Walter Sportswear.

Labor Worksheet
Each phase of the sewing process is broken down into Standard Allowed Minutes (SAM), which is priced and aggregated to calculate the sewing cost of the garment.
Courtesy: Gerber Garment Technology, Inc.

Counter Sample			Labor Worksheet							GGT/GIS

Style:	95JKTPRT							
Division:	WOMEN		Notify:	2848				
Season:	FALL		Approved:	peter chen				GIS
Q'ty:	9,600		Date:	November 10, 1995				
Sizes:	6 - 20		Modified:	November 10, 1995				
Fabric:	90/10 Linen/Cotton		Modified:	3:05 pm				
Description:	Missy fully lined 1 btn closure blazer w/pocket			Page 41 of 43			Identifier:	Basic

**** D - Dutiable N - Nondutiable**

									Base Rate		
**	Part #	Operation #	Contractor	Description	Factory	SAM	Code	Amount	Cost		
N		CU080226		Cutting – Blazers – Missy	DL1	2.0000	D	0.1160	0.2320	0.2320	
N	BFCNG380S			Front/Neck Facing	DL1	1.5000			0.1521	0.1521	
N	BFCNG380F			Front/Neck Facing Fusing	DL1	0.9100			0.1074	0.1074	
N	BSLV382			2 Piece Sleeve	DL1	6.9000			0.7069	0.7069	
N	BBK382			Back Lining	DL1	1.4800			0.1583	0.1583	
N	BFL382			Front Lining	DL1	5.6900			0.5861	0.5861	
N	BBK382S			2PC Back	DL1	1.2300			0.1250	0.1250	
N	BFA382			Front Assembly	DL1	14.9600			1.6127	1.6127	
N	BFA23382F			Front Fusing Assembly	DL1	0.7500			0.0885	0.0885	
N	BPKT2382			Oversized Pocket	DL1	5.8300			0.6105	0.6105	
N		GC430279		Press shldr, upper bk & slv	DL1	1.8721	C	0.0981	0.1837	0.1837	
N		GC405279		Press body & sleeves	DL1	3.6531	C	0.0981	0.3584	0.3584	
N		GC424279		Mark buttons	DL1	0.3521	B	0.1180	0.0415	0.0415	
N		GC406275		sew front button	DL1	0.7652	B	0.1180	0.0903	0.0903	
N		GC207279		Button, trim & tag	DL1	0.5842	B	0.1180	0.0689	0.0689	
N		GC848275		Blow lint	DL1	0.2224	B	0.1180	0.0262	0.0262	
N		GC201279		Bag & tag	DL1	0.2955	B	0.1180	0.0349	0.0349	
N		GC652244		Outseam and inseam slv lining	DL1	1.0420	A	0.1030	0.1073	0.1073	

Total Parts	4.1475	Total Ops	1.1432	Total Cont.		Total SAM	50.0366	Total Dutiables		Total Labor	5.2907	5.2907

oopbuilc 23 Aug. 95 Copyright (C) 1990-1995 Gerber Garment Technology, Inc.

Special machine work will be balanced with single-needle operations. Operators are usually paid a **piecework rate** calculated on the number of operations they complete in a day, though this rate cannot by law be lower than minimum wage. Work is measured by counting the work tickets each operator collects or from the information gathered by the "swipes" on a bar-coding reader attached to each sewing machine. Efficiency usually increases as a garment becomes routine with many operators. Reducing the "through put time" (time on the sewing floor needed to complete all the garments in a cut) is critical to maximize profitability.

Operator:
Single-Needle Machine
Overlock Machine (or Sew-Overlock Machine)
Blind-Stitch Machine
Special Machine

The method of construction is determined by the kind of garment, price, and sophistication of the sewing operation.

1. Section work or progressive bundling. Each operator on the assembly line usually sews only one part of the garment. Manual movement of bundles from operator to operator is typical of traditional factories.

UPS (automated garment delivery systems) carry parts of garments from one operator to another, speeding production time as computerized programs automatically adjust deliveries to each work station based on the productivity of the operator. The location of each garment in a cut is constantly available to the sewing room management, and through put time is greatly reduced. It is critical to have all the trims and findings before putting the cut into production to maximize the profitability of a garment moving system.

2. Complete garment construction. Most of the garment is sewed by one operator, except for finishing details that require special machines (such as overlocking the seams, hemming, and buttonholes), which may be done by specialized workers. This method is most often used for better garments.

3. Modular manufacturing. A group of operators functions as a team to produce a cut. Operators are cross-trained to do several of the sewing tasks needed to construct the garment: A balanced process has team members who trade jobs when the

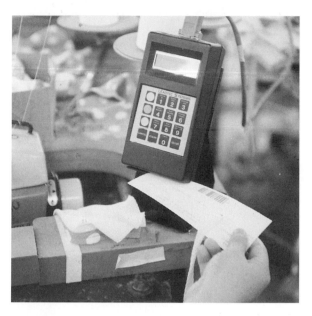

Piecework
The sewing operator swipes at a bar-coded work ticket as each phase of the construction process is begun. The LeadTec computer system automatically times each operator so that efficiency can be monitored and used to generate payroll, control the work in progress, and track each garment.
Courtesy: Frank Walter Sportswear.

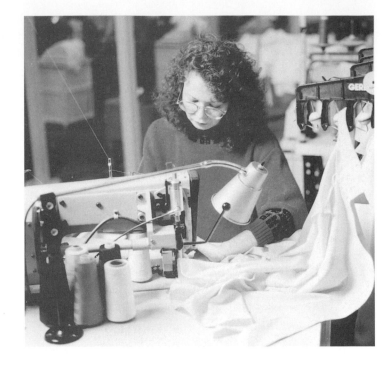

The GERBERmover® unit production system is a computer-driven system that automatically sends garments to the next operators as an operation is completed.
Courtesy: Gerber Garment Technology, Inc.

Single-Needle Lockstitch Machine
This machine sews a straight seam in a single stitch. Another name for this machine is *single needle*.

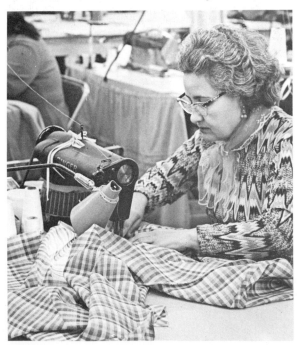

work flow slows down at any phase of production. Often, team members work standing up, moving freely between operations; this is less physically demanding than sitting down. When machines break down or need adjusting, they are quickly replaced with a working unit. A slightly greater machine-to-operator ratio is needed to keep the "mod" producing at highest efficiency. Pay is determined by the group compensation process that divides the total earnings equally among all the workers in the mod. Peer pressure to raise the productivity of each team member motivates all members to work productively. In addition, modular manufacturing is most effective when problems are solved by workers closest to the manufacturing process.

Technology has also increased the productivity of the sewing machine operator. Computerized sewing machines can be programmed to sew a specific number of stitches to perform a standard operation, such as setting a zipper or sewing a man-tailored collar. The operator manipulates the fabric pieces in the machine, which automatically performs the programmed sewing operation. The U.S. government classifies and defines *stitching methods* and *seam types* in reference manual, *Federal Standard 751a,* which may be purchased from General Business Service Center, Washington, D.C. #20025. Designers are often required to designate specific stitch types, especially when dealing

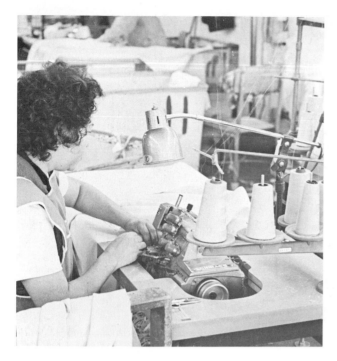

Sew-Overlock Machine
This machine overlocks the edges of the fabric, trims the seam, and sews the seam with a straight stitch, all at the same time.

with foreign contractors. Sixty-two stitches are divided into eight classes, numbered:

100 single-thread chain stitches
200 hand stitches
300 lockstitch (hook and bobbin)
400 multithread chain stitch
500 over-edge and safety stitch
600 cover stitch
700 single-thread lockstitch

Most of the stitches are in the 300 and 500 classes. Seam types are classified by capital letters, for example (FS) refers to flat seams, (EF) edge finishes, (SS) superimposed seams, (BS) bound seams, and

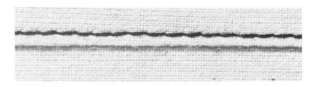

The single-needle stitch is the most versatile machine. It produces a straight stitch that can be lengthened or shortened and is used for joining the garment pieces, top stitching, and finishing. The Federal Stitch Type is 301.

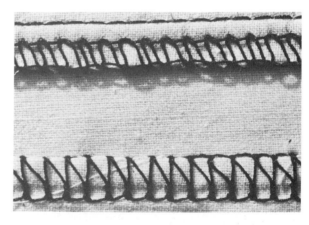

The top example shows an overlock stitch designated as a 512. This may be used for woven fabrics and rigid knits. The bottom example is a sew-over lockstitch (FST 504), which is most often used to join stretch fabrics because it extends and contracts with the fabric.

The example to the left shows the backside of a hem of the 103 blind stitch, while the right side shows the face of the fabric. Contrast thread has been used to show the stitches. Thread the same color as the fabric would be less noticeable.

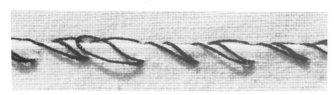

Blind-Stitch Machine
The hem is finished with a stitch that is barely visible on the right side of the fabric. Many times, clear polyester thread is used so that it will not have to be changed when garments of different colors are being sewed.

(OS) ornamental seams. Lowercase letters designate the specific type of seams within the family. For a detailed description of federal seams types, refer to the *Guide to Apparel Manufacturing* by Peyton B. Hudson (MEDIAApparel, Incorporated; Greensboro, North Carolina, 1996) or order the government manual.

Efficient construction is as important as maintaining quality standards, which have been established by the manufacturer. *Quality control* refers to inspections that take place throughout the manufacturing process. This important aspect of manufacturing is critical no matter what sewing process is used.

Time and Motion Engineer

The apparel engineer streamlines the production process and analyzes the Standard Allowed Minutes to determine the production cost of each garment. Once production time is established for an operation, analyzing each operator's ability to perform a task allows the engineer to load the factory effectively. An operator who is working at 85 percent efficiency may need assistance to streamline the *"gets and puts,"* defined as how the pieces of the garment are placed under the needle and back into the bundle. An operator who is working at an excessively high efficiency rate may be cutting corners and placing a burden on trimmers or others on the production line by sacrificing accuracy for speed.

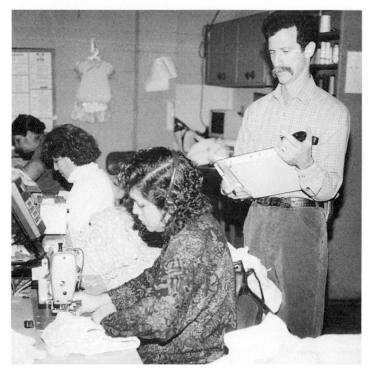

Time and Motion Engineer
The sewing engineer studies the operator's movements to determine the time it takes to complete each phase of the sewing process.
Courtesy: Frank Walter Sportswear.

Presser

Intermediate underpressing occurs during the manufacturing process (opening seams, pressing facings, and so forth) when needed during the sewing operation.

Finished pressing occurs when the garment is completed. Tunnel pressing systems use a wet/dry

Underpresser
Parts of the garments are spot pressed during the construction process.
Courtesy: Frank Walter Sportswear.

Finished Pressing
Completed garments may be pressed by passing them through an automated steam press.
Courtesy: Frank Walter Sportswear.

process in a steam tunnel to press the finished garment. Form pressing is a process that steams the garment from the inside when it is placed over a body form and steam is forced through the garment. Pressing is critical to the shelf appeal of the product.

Hand Finisher

Sews on special buttons, tacks, cuffs, hems, and so on. (This person works only on more expensive garments.)

Hand Finisher
Final trims and findings are sewn by hand on better garments.
Courtesy: Frank Walter Sportswear.

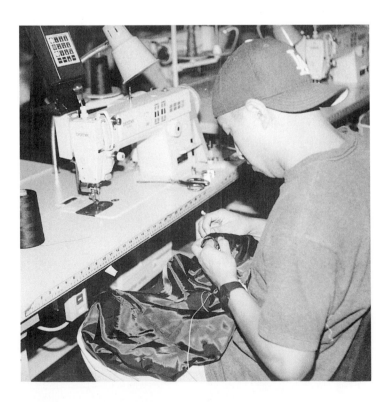

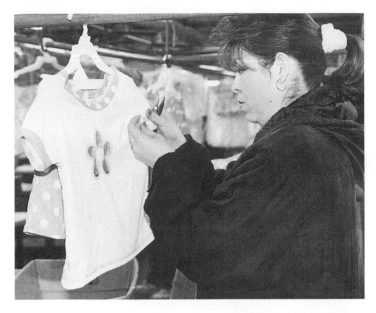

Quality Control
Each completed garment is carefully inspected before being sent to the shipping department. Damaged garments are either repaired or sold as seconds.
Courtesy: Frank Walter Sportswear.

Quality Controller/Trimmer

Trims threads, checks for sewing errors, hangs garments on hangers, attaches hang tags, and covers each garment with a plastic bag. When garments have been incorrectly sewn, the quality controller returns them to the factory or the contractor to be repaired.

May place retailer's sales tags on the garments at this point. Computerized inventory systems log in a garment as it is completed by the factory or contractor by scanning the bar-coded ticket.

Shipping
Head Shipper/Warehouse Manager

Computerized inventory systems allow the shipping department to know what is on hand in the warehouse and to pull orders for the stores (selecting the sizes, styles, and colors specified on the orders) and to ship garments according to the retailer's instructions. Management of stock on hand is critical to the profits of the company. Unsold garments represent assets spent and not recovered. Reducing the stock on hand (held in the warehouse) is critical to the profitability of a company.

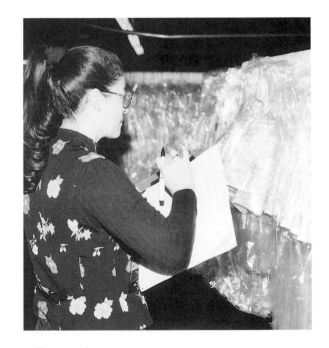

Pulling Orders
The specific garments that stores have ordered are pulled for shipping.
Courtesy: Frank Walter Sportswear.

Designates the carrier (which company will deliver the shipments).

Packer

Packs shipments into boxes or garment bags.

Computerized Garment Control
Factories with computerized management systems track each garment through the sewing and finishing process and log the completed garment into inventory to be shipped.
Courtesy: Frank Walter Sportswear.

Finance Department

Computerized accounts receivable (payments due for merchandise sold) and accounts payable (bills for goods and services incurred in the manufacturing process) is one of the first departments to be automated.

Large fabric suppliers and apparel manufacturers are implementing electronic check transfers that will eliminate paper checks and make direct bank payments. JC Penney insists that all vendors have electronic funds transfer. Vendors who are not capable of electronic money transfers can hire a service as an intermediary to facilitate the exchange of funds.

Sends bills and invoices to the stores. Collects payments and manages cash flow.

DEPARTMENTS NOT DIRECTLY INVOLVED WITH CONSTRUCTION AND SHIPPING

Showroom

Head of Sales	*Stylist*
Road Salespeople	*Model*
Showroom Staff	*Clerical People*

Generally, a showroom is centrally located in a regional apparel mart. Occasionally, if the factory is

in the apparel district, it will contain an in-house showroom. Sales activities are carried on here for buyers who visit the manufacturer. Usually, the sales staff contacts out-of-town accounts by mail, FAX, E-Mail, and telephone on a regular basis to check on sales and prevent problems. Salespeople may also call on buyers in the store.

Electronically linking the manufacturer and retailer is increasing. The most sophisticated link, Electronic Data Interchange (EDI), is a business strategy called "quick response". EDI begins when a garment is sold and the bar code is scanned into a computer at the point of sale (POS). This information is changed to a standard electronic format and sent to the participating vendor. The manufacturer receives the information directly or uses a third-party network or contractor who downloads the computerized information to the vendor in the form of an order. Manufacturers and retailers who have established agreements to automatically replenish items sold can immediately begin the manufacturing process. EDI cuts the time it takes to write and approve an order to one day from a traditional 14 days because sign-offs from different levels of authority, mailing time for a hard-copy order, and analysis of sales are done on a daily basis. Retailers maintain a model stock (a predetermined range of sizes, styles, and colors) needed to satisfy consumer demand. The cost of stocking unsold merchandise is high, and both retailers and manufacturers want

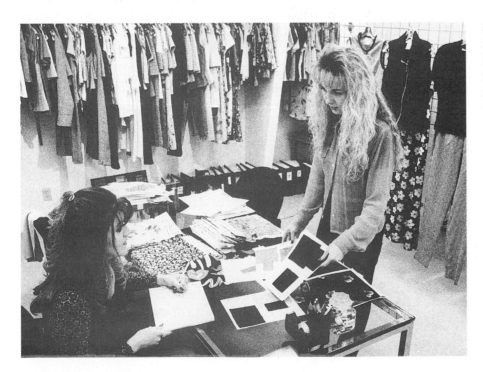

Sales
Sales staff work with retail store buyers in company showrooms, or they may go to the retail store to show the line.
Courtesy: La Belle, California.

to eliminate warehoused inventory. Cutting and manufacturing to order is a method to control inventory costs. Several apparel marts have created up-link studios which can be rented by a manufacturer who wishes to create a virtual showroom, a video presentation of merchandise almost like a visit to the actual facility but televised to a remote site. Using multimedia technology, a salesperson can speak directly to a retailer and can transmit video images of samples displayed on a hanger or a model. This advanced technology is expected to be more widely implemented in the future.

Advertising and Promotion Department

Advertising Manager *Artist-photographer*
Copywriter *Fashion Coordinator*

Plan and execute marketing bulletins, advertising allowances, and trade journal advertisements. In general, only the largest companies maintain a staff in this area, though computer graphics programs allow a commercial artist to produce high quality graphics and photographs easily using a personal computer (PC). Smaller manufacturers will outsource (hire specialists on a freelance basis) to produce printed material.

Accounting Department

Accountant *Clerical People*
Bookkeeper

This department was one of the first to be computerized, using standard financial software programs to handle billing, credit checks, collection of delinquent accounts, and all other bookkeeping. Large retailers are initiating automatic funds transferals that will rely on electronic payments for goods received, charge-backs (retail demands for markdown allowances, advertising costs, and so forth), and other financial exchanges.

Are responsible for payroll, commissions, and general tax accounting.

Pay contracts, bills, and so on.

Finance Department

Investment Counselor (Tax Adviser)

Advises on major capital expenditures and other tax saving procedures. In public compa-

Computerized Accounting
The business processes, such as accounts payable, accounts acceptable, payroll, fabric and supply ordering, and other business processes, were the first to be computerized in most apparel firms.

nies, this department handles legal affairs and stockholder activities.

Factor

A finance company that buys a manufacturer's accounts receivable (retailers' orders that have not yet been delivered and paid for). The finance company takes as a commission a percentage of the total dollar amount and gives the manufacturer the balance of the money. In this way, the manufacturer has ready cash with which to operate while the garments are being made and shipped. Factors also provide credit information on retailers and help a business manage cash flow and capital acquisitions. Sometimes, the factor will take over the billing and financial aspects of the business.

Banking Services

Businesses often need loans and other financial services, such as cash flow management, mortgages, and so forth. Specialists in commercial banking with experience in apparel manufacturing business practices work closely with the finance department when their services are required.

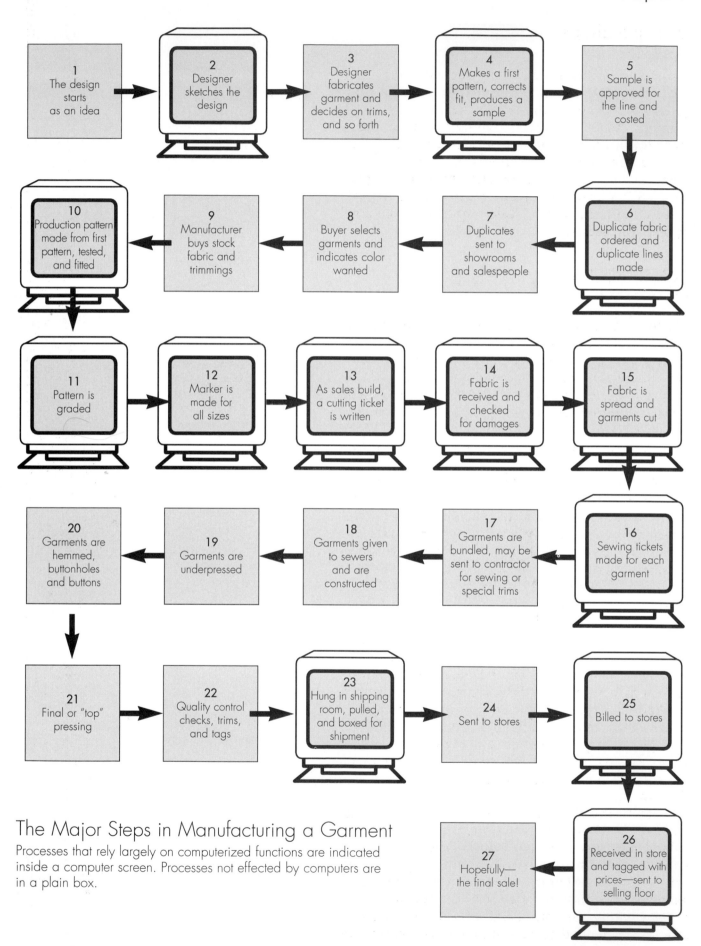

The Major Steps in Manufacturing a Garment

Processes that rely largely on computerized functions are indicated inside a computer screen. Processes not effected by computers are in a plain box.

Machine Shops
Machinist

Manufacturers who have many special embroidery and decorative-stitch machines, particularly lingerie and bathing suit manufacturers, use a machinist to install various attachments on the heads (machines) they already own. Additionally, this department may print labels, boxes, and so forth. Some manufacturers periodically hire an independent sewing machine repair service to keep the machines operating and to make minor modifications in machine setups.

TRADE UNIONS AND LABOR CONDITIONS

Clothing in colonial America was made by women after their other household chores were complete. Early American families set aside a room for weaving and sewing. Fashion was beyond the reach of most people. Those who could afford custom-made garments purchased them from dressmakers and tailors who made them to measure, styling them from European fashion plates and dolls. Most fine cloth was also imported.

At the beginning of the nineteenth century, a revolutionary concept that formed the basis of the apparel industry was born. Garments were produced before they were sold to as-yet unknown customers. Sailors were the first people who needed to purchase ready-made garments, as they did not have the time to have a garment tailored. Enterprising businessmen began to cut fabric into garments and to farm them out to home workers. Women were eager to earn money to supplement their meager incomes. Prices were kept low by the overseers, who played off the out-of-town sewers against impoverished workers from the city slums. In 1846 Elias Howe produced a practical sewing machine. This invention revolutionized the home-sewing industry, though at first workers thought it would put them out of business. Soon most home sewers had purchased a sewing machine to speed their work.

When the first wave of Jewish immigrants arrived in the United States during the 1880s as a result of political upheavals in Russia, the Golden Land turned out to be an urban slum or ghetto, and there was a desperate need to find work. Men, women, and children were recruited as sewers, and the sweatshop was born. Families were crowded into tenements divided to accommodate three families

where previously one had lived. The rooms were cramped and airless and became breeding grounds for tuberculosis and other diseases. Home workers labored long hours under such conditions for wages that would not sustain life.

The Jewish immigrants from Russia were a diverse group. Other countries usually sent farmers or semiskilled laborers to the United States, but the Jewish community that came intact to the New World included scholars as well as laborers. In Europe, the Jewish immigrants had experience fighting prejudice, and many knew how to organize their fellow workers to change repressive conditions. Thus they began to fight the depressing working conditions and subsistence wages by organizing strikes and walkouts.

Several unions were formed at the turn of the century, and each strike became a rehearsal for the next one. The cloakmakers and shirtwaist workers (many of whom were women) became more sophisticated at fighting for better wages and working conditions. By 1910, the International Ladies' Garment Workers' Union (ILGWU) was firmly established and had stimulated public interest in the plight of the sweatshop worker. The Protocol of Peace was formulated to resolve the many problems that existed between manufacturers and workers. This document established fixed hours, a wage scale, and the abolition of "sweating" or homework. Though the Protocol did not survive the decade, it laid the foundation for safety and health conditions, vacations, and retirement benefits that became the basis of American life in general several decades later.

The Triangle Shirtwaist fire on March 25, 1911, during which 146 lives were tragically lost, demonstrated more than any other single event the need for workers to unite to provide a safe workplace, and labor organizations that represented workers in the men's wear and ladies' industries grew strong. Unions in the garment trades suffered setbacks in the 1920s when they were taken over by the communist movement and again during the Depression of the 1930s when bitter competition for food and jobs decimated them. Franklin Roosevelt's New Deal encouraged unions to reinstate decent work and wage standards, and the government enacted supportive labor legislation. David Dubinsky accepted the challenge of removing the communist element during the 1920s, reorganized the ILGWU during the New Deal and World War II, and remained the central labor figure for the apparel industry for 30 years.

During the last three decades, improved technology, legislation (The Fair Labor Standards Act), and an increase in apparel and textile imports have changed the role of labor unions in the apparel industries. Garment-worker unions are strongest in New York and the South. In 1995, the three major garment labor unions, Amalgamated Clothing and Textile Workers of America (men's wear and textiles), The International Ladies' Garment Workers' Union (ILGWU), and the United Garment Workers of America (UGWA), consolidated into one organization, the Union of Needletrades, Industrial & Textile Employees, or UNITE.

There is a trend toward nonunion shops in the West. Southern California has the largest concentration of apparel manufacturers in the western United States. The apparel industry is the largest manufacturing sector in the area and surpasses New York in total production. A two-tiered industry exists. Legitimate manufacturers and contractors realize the importance of dealing fairly with employees, obeying child labor laws, hiring workers with appropriate work permits, paying minimum and overtime wages, and maintaining a safe work environment. Others, called the underground economy, have abusive labor practices and are able to produce garments at lower prices. Pressure on the legitimate sector to remain competitive is fierce.

The manufacturer is squeezed by the retailer to make a garment at the lowest price. Taking production off shore or working with illegal contractors are options which give the retailer the clout to demand an artificially low price. State and federal labor departments enforce fair working conditions, and utilize a law passed during the 1930's allowing confiscation of goods which are being made by an illegal contractor. The retailer contracting for private label merchandise (garments branded with the store name or label) and the manufacturer using a domestic contractor are held responsible for using legitimate contractors.

Legitimate manufacturers and contractors in all parts of the country are challenged to streamline the sewing process, utilize technology to reduce the cost of sewing a garment, monitor employer compliance with labor laws, cooperate to identify legitimate contractors and isolate those who are illegal employers, educate the workers and managers to more efficiently manufacture the product, and maintain the competitiveness of the domestic industry. Capitalizing on innovative management techniques to make working at a sewing machine attractive to people born in

America is the final challenge. Immigrants have traditionally found employment in garment factories the first step to assimilation into American society. This trend is especially true of the west coast industry. Few people born in the United States work in the sewing trades. During the last decade of the twentieth century, strict immigration laws have reduced the flow of foreigners who are willing to work in the apparel factory. The domestic industry continues to face a challenge to make a competitive product with a shrinking labor force that earns a high wage comparative to other countries in the world.

COMPUTER-ASSISTED APPAREL PRODUCTION

Clothing has been manufactured in essentially the same way since the invention of the sewing machine in the mid-nineteenth century. Most companies, especially small, underfinanced manufacturers and contractors, use old-fashioned, labor-intensive methods because they cannot afford the technology upgrades. Sewn-product manufacturers will be forced to reduce their labor force and streamline the manufacturing process to remain competitive in the global economy because wages are higher in the United States than in many emerging countries.

Computers are revolutionizing the apparel industry. Small- and medium-size manufacturers are now able to afford to purchase systems to speed accounting and inventory control and to reduce production costs. Several factors have made this possible during the last 10 years. Technology has improved and the personal computer (PC) can run sophisticated software systems. Many companies now offer similar systems, and competition has also helped to lower hardware costs.

Foreign competition has forced domestic manufacturers to decrease production costs and reduce delivery time to capitalize on proximity to the market. Called "just in time manufacturing," increased flexibility occurs when manufacturers can cut smaller lots, reduce inventory, mark-down allowances and other selling costs, and deliver rapidly. When stores can carry smaller inventories of the right merchandise, avoiding markdowns, American-made garment are more profitable.

Importers also find computers cut down lead time when producing apparel offshore. Domestically designed garments and computerized patterns can be graded on a system and efficient markers made using accurate American technology.

The domestic computer can transfer patterns overseas in a matter of minutes via a telephone hookup to a similar system. The garment can then be manufactured in a foreign country to take advantage of low labor costs abroad.

Production data management systems use diagrams, and printed instructions which can be translated to transcend the communication barrier when dealing with non-English speaking contractors, both domestic and foreign. Software programs have voice capabilities and can communicate directions which correspond to photographs and diagrams explaining construction details in several languages.

Computerizing the Product Development Process

The design room has been the last department in most manufacturing companies to be computerized. Computer-aided design (CAD) technology for apparel has existed for more than 20 years. Why the lag in totally computerizing the "front end?"

1. Design systems are expensive because of the large amount of memory needed to run graphic

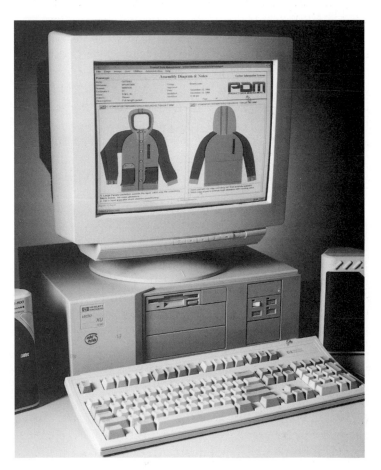

Production Management Systems
Product Data Management (PDM) allows all phases of the design and production of a garment to be tracked and monitored. Networked PCs are placed in all departments that process the garment.
Courtesy: Gerber Garment Technology, Inc.

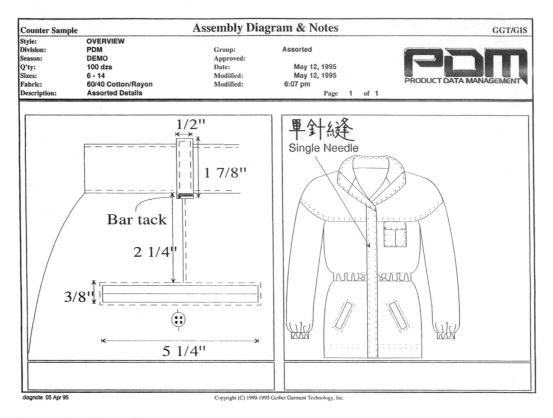

Counter Sample	Assembly Diagram & Notes		GGT/GIS
Style:	**OVERVIEW**		
Division:	**PDM**	Group:	**Assorted**
Season:	**DEMO**	Approved:	
Q'ty:	**100 dzs**	Date:	**May 12, 1995**
Sizes:	**6 - 14**	Modified:	**May 12, 1995**
Fabric:	**60/40 Cotton/Rayon**	Modified:	**6:07 pm**
Description:	**Assorted Details**		Page 1 of 1

diagnote 05 Apr 95 Copyright (C) 1990-1995 Gerber Garment Technology, Inc.

Computerized Spec Sheet

Instructions may be written or spoken in a foreign language to accommodate contractors who do not speak English.

Courtesy: Gerber Garment Technology, Inc.

Custom Textile Design

CAD systems allow the apparel designer to experiment with different textile patterns and colors and to customize them for the apparel line. Artworks™ System from GGT consists of a high-performance desktop PC- and Windows™-based softwear.

Courtesy: Gerber Garment Technology, Inc.

programs. Accessories such as scanners and color printers are needed to utilize design software programs fully.

2. Sketching directly on the computer screen with a stylus is awkward for a person trained to draw with a pencil and pen.

3. Early images were amateurish and lacked style.

4. The domestic design process was not threatened by competition. A critical skill that a successful apparel designer possesses is the ability to adapt a fashion trend to a specific customer. Foreign designer apparel sells well in the United States, but it is difficult for an offshore manufacturer who is not geared to the volume fashion market to create garments that will be successful in the United States.

5. Many designers were unfamiliar with the computer as a graphic tool and were unwilling to master computer skills. Few schools could afford the technology to teach computerized design.

6. It is easy to sketch when trained as an artist, and many designers find drawing inspirational. Sketching a garment is relatively simple when compared to drawing an architectural plan, and the pressure to switch to CAD systems was less intense.

7. Hiring sketching talent is relatively inexpensive.

8. Many designers purchase market fabrics and do not have to create fabrications and color ways.

9. The designer has been relatively isolated and has not had to interface with production, sales, and the ultimate consumer to create a mass-produced design.

Pressure to computerize the design room in the next decade will be driven by economic and practical reasons. An increasingly large segment of domestic customers are demanding unique apparel. Called **mass customization,** this trend will most certainly force designers to offer a range of options for certain categories of apparel so the customer can select color, fit, and silhouette options.

The Textile/Clothing Technology Center [TC]2 defines the traditional "push" apparel production channels as sectors of the industry cooperating to push mass produced into the market place: Fiber—Textiles—Apparel Manufacturing—Retail—Consumer. Under this system, an apparel manufacturer purchases textiles, creates large amounts of the same product, and ships it to the stores, with the expectation that consumers will purchase the majority

of the goods with no input into the creative process. Unfortunately, betting that the customer will purchase all that is shipped to a store doesn't always work.

In the early 1990s [TC]2 introduced modular manufacturing to the United States, and a change from the push to the pull economy began on a small scale. Central to the concept of mass customization is the concept of cutting one-ply high and direct interaction between the designer/manufacturer and the customer. The computer is critical to the success of the pull economy because:

1. customized patterns must be quickly and easily made and the same program used to drive a single-ply cutter
2. the designer communicates with the customer directly to incorporate choice into the development of the product
3. the computer is used to track every phase of the order and to facilitate shipping directly to the customer

Manufacturers who control the textile production process are most successful in the pull economy. This can be done by using a single staple fabric (like denim), creating fabric in-house (typically knitting fabric), or printing fabrics on prepared for print (PFP) base goods. The benefits of a pull process include reduced handling costs, elimination of the warehousing and retail overhead, and no carrying costs for stock on hand or marking down what is not sold. Continued refinement of technology will increase the options for the customer. Body-scanning technology will allow a customized fit, and digital printing will allow for greater variety in print design and colorations. The pull-and-push process will probably coexist in the future, and specific categories of merchandise and distribution channels will respond to consumer demand for specific products.

Levi Strauss has developed a pull sales process for basic jeans by opening several direct retail stores that sell custom-fit jeans to women. Sales associates measure each customer, try on the customer a variety of styles and sizes, and determine exactly how the pant should fit. Single-ply cutting allows one pair of pants to be cut, sewn, and shipped to the customer within two weeks.

Other pioneer designers are already going directly to the customer, bypassing the retail sector entirely. Often, the key to success in this arena is

creating unique textiles, and the CAD is directly linked to patterned fabric design. One by one, the barriers to integrating CAD into the apparel design process are coming down.

1. CAD systems still require high capacity PCs, but the cost has come down dramatically in the last three years. In the past, most graphics programs were developed for Macintosh computers. The majority of CAM and business applications are DOS/IBM (Windows) based. The recent development of power PC that can run both applications will unify the hardware needed to power the design room with systems used in CAM and business departments of a manufacturing firm.

2. Software programs such as SNAPFASHUN© allow the designer to easily combine pictures of silhouettes and details from a "pictionary" of sketches that is constantly updated with current styles.

3. Images have become more sophisticated. Photographs can be modified with a three-dimensional simulation of a garment in actual fabric print or color.

illustration #1 *illustration #2*

Sketch Cad Systems

SnapFashun™ is a library of fashion details and items that are completely interchangeable with each other. The designer selected a variety of details and silhouettes, which are periodically updated from successful garments in the marketplace. The software assembles the computer illustrations into an infinite number of new styles.
Courtesy: SnapFashun.

illustration #3 *illustration #4*

illustration #5 *illustration #6*

4. Directly linking to customers will become critical to the success of upscale clothing in the future. In addition, reducing design lead time will force the design department to assume more marketing tasks. Retailers wishing to create unique merchandise are demanding input into the design process. Interactive design is possible by real-time linking of a two computers. Designer and retailer can work on a sketch, approve the concept, and agree to create a sample in a matter of minutes at different locations.

5. The educational community has become comfortable teaching CAD in the area of graphics, architecture, and visual communications. Gradually, colleges and universities are acquiring computerized apparel design labs that allow more students to learn to use the tool. Software designers have generously discounted their products to educators teaching CAD.

6. The computer is recognized as a universal graphics tool, and more students are comfortable using it. CAD design packages assist persons who do not have drawing skills.

7. Persons trained in CAD tend to be paid higher wages but can perform more efficiently and assume other duties.

8. Pioneer CAD apparel designers mastered computer skills to develop unique fabrications and then readily translated the technology to sketch silhouettes and details.

9. Future successful designers must interact with the production, marketing, and ultimate customer as the market demands rapid response to consumer demand and mass customization.

What Will the Design Department of the Future Look Like?

Profound changes in technology and a revolution in the way consumers will acquire goods and services will gradually force the apparel manufacturer to integrate product development into all phases of apparel design, production, and sales. Body scanning is in the developmental stages and, when perfected, will allow customized patterns to be made computer generated for the individual body.

Product development and presentation costs for a typical firm are broken down as:

8%—concept stage; generating new ideas
8%—developing story boards and preselling concepts

37%—sample production
13%—textile selection and development
17%—merchandising the line and estimating
 initial garment costs
17%—marketing and sales costs

Computer and multimedia technology applications will speed each phase of product design and sales:

Concept Phase:
1. research the World Wide Web (WWW/Internet) coverage of foreign fashion shows; catalog and present retail products
2. use software-based fashion reports to discover new trends and style details

Develop Storyboards and Preselling Concepts:
1. utilize software-based programs to sketch, color, and design product

Computerized Storyboards
The ArtWorks™ system allows a designer to simulate fabric and color changes on photographs of sample garments.
Courtesy: Gerber Garment Technology, Inc.

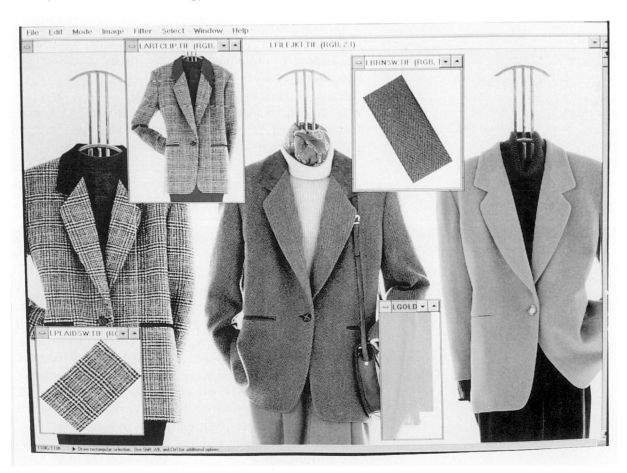

2. link directly to buyers in remote locations to create a "virtual" (simulation of reality) sample collaboratively
3. use software and graphics programs to develop storyboards that can form both sales catalogs for sales staff and retail catalogs
4. create a digital video of the virtual sample on a live model

Sampling:
1. make sample using a patternmaking system
2. computerize the sample marker and compute accurate yardage
3. start the cost sheet, pattern sheet, and specs that will guide production of the ultimate garment
4. begin to track purchase of stock fabric, lining, interlining, and findings

Textile Development and Selection:
1. use on-line directories and E-Mail to locate and correspond with fabric, yarn, and trim vendors
2. explore a wide range of color ways and patterns
3. develop knit and woven patterns in a wide range of colors and textures to customize textiles
4. simulate yarn and fabric wear and care specifics
5. create unique fabric patterns and digitally print (using a process that will be technology similar to printing a color Xerox today) a limited amount of yardage to cover initial samples

Line Merchandising and Costing:
1. rework the designer cost sheet to reflect overhead and other business related factors
2. project deliveries and production schedules
3. easy retrieval of previous style information, cost sheets, and data to speed costing and the updating of production specs
4. illustrate spec sheets with diagrams, measurements, and verbal and written specifications in any language

Marketing and Sales:
1. use laptop PCs to computerize ordering and successful sales formulas for sportswear, size distribution, and so forth
2. connect regional offices and factories to track production and delivery schedules via E-Mail
3. go directly to retail customer by sales through on-line catalogs on the WWW, retail kiosks, infomercials, and home shopping networks
4. track sales of individual styles and project fabric purchases

5. link directly to retailers to have continuous inventory and sales updates or automatic stock-replenishment programs
6. maintain inventory information prior to shipping
7. develop CD-ROM sales presentations
8. allow the consumer to customize the product by selecting from a menu of colors, prints, and made-to-measure garments specifically for the particular body type and taste

The technology exists and has been adapted to apparel production, and use of the computer and multimedia will expand during the first decade of the twenty-first century, driven by large retailers who demand efficiency, rapid garment delivery, low prices, and exacting specifications. Computer applications will be discussed in detail throughout the following chapters.

THE DESIGNER'S ROLE IN PRODUCTION

The designer must understand the production procedures of the factory. If the designer is to produce a garment compatible with the price range and technical limits of the production system, he or she must understand the whole production process. This is particularly important when selecting fabrics. Often a factory cannot sew a delicate fabric, or new machines or techniques will have to be used on a new fiber or fabric construction. Generally, the designer will recognize potential problems when he or she constructs the sample in the design room. The designer should test how each new fabric reacts to pressing, washing, or dry cleaning. Often, a manufacturer will have a washer and a dryer on the premises to test washable fabrics. The designer will pass on all this information to the production person, who may modify the sewing or pressing techniques for stock goods.

The cost of sewing a garment can be reduced if the designer is aware of specific seam-and-finishing applications that do not detract from the aesthetic appeal of the garment but that can speed the construction and allow the garment to have a lower SAM or construction time. Progressive manufacturers should cost the sewing portion of the garment with these shortcuts in mind and should include the designer in the process so that the appeal of the garment is not compromised.

The designer plays an important role in the sales department too. He or she will often conduct sales meetings to inform salespeople of reasons for the styling of a line and specific fabric information they will need to sell the merchandise to buyers. Designers should have contact with retailers and other outside sources to discuss fashion trends and consumer reactions. Visits to stores to see how their garments fit a variety of sizes and figures is important for all designers. Sometimes, the designer is promoted as a personality and makes public appearances at fashion shows or in retail stores.

All this interaction between the designer and the sales and production departments of a manufacturing plant is easy to understand when we remember that a designer's primary job is to create a product that sells. *No matter how large or small the manufacturer, to stay in business season after season, the firm must make a salable garment.*

THE FREELANCE DESIGNER

The freelance designer should determine the extent of responsibility that the manufacturer expects before accepting a job. Some designers are hired only to sketch new styles. The manufacturer adapts these sketches to fabric that is preselected and supervises the sample development and production. A stylist is another type of freelance designer who edits a line, suggesting which styles are most likely to sell and adding market items that are selling well. A stylist may not even sketch the garment but usually has a background in retailing and can tell what will sell.

A freelance designer may sketch the garment and produce the first pattern and sample. This designer is usually not involved in the marketing or production of garments.

A company may contract with a freelance designer to do an entire line or one phase of a line that requires special knowledge. For example, a coordinated sportswear manufacturer often hires a specialist to design sweaters. The manufacturer should spell out the responsibilities of the designer before the work begins. Usually, the manufacturer supervises all aspects of the production. A freelance designer is not paid benefits or included in the company's pension or bonus plans and does not work during months when there are no design activities, so the manufacturer realizes a substantial savings by not having an in-house designer.

Summary

The major departments in an apparel manufacturing firm are design or product development, production, and sales. No matter how large or small, these three areas require specialized attention and a manufacturer cannot be successful if any one of them fails. As companies grow, personnel are added in other areas not directly involved with the production and shipping of garments. Advertising and promotion bring the manufacturer to the consumer's attention. Showrooms in larger markets replace contract salespeople when volume is substantial enough. An accounting department and legal and financial assistance are needed by even the smallest companies.

Contracting out various phases of product development, production, and sales allows entrepreneurs to enter apparel manufacturing with relatively small investments. Domestic contractors also provide specialized accessories and services to the largest manufacturers. Offshore production allows an importer to contract out all phases of the business except product design, shipping, and finance.

The main phases of garment production are pattern and marker preparation, grading, cutting and bundling, sewing and special trims, and, finally, shipping. All areas of garment construction now are being computerized, speeding design and production time and reducing the number of personnel required to make a garment.

Trade unions have worked throughout the history of the garment industry to improve the conditions of apparel workers. Specialized unions represent workers who produce women's apparel, men's wear, uniforms, and jeans.

The design department of the future will be computerized and linked to all the other processes of production and distribution of the product to the customer. Improved technology will reduce the time it takes to get the right product at the right time to the customer. Mass customization will provide well-fitted garments via a variety of electronic distribution methods to the ultimate consumer.

The designer's role in the production of garments depends on the size of the manufacturer and the designer's ability. Usually the designer must interact with sales and production to make sure the original design concept is understood by the sales team and is translated into a production garment of high quality. Freelance designers are hired to produce specialized garments or limited lines, depending on the needs of the manufacturer.

Review

WORD FINDERS

Define the following words from the chapter you have just read:

1. Bundling
2. CAD and CAM
3. Capital
4. Computer graphics
5. Contractor
6. Cutting ticket
7. EDI
8. Factor
9. Findings
10. First pattern
11. Grader
12. In-house shop
13. Just in Time
14. Marker
15. Mass customization
16. Overlock
17. Piecework
18. Presser
19. Production pattern
20. Production person
21. Production tickets
22. Quality control
23. Standard Allowed Minutes (SAM)
24. Section work
25. Salvage
26. Showroom
27. Single-needle machine
28. Spec sheet
29. Spreading
30. Trimmings
31. Virtual sample
32. World Wide Web

DISCUSSION QUESTIONS

1. List two advantages a large manufacturer has over a smaller manufacturer.
2. Discuss the advantages and disadvantages of an inside shop as compared with an outside shop.
3. Large or small, what must an apparel manufacturer do to stay in business?
4. Why should a designer be familiar with production procedures?
5. Describe how two areas have been changed because of computer applications.
6. What advances have the garment trade unions spearheaded for their workers during the twentieth century?

CHAPTER **2**

What Does a Designer Do?

What exactly does a designer do? No two designers will answer this question in the same way because each designer does so many different things. As a rule, designers work for a wholesale apparel house or manufacturer, and their duties include a range of interrelated jobs.

Usually the designer is directly responsible to the head of the company or the division. The head of the company or chief operating officer (COO) directs the overall operations that allow the company to function. The COO supervises the sales personnel as well as the functions considered to be the business side of the operation. In addition, depending on the size of the company, the COO may work closely with the designer in choosing fabrics and finalizing the styles selected for the line.

As outlined in the previous chapter, the average apparel firm is divided into three major departments: design, production, and sales. The designer is actually a participant in all three departments. The best way to present a picture of the designer at work is to trace the creation of a line. The line begins as a series of ideas in the designer's mind, ideas that are made concrete in the design process, then sold to the retailer, and finally sold to the customer. Let us trace the process.

RESEARCHING COLORS AND FABRICS

The first step in creating a new line is to research fashion and consumer trends. The numerous excellent sources of fashion information will be discussed

When you have read this chapter, you will understand:

1. The diversity of duties a designer may have.

2. How aesthetic appeal, price, timing, fit, and durability interact to make a garment salable.

3. How a designer develops a line.

4. The personnel needed in a design room.

5. How a line is merchandised and distributed.

6. The importance of pattern development.

7. Manufacturing categories in women's apparel.

8. How to interview for a design job.

Lisa Millward reviews textile line with her assistant, selecting patterns and colors that will fit into her line.
Courtesy: Lisa Millward, La Belle, California.

in great detail in Chapter 3 (which explores fabricating a line and sources of inspiration). Generally, the designer will begin by investigating color trends. Information on color trends for the coming season usually comes from fiber and fabric companies and professional color services. On the basis of these general predictions, the designer selects the colors that will make the line unique and salable. Once the color story is set, the designer begins to review textile lines.

Often, someone from management—perhaps the head of the company, the merchandise person (head of sales), or the stylist—will assist the designer in selecting fabrics and colors. Those people who participate in the selection will exchange information on new fabrics and incorporate them into the mix of proven fabrications. Fabric (also called piece goods) is a great source of inspiration, and the excitement it generates starts the creative process.

In some apparel companies, the fabric is designed and created in-house. This is especially true of knit fabrics that can be easily customized and knit in small quantities of a pattern and color-way. Woven fabrics require more complicated looms,

larger yardage runs, and exacting finishing techniques and are therefore rarely created by the apparel manufacturer. The designer who creates the fabric also starts the process by researching color and then shopping the yarn market. Customizing fabrics is discussed at great length in Chapter 6.

Frequently, a style is carried over from one season to the next because it has sold well. Manufacturers tend to run (continue) with a hot number as long as the style will sell but only when a style has proved itself by continuous reorders. The designer must know the styles that have become hot items. He or she will then refabricate the style to make it more attractive to buyers. (*Refabricate* means to put the "good body" into another fabric.) Many times a designer is asked to incorporate parts of a good body into a similarly styled garment or version of the original.

CREATING STYLES

Once fabrics have been selected, the designer begins to create styles for the line. The refabrications and versions of good bodies from the last season may provide the basic styles or staples of the new line. Then the designer begins to style the new garments.

Most designers work within the narrow constraints of the category that has been assigned to the manufacturer by the stores that purchase the product. For example, a missy, moderate dress manufacturer may be further defined by retailers as

Styles to be made up as samples are swatched and pinned to a workboard according to the fabric so that all members of the design team know what work is in progress. *Courtesy: Joan Martin.*

specializing in print dresses made in easy-care fabric. Usually, it is very difficult to change this reputation drastically because customers come to a manufacturer expecting to find a special kind of merchandise. Often, buyers will allocate money to the specific category of merchandise and the manufacturer who has a reputation for producing it well. This can be a dangerous trap for a manufacturer. Overspecialization is disastrous if the category of merchandise sold goes out of fashion. To avoid overspecialization, the manufacturer should diversify the product line so that it is current with trends in the fashion market.

The designer must think of the customer who will buy the merchandise. Some manufacturers sell directly to the customer by opening their own stores to test merchandise or outlet stores that sell closeouts and overcuts at a reduced price. Outlet stores are usually located at a distance from established retailers who sell the product at full price.

Original Garment

Versions of a style that has sold well should incorporate the most important style features of the original garment. Sleeves may be changed to make the version appropriate for the new season. Fabric is often changed when the original is no longer available.

Creating Styles
Lisa Millward, designer for La Belle, sketches many more designs that will appear in the line. After evaluating and editing, she will decide the sketches to make into samples and then edit them again.
Courtesy: Lisa Millward, La Belle, California.

Other manufacturers reach the customer directly through catalog sales, home shopping networks, and on-line catalogs. This trend is likely to continue because it is more profitable and allows the manufacturer to control production more efficiently.

The customer is eager to explore new ways to purchase goods of all types. In 1995, approximately 23 percent of the population had home computers, and 77 percent had televisions. Is expected that PC ownership will equal that of televisions during the first decade of the twenty-first century. Linking these two technologies will provide many new ways to distribute apparel. The typical PC user is eager to link to on-line services. Trained by video games, this younger customer is readily accepting new ways to shop. Selection, convenience and value, as well as the ability to shop at home and overcome the problem of inept salespeople, are all factors driving this new trend.

Designers must stay in touch with their customer to understand what the customer wants and what the customer's figure problems are. Some designers visualize an "ideal customer," a person who

wears their garments well. Good designers never lose sight of the individual who will ultimately have to find the garment attractive enough to purchase it, no matter how large the manufacturer or the way the merchandise is distributed. Designers constantly shop stores and other retail outlets that distribute their line and similar merchandise to evaluate how their styles are selling. Salespeople usually are eager to share news of hot items. Electronic shopping is readily accessible to evaluate the products being offered. Most manufacturers will knock off (copy identically, or slightly change) good sellers. Designers also shop better lines to find out what is selling at more-expensive price points. Often, these are indicators of what will be hot next season at a lower price.

The following specific requirements for a good style also must guide a designer as he or she creates the actual garments.

Aesthetic Appeal

The garment should be attractive to a specific customer. Customers' aesthetic requirements differ with every size, price, and age range, but everyone is looking for a stylish garment. Therefore, the fabric in every garment should be attractive and fashionable in print and color. Most customers touch a garment immediately after being visually attracted to it, so the hand (feel) of the fabric is as important as its appearance. It is a challenge to communicate how the fabric feels when selling via television or on-line.

Hanger appeal is very important in the customer's first evaluation of a garment in a retail store. Clothes that do not present themselves well on a hanger (a halter dress, for example) benefit from being displayed on a mannequin. A garment that looks attractive on a hanger has a much better chance of selling than a garment that does not.

Computer simulation will allow the customers to "see" a garment on their body in a variety of environments. In the future, consumers will be able to customize fabric colors and patterns, garment fit and styles for their specific needs. Designers can set up a variety of choices that will provide the customer with aesthetically appealing garments and allow them to select an individualized outfit.

The designer should create each garment for a specific kind of occasion. For example, a showy garment is fun to look at and display, but where would it be worn? Accessorizing a garment is important

too, and the designer can help the customer pick accessories by adding a belt or trim that suggests a color for shoes and bag. A garment that can be accessorized easily and yet is suitable for a range of activities is likely to sell.

Price

The garment should be a good value for its price. If the price is too high, the customer will probably not try it on, even if she likes the style. When the designer styles a garment, he or she must consider the price of every detail, from the initial cost of the fabric to trims and construction methods. Ultimately, the garment's success or failure may depend on cost.

The price of a garment is relative to the prices of garments that surround it in the store and compete with it in the market. The manufacturer's sales department tries to sell the line to the department or store that has the most compatible merchandise, both in price and "look" of garments. Generally, a store organizes its departments by grouping similar merchandise in "price points." These are price ranges that appeal to a specific customer. The buyer tends to concentrate purchases in the middle of the assigned range, with a few lows, especially at sale times, and occasional high prices to include fashion merchandise. Manufacturers must maintain similar price points so that they fit clearly into a department. Usually, a line will not sell well in a department if it is the most expensive offered. Furthermore, the designer must be careful not to select a fabric or print that is used by other manufacturers for a lower-priced garment.

Timing

Successful designs usually fit into a general fashion trend and satisfy the customer's desire to be unique and fashionable. Again, how these requirements are met varies greatly for different customers. During the same period, the young junior customer may be buying authentic work overalls, the young missy (contemporary) customer may be looking for copies of European prêt-à-porter (ready-to-wear), and the designer customer may be looking at Paris couture. Many excellent products have hit the sale racks because they were too early or too late for the fashion taste of the moment. The designer must be aware of general fashion trends and, more important, the trends that are influencing his or her particular market.

Fit

Once the customer has selected a garment to try on, the chance of selling that garment improves. Now, the way the garment looks on the customer's figure is crucial. The customer wants the garment to fit and make her look taller and more slender. If the designer has created a garment to fit a slender, tall model, many average customers with figure problems will be disappointed when they try it on. The garment that conceals figure problems, flatters the face and body, fits well, and is pleasingly proportioned will be a success—and success means a garment that sells!

Experiments to customize the fit of a mass-produced garment have begun with jeans. Levi Strauss introduced a made-to-measure program for basic jeans in 1995. Body measurements, combined with trying on standard-size jeans allow each customer

Fitting
Fitting the first sample is a critical part of design. The garment should fit the customer's figure, but it should also look good on the hanger so that the customer will be tempted to try it on.
Courtesy: Joan Martin.

to create a personal spec for a customized pair of jeans. This data is fed into a computer and a single pair of jeans is cut, sewn, and shipped to the customer in about three weeks at a cost approximately one-third higher than off-the-shelf pants.

Body scanning to determine the exact measurements of a body is being developed by the Textile and Clothing Technology Corporation, [TC]2. Levi will pioneer the use of body scanning to customize jeans, and this technology will transfer to many types of garments. Better standards of fit for mass-produced garments will follow. Technology exists to customize patterns quickly, and single-ply automatic cutters make cutting one garment profitable.

Care and Durability

Most customers examine a garment to see if it is well made. Easy care, particularly wash and wear, is an important part of making a satisfactory garment. If the designer chooses a wash and wear fabric but lines the garment with a fabric that must be dry-cleaned, the designer defeats the outer fabric's purpose. Many chain stores recognize the importance of durability. A chain store may give the manufacturer specific instructions about how the garment should stand up to washing and ironing. High-priced garments usually require dry-cleaning because they are made of delicate fabrics and because there is less customer resistance to the maintenance cost. The successful performance of garments also depends on the designer's care in selecting trims and findings.

Usually, the responsibility for performance is shared by the production and design departments. If a fabric performs badly, the manufacturer may choose not to use it. If the fabric is faulty but is already made into garments, the manufacturer may attempt to place the responsibility on the textile mill that sold the fabric. Care and durability are particularly important in designing and selling children's apparel, uniforms, and work clothes.

With aesthetics, timing, fit, and other considerations in mind, the designer plans the styles. The number of models or pieces in the line depends on the type of garment, the price range, the method of distribution, and the number of lines made by the manufacturer. A variety of garments will be planned for each type of fabric selected and for each category of garment in which the house specializes. A certain portion of the line will be conservative staples, and a certain portion will be more fashionable.

The designer chooses the belts, buttons, and other trimmings. The choice of both fabric and trimmings is influenced by price as well as appropriateness.

DEVELOPING A LINE

The techniques used to develop a line vary. A designer must be able to draw or create a working sketch or *croquis*. The sketch may be hand drawn or created on a computer. This working sketch may be shown to the product development team during discussions about the garments that are to be made up. The working sketch is given to the assistant as a guide in making the pattern. The silhouette or shape of the garment is important because it tells the patternmaker how much fullness should be in a skirt, a sleeve, or a bodice. Copies of the working sketch identify the sample pattern. The sketch is also used on the cost sheet. When production is computerized, hand-drawn sketches are scanned into the system and replicated on all the working documents necessary during production.

A working sketch differs from an illustration. A *fashion illustration* is a finished, carefully rendered drawing that glamorizes a garment. A designer who is fond of drawing may prepare a more elaborate sketch for use outside the workroom but also will

Working Sketches
Style sheets, like this one from Lisa Millward's line, illustrate the pieces in a group.
Courtesy: Lisa Millward, La Belle, California.

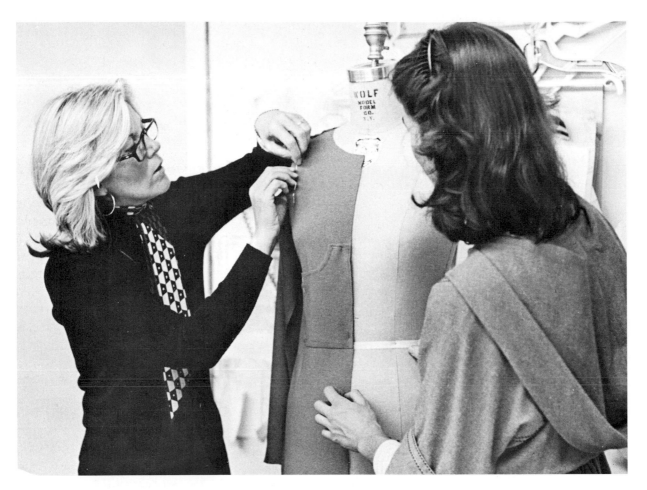

Draping
Usually, only half the garment is draped to begin the pattern. Joan Martin is making corrections before the pattern is made by the assistant designer.
Courtesy: Joan Martin.

draw a working sketch to guide the patternmaker in constructing the garment. A designer does not have to know how to illustrate but must know how to draw or create a computerized working sketch.

Some designers are inspired by working with muslin or the final fabric, draping it on a dress form or even on a live model. If a dress form is used, the designer drapes and pins the muslin into a three-dimensional form that is really a soft sculpture. When the designer is satisfied with the look and fit of the drape, the fabric is removed and the shape is transferred to a flat pattern. This pattern is made into a complete muslin (the first drape is often done on only half the dress form, and a complete garment is necessary to check the fit). After corrections, the pattern is cut out of the sample fabric and made into the finished sample. Some designers prefer to *work on the flat,* also called *flat patternmaking,* which is a method of developing a style by making changes according to geometric

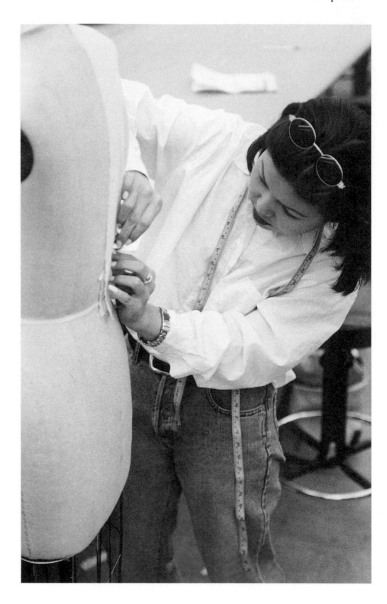

Muslin Drape
Muslin is an inexpensive cotton fabric that is usually used to create a first pattern for a woven garment. Muslin is available in several weights to approximate the final fabric.

rules in a basic block or sloper (a simple pattern with standard ease) and then completing the test muslin. Of course, the pattern can also be made on a computer.

The choice of method depends on the designer's preference and training and the type of garment. Whatever the method, the result must be a garment that fits a human body. A model may show the style to buyers who come to the showroom to choose garments from the manufacturer's line and place orders for their stores. Less-expensive garments are shown on a hanger. Designing is truly experimental. Every designer makes a great many unsuccessful samples. A good design has the fortunate combination of the right fabric, the right cut, the right trimming, the right price, and the right margin of profit.

THE DESIGN ROOM

The designer's primary responsibility is the creation of seasonal collections, but he or she is also head of a department and has executive functions. The designer is expected to take charge of the personnel in the design (or sample) room. The designer must cooperate with the sales force, the production department, and the merchandisers because creating a line is a team effort.

The designer usually has a staff in the design room to help develop ideas and execute sketches for the line. The designer must coordinate all staff activities and make sure the flow of work is constant. The number of people employed in the design room depends on the volume of work. The more functions a designer can perform in the design routine, the more valuable that designer is to the firm.

A typical design-room staff is described in the following list. Each job requires at least one person, depending on the amount of work to be completed.

1. *Assistant designer.* This person is usually a good patternmaker. The assistant may work on the flat, drape in muslin, use a computer to make the pattern, or combine several methods, but he or she must make an accurate pattern that translates the designer's working sketch into an actual garment.

2. *Sample and duplicate cutter.* The cutter uses the designer's first pattern to cut sample garments and duplicates out of sample fabric. Duplicates are extra samples used by the salespeople and

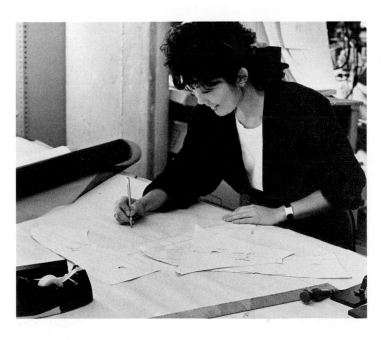

Assistant Designer
The assistant is using the flat-pattern technique; that is, she is translating from the sketch to the first pattern without draping the design first.
Courtesy: Tadashi.

other showrooms to sell the line. The design department frequently supervises the construction of the duplicate sample line. Duplicates are also called *dupes.*

3. *Samplemaker.* This person constructs the sample garment and may press and hand finish the sample. The samplemaker works with the designer and the assistant designer to fit the sample perfectly to the model. Usually, the samplemaker has had a great deal of experience in factory sewing methods and can spot potential difficulties. She can alert the designer to sewing problems that can be solved by the production-pattern person or the staff of the design room. The success of a designer's styles depends on a good samplemaker. For this reason, the samplemaker is generally paid by the week, not by the piece, because the number of samples completed is much less important than a carefully made garment.

Sample Cutter
The sample cutter cuts one garment. If the first sample is successful, duplicates will be cut for out-of-town salespeople and reference samples.

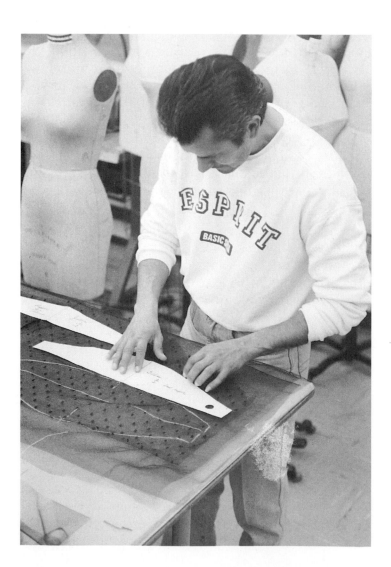

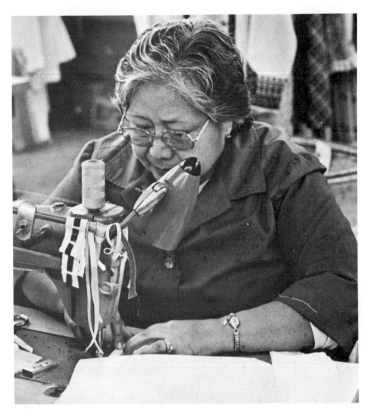

Sample Construction
The construction of the sample takes much more time than the construction of the same garment in production. Care must be taken at this stage to produce an attractive garment, and the sample maker works with the first patternmaker to make corrections in the sample pattern.

4. *Sketcher.* A sketcher or computer operator may be employed to make working sketches for the designer and illustrations for the final promotion of the line. Working sketches are pencil croquis or computer flats (a flat rendering of the front and back of a garment) made from the designer's rough idea of the garment. The flats are used in the sample room. The flats must interpret precisely the silhouette (shape and outline) of the garment and draw all seam lines and trims. Illustrations are smart fashion sketches that are used for storyboards (color renderings shown to a buyer prior to a sample being made), in the showroom book, or for advertisements. Usually, these sketches are color renderings that emphasize the texture and/or print of the fabric. Because manufacturers are trying to cut costs, the designer is encouraged to learn how to operate CAD programs that translate working sketches into finished illustrations or modify photographs to resemble the new sample.

5. *Miscellaneous duties.* These include shopping for findings and trimmings, supervising the making of duplicates, running the design room in the absence of the designer, filling out cost and spec sheets, and supervising the receipt and storage of sample fabrics. In a large house, these duties may be the responsibility of one full-time employee; otherwise, the duties are part of the assistant's job.

Working Sketch

Frequently, the working sketch will include measurements, colors, and other style notes. In contrast, the fashion illustration is drawn to show the garments at their fashionable best. The illustration does not show all the technical details.

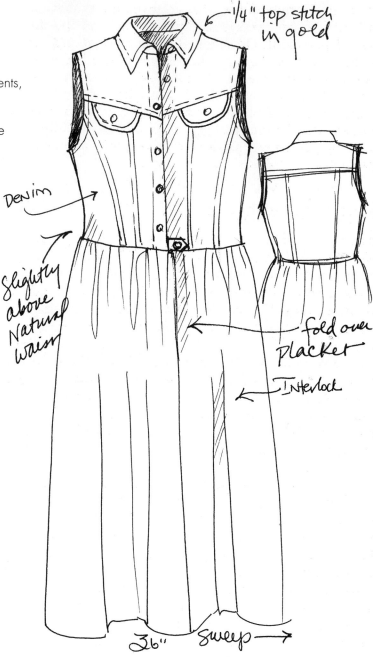

6. *Freelance models.* Fit models try on samples so that the designer can fit and evaluate the garments. Models are also used to show the salespeople and buyers the samples during sales meetings and market weeks. The fit model also works with the production patternmaker to perfect the fit of stock garments.

Beginners are rarely hired as designers. The responsibilities a designer must assume are so great

that any manufacturer with an investment at stake will require an experienced person to head the design department. Occasionally a small or struggling house will hire a novice, but as a rule the beginner is hired as an assistant to the designer. In this capacity, he or she will perform a variety of services, depending on talent and training. The different jobs undertaken in the design room are an excellent starting place for a student who wishes a career in designing.

MERCHANDISING THE LINE

After all samples are finished, usually right before the season, the line is appraised and merchandised to weed out the potentially unsuccessful styles. Many of the samples are discarded. If they cannot be fitted into the manufacturer's price range, even some of the most attractive numbers may be discarded.

How a line is merchandised depends on the policy of the manufacturer. The designer may show the line to the company head, who will review each piece. The company head decides whether the consumer will be willing to pay the price that will make the garment a profitable item. In one successful firm, if the head of the company is doubtful about a style, he asks the fitting model for her views. Models sometimes develop great sensitivity to the line because they show garments day after day and overhear the buyers' frank remarks about styles. In large firms, the salespeople are asked to participate in weeding the line because they also have great sensitivity to buyer reaction. The production person should be the technical adviser at the merchandising meeting so that he or she can evaluate the practicality of the designs with regard to cost and product. The designer and merchandiser round out the evaluation team at a typical merchandising meeting. Some houses merchandise the line using the advice of several favorite buyers whose consistent success with the line proves their familiarity with customer reaction. Generally, weeding by any method reduces the line to relatively few garments. For production to be economical, only a few styles can be developed, but only a few really good numbers are needed for a house to have a successful season. As the price of the line increases, the number of pieces in it usually increases as well. High-priced lines contain many styles because these customers demand exclusiveness above all else.

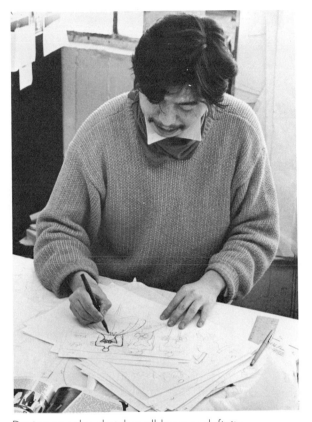

Designers who sketch well have a definite advantage because their ideas can be communicated to coworkers quickly. *Courtesy: Tadashi.*

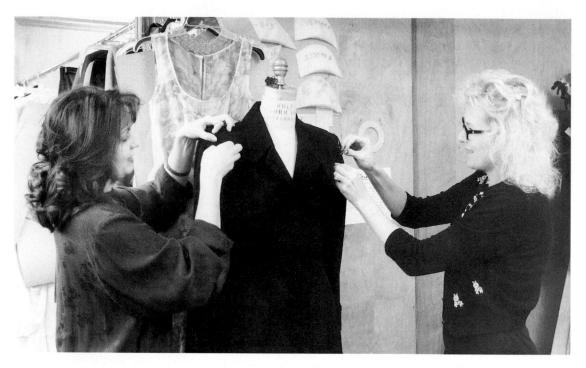

Production Patternmaker
The production patternmaker makes a first production sample, and then perfects it until it is easy to construct in the factory. The designer often assists the production patternmaker to make sure that the garment retains the look of the sample.
Courtesy: Lisa Millward, La Belle, California.

PATTERN DEVELOPMENT

The designer's involvement in the development of the production pattern varies greatly from company to company. At one extreme, the designer may never see the final product because all production procedures are separate from the design room. At the other extreme, the designer may be responsible for making the production pattern and supervising the grading and marker making. The latter system is prevalent in small firms.

Typically, the designer is called upon to make aesthetic decisions about the production garment when changes in pattern or proportion must be made to make the garment fit better or make it easier to produce. The designer may be asked to advise the production area on how to reduce the yardage in a garment.

Once the line has been merchandised and the styles are chosen, the designer usually gives the first sample to the production patternmaker. It is necessary to make patterns for each garment in each size offered. Missy lines offer their garments in sizes 6 to 16, and junior lines are sizes 3 to 13. Pattern development is such an expensive process that produc-

tion patterns are not made until the line has been weeded and successful styles have been established through early sales. In most cases, the first pattern used for the original sample is made to fit a model who is not a perfect commercial size. (Showroom models have the idealized proportions used in fashion drawings—broad shoulders, narrow hips, long legs—so they can show samples with great elegance and chic. The more-expensive houses use tall women for models; popular-priced houses may use shorter models; the least-expensive, or budget, houses show the garments on hangers.)

The production patternmaker cuts an accurate or perfect pattern for each sample chosen for the line. The original sample and pattern guide the production patternmaker. The result is a pattern in the stock pattern size (whatever regular size the manufacturer uses as a standard). Usually this is a size 8 or 10 in the missy range and a size 7 or 9 in the junior range. The patternmaker can drape, use the flat method, or a computer to duplicate the sample. Additionally, the patternmaker tries to simplify the pattern because a factory sewer will construct the production garments, not a skilled samplemaker. Speed and accuracy are two reasons why many companies computerize both the sample and production phase of pattern development.

The patternmaker has a stock sample cut and made in the factory to "prove" the new pattern. Frequently, several production samples will have to be made before the fit and the pattern are perfected. The production sample is fitted on a fit model, a woman whose measurements are the commercial measurements for the stock size. The stock sample is compared with the original designer sample to see

Patternmaking Tools

Traditional patternmaking tools include rulers, a brush for cleaning the pattern, pushpins and a weight to secure the pattern as it is traced, French curve for smoothing the curved lines, various pencils and markers, transparent tape, rabbit punch for holes that allow pattern pieces to be hung on a pattern hook, large stapler for putting double pattern pieces together, transparent rulers, tape measure, pins, notcher for marking the pattern, hole punch for marking darts, paper shears, tracing wheel for marking, fabric shears, seam-ripping scissors, and staple remover.

Computerized Patternmaking
A computer becomes the tool that eliminates the need for paper and traditional patternmaking implements. Storage is simplified as well.

that the stock fits properly and is as salable as the original. If the designer has a good understanding of garment construction, the sample will be designed with seams in the proper places. Otherwise the patternmaker may have to change the lines of the garment so that it can be cut in a standard way and laid out economically.

The designer usually joins the head of production, the head of sales, and the production pattern person to discuss the final garment that is chosen as the prototype for stock (garments that are manufactured and sent to the stores).

DISTRIBUTION

The sales department consists of the head of sales (also called a merchandise person), showroom staff, and the salespeople who work under his or her direction. The showroom staff is in charge of the showroom, maintaining the current sample line, and contacts buyers to review the line when visiting the market. Assistants compile and record all orders placed, handle special orders and trim replacements, and manage other details relating to retail stores and their orders.

Buyers from retail stores in all parts of the country are invited to visit the showroom for sea-

sonal showings. Between market visits, buyers replenish their stock in the following ways:

1. A buyer may reorder runners (styles that sell well and have been recut several times) by phone, following up with written confirmation order (called *paper*). Some stores establish automatic replenishment programs with vendors of staple products linked by Electronic Data Interchange (EDI) technology.

2. Traveling salespeople regularly visit established customers, taking some numbers from the line—especially new styles added since the line opened—as well as a book of illustrations and a complete set of swatches. Most manufacturers who sell to speciality stores contact their buyers this way.

3. As a rule, a retail store is affiliated with a buying office. In this way, groups of retail stores in different cities can join in a loose federation to obtain up-to-date information on the market. When buyers go to New York or California, their buying office may brief them on "resources," as the wholesalers are called. If needed, buying office representatives may help out-of-town buyers in the market. Buying offices constantly review the local market and the lines in their price and size area. They furnish member stores with information on new items and new resources by publishing bulletins and presenting fashion shows during market weeks. Furthermore, a buying office may purchase merchandise for member stores between the regular buyer's visits.

Showroom Personnel: Selling
The showroom personnel have two important responsibilities: selling the line and guiding the buyers in their selections. Saheen Sadjah, merchandiser of a men's wear line, works with major accounts.
Courtesy: Saheen Sadjah.

4. The sales staff can maintain direct contact with retailers by sending them multimedia presentations of new styles or direct electronic links.

The designer will often begin a new season by presenting the line to the sales staff and explaining the styling and theme at a sales meeting. Often, the designer will join the sales staff when they are working the line with a buyer who makes many purchases or who represents a prestigious store. Sometimes, the buyer will arrange an in-store promotion when a designer visits. A newspaper advertisement or fashion show (called a *trunk show* if the merchandise shown is for the next season) will be planned to bring in more customers than usual. This gives the designer an opportunity to see the garments on a variety of customers.

A sales-oriented manufacturer will go to great lengths to provide services for retail customers. An initial order may not be large because the buyer is waiting to see how well the stock is made and how it sells on the floor. The numbers that *check* (sell well) are reordered in greater quantity, so small ini-

Showroom Personnel
The showroom personnel show the line to the buyers, maintain sales records, and stay in contact with buyers by telephone, fax machine, and computer.
Courtesy: La Belle, California.

tial orders may lead to profitable sales later. The styles that do not sell are ignored and marked down for the sale racks. A buyer learns the types of garments that sell the best and the most profitable vendors by analyzing sales records. The records show how many pieces have sold in each style, size, and color. Armed with this information, a buyer will return to a manufacturer to reorder hot items and try new styles. The manufacturer and the retailer establish a good relationship based on their understanding that good styling means profits for both.

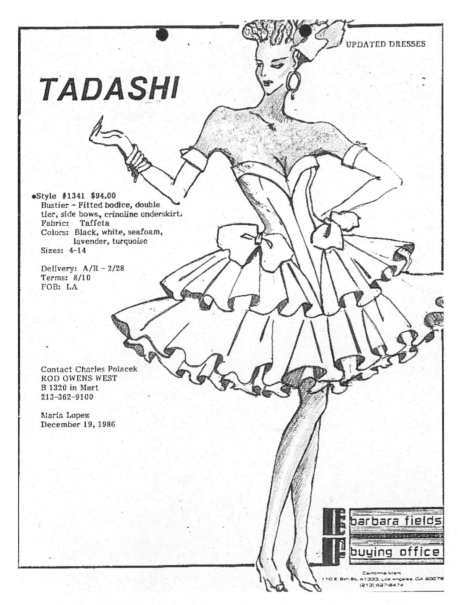

UPDATED DRESSES

TADASHI

●Style #1341 $94.00
 Bustier – Fitted bodice, double
 tier, side bows, crinoline underskirt.
Fabric: Taffeta
Colors: Black, white, seafoam,
 lavender, turquoise
Sizes: 4–14

Delivery: A/R – 2/28
Terms: 8/10
FOB: LA

Contact Charles Polacek
ROD OWENS WEST
B 1320 in Mart
213-362-9100

Maria Lopez
December 19, 1986

barbara fields
buying office

California Mart
110 E 9th St. A1333, Los Angeles, CA 90079
(213) 627-6474

Buying-Office Bulletin
Bulletins cover new resources and noteworthy styles. Bulletins help buyers to preview what is available in the market before the buyers make the buying trip.
Courtesy: Tadashi.

CUSTOM DESIGN

The smallest manufacturing firm is the single designer or seamstress who creates garments for private customers. This person handles all the aspects of the business we have outlined. This is an awesome task for one person, even though that person may produce a limited amount of merchandise. Many designers prefer to work on a small scale because they are not hampered by the creative limitations imposed by mass production. Custom designers enjoy enhancing the appearance of clients directly without the barriers of a salesperson or store.

The custom designer should have a good grasp of patternmaking to have flexibility in creating designs. A knowledge of fitting is essential. Usually, the custom designer pads out a commercial dress form to represent a client's figure. A good sketch artist can save many hours of sales time by sketching garments for clients before they are fitted in the first muslin.

Purchasing fabrics is usually a problem for the small designer because he or she often does not purchase enough of one fabric to buy wholesale. Good fabric stores will often sell small amounts of fabric at a discount to an independent designer because the designer will purchase a great deal of fab-

Production Patterns
Production patterns are cut out of pattern manila, a heavyweight paper that is cumbersome to store.

ric over the year. In addition, a custom designer can obtain a resale number from the state in which he or she works that permits the purchase of materials at a discount and eliminates sales tax on items for resale.

The custom designer often hires a skilled seamstress to assist in producing actual garments. A good accountant is a great help to the independent designer and can assist in determining a fair markup figure to charge so that the business will be profitable.

Sales are best promoted by word of mouth. A satisfied customer will bring friends to the designer who creates attractive garments. Some custom designers will participate in fashion shows for women's groups. This is an expensive but effective way to solicit clients. Often, people who are hard to fit in commercial garments make valuable return customers. Advertisements in local newspapers and magazines will also attract clients.

DEVELOPING A TASTE LEVEL

Buyers return to their established resources for a specific type of styling, so a designer may be successful at one house and unsuccessful at another. A person develops a taste level by constant exposure to better merchandise in stores, in publications, and on the streets. Good taste is the ability to recognize styles that will appeal to a specific segment of the market. The beginner should avoid specializing in one category before experimenting with researching and designing for several different customers. Fortunately, the beginner has a wide choice of areas in apparel design.

Successful designers do not design commercial garments for themselves. Designers create a product for a specific customer and are usually most successful when they view the customer objectively and do not impose personal design restrictions on their product. For example, the designer with a figure problem should not design a line just to camouflage that problem. The woman designer who is sensitive to a specialty customer—the petite woman or a large-size figure—should identify with the design problems involved in creating apparel to flatter these figure types without confusing the problems with those of her own figure. Often, men are successful designing women's apparel because of their objectivity. More and more women designers are entering the men's wear field for the same reason.

Missy Apparel
The missy market is more sophisticated than the junior market because a more mature customer wears this category.

MANUFACTURING CATEGORIES

The following list describes the many categories of apparel. Remember that this list is even further divided by price ranges—budget, moderate, better, and designer—so there are many areas of apparel production available to creative designers.

Women, half-sizes, large women, talls
Missy and junior
Junior petite, subteen
Children (3 to 6X and 7 to 14), toddlers, infants
Contemporary
Daytime dresses
Cocktail and evening wear, formals
Sportswear, separates, knits
Coats and suits, rainwear, outerwear
Specialized garments
Uniforms, work clothes
Active sportswear, bathing suits
Bridal wear
Maternity
Theatrical costumers
Apparel for the handicapped
Intimate apparel
Sleepwear
At-home, robes
Lingerie, slips
Foundation garments, girdles, bras
Blouses, shirts, tops
Accessories (shawls, scarves, and so forth)
Shoes, bags, gloves, neckwear, and so on

Missy and junior are the two major divisions in women's apparel. Missy garments are styled for a mature figure—that is, a woman with a back neck-to-waist measurement of about 16+ inches for a size 10. This customer has a mature bust and slightly larger hips than a comparable junior size. The term *missy* defines a size range as well as a type of styling that is usually conservative or very basic. Actually, a vast range of styles is included in missy garments, from basic (sometimes called "dumb" because frequent repetition has made the styling predictable and easy for many women to wear) to high fashion. The term *contemporary* is used to describe garments made in the missy size range but with the most current styling. **Bridge** lines are those that have upscale styling and more-expensive prices but are not as costly as designer lines.

A junior garment is cut with a shorter back neck-to-waist measurement than the comparable missy size. The customer who wears this kind of garment tends to be younger than the missy customer. Like the missy category, the junior category has a range of looks, from young apparel designed for a schoolgirl (called bubble-gum junior) to more sophisticated styling designed for the young career woman. The career category is often called *contemporary junior,* and the styles fit a figure shorter and younger than the missy figure.

Double-ticketing is the practice of using both junior and missy sizing on a ticket. The garment may be labeled 9/10 or 11/12. This was first done in

Contemporary
The contemporary customer is willing to experiment with a more fashionable cut and color combinations.

Bridge
The bridge category is more expensive than contemporary but less expensive than designer. Style and quality is important to this customer.

an effort to capture a greater range of customers. Usually, the garment will fit a standard missy or junior figure. There is no way of regulating how a garment fits, however, and therefore there is a tremendous range of standards for each size. Although mass merchandisers like Sears and JC Penney have tried to eliminate size differences among manufacturers who sell them merchandise by making them all conform to the same body measurements for each size ordered, the independent manufacturer prizes its "fit" as just right for its particular customer, so size standards in the industry as a whole vary greatly.

It is most important for a manufacturer to define its customer. If a line lacks a target market,

the buyer will not know where to sell the merchandise. Department stores plan their departments to carry particular items in a specific price range. Vendors are assigned to specific departments on the basis of image (or styling reputation) and price. A specific image will concentrate the impact of the merchandise and give the designer a focal point for styling.

Consider the many jobs described in these two chapters. Apparel firms of every kind and in every price range need many specialized people to make them function. Most manufacturers hire a staff designer. For a young person who has developed skills in designing, patternmaking, sewing, and other areas of production, the opportunities are abundant. The desire to work hard in an exciting, fast-paced, ever-changing industry, the ability to master technical skills, and the determination to cultivate a sense of taste are the necessary ingredients for a successful career in apparel manufacturing.

INTERVIEWING FOR A JOB
Portfolio and Résumé

A *portfolio* is a representative collection of a designer's best work. The material should represent the kind of work the designer wants to be hired for but not be so narrow that more general jobs are eliminated in the eyes of the interviewer. A manufacturer will often ask a prospective designer to design some garments that would be appropriate for its line. This is a fair request as long as the designer does not leave the sketches with the manufacturer before being hired for the job. Designers who have CAD skills should be sure to include computer designs in their portfolio and note the software programs used to create the designs.

A *résumé* is a brief summary of work experience and education. The résumé is headed with the candidate's name, address, and phone number. Work experience should be listed by date and employer. List the most recent job first, and include a brief description of the job and specific duties. List schools attended and awards and degrees received. Type neatly on one page. Professional résumé services will write and print a resume for a fee.

The student should collect school projects and review them with an instructor before graduation to evaluate the strengths and weaknesses of the portfolio. Ask for suggestions for filling gaps in your

Junior Apparel
The junior market appeals to the trendy young buyer. Fads are important for this customer.

work. Students are wise not to be too specific about the type of design they want to do after leaving school. A period of apprenticeship as an assistant designer to gain a concrete idea of the requirements of a specific job will enable you to develop more realistic career goals. The résumé can also include specific skills and computer proficiencies the individual has.

Research a company before you interview for a job. Shop a manufacturer's line and then select designs from your pool of work that are suitable or slightly more fashionable than the apparel produced by that company.

Select material from your designs that looks as though it was done by one person, but make sure you show enough variety to emphasize your strengths. A portfolio is often judged by its weakest example, not its strongest. Show from 12 to 15 pieces of work. Make sure the illustrations are clean and neatly mounted or matted. Published material is especially effective because it shows that your designs have been significant enough to be advertised by retailers.

The job seeker is evaluated in many ways. The total package is important. Stress your desire to participate in the team effort needed to make the company a success. A huge portfolio is awkward to look at and spoils the image of the person who carries it. A portfolio should be a neat, flat case of a reasonable size that contains your well-edited designs. Actual garments can be taken to show sewing skills if that is important for the job; slides of garments can also be added to the portfolio.

Preparation for the Interview

To avoid excessive nervousness, prepare carefully for the interview. Here are some important tips:

1. Plan what to wear to the interview based on the job for which you are applying. You will intimidate a designer if you dress in expensive business apparel when applying for a job as a sample cutter or assistant designer. When you move up the career ladder and interview for a design job, a good rule of thumb is to select interview outfits that demonstrate your creative personality. A creative person may ignore the blue or gray business suit as a must for an interview but should dress as a confident team player within the framework of the business organization.

COLOR BLOCKING & SPLICING

city: PARIS
etaller: TIFFANY
fabric: WOOL BLEND
color: TAUPE, BLACK & WHITE

city: PARIS
label: LOLITA LEMPICKA
color: ORANGE & BURGUNDY

41

*WAS DISPLAYED W/
MATCHING ORANGE STRAIGHT SKIRT

Trends

Foreign trends are interpreted for many apparel categories.
Courtesy: Report West.

2. Know the exact time and place of the interview. Make an appointment to speak with the proper person. Arrive on time or a few minutes early.

3. Know the interviewer's full name (and how to pronounce it) and title.

4. Investigate the company. Shop the line of a manufacturer or at least a store that carries the kind of merchandise it makes.

5. Prepare questions to ask the interviewer. Accepting a job is a two-way street. Ask about growth potential and advancement possibilities.

6. Fill out an employment application neatly (in pen) and completely. Bring two copies of your résumé, and leave one with the application. Give the other to the interviewer.

7. Greet the interviewer by name. Shake hands firmly. Smile and be as relaxed as possible. Listen and respond alertly to questions. Look the interviewer in the eye as you speak.

8. Do not chew gum or smoke.

9. Ask about the requirements of the job as early in the interview as possible. Then you will be able to relate your skills and abilities to those requirements. Be prepared to answer questions about your goals and abilities. Show your portfolio as reinforcement for your career goals.

10. Answer questions truthfully and as precisely as possible. Do not over-answer questions. Do not make derogatory remarks about present or former employers.

11. Ask for the job if you are interested in accepting the position. Accept an offer on the spot if you want the job. If necessary, arrange a specific time to think it over. Call the interviewer with a response even if you have decided not to take the job.

12. Thank the interviewer for his or her time and consideration. In several days, follow up with a note summarizing your interest in the job.

Summary

Product development is the primary responsibility of a designer, though specific duties vary from company to company. A designer starts a new line by researching color trends and fabric lines. Styling is determined by the designer's taste level, the price of the line, the season and degree of fashionability of the house, and past performance of specific styles. Fit, care, and durability are important factors in how a garment sells.

The designer, assisted by the design-room personnel, may sketch, drape, use a computer, or flat patterns to create the first samples. A typical design room is staffed by an assistant designer, first patternmaker, sample cutter, and sample makers. Larger houses add sketchers, fit models, and other assistants.

Merchandising the line is important to weed out styles that may not sell well. The final line is shown to store buyers in the showroom, taken to accounts by traveling sales representatives, and promoted through trade advertisements and buying office networks. Production pattern development follows sales and prepares the first sample to be sewn efficiently in a factory and to fit an average customer. The designer is usually involved in sales presentations and all decisions that affect the aesthetic of the product.

Custom designers often perform all of the design and manufacturing activities and have direct contact with the ultimate consumer. This allows them to be creative and flexible with the goal of pleasing a single individual.

There are many manufacturing categories that are further broken down by price, allowing the creative designer a great variety of manufacturing areas in which to work.

Interviewing for a job as a designer requires attention to physical appearance as well as preparation of a résumé and portfolio demonstrating the ability to create commercial garments. Prepare for an interview by researching the manufacturer's line and competition and selecting work from your portfolio that relates to the product. Present yourself as a confident team player within the framework of the business where you are seeking employment.

Review

WORD FINDERS

Define the following words from the chapter you have just read:

1. Buying office
2. Check out
3. Completion date
4. Double-ticket
5. Drape
6. Duplicate
7. First pattern
8. Fitting model
9. Hand
10. Hanger appeal
11. Illustration
12. Muslin
13. Portfolio
14. Prêt-à-porter
15. Refabricate
16. Resource
17. Résumé
18. Sample maker
19. Showroom girl
20. Silhouette
21. Stock pattern
22. Taste level
23. Version
24. Weed the line
25. Working sketch

DISCUSSION QUESTIONS

1. List and discuss the requirements for a successful style.
2. What are the designer's responsibilities outside the design room?
3. How does a buyer contact the manufacturer between trips to the market?
4. Explain the two meanings of the term *missy*.

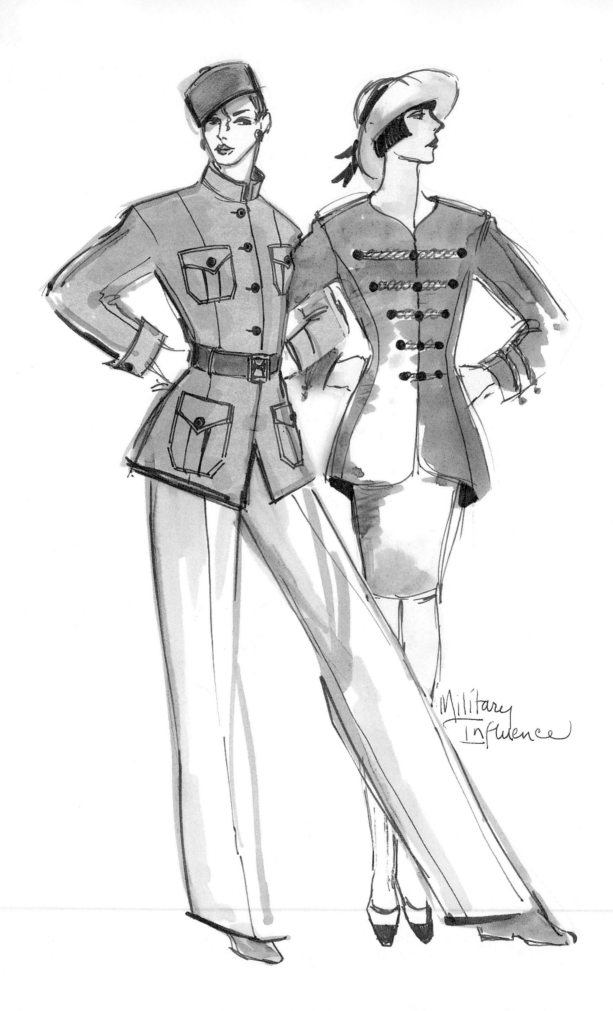

Military
Influence

CHAPTER **3**
Sources of Inspiration

Paris couture and European prêt-à-porter (ready-to-wear) are the traditional sources for fashion trends. Each year at show time, buyers, fashion editors, and manufacturers flock to Paris, London, and Milan to review the new styles. Manufacturers of missy and designer apparel tend to watch couture shows with the greatest interest. The manufacturers of junior and young contemporary clothes avidly follow the trendy prêt-à-porter styles because they can be produced easily for a young customer.

Before the shows begin, U.S. publications preview the openings with articles on fabric trends, rough sketches or style predictions, and interviews with designers. As soon as the shows are over, fashion editors select the styles they feel are prophetic and send photos, sketches, and stories to the United States for publication in consumer and trade fashion magazines and newspapers. Retailers and manufacturers depend on subscription fashion-trend publications (such as *Report West* and *FOCUS* by Pat Tunskey), which in turn depend on the Paris shows for the bulk of their predictions.

A flood of fashion predictions hits U.S. fashion publications after these shows. In following months, U.S. editors' tastes are repeated in photo editorials in monthly glossy fashion magazines (that is, magazines printed on shiny paper). Thus the information is passed on to consumers almost as soon as the designer receives it. But it is important to remember that all European collections we see in domestic publications have been edited by U.S. journalists. In fact, before people in the United States had access to the Internet, many potentially important ideas

When you have read this chapter, you will understand:

1. How a fashion trend evolves.

2. That trade papers, consumer magazines and newspapers, and other printed and electronic sources can provide design inspiration.

3. How collecting scrap and starting a sketchbook can lead to a better knowledge of the market.

4. The importance of foreign designers and U.S. fashion leaders.

5. How draping and patternmaking can be used as creative resources.

6. The need to explore other sources of inspiration.

7. The skills needed for shopping a retail store to develop a taste level and understand a particular market segment.

COLOR BLOCKING & SPLICING

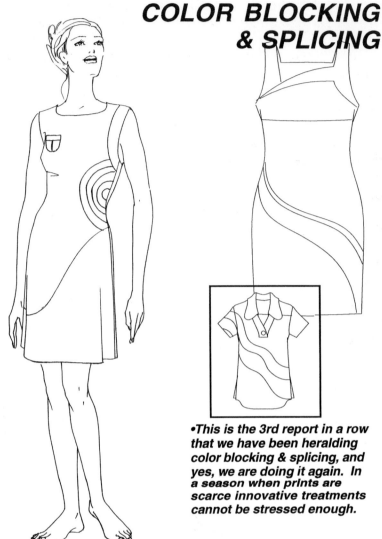

•*This is the 3rd report in a row that we have been heralding color blocking & splicing, and yes, we are doing it again. In a season when prints are scarce innovative treatments cannot be stressed enough.*

Courtesy: Report West.

never reached U.S. designers unless they attended the shows or read European fashion magazines.

European collections are now available on the Internet. Designers can research on the WWW and see photographs of the Paris runways to interpret entire collections before they are available in European retail stores or photographed for fashion magazines. Manufacturers who specialize in copying trendy garments can speed the fashion cycle by two or three months using this method.

A fashion trend born in Europe is not necessarily destined to succeed in the United States because some ideas are too advanced or impractical for the U.S. lifestyle. Generally, though, the influence of Paris will be felt eventually as it filters into the fashion mainstream and is reinterpreted by SA (for

Seventh Avenue in New York, where most established garment manufacturers have offices and where U.S. ready-to-wear manufacturing is centered). Because U.S. fashion retailers, fashion editors, and manufacturers watch European design carefully, it is a source of common inspiration that is usually translated into apparel for the U.S. consumer.

While reading about European sources of fashion trends, you may have thought that many U.S. designers create similar garments because they are inspired by a common source. This is indeed a frequent occurrence, but many U.S. designers are wary of this tendency toward uniformity. To avoid duplicate styling, some U.S. designers use Paris fashion trends only as a frame of reference and do not copy the styles exactly. Although these designers are influenced by colors, silhouettes, and details, they reinterpret the foreign trends so that the garments they produce are uniquely suited to their customers and their firms' production limitations.

Other designers follow the fashion trends for amusement but find their inspiration elsewhere. Specific markets, such as swimwear, develop completely different sources of inspiration. Generally, the most exceptional styling comes from designers who have unusual sources. The designer who creates a trend and develops a unique product will have a loyal following of retailers and customers.

TIMING

Timing is an important aspect of successful styling. Most designers try to fit their garments into the general fashion climate. *Climate* is a combination of new trends in fashion, the general economic condition of the country, current technological developments, and current retail trends. If current fashion tends toward the loosely fitted garment with a crisp shape in a rigid fabric, the designer working with soft knits that are cut to reveal the body shape will be out of the fashion mainstream. However, this soft styling will appeal to a small segment of the market. In time, this particular styling may become the predominant fashion trend, and then the crisp silhouette of the loosely fitted garment will be passé.

A designer must understand his or her specific market. Novices mistakenly think that the newest fashion trends are appropriate for every line. In fact, the successful designer understands general fashion trends and interprets them for a specific customer. The designer must change the product enough to stimulate the customer to purchase the

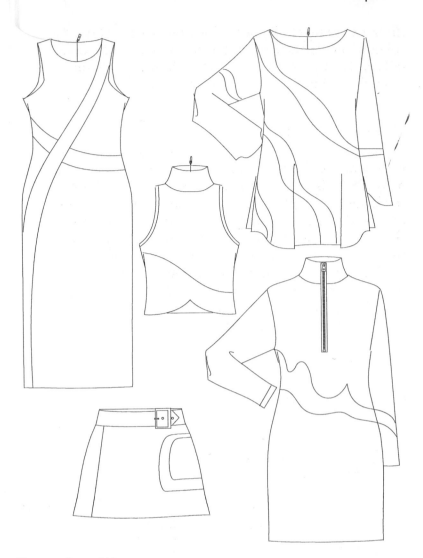

Courtesy: Report West.

new item and yet not design a garment that is so high fashion that it scares the consumer away. A designer in the budget market would analyze styles that have become staples or hot items in the moderate market and interpret them at a lower price point for the volume market. The customer tends to "shop up" and is usually ready to adopt a fashion a season after it has been advertised at higher prices.

Fashions tend to evolve, and any item will have several phases to its fashion life.

Start of a Fashion

A new style or silhouette is shown. The style may catch on slowly or even fail at first. Often, but not always, the innovative style appears first in a high-priced garment. Some fashions start "in the streets" (that is, they are created by nonprofessionals for

their own wear). Finally, the new style begins to "check" (sell) with the more fashion-conscious retailers. During this phase, the style will be covered in trade and consumer fashion publications.

The Fashion Evolves into a Staple

The style becomes a hot item for the original manufacturer, and several retailers begin to sell in large quantities. Other manufacturers *knock off* (copy) the original, often at a lower price. Many manufacturers design versions of the successful style. Generally, department stores across the country sell the item at several prices in a variety of fabrics. At this point chain store manufacturers reinterpret the strong trends, knock them off, and offer them at even lower prices. Retail stores will advertise the style heavily in newspapers.

Evolution of a Fashion Cycle

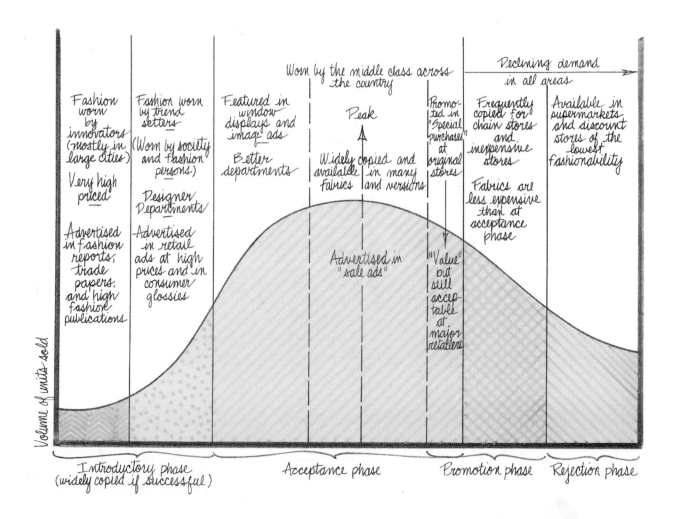

	JANUARY	FEBRUARY	MARCH	APRIL	MAY	JUNE
THE DESIGNER	Style early fall →		Duplicate sample line	First of month, early fall goes into showroom		Shop and research spring cruise
		Shop for fall fabrics Sample, design, and construct				
		← Refabricate summer promotions →	Research late fall and holiday colors and fabrics	Style late fall and holiday	Duplicate samples →	Late fall and holiday, breaks late May or early June
					Interstoff, international fabric show, Germany	
		Paris couture shows, spring		European prêt-à-porter shows, fall		
THE MANUFACTURER	Summer line goes into showroom right after New Year →			Sell early fall Sell summer promotions and reorders →		Sell late fall and holiday Order fall fabric
	Order summer stock fabric		Manufacturer and ship summer →			
					Manufacture summer promotions and reorders	
		Ship and produce spring clothes (reorders) →				
					Manufacture early fall and ship →	
THE DEPARTMENT STORE	Receive spring/cruise → Sell spring Stores have new color story		First spring markdowns		Major spring → markdowns ←	
		Rainwear important in coat department				
	After-Christmas sales of holiday and late fall garments			Early summer—sell summer → Summer promotions Easter promotions for children's wear Swimwear opens	Graduation dresses Wedding promotions →	

JULY	AUGUST	SEPTEMBER	OCTOBER	NOVEMBER	DECEMBER
Style spring	Duplicate spring	Early October, spring goes into showroom			Research early fall colors and fabrics
					Duplicate samples
	Refabricate and do fall promotions	Research summer colors and trends— sample fabric for summer	Style summer →		
				Interstoff, international fabric show, Germany	
	Paris couture shows, fall		European prêt-à-porter shows, spring		
Sell reorders and promotions		Sell spring cruise			
Manufacture and ship fall		Order spring stock fabric	Manufacture cruise and spring. Ship late November–early December		
Order late fall and holiday fabrics			Set Christmas catalogue merchandise	Ship Christmas catalogue merchandise	
		Manufacture and ship late fall and holiday →			
Early fall →	Selling →	Fall opens Sell fall →			First fall markdowns
					Children's party clothes
	Coats important now				
	Furs open				
Summer clearance		Early fall markdowns →		Christmas catalogue goes to customers mid-month —	Christmas promotions sells
	Back to school for young apparel —		Holiday merchandise → arrives —	sells	
					Mark down glittery-dressy after Christmas
→	→ Swimwear sales				

Staple Becomes Chain Store Merchandise

Manufacturers who sell to chain store catalogs must design their lines many months before the selling date. For this reason, styling is usually conservative and emphasizes proved items. If the style is successful in the catalog, it may be repeated for several issues. When sales decline, the item is dropped.

Closeout and Demise

The style is knocked off in very inexpensive fabrics for the lowest possible prices. Many people wear versions of the style. The cheapest versions have lost the original subtlety and good fit. Finally, the style is closed out at all price levels, but 10 or 20 years from now, it may be rediscovered in a wave of nostalgia and reinterpreted in the context of that period.

Timing has another meaning for the designer of ready-to-wear. The designer works long before the season, usually six to eight months before the garment is finally sold to the consumer. A designer must anticipate the weather across the country during the *selling period of the garment,* rather than the weather when the customer will wear the garment. Retail seasons differ considerably from actual seasons. For example, spring merchandise is shipped to the stores during January and February, generally the coldest months of the year. The garments emphasize pastel colors but are neither too lightweight nor too bare because the selling season precedes the actual wearing season. The customer wants to buy the latest style now, although he or she will not wear it until the weather warms. The designer must understand and anticipate weather probabilities, general fashion trends, and retailers' schedules.

Study the timetable on pp. 94–95 and follow a traditional season's merchandise through these processes: designing, selling to the retailer, manufacturing, shipping, and selling to the customer. Different categories of merchandise have different calendars. Importers and chain store manufacturers often add six to eight months to the design and production phase. Retailers often alter the calendar by staging special promotions, especially during a year when retail sales are slow, but this overview will alert the beginner to the lead time necessary to produce a line. Manufacturers try to have fresh merchandise flow into the stores on a monthly basis and often stagger the delivery of seasonal groups so that there is a flow of merchandise during the selling period.

PRINTED SOURCES OF INSPIRATION

Successful designers must motivate themselves when they begin to design for a new season. If no fresh ideas occur to them spontaneously, they must do some research. Published sources of fashion trends should be basic to a designer's weekly reading. In addition to the domestic fashion reports, which most designers read, there are many foreign magazines that report on specialty markets or present an in-depth look at European couture and prêt-à-porter. Foreign publications are valuable because they are free from the bias of a U.S. editor. The more widely a designer reads, the more imaginative his or her ideas will be.

Trade Newspapers

Women's Wear Daily (WWD)/Fairchild Publications, 7 East 12th Street, New York, NY 10003. This is the most important trade publication for women's apparel. *WWD,* a daily newspaper published in New

Trade Newspapers
California Apparel News, a weekly publication, covers California manufacturers and fashion trends.
Courtesy: California Apparel News *and Michele Markman.*

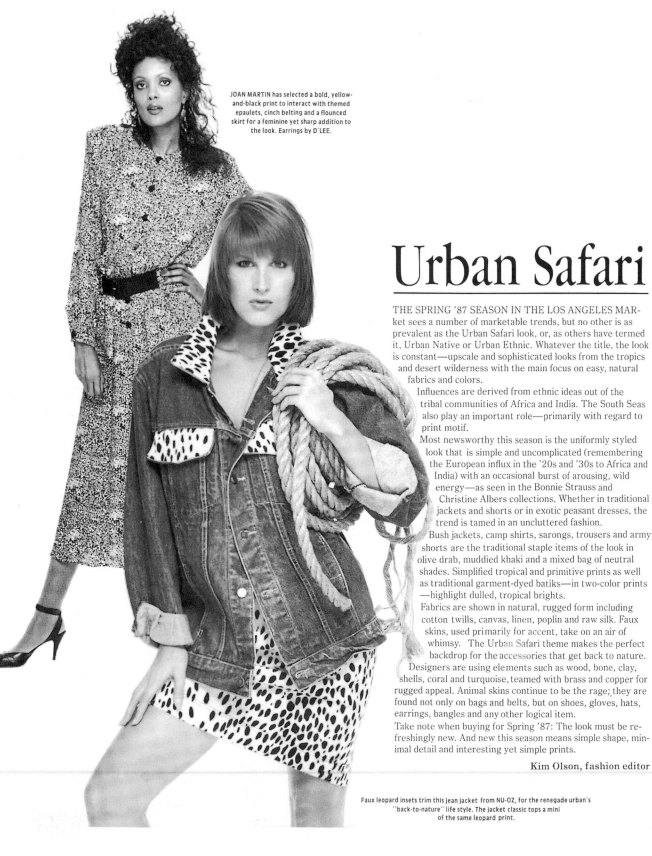

JOAN MARTIN has selected a bold, yellow-
and-black print to interact with themed
epaulets, cinch belting and a flounced
skirt for a feminine yet sharp addition to
the look. Earrings by D'LEE.

Urban Safari

THE SPRING '87 SEASON IN THE LOS ANGELES MAR-
ket sees a number of marketable trends, but no other is as
prevalent as the Urban Safari look, or, as others have termed
it, Urban Native or Urban Ethnic. Whatever the title, the look
is constant—upscale and sophisticated looks from the tropics
and desert wilderness with the main focus on easy, natural
fabrics and colors.

Influences are derived from ethnic ideas out of the
tribal communities of Africa and India. The South Seas
also play an important role—primarily with regard to
print motif.

Most newsworthy this season is the uniformly styled
look that is simple and uncomplicated (remembering
the European influx in the '20s and '30s to Africa and
India) with an occasional burst of arousing, wild
energy—as seen in the Bonnie Strauss and
Christine Albers collections. Whether in traditional
jackets and shorts or in exotic peasant dresses, the
trend is tamed in an uncluttered fashion.

Bush jackets, camp shirts, sarongs, trousers and army
shorts are the traditional staple items of the look in
olive drab, muddied khaki and a mixed bag of neutral
shades. Simplified tropical and primitive prints as well
as traditional garment-dyed batiks—in two-color prints
—highlight dulled, tropical brights.

Fabrics are shown in natural, rugged form including
cotton twills, canvas, linen, poplin and raw silk. Faux
skins, used primarily for accent, take on an air of
whimsy. The Urban Safari theme makes the perfect
backdrop for the accessories that get back to nature.

Designers are using elements such as wood, bone, clay,
shells, coral and turquoise, teamed with brass and copper for
rugged appeal. Animal skins continue to be the rage; they are
found not only on bags and belts, but on shoes, gloves, hats,
earrings, bangles and any other logical item.

Take note when buying for Spring '87: The look must be re-
freshingly new. And new this season means simple shape, min-
imal detail and interesting yet simple prints.

Kim Olson, **fashion editor**

Faux leopard insets trim this jean jacket from NU-OZ, for the renegade urban's
"back-to-nature" life style. The jacket classic tops a mini
of the same leopard print.

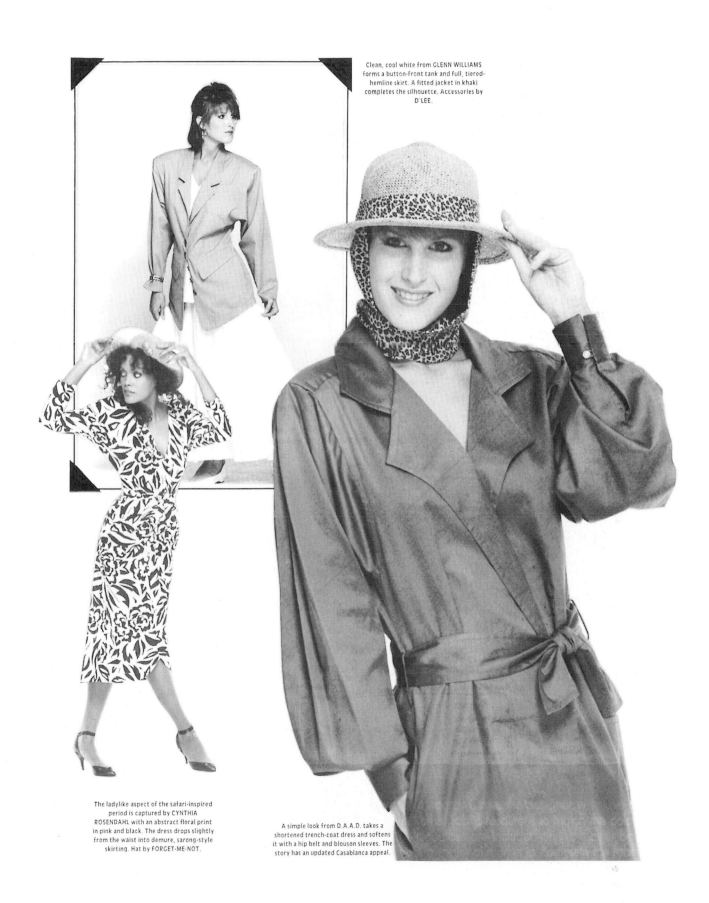

Clean, cool white from GLENN WILLIAMS forms a button-front tank and full, tiered-hemline skirt. A fitted jacket in khaki completes the silhouette. Accessories by D'LEE.

The ladylike aspect of the safari-inspired period is captured by CYNTHIA ROSENDAHL with an abstract floral print in pink and black. The dress drops slightly from the waist into demure, sarong-style skirting. Hat by FORGET-ME-NOT.

A simple look from D.A.A.D. takes a shortened trench-coat dress and softens it with a hip belt and blouson sleeves. The story has an updated Casablanca appeal.

York, covers women's and children's apparel in the United States. Reports from abroad are published after the couture and prêt-à-porter shows. Known as "the Bible of the women's apparel industry," *WWD* includes retailing activities and want ads. Fairchild also publishes the *Daily News Record (DNR),* which covers the men's wear market.

***California Apparel News*/Fashion Publications** 110 East Ninth Street, Suite 725, Los Angeles, CA 90079. A trade publication that covers the West Coast market. It is published weekly and includes want ads.

Apparel Industry Magazine Covers technical manufacturing news.

Fabric News to the Trade.(commonly called *Trade).* 21 East 40th Street, New York, NY 10016. A directory to New York textile firms and industry news.

Stores. 100 West 31st Street, New York, NY 10001. A trade magazine for retail stores.

Daily or Weekly Consumer Newspapers

Daily newspapers for each city carry current fashion information and advertisements for local retailers. The advertisements throughout are as valuable as the fashion pages. Manufacturers can subscribe to retail advertising reports that compile the best regional store advertisements and publish them according to category.

New York Times Sunday Magazine The magazine is particularly important to the fashion trade because many retailers and manufacturers advertise in it. Occasional fashion supplements are published.

W A monthly newspaper with a great deal of color printing, put out by the publishers of *Women's Wear Daily.* It carries reprints of "soft" news (interviews with personalities, fashion reports, society news, and so on) featured during the month in *WWD.* Included are manufacturers' and retailers' advertisements that have not been carried in the daily paper.

Consumer Domestic Magazines (Glossies)

Children's and Young Girl's Wear. *Ladies Home Journal*—occasional articles on children's wear; *Seventeen*—the publication that most influences children's and teens' wear in the United States.

Young Women. *Glamour* and *Mademoiselle*—magazines that appeal to high school and college students and young businesswomen; both maga-

zines stress contests and articles that promote audience involvement.

General and High Fashion. *Vogue, Vanity Fair,* and *Harper's Bazaar* coverage of U.S. and foreign fashion scenes aimed at the fashion-conscious mature woman. *Elle* is published in the United States as well as in France and features youthful designer apparel. *Taxi* is an upscale fashion magazine featuring high quality photographs of trendy apparel.

Magazines with Some Fashion Articles. *Town and Country*—appeals to the very upscale reader; *Redbook* and *Cosmopolitan*—both are for career women and young married women; *Woman's Day, Ladies Home Journal,* and *Family Circle*—mainly for homemakers.

Men's Fashions. *Gentleman's Quarterly*—now published monthly, this magazine is the most influential men's wear fashion publication. *Playboy* and *Esquire* also feature men's fashions.

Patternmaker Publications, Pattern Books

The home-sewing market is well covered by monthly publications from the three largest pattern companies: Vogue, Butterick, and Simplicity. In addition to these monthly publications, which are available on the newsstand or by subscription, large, comprehensive pattern books can be purchased from yardage stores when the books are out-of-date. Pattern books are valuable reference materials for designers and students. *Sew News* and *Threads* are two important home-sewing magazines that are good resources for crafts ideas.

Design and Retailing Reports

These reports require an annual subscription because they do not rely on advertising for support.

Here and There, Report West/Snapfashun, Doneger Design Direction (D3), Faces, **and** ***The Fashion Service (TFS),*** Published in England, France, and the United States. These expensive reports, intended for U.S. industry, feature detailed fashion and fabric information from European couture and prêt-à-porter.

Color Projections (by Pat Tunskey), Color Box, Huepoint, Color Play, and Design Options. Color services that predict color trends for various markets 18 months before the merchandise is shipped to retailers.

Courtesy: Report West.

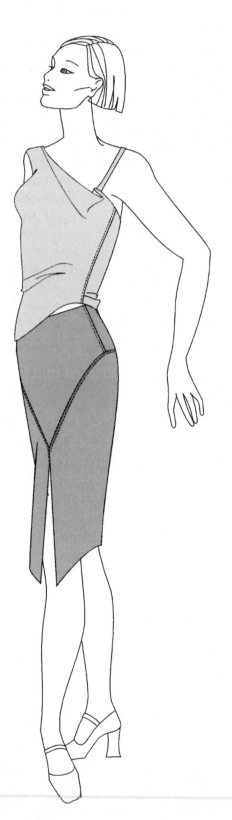

Courtesy: Report West.

Tobé A retailer report that features analysis of national retailing trends, reports on hot manufacturers, and details on growing consumer trends. Available to retailers but not manufacturers, on a subscription basis.

Buying Office Reports. Buying offices compile specialized information on fashions and vendors for member stores.

Video Fashions, Inc. Video fashions of European prêt-à-porter collections. Most designers make videotapes of their fashion shows for the use of the press and retail stores. Elsa Clinch also covers designer fashion shows for CNN.

Foreign Trade and Fashion Publications

Specialized magazine vending services, large newsstands, and speciality bookstores located in cities with apparel manufacturing and retailing centers sell a variety of foreign fashion magazines. Designers also subscribe to foreign fashion publications using a distribution service such as International Fashion Publications in Los Angeles.

Vogue is published in France, England, Italy, and Australia. Each edition covers domestic fashion for that country plus foreign designers. Special editions, for example, *Uomo Vogue* and *Vogue Mare* (men's sportswear for sailing) in Italy and *Vogue Homme* in France, cover men's wear and active sports that influence fashions. Likewise, *Harper's Bazaar* is published in Italy and in England as *Harper's* and *Queen* and covers the upscale designer market. Popular Italian fashion magazines include: *Linia Italia, Belezza,* and *Eleganza* (high fashion), *Bimbi Eleganti* (children's wear), *Calze Moda Maglie* (knitwear), and *Sposa* (bridal wear).

In France, *Elle* and *Marie Claire* are focused on the young market, and *L'Officiel de la Couture et de la Mode de Paris* reports on the couture market. Germany publishes *Brigitte, Chic,* and *Mode* which focus on the German fashion scene.

Domestic Trade and Special Interest Publications

Apparel Executive. Apparel Institute, 77 Maple Drive, Great Neck, NY 11021. Journal for top-level management.

Apparel Manufacturer. Forge Associate Publications, Inc., Riverside, CT.

Fashion Magazines
Many foreign and domestic fashion magazines are available. The designer should be familiar with domestic magazines because they cover current developments in U.S. fashion. Foreign magazines tend to have more avant-garde fashion information.

Bobbin. Bobbin Blenheim Publishing, PO Box 1986, 1110 Shop Road, Columbia, SC 29292. Focuses on manufacturing techniques, supplies, and equipment for the sewn products industry. Published in connection with the Bobbin trade shows.

Body Fashions. Harcourt Brace Jovanovich, Inc., 757 Third Avenue, New York, NY 10017.

Retail Week. 380 Madison Avenue, New York, NY 10017.

Historical Publications

For historical research, the following publications are available in many research libraries across the country.

Bazaar. Late 1860s to present (began in 1866, but early copies were sometimes lost).

Godey's Lady's Book. 1830s to late 1890s.

Ladies' Home Journal. 1883 to present.

Le Bon Ton. 1912 to mid-1920s.

Sears and *Montgomery Ward.* catalogs. Old editions reprinted at periodic intervals.

Vogue. (USA). 1893 to present.

GOOD WORK HABITS

Besides printed fashion information, color trends from fiber companies, and fabric information from textile firms, the alert designer has other sources of inspiration. The way the designer uses these sources makes the difference between innovative designing that has a unique personality and styling that simply repeats market trends. The designer must be aware of current lifestyles and trends. Designers should develop a sensitivity to objects and ideas. In many instances, painters, sculptors, and other fine artists develop trends long before the general public picks them up as commercial fashion. Constant exposure to museums, art galleries, and popular events is important for every designer.

Another asset is the designer's intuition. Learn to respond to the demands of your own life. Perhaps to solve a clothing problem, you have will create a new style. Claire McCardell's innovation in the late 1940s stemmed from a personal style problem. She felt that women should have casual garments for everyday life. Designed for Townley, her uncomplicated and easy-to-wear dresses and pants were the basis for U.S. sportswear. One of McCardell's clever garments was an inexpensive wrap dress that gave women an alternative to the dowdy housedress.

In 1984, Donna Karan left the sportswear firm "Anne Klein" where she had been the designer since Anne Klein died. She created the bodysuit to wear under all the other pieces in her collection. The bodysuit became a staple in future lines and was widely copied. It solved the problem of keeping the blouse smooth under a skirt or pants. Several surfers have capitalized on the casual apparel connected with California beach life and have developed large men's wear companies. Sports professionals in mountain climbing, hunting, fishing, boating, and equestrian sports began manufacturer apparel for a specialty category, only to find wide distribution with the general public seeking unique clothing. Product development for this type of apparel differs greatly from following commercial fashion trends. Travel to research other countries and to participate in the sporting activity are important sources of inspiration for designers of these apparel categories.

Scrap

To benefit the most from constant exposure to fashion information, a designer must develop two good working habits. First, cut out any picture that appeals

Color Predictions
Fiber companies and fabric converters publish color predictions before the season to give manufacturers and retailers fashion direction. Color reports are also presented by some fashion reporting services.

to you, triggers your imagination, or has a detail you like. Keep these clippings ("scrap") in a folder and refer to the folder often, adding clippings constantly. Scrap can suggest styling possibilities, details, trends, and color combinations that you may not have thought of. But the scrap folder should be a source of inspiration, not a substitute for it. Copying published styles has little merit unless the designer greatly modifies the styles. Scrap should be used as a pin to prick the imagination and stimulate creativity.

Sketch- or Croquis Book

The second important tool is a sketch- or croquis book (*croquis* is the French word for a drawing of a style or pattern). Handy-size sketchbooks with plain black covers and unlined pages are available at most art stores. Keep your sketchbook with you at all times, and fill it with quick, informative sketches, impressions, and color and fabric swatches. The sketches can be rough because they are for your reference only. Make as many notes as necessary to clarify your visual ideas. Use your sketchbook to record memorable garments you see in stores or to sketch details and styles you find while doing period research. To develop the habit of sketching, set aside some time each day for working on your sketchbook. While riding on the bus or visiting a store, add at least 10 sketches or ideas to your book. If you are consistent, you will find that sketching your ideas is an effective way of recording impressions for future use. As you finish them, keep your sketchbooks for reference.

Researching Other Designers

Fashion is evolution, not revolution. Commercial designers must be aware of the general fashion climate, that is, trends that influence all phases of design, such as skirt lengths, use of shoulder padding, and fit. Designers must also research the particular area they are creating for in two ways:

1. Next season's new silhouette, details, and fabrications.
2. Current hot items that will probably be carried over to next season.

Innovative foreign fashion trends give the best clues to what is coming a year in advance. Good U.S. designer lines often preview next season's direction. The current market contains specific hot items to be

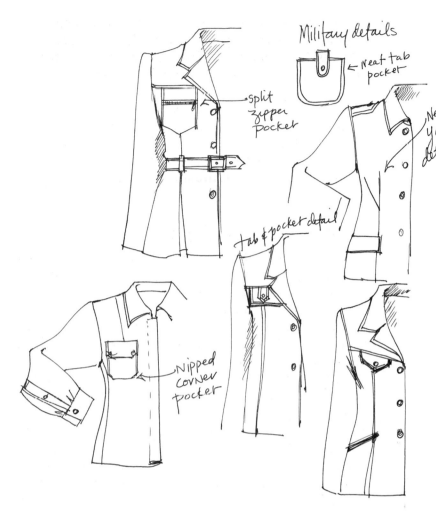

Military details

← Neat tab pocket

split zipper pocket

Neat y dart detail

tab & pocket detail

Nipped corner pocket

Sketchbook
A designer's sketchbook should be a handy size so that it is easy to carry on shopping expeditions. The designer should develop the habit of sketching garments and innovative ideas. These can be quick sketches, even sketches of half of the garment, so long as the essence of the style is recorded for later reference.

reinterpreted. Reading trade papers, magazines, and fashion reports gives the designer an overview, but firsthand contact with actual garments is the most effective way to understand them.

U.S. stores in large cities often have foreign designer merchandise as soon as foreign stores do, but the selection has been edited by buyers who may not purchase the most advanced styles. Many designers travel to Europe to attend the prêt-à-porter shows and shop stores, especially in London, Paris, Milan, Florence, and Rome. In the spring, designers shop Saint Tropez and other resorts to see summer merchandise on the streets and in the shops. Europe is an important trendsetter. The government subsidizes some manufacturers, prices are higher, and the customers expect greater innovation, so volume is less important than creativity. In addition, foreign customers purchase a great deal of innovative European clothes. The foreign textile industry is geared for smaller runs of innovative fabrics, allowing designers more fabric choices.

Shopping U.S. stores is also rewarding. Focus on lines that are progressive and innovative. The U.S. designer scene is a creative and important one, greatly influencing lower-priced ready-to-wear. The advantage of shopping U.S. designers is that trends

Table 3.1

	France	Italy	United States	England	Germany	Japan
Sportswear Collections	Anne-Marie Beretta Jean-Charles Castlebejác Jean-Paul Gaultier Issey Míyake Claude Montana Thierry Mugler Angelo Tarlazzi Chantal Thomass Kansai Yamamoto	Giorgio Armani Byblos Cerruti Max Mara Moschino Prada Jill Sander Sportmax Gianni Versace	Azzedine Alaia Tommy Hilfiger Jeanne-Marc Donna Karan Anne Klein Calvin Klein Ralph Lauren for Polo Shamask Zoran	Katherine Hamnet Betty Jackson	Escada by Margerthia Ley Mondi	Comme Des Garçones by Rei Kawabuko Yogi Yamamoto
Total Collections of Elegant Clothes	Pierre Cardin House of Dior Enrico Coveri John Galiano for Givenchy Karl Lagerfeld for Chloe and Chanel Andre Lang Helmut Lang Harve Leger Ozbec Yves Saint-Laurent Emanual Ungaro	Laura Biagiotti Dolce & Gabbana Erreuno Gianfranco Ferré Gilliano Andre Lang Mariuccia Mandelli for Krizia Angela Pintaldi Mila Schon Luciano Soprani for Basile Valentino Gianni Versace	Adolfo Geoffrey Beene Bill Blass Oscar de la Renta Galanos David Hayes Marc Jacobs Norma Kamali Todd Oldham Isaac Mizrahi Richard Tyler	Sybil Connley Jean Muir Maxfield Par Zandra Rhodes	Helmet Lang	Hanae Mori
Sportswear/Leather Accessories & Silk Prints	Hermès	Gucci Trussardi				
Young Designer Looks	Cacharel Kenzo Tadaka	Benetton		Body Map		
Knits	Sonia Rykiel	Missoni	St. John Knits Adrienne Vittadini	Patricia Roberts		
Eveningwear Specialists	Jacqueline de Ribes		Carolina Herrera			

are more readily adaptable to the domestic customer and a good selection of merchandise is usually available.

Try on garments to examine the fit and construction details. Use your sketchbook to record each detail. Of course, you cannot sketch in the store, so train yourself to remember important details. Take notes on construction details and fabric treatments. Purchase garments that have a special shape or a complicated construction. Do not be intimidated by salespeople in a store. Dress appropriately and have a friendly, courteous attitude, and you will be welcome.

The designer market constantly changes, but the following list will guide you to the designers that set trends in each category. Fashion reports such as *Focus, Here and There,* and *The Fashion Service (TFS)* offer shopping guides to foreign and domestic stores in the large fashion centers. Do not neglect the small boutiques where innovative custom designers show their clothes. News of these "finds" travels quickly in the fashion world. Read newspapers and take notes on what is new.

Shopping Retail Stores
The designer should be aware of merchandise in retail stores. Shopping should be done continuously and should not be limited to a specific area or store.

Consider the following specific points as you shop a retail store:

Your Manufacturer's Garments

1. Determine how the manufacturer's garments fit into the price structure of the particular department where they are sold.
2. Talk to salespeople and check customer reaction to the garments. Check the fit of the garments.
3. Check the sales records with the buyer or assistant buyer.
4. Check the markdown rack for your mistakes.
5. Observe how your garments fit customers with less-than-perfect figures. This is the ultimate test of your product.

Other Manufacturers' Garments

1. Check higher-priced garments and original designs for fashion trends. Many manufacturers buy garments they feel will sell well and then knock them off. All fashion is in public domain (that is, not copyrighted) once it is for sale in a store.
2. Check general trends in colors, promotions, and silhouettes. Observe the items that are checking in your own fashion area and in other merchandising areas.
3. Compare similarly priced garments with your garments. Do yours look like a good buy?
4. In your price range, look for hot items and items that are checking.
5. Know the vendors, especially the larger ones, and the innovative stylers. Know vendors in your price category and in more expensive categories.

Fabrics

1. Often, prints and fabrics are used by several manufacturers. It is to the manufacturer's advantage to have a fabric used in garments that are more expensive than those of its line. The same print used in lower-priced garments is a disadvantage and may signal the need to change the print.
2. Check new merchandise for fabric trends. Particularly important here is European ready-to-wear.
3. Some fabrics do not stand up under handling. Note fabrics that retain their hanger appeal and do not look shopworn.
4. Check fabric trends and colors in other areas: higher-priced, more advanced styling, junior, sportswear, and designer. Check color trends in accessories, shoes, and handbags.

5. Avant-garde fashion stores (those that are original and trend setting) often feature prophetic colors and fashions.
6. Check the fabrics you have had difficulty working with to see how other manufacturers have solved construction problems. Be aware of shortcut finishes and new detail methods.

Organizing Your Store Information

1. Many stores do not like a person to sketch or make notes while on the floor (in the store). Develop your memory and always carry your sketchbook to record important styles. Then you can sketch after you have left the store. Feel free to sketch or photograph garments displayed in windows. A camera is a handy tool for photographing people in the streets as well.

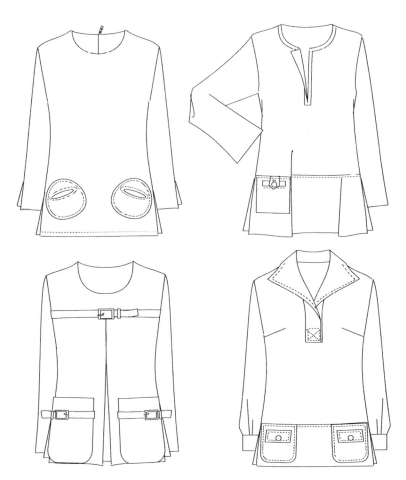

Shopping Stores
Report West by Bill Glazer focuses on current trendy stores and illustrates the importance of keeping abreast of current retail trends. Elaborate sketches the clothes are rarely necessary. The illustrations should show the silhouettes and the details of the clothes. *Courtesy:* Report West.

•**Tunics were hot news all over Europe. They appeared in the junior and updated area but were certainly newer for the junior customer. Merchandising is key here as some tunics get mistaken for dresses. Best shown with pants or the newer and longer slim skirt.**

2. Analyze the new things you see. Project wearable modifications into high-style trends if you are designing for the mass market.

3. Note advertised merchandise and items featured in department displays and store windows. The retailer thinks these items are more important than the general stock and wants to call them to the consumer's attention.

4. Notice overall fashion trends. See how a trend can be duplicated in different categories of merchandise. Decide whether a trend is on the ascent or has peaked.

5. Try on garments that seem to be the coming style. Especially try on new silhouettes and proportions; then analyze them. The style need not be flattering for you, but trying on the garment is the best way to judge proportion.

6. Check garments for any construction and finishing details you can incorporate into your line. Do not be intimidated by better stores or designer departments. Look at as much merchandise as possible in higher price ranges. *Hint:* If you dress like the store's average customer, you will not feel like an intruder.

7. Go to the stores several times a week, if possible. Visit different kinds of stores in many areas because a fair sampling of stores is essential. Include small boutiques and custom shops as well as large department stores.

8. Buy and wear as many commercial garments as you can afford. Try to analyze them in terms of comfort and clever design. Your own experience wearing clothes adds to your knowledge of design and function. Observe the selling patterns of new merchandise in department stores. Try to attend trunk shows and import shows. Trunk shows feature a manufacturer's new line that has not yet been shipped to the store. Look for the newest trends in styling and apply them to your merchandise.

9. Department stores are constantly trying to increase their sensitivity to consumer demand. Be aware of department organization, merchandising policies, and new techniques in display. Watch imaginative small stores for new selling methods. Often, merchandising changes will influence styling and buyer demands. By analyzing what you see, carefully reading trade papers, and talking to knowledgeable sources, you can be on top of these changes. Then, by altering your design projections, you can keep up with the changes or keep ahead of them.

Sample Fitting
The designer and the patternmakers must fit and refine the original garment until an attractive, well-fitted first sample evolves.

The four Rs of shopping are: *remember, record,* and *respond to all you see in fashion merchandising. Return frequently to the stores.*

DRAPING AND PATTERNMAKING

Designers who are able to drape and make their own patterns frequently find that the design they have imagined is altered as they drape it because working with fabric on the human form suggests added design dimensions. Many designers are excellent pattern-makers, and they can envision what the final product will look like and what construction problems may develop. They can suggest to the sample maker details that will enhance the total design and also sewing techniques that will save time and trouble.

The designer must have constant contact with the garment as it is constructed—even if the pattern is made by an assistant pattern-maker. Fitting the garment correctly is an essential part of the designer's work. The image on paper, on a computer screen, or the idea in the designer's head is unimportant compared with the actual garment. Furthermore, characteristics and construction details can be a fertile source for design inspiration.

OTHER SOURCES OF INSPIRATION
Ragbag

A rag bag or a swatch bag holds a collection of fabric swatches. The swatches will be more valuable if

they are labeled with fiber content, source, price, and date. Touch each swatch and develop your tactile sense. Imagine the garments that a fabric could be fashioned into. Invent new combinations of colors and patterns.

Collecting Trims and Fabrics

Period trims, buttons, fabrics, and ribbons are a rich source of inspiration. Often, they can be copied for modern production. Antique stores and sales are an excellent source for antique trims, and antique textiles are often handled by specialized dealers.

Collecting Garments

Collect both historical and contemporary garments that appeal to you. Wear other designers' clothes so you can experience firsthand a new silhouette, fabric, or concept. Be aware of fashion trends and details in other areas of clothing—for example, men's wear, active sportswear, uniforms, and children's wear. Garments from the early twentieth century are widely available in secondhand clothing stores and are a tremendous source of design inspiration.

Museums and Fine Arts

Numerous museums have fine collections of period and contemporary garments, particularly the Metropolitan Museum in New York, the Smithsonian Institute in Washington, D.C., and the Los Angeles County Museum of Art. Also, many museums maintain excellent libraries of fashion books and periodicals.

Three outstanding collections of historical apparel are housed in Paris and London. In Paris, Le Centre du Documentation de la Mode Parisienne has collections of twentieth-century couture design. Both garments and sketches are available for viewing by special request. In the fall of 1985, the Musé des Arts de la Mode opened in Paris, adjacent to the Louvre. This museum exhibits historic couture garments and has a retail store that sells current couture garments and experimental styles from new Parisian design houses. The Victoria and Albert Museum in London has a vast collection of costumes and periodicals, which the museum displays in a permanent exhibit.

Do not confine yourself to the costume departments in museums; visit all sections. Pay particular attention to special exhibits because they may re-

flect a trend in public interest, and they usually contain the best examples of a particular type of work.

Contemporary fine arts and commercial graphics are an important influence on color combinations and general fashion trends. On many occasions these areas have started a trend that has become the commercial fashion several years later.

Historical and Ethnic Costumes

Garments from the past are invaluable for design inspiration. A designer can use old magazines, reference books, period movies, and actual garments. Norma Kamali, for example, researched the 1940s to find inspiration for her custom and ready-to-wear collections in the late 1970s and was the driving force for popularizing the shoulder pad. Most cities preserve garments in public and private collections. Most libraries have periodicals of historical interest.

Ethnic costumes—that is, costumes worn by the people of a specific area—are a rich source of inspiration. Beware of accepting a modern designer's interpretation of an ethnic costume. If fashions of a particular culture are becoming a trend, do original research on the culture and costumes rather than relying on secondhand information.

Films, Television, and Videos

Costumes designed for the movies used to initiate many commercial trends. Several decades ago, movie stars were always expensively and elaborately costumed. The trend toward more realistic movies has altered their fashion impact, but occasionally a movie will still influence contemporary fashion, as did *Flash Dance*. The costumes in this film generated a wave of off-the-shoulder blouses and dance wear. Sometimes a studio will promote a film's costumes as a commercial fashion trend, but these attempts to influence fashion directly are rarely effective. Truly original and timely film costumes will catch on without being promoted.

Children's wear is directly impacted by movies and television. Licensing arrangements sell the rights to develop products with images of characters popular with children for each category of apparel. Often, these licensing arrangements are more profitable than the movie or TV production.

Television shows depicting wealth have influenced apparel trends. *Dynasty, Dallas* and the spin-off evening "soaps" have made their costume designers famous. Retail collections of apparel cash

in on the consumer's desire to look like a glamorous movie star.

Music videos team fashions with the latest popular songs. Fashion designers have used the music video as an important advertising tool. Singers often commission high-fashion costumes to complement the themes of their videos.

Lifestyles

Designers should attend popular events that appeal to their customers. They should observe life around them and investigate how people in different situations live and dress. They should observe people at beaches, sporting events, and underground cultural events. For example, the bathing suit designer should be an expert on beaches from Southern California to Saint-Tropez. Tennis clothes designers should play the game and attend tennis events in all parts of the country.

Fashion from the streets (that is, created by nonprofessionals) is a potential influence on all levels of ready-to-wear. Crafts and hobbies currently in vogue will also influence design, as will travel.

Observe, record, and experience the events that shape current lifestyles.

Home Furnishing Trends

Many trends that influence fashion originate in home furnishings. Usually, the way people style their homes influences the way they style their clothes, and vice versa. Observe the trends published in such interior design magazines as *Elle, Interiors, House Beautiful, Martha Stewart Living, Metropolitan Home,* and *Architectural Digest.* Color trends in wall coverings, linens, fabrics, and paints may influence apparel colors. Upholstery fabrics are frequently modified for use as apparel fabrics. In general, real upholstery fabrics are unsuccessful as apparel fabrics because they are too expensive and the finishes are inappropriate for garments. Reinterpreted upholstery patterns and weaves, however, make excellent apparel fabrics.

Summary

Timing means several things to the designer. First, knowing where the created merchandise falls on the fashion acceptance curve is the key to understanding the amount of newness that a customer will accept. Timing also represents the deadlines that govern when a line must be ready for the retailer to buy and receive merchandise in the store.

Research is vital to creativity. Fashion does not occur in a vacuum, and a designer should become aware of market activities through reading trade and consumer newspapers, foreign and domestic fashion magazines, and design reports and through researching period fashions.

Good work habits are essential to researching fashion trends. A designer should save sketches and constantly use a sketchbook. Researching foreign and domestic designers for general trends and for specific styles and details is important. Studying actual garments in a retail setting is the best way to understand their construction and fabrication. Designers compare their designs to other manufacturers' garments, study fabrics in all markets, and analyze the general trends to understand what is likely to happen in the future.

Draping and patternmaking are skills that will help a designer's creativity. Often, working with the fabric on a dress form will influence styling. Other sources of inspiration include collecting fabric swatches and trims and researching period garments, art trends, and historic and ethnic garments. Movies, television, and videos as well as lifestyle cycles and home furnishings also influence fashion trends.

The pleasure and excitement of designing stems from the research and exposure to the world and society that stimulate a designer to create a new style.

Review

WORD FINDERS

Define the following words from the chapter you have just read:

1. Acceptance phase
2. Avant garde
3. Consumer publications
4. Ethnic costume
5. Fashion from the streets
6. Fine arts
7. Glossy magazines
8. Norma Kamali
9. Anne Klein
10. Krizia-Mariuccia Mandelli
11. Karl Lagerfeld
12. Ralph Lauren
13. Missoni
14. Issey Miyaki
15. Prophetic
16. Ragbag
17. Rejection phase
18. SA (Seventh Avenue)
19. Scrap
20. Sketchbook
21. Staple
22. Kenzo Takada
23. Trade publication
24. Timing
25. *WWD* and *W*

SHOPPING WORKBOOK

Visit department stores and specialty shops to complete the following shopping worksheets. Try to collect many impressions of the stores and merchandise. Do not think in terms of buying garments for yourself. Rather, determine how the things you see would appeal to the general buying public. Men should shop with women to benefit from the trying-on phase of this exercise.

SHOPPING WORKSHEET

Purpose: Compare junior sportswear with missy sportswear. Shop in a department where garments are moderately priced.

Source: A large suburban or downtown department store. Try to compare similar merchandise.

CRITERIA	MISSY	JUNIOR
1. Try on a pair of pants in the size you usually wear.	Size tried on ___ Usual size ___	Size tried on ___
2. Measure the leg length and width for each pair of pants.	Inseam ___ Cuff width ___	
3. How are the seams finished?		
4. Compare the fit of the two pairs of pants.		
5. What is the price of each pair? (Try to pick pants that are comparable.)		
6. Compare and contrast the fabric choices on the basis of fashionability and durability.		
7. Try on a top in each department. Compare fit, especially bust size, length, and sleeve length.		
8. Compare finishing details. Check seam allowances, cuffs, and hem finishes.		
9. Compare merchandise selection in general and the variety of colors available. Which department showed more fashion innovation?		

SHOPPING WORKSHEET

Purpose: To note and sketch a fashion trend you think is prophetic.

Area: Fashionable misses or designer garments, either sportswear or dresses.

Source: Large department store or better specialty store.

CRITERIA	COMMENTS AND OBSERVATIONS
1. Describe the garment you feel is innovative. Consider silhouette, details, and unusual elements.	
2. Who made the garment?	
3. What store and department is the garment sold in?	
4. What is the price?	
5. Comment on any similar merchandise you see in other departments.	
6. Describe the fabric and color.	
7. Sketch the garment, noting all important details.	

SHOPPING WORKSHEET

Purpose: Compare a moderate missy dress with a better or designer dress. The moderate dress should be under $110, the better or designer dress should be over $250. Compare street dresses.

Source: Shop two different departments of a large store.

	OBSERVATIONS	
CRITERIA	MODERATE	BETTER DESIGNER
1. What is the price of each garment?		
2. What fabric is used in each?		
3. Compare the fit of the two garments (select the same size and general silhouette).		
4. Compare the finishing techniques on each garment.		
5. What type of lining is used in each garment?		
6. What size of hem is used?		
7. How large are the seam allowances?		
8. Does the dress carry the manufacturer's label or the store's label?		
9. What do you conclude about each department, based on your shopping experience?		

CHAPTER **4**
Designing a Successful Garment

ashion can be defined as the ideal of beauty that is currently accepted by a given segment of the population. Fashionable apparel is a group of garments that are more or less new and arc accepted by a group of people as desirable and beautiful. The aesthetics of garment design are difficult to define specifically. Fashion is constantly changing, and as a new fashion becomes popular, a new standard of beauty becomes desirable. Often, a new fashion begins when the proportion of a garment is altered, for example, a silhouette is changed or a skirt is lengthened. Usually, when a truly innovative fashion begins, it takes a long time for the general public to retrain its eye and develop an appreciation for the new look. People tend to emulate trendsetters and fashion leaders, so more and more people will accept and wear the new style. As more people wear the item and interpret it in many different ways, the mass of people finds it easier to accept the fashion as beautiful. Conversely, as a fashion saturates the marketplace and is interpreted in many inexpensive versions, fashion leaders tire of it and reject the style as passé. Then these leaders experiment with a new style. Because of this constant cycle, the criteria for a beautiful garment are constantly changing.

The human body comes in many shapes and sizes. Design principles should be interpreted for each figure. When people deviate from what is decreed beautiful by current fashion, they try to minimize the difference between their appearance and the ideal by clothing their bodies to resemble the ideal. The current ideal for women is a tall, slender,

When you have read this chapter, you will understand:

1. Why changing fashions alter the ideal of beauty.

2. That defining the customer's needs helps the designer to create a successful garment.

3. That fabric choice and methods of construction determine the price and value of a garment.

4. How the elements and principles of design govern the creation of successful garments for each period.

youthful body. Most women wish to emulate the fashion models they see in magazines and movies and on television. Today, most successful clothing uses visual devices to make the wearer seem taller and more slender than she actually is. Yet, a woman who is very tall may wish to minimize her height visually so that she will look more like an average person. The short, overweight woman will try to emulate the ideal as closely as possible, given her figure. Clothing can greatly alter a person's appearance and can compensate for discrepancies between an average body and the current fashion ideal.

THE THREE FACETS OF A SUCCESSFUL DESIGN

Three elements are vital to creating a successful commercial garment.

1. *Knowledge of the consumer*—a garment should be suitable for the age, image, occasion, and lifestyle of the person who is purchasing it.
2. *Make plus fabrication equals price*—consumers evaluate the cost of a garment by anticipating the use and pleasure they will receive by wearing it and how much they can afford to pay for the gratification. Construction and fabrication are major factors in establishing the value of a garment.
3. *Aesthetics*—the design, color, and decoration of a garment should enhance the face and figure of the person who is purchasing it.

The customer's desires are dictated by social and psychological factors. Price involves the combining of fabric and construction techniques to make a garment appropriate for a specific end use. Aesthetics involve the three-dimensional rules of construction called *the elements and principles of design*. The principles of design are the rules that govern how these elements are combined. If you were baking a cake, the principles would be the directions of the recipe and the elements would be the ingredients. Elements are raw materials that must be combined successfully. The rules, or principles, are flexible and should be interpreted within the context of either current fashion or the particular problem a designer is trying to solve. The designer who is making costumes for a movie or a play may use fashion principles in a way directly opposite to that of the ready-to-wear designer who

wishes to dress clients in the most becoming current fashion.

Principles	Elements
Proportion	Silhouette
Balance	Line
Unity	Color/Value
Rhythm	Texture
Emphasis	

THE CUSTOMER

The clothes people wear often determine what others will think of them when meeting them for the first time. Clothing is a cue to identifying occupation, status in the community, and self-image. In Western society, there is strong cultural pressure toward modifying one's appearance to conform to an acceptable image. This image differs depending on occupation, age, occasion, and the area of the country a person lives in. A worker living in a large commercial Eastern city would be expected to dress conservatively in businesslike suits or dresses. The same worker in a rural setting could wear more informal clothing and still be appropriately dressed for his or her occupation.

The designer must define the customer. Many designers invent an imaginary person with all the attributes of their customers. Intelligent designers study their customers in their natural settings, observing how they dress and analyzing their lifestyles. The five Ws can be used to construct a customer profile.

1. *Who is the customer?* Define the age range of your typical customer. Figure problems may differentiate your customers from the general population. Are they petite, tall, pregnant, or full-figured, for example?

2. *Where does the customer live?* Climate is an important factor in selecting apparel. Brighter colors and lightweight fabrics are typical of the Sunbelt states. Colder climates require a greater variety of apparel. The city customer tends to dress in more-formal apparel for business than the resident of a small town. Some apparel is not restricted to certain climates. Evening wear is worn under coats, and climate, therefore, is not as important a design factor as it is in sportswear.

3. *What does the customer do?* The occupation of a customer is important for several reasons. First, it will dictate the image the person must

Dramatic silhouettes are best worn by a tall, slender person!

maintain in the community. A lawyer or bank executive must dress very conservatively. Many business women will only wear a tailored skirt suit, emulating masculine attire to blend in with the predominantly male work force. An executive in fashion or advertising dresses in high-fashion garments to stress her understanding of the current ideal of beauty. A person who works in a service industry often wears a uniform. Finally, a woman who works outside the home will have more income to spend on apparel; she will place a high value on looking appropriate on the job and thus will be stimulated to purchase more-expensive clothing. A homemaker requires a very different wardrobe: She might spend more money dressing for a glamorous evening event or only purchase casual sportswear.

4. *When does the customer wear the clothes?* The great diversity of leisure events and sports has changed the U.S. wardrobe. Businessmen and women have distinctly different wardrobes for work and leisure. Bright and fanciful sportswear and lavish evening wear are welcome alternatives to the business suit, and a businessperson can often afford better clothing for all occasions.

5. *Why buy a garment?* Customers purchase a garment for its novelty, usefulness, and value. A successful purchase answers a need the customer has. Needs are very diverse. New clothes can make a person feel glamorous or like a fashion innovator. Work clothes will be valued if they are durable and easily cared for.

The answers to the Who-What-When-Where-Why questions change each season and are different for each category of merchandise. Both designers and retailers constantly reevaluate the customer's profile to create and select merchandise that will sell. Economic conditions often affect the merchandise mix that customers purchase. During recessionary periods, very inexpensive clothes can be expected to sell in great volume because people have less money to spend on clothing. Other customers purchase expensive clothes during the same time period because fewer items are purchased and are worn longer. Social conditions affect clothing purchases; for example, the home-sewing market faced recession during the period when women returned to work because they had less time to make clothes, so career ready-to-wear sales improved. The attentive designer must research current events and use them to predict how consumers will spend their apparel dollars.

Electronic shopping will become more popular in the next decade. Designers will be able to offer a larger selection of options including customized color, surface patterns, and customized fit. Mass customization is a trend among innovative manufacturers; some sell directly to the customer via catalog, home shows and televised shopping networks.

MAKE PLUS FABRIC EQUALS PRICE

The quality of the fabric and the garment's construction ("make") are two main factors in determining a garment's price. Usually these two components account for one-half to two-thirds of the wholesale cost of the garment. Today's customers are more sophisticated and are concerned with the value of a garment more than its price. They evaluate construction details and fabric to make sure that the garment will wear well and withstand cleaning processes. Seams should be sewn with small, even stitches. Sturdy garments should have reinforced seams. Tailored garments should have crisp interfacings and well-made linings. Hems should be closely stitched with a blind stitch, preferably in a colored thread to match the garment instead of the clear thread that often pulls out. Buttons and fastenings should be firmly sewn to the garment. A spare button sewn into an inner seam of the garment is always a welcome addition.

Fabric should be appropriate to the garment's design. Some customers prefer natural fibers that

Table 4.1

	Fiber	Construction
Warm or hot climates	Cotton Linen Rayon	Lightweight wovens and knits; gauze and open weaves; puckered surfaces that allow for greater air circulation near the body; smooth finishes. White and light colors reflect the heat and are psychologically cool.
Temperate climates	Acetate Rayon Cotton Linen Polyester Nylon Silk Acrylic Lightweight leather Lightweight wools	Midweight weaves and knits in a wide range of colors that may be modified by wearing layers of clothing to adapt to temperature variations.
Cold	Wool Nylon Acrylic Furs Heavy leathers Hairblends like camel, vicuña, and alpaca	Heavyweight knits and wovens. Tightly woven fabrics to stop the wind. Fiber- or down-filled inner layers quilted to add warmth. Psychologically warm colors are red, orange, bright yellow, and black.

perform and have a good "hand" (the feel of the fabric). Manufacturers of synthetic fabrics have developed more sophisticated blends that have easy-care characteristics without the negative plastic hand and unbreathable weaves of early polyesters. Junior customers are rediscovering polyester, and shiny knits and wovens are fashionable with an age group that did not experience the sixties. The designer must select the appropriate color, print, and weave to execute the design. The fabric must be the correct weight and fiber for the climate the garment will be worn in.

The quality of the fabric will greatly affect the wear that can be expected from a garment. The designer evaluates each fabric's care requirements and matches them with the end use of the garment being created. For example, a fabric that requires drycleaning presents a continuous investment over the lifetime of the garment and is appropriate for a silk blouse but not for a pair of jeans or children's wear.

AESTHETICS

An apparel designer is a sculptor who uses the basic human body as a form for a soft fabric sculpture that enhances the figure. Apparel is three-dimensional, which means it has volume. The designer usually begins to sketch a garment in two dimensions, visualizing the back and sides as the details are drawn. Flat fabric is seamed and structured to have a three-dimensional shape. The silhouette is the most obvious design element. Then the eye of the viewer moves to the subdivisions created by seams and other design elements. The elements that influence three-dimensional structure are the proportion of the spaces, the use of line, the balance and unity of the design devices, and the rhythm and emphasis of the details within the garment.

The Silhouette

The silhouette is the most dominant visual element of a garment and dictates a great deal of the other styling elements that make up the design. Fashion cycles often focus on a specific silhouette, but because of the diversity of modern life, many kinds of apparel are used concurrently, and a person usually has a great variety of silhouettes in his or her wardrobe at any one time. Silhouettes are modified by adding fabric, padding various parts of the body, or corseting the waist or bust to create a specific illusion. The shape of the silhouette usually complements the shape of the

body, but exaggeration is often used to create a special effect or balance and to emphasize a part of the body that is a current focus of fashion.

Aesthetically the *natural body silhouette* is best worn by an active, physically fit figure. The comfort and functional advantages of stretch bodysuits and leotards are desired by all figure types. One device to make this silhouette more wearable is to use body-hugging attire on parts of the body that are the shapeliest and another layer of clothing where the figure is less desirable. For example, large thighs can be minimized with dark tights and a small wrap skirt added to the leotard. A large waist can be camouflaged by teaming a dark bodysuit with a tonal leg covering or by adding a vest or sweatshirt to the bodysuit to balance the larger area.

Bathing suits are made for various kinds of figures from matronly to youthful. The difference is often found in the underconstruction of the suit as well as the cut of the outer shell. Fuller figures require a defined bustline and have an underwire bust support or structured bra cup that is preformed in durable interlining fabric to provide support. Suits for a mature figure are often designed with a small skirt added to the suit to hide the hipline. Slim legs can be made to look longer if the leg line on the suit is cut up slightly. Conversely, a straight leg line at the crotch will make the thighs seem wider.

Color and pattern are very important for styling active wear. Color is often engineered to give a special effect to the bathing suit. Dark colors tend to recede, making an area seem smaller. They are used at the bust and hipline to reduce the width of these areas. Diagonal patterns and stripes are also effective slimming devices. Colors are important in styling bathing suits because so much skin is exposed. Dark, rich colors and bright colors tend to enhance a tan and are very salable. White is an excellent contrast to a tanned skin but is difficult to make opaque when wet, so it must be used with care in the area of the crotch and bust.

Natural Body Silhouette

Typical garments: Very active sportswear and exercise suits, bathing suits, and dance costumes.

Function: Freedom of movement is most important. Knits are often preferred, and their naturally stretchy structure is enhanced by using Lycra© and Spandex© fibers to increase stretch.

Structure: Stretch fabrics make construction lines less important for fit. Tight fit emphasizes the body's curves with little chance to camouflage figure problems.

Decoration: The most important aspect of active wear. Dark colors like black, navy, and brown will minimize figure curves best. Diagonal stripes will slim the figure. Bathing suits are often styled with prints that focus on one area of the figure and create a two-dimensional style impact.

The *slim-line silhouette* hugs the figure with very little air space between the garment and the body. This is the classic tailored silhouette. The tailored silhouette for women is very acceptable for business apparel because it is similar to the man's business suit. Pants must fit well to enhance a figure. There are two kinds of pants: the snug fit, typical of tights or a snug jean, and the looser trouser.

The trouser is often styled with darts or release pleats to compensate for the *drop,* the difference in measurement between the waist and the hips, which is usually 10 inches or more. The trouser should fit smoothly over the top of the hips and fall in a straight sweep of fabric from the fullest part of the upper hip to the cuff. Pants that cling to the thighs or fit too snugly through the seat will emphasize the width of the hips and accentuate the fullest part of the figure. This pants is more often tailored in wool and in blends of cotton and synthetics because the loose fit does not overstress the fabric.

The snuggest pants are tights, made from knit fabric augmented with Lycra®, which adds stretch so the pants will cling to every curve of the body. Lycra also makes the knit fabric "recover," allowing the garment to retain its original shape, even at such pressure points as the knee or the seat.

A jean is made in sturdy, heavyweight denim. The typical jean fabric is an 11+-ounce denim, which is durable enough to support the figure. People want the right fit, appropriate for their age, fashion image, and body type. This is likely to change constantly. The durable fabric, the flat-fell seams, and a heavyweight zipper are designed to have direct contact with the figure from the thighs up. Jeans are too tight if they are uncomfortable at the crotch area, wrinkle through the thighs, are uncomfortable to sit in, or force extra flesh above the pant at the waist area.

The illusion of height is easily created with pants and a slim-fitted blouse. Pants automatically make a person look taller because the torso from the waist down is covered with a single expanse of fabric. Artificial devices such as high-heeled and platform shoes add physical height. The shoes can be covered with the pants leg and will not be visible. Upswept hairstyles and a slight flare in the pants leg will also increase the illusion of height.

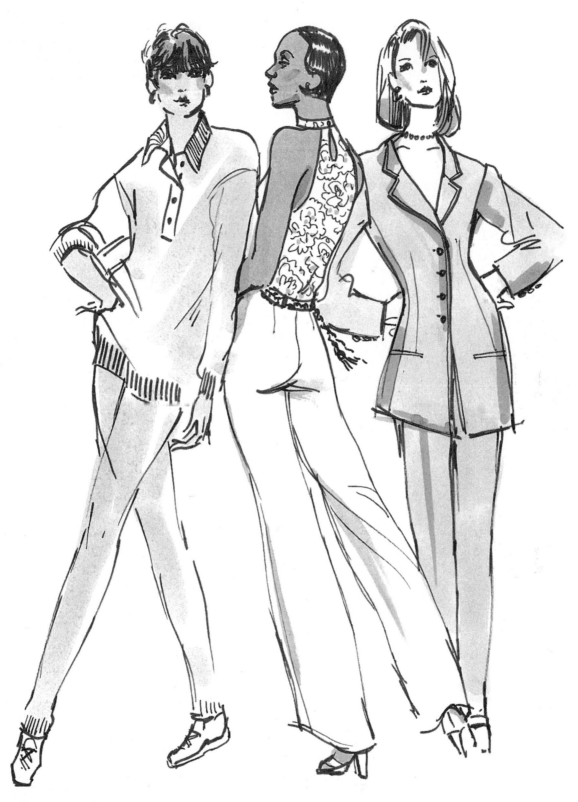

Slim-Line Silhouette, Pants

Typical garments: Snugly fitted jeans or pants made from knit fabrics with a slim leg (typically called a *straight leg* or *boot leg*.

Function: Freedom of movement is impaired unless stretch wovens or knits are used as the bottom weights.

Structure: Darts and seams must be used for woven fabrics to achieve a fit this close to the body. This is a good silhouette for knits. When a contrast top is used, the length of legs will be emphasized.

Decoration: Darker pants will tend to make the legs look longer and the hips smaller because dark colors recede visually.

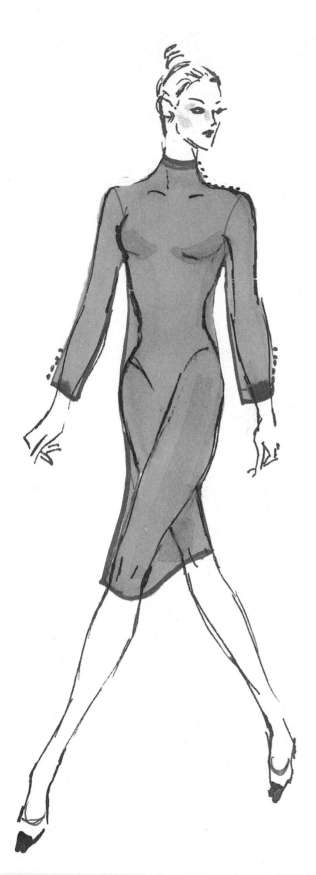

The *slim-line skirt silhouette* is very flattering for most figures. A straight, tailored skirt slims visually because no bulk is added to the figure at waist and hips. When worn with a tailored jacket, padding and construction techniques fill in and balance a figure that is narrow in the shoulders or has a small bustline. Tailored garments are made of heavy fabrics that are seamed and padded so that the jacket has a firm structure that can camouflage many figure problems. The length of the jacket depends on the height of the wearer and the kind of bottom it will be worn with.

A jacket should cover the crotch if worn with pants or hit the figure high on the hip so that the jacket hemline does not lead the eye to the wrinkled crotch area. On a short person, a jacket that is too long will reduce the length of the skirt and appear to make the person shorter. The length of the jacket also depends on the color of the bottom. A contrast jacket should be carefully balanced for length because the hem and the color area will stand out against the skirt. A one-color suit will have a less distinct body division, and there will be more leeway for the length of the jacket. A short dressmaker jacket is most flattering when worn with a skirt that is slightly eased or gathered at the waistline. A short jacket will make a short person look taller because of the visual contrast between the shortness of the bodice and the longer expanse of the skirt or pant. Fashion dictates that hem length and the length of the jacket should relate to skirt length.

The tailored silhouette is also appropriate for dresses. The classic shirtdress has a slim silhouette. This is a very flattering style for many figure types because the vertical line the jacket makes carries the eye the length of the dress and tends to slim and elongate the figure.

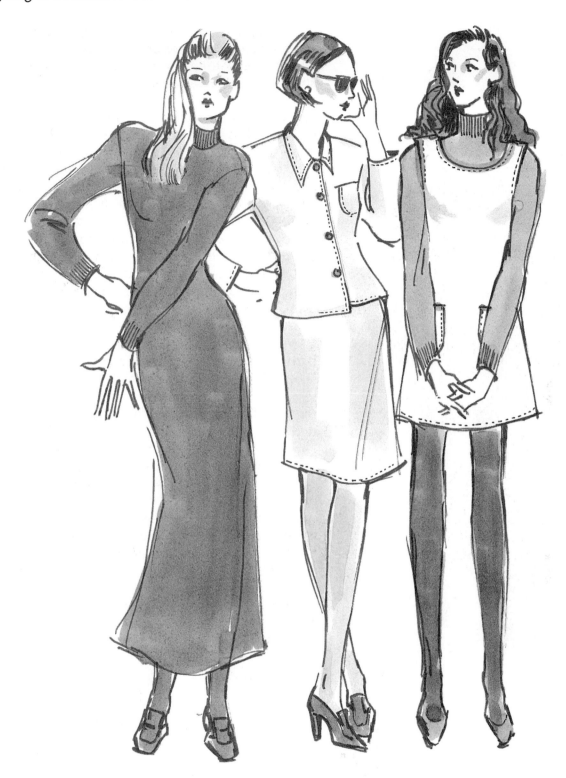

Slim-Line Silhouette, Skirts

Typical garments: Slim suits and clinging dresses fitted with darts and seams if cut in woven fabrics. This is the equivalent of the man's business suit and is called a *tailored silhouette.*

Function: Movement is impaired by the slim skirt unless slits or pleats are added to help leg movement. Fitted jacket limits exaggerated arm movement.

Structure: Vertical lines, slim lapels, and small details will make a person seem taller and slimmer. Slightly padded shoulders balance a wide hipline, a good way to camouflage a thick waist, as the silhouette is basically rectangular.

Decoration: Similar colors in the jacket and skirt emphasize height. Darker suits will shorten the figure but tend to make the hips seem smaller.

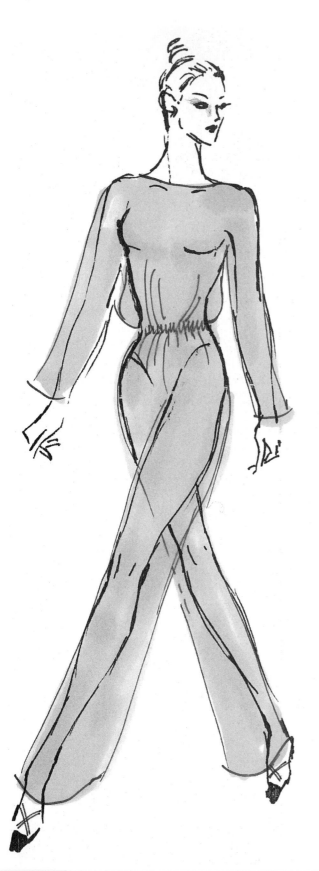

Soft dressing describes garments styled with more ease and a looser fit. Softer, thinner fabrics are usually used for this silhouette. Details such as structured collars and pocket flaps typically used in tailored garments are usually inappropriate for this kind of styling because the fabric is too light. Ease, shirring, tucking details, and other decorative means of controlling ease are the styling devices used to create soft garments. These clothes are particularly appropriate for warm weather because of their loose fit and thinner fabrics, which allow air to circulate near the body. This kind of styling tends to look dressier than tailored garments and is often used for special-occasion and after-five dresses.

Soft pants are usually styled in lightweight fabrics. Pleats and gathers are used to control the drop. Fullness in the hip area will visually enlarge the lower torso. This style is very appropriately worn to balance a slender hip with a heavy bust. A figure with a large hipline and a small bust and shoulder can balance these two elements with the use of fuller sleeves, shoulder pleats, or a ruffle at the neckline combined with a softer pants. A slender, well-balanced figure can also wear this kind of silhouette well. The soft pants is comfortable and easy to move in, making it an appropriate exercise garment for cold weather. Sweatshirt fabrics are made into pants with a drawstring or elasticized waist and pants legs finished with a knitted rib banding or elastic so that they do not flap when used for jogging.

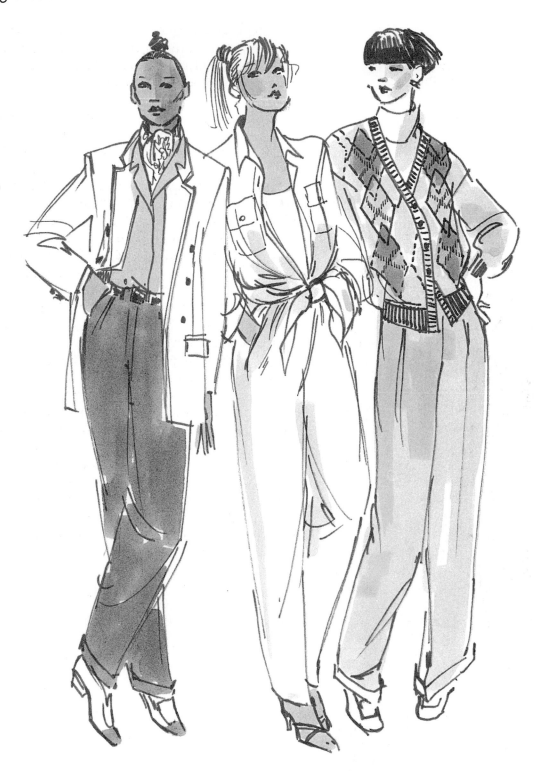

Moderate Silhouette Modification, Pants

Typical garments: Softly pleated pants and trousers styled with a straight, flared, or slightly ballooned leg. A soft shirt would be a typical top. This is a typical silhouette for cold-weather active sports.

Function: Movement is easier and shoulders may move unimpaired. Knits and wovens may be used successfully in this silhouette.

Structure: Less need for seam and dart lines. Ease or gathers are used to fit the garments at waist and bust. Knits are often styled with rib banding instead of structured waistbands. The silhouette can be used to camouflage many figure problems, creating basically a wide, rectangular silhouette.

Decoration: Appropriate for bolder prints. Same rules of color to emphasize height and diminished width apply.

Soft dressing in skirt silhouettes includes full dirndles and gathered skirts. When this silhouette is made in lightweight fabrics, the effect softens and dresses the heavier figure with an illusion that fabric instead of flesh is adding volume to the figure. Soft bows, ruffles, tucking, and pleating details are typical for this feminine style. The moderate skirt silhouette is basically rectangular and adapts itself to camouflaging the figure that is thick through the waistline and hips. A dress that is one color will lengthen the figure. Darker and neutral tones will seem to recede, making the figure seem more streamlined. The shift or float version of this silhouette is flattering for heavier, shorter figures because the waistline is not defined, and this gives the person a longer line suggesting height. The important elements of this silhouette when styling a dress to flatter the smaller, bulky figure are fabric and color.

Gathered fabric tends to lead the eye to the source of the gathers. This can be used effectively to highlight a heavy person's face, neck, and shoulders, often their best features. Gathers coming from the snug cuff of a full sleeve will focus attention on small, attractive hands, often a good feature for the larger woman who also wishes to cover fleshy elbows and arms. Conversely, a soft gathered blouse in an elegant fabric will cover bony elbows and overly thin arms and add femininity for an angular, thin person.

The soft silhouette can be contrasted with fitted garments. This will accentuate parts of the body. For example, a person with full hips can wear a soft dirndl contrasted with a belt to accent a slim waist and a fitted top. This will focus attention on the slim parts of the figure and diminish the size of the hips by hiding them with the soft gathers of the dirndl.

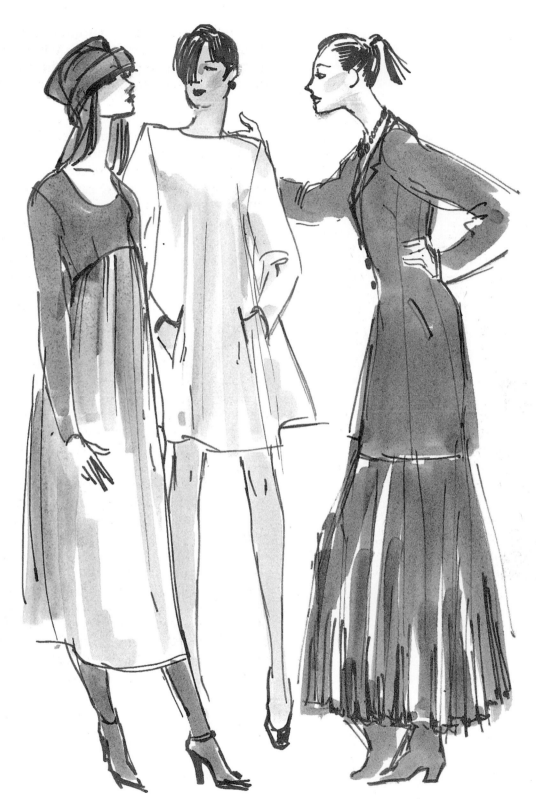

Moderate Silhouette Modification, Skirts

Typical garments: Dirndls and fuller blouse silhouettes. This silhouette is typically called *soft styling*.

Function: Movement is easier, and legs and torso are unimpaired. More bulk surrounding the hips.

Structure: Gathering and ease is the primary styling element. Yokes to control the shirred areas are popular styling devices. This rectangular silhouette may be used to emphasize a small waistline by contrasting the two larger areas of the bodice and skirt with a bright belt.

Decoration: Appropriate silhouette for larger prints as well as small and soft textures.

The *wedge* uses padding or fullness at the shoulder to increase the visual width of the bodice top. This gives the figure a masculine look. Width at the shoulders tends to make the hip area look narrower by comparison; the bottom is usually slim to contrast with the shoulder width. This silhouette also makes a person seem taller. The effect is easily achieved in a tailored suit, where shoulder pads are hidden by heavy fabric. The lapels of a jacket can be slightly enlarged to increase the illusion of width. Extreme shoulder extension tends to overpower a small figure. Slight padding or sleeve extension can effectively balance any figure, and squaring the line of the shoulders makes a person seem taller and more youthful.

Shoulder pads support the garment and make it look more attractive on the hanger, adding to its initial appeal in a store. Shoulder pads may also be added to soft garments, though they are usually smaller and should be covered in self-fabric so they are not obvious. To duplicate the wedge effect in evening gowns, crisp fabrics like taffeta or silk organza may be used. A great deal of volume can be added with sleeves in a leg-o'-mutton style, contrasted with a slim skirt. Ruffles at the shoulder line also create a wedge silhouette.

Batwing, dolman, and raglan sleeves that are cut with a great deal of fabric under the arm will create a wedge silhouette. This silhouette is a style variation that tends to be popular when more masculine values are attributed to women. Shoulder pads were very popular in tailored suits during World War II, when women were encouraged to join the work force.

Extreme Silhouette Modification, Shoulder Wedge

Typical garments: Shoulder pads or other style devices like leg-o'-mutton sleeves and shoulder ruffles are used to create the wedge shape. Width at the shoulder is most effective when contrasted with a slim bottom.

Function: This fashion is often popular during times when independent women are valued by society.

Structure: Padding is essential for achieving this look in a tailored garment. Larger lapels that reflect the wedge shape enhance the illusion. Hips seem smaller with this shaped top.

Decoration: Details like epaulets on a wide shoulder will accentuate the shape. Lighter tops over dark bottoms will increase the illusion.

The *hourglass* is a feminine silhouette because it contrasts a full bust with wide hips. The narrow waist is the accent that provides contrast between wider areas of the figure. This has been a dominant theme throughout fashion history because it emphasizes typical feminine figure characteristics. In the past, waist cinchers were used to pull in the waist. Sometimes these cruel efforts to make the flexible waist area smaller were so harsh that women fainted from being corseted. Corseting would begin early for girls, and often several of the lower ribs would be broken by constant compression. This practice made women's waistlines consistently smaller. During the 1960s, shift dresses became fashionable, and for the first time in many decades women stopped trying to compress their waistlines. When belts returned to fashion almost a decade later, clothing manufacturers found that women's waistlines had increased over an inch per size.

The visual illusion of a small waistline is still possible through techniques similar to those used in the past but without severe corseting. A contrasting belt worn with a flared shirt to define the waistline and a romantic blouse with a full sleeve can create the hourglass silhouette. This effect is enhanced when skirts are longer than the knee. The sweep of a long, flared skirt makes the waist seem even smaller. The fitted waistline and a slightly fuller sleeve with a very full skirt has been a successful evening- and wedding-gown formula for many years because of its femininity. The hourglass silhouette should be carefully worn by very small women. Petite women may wear the silhouette, but the proportion and volume of the skirt should be modified so the person does not seem overwhelmed. A bulky torso and large waistline is better concealed by another silhouette.

Extreme Silhouette Modification, the Hourglass

Typical garments: Flared skirts teamed with tops that have full sleeves and a very fitted waist create this illusion. This silhouette is very feminine because the hips and the bust are subtly increased by contrast with a very small waist.

Function: Movement may be impaired, especially when the waist is tightly bound and when long, full skirts are worn.

Structure: Fitting and padding are used to define the shoulder line and the waist. Contrast colors at the waist effectively direct attention to the tight portion of the garment. Flared skirts and peplums add to the illusion.

Decoration: Emphasis at the widest part of the wedge, either at the hem or the neckline, will exaggerate the illusion.

Extreme *volume* is sometimes a popular fashion silhouette. To achieve this look, several layers are usually worn at one time. The figure is minimized, and the draping and design of the fabric become most important. Often, a mix of prints and textures is popular because the figure is less visible and decorative elements of fabric and design take over.

The extreme-volume silhouette is a classic and acceptable theme for outerwear even when slim silhouettes are fashionable for other clothes. Bulk implies psychological warmth as well as physically providing it. Long-haired furs, heavy wools, bulky quilts often filled with down or fiber, and heavy leathers are typical cold-weather fabrics. Bulky sweater knits worn over wool shirts and long skirts are popular during the winter. Coats are often voluminous enough to cover suits and dresses. Capes and large shawls are popular additional accessories during cold weather.

These full garments successfully camouflage many figure problems, and large women have a wide variety of wardrobe choices when fashion decrees fullness is beautiful. The very petite woman will have to balance the size of her clothes and accessories with the size of her figure to achieve the look of volume without being overwhelmed by her clothing. One way to do this is to wear slightly shorter skirts and keep the colors of all the components of an outfit in one tone. Wear smaller prints. Keep handbags and scarves smaller than those worn by large people. To appear taller, wear stockings and shoes that match the skirt. This silhouette is very effective and dramatic on a tall woman. It will successfully camouflage angular body lines if worn by the tall, slender woman.

The extreme-volume silhouette is difficult for most figures to wear when fashion decrees that pants should also be very full. This silhouette emphasizes the width of the hips and legs and makes a person seem shorter, so only a tall, slender person can effectively wear the full pants. The most successful way for a great variety of figures to wear the extremely full silhouette is to keep the volume above the hipline and contrast it with slim pants. Dark pants will make the person seem taller, even though he or she wears bulky tops. This modified silhouette is the typical cold-weather active-wear garment. A parka or bulky sweater is worn over slim pants, often made of stretch material for added mobility.

Extreme Silhouette Modification, Figure Volume

Typical garments: Layering several bulky garments over each other creates extreme figure volume. This silhouette is particularly appropriate for cold-weather dressing and is often found in outerwear.

Function: Warmth is the most obvious function of the full silhouette, but when the style is fashionable, it will be adapted to warm weather by draping voluminous layers of lightweight fabric on the body.

Structure: Styling devices are full cuts and bulky fabrics. Quilting, fur, and heavy leathers are often used for warmth. Layers of clothing generate this effect.

Decoration: Ethnic clothing is often popular during periods when volume silhouettes are fashionable because costumes such as caftans are full and figure enveloping. Pattern mixes are popular, and large prints accent the volume of clothes.

People with large figures will sometimes wear bulky pants in the hope that the fabric volume will hide their figure problems. Usually, the total silhouette is overwhelming. A large person may choose to modify this effect by wearing a loose tunic that covers the thighs and a straight-leg pants all in one color. This will lengthen the torso and avoid focusing on the waistline. The continuous line of the pants will make the very large person seem taller; yet, the hips will be covered—usually a problem area for the large woman. Caftans are also popular with extremely large women because they offer a long, continuous line and cover the figure without attempting to fit any area snugly. These garments are more attractive when worn for casual events at home. They are not appropriate for street or business wear.

When fashion decrees that volume is important, summer clothing is often made from lightweight cottons that are gathered at the waist and worn loose enough to allow air to circulate near the body and keep it cool. Often, the outline of the body is visible through the sheer fabric, and even though the garments are full, the illusion is of a slender body.

A great variety of silhouettes is usually contained in an individual's wardrobe because of the many different occasions people dress for. Wardrobe diversity also reflects changes in fashion that continually modify the stylish silhouette. Most people do not purchase an entirely new wardrobe when a style changes: They often combine old and new garments to create fashionable outfits—diversity is the rule rather than the exception. In addition, people with figure problems often dress in conservative silhouettes that flatter their figures, and ignore radical fashion changes.

Extreme Silhouette Modification, Figure Volume Pants

Typical garments: Layering several bulky tops over full pants creates this effect. More popular is wearing bulky garments over the torso, contrasted with a slim trouser.

Function: Warmth is the primary goal. This silhouette is often adapted to active winter sports, where the mobility of the legs is more important and warmth is necessary.

Structure: Tailored garments as well as draped shawls and capes over pants are popular. Wide-leg pants and versions of jodhpurs and harem pants are typical of this silhouette. The torso appears bulky and large. Fabrics are light in warm climates, and a great deal of ease is added to increase the volume of the garment.

Decoration: Large prints and bold colors are used effectively for this silhouette.

Line

Line refers to the edge or the outline of a garment and the style lines that divide the space within a garment. Line can create visual illusions, such as height, which can lengthen or shorten the figure, and width, which can make a figure seem thinner or heavier. Because the eye follows a line, the line can attract the eye to particular areas and draw it away from less desirable areas. Straight, diagonal, and curved lines are all used in garment design.

The two rectangles represent a human body in garments of two different lengths. The first rectangle has the same proportions as an average body wearing a dress that comes to the middle of the knee. The second rectangle represents an average body wearing a garment that covers from shoulder to ankle. These rectangles will be used in many abstract examples of apparel design. Study the illustrations to see how line can visually deceive the eye. Color exaggerates the effect of line. Which rectangle looks the narrowest?

Line leads the eye and can be used in apparel design to reinforce the theme of a garment. The characteristics of line are its path and its length. A horizontal line will direct the viewer across the garment, emphasizing its width at that point. Off-the-shoulder, square, and boat necklines will shorten a long face and make the shoulders seem broader. If worn by a short person, they will make the person seem shorter. A band or seam at the hipline will make the hips seem wider.

Which rectangle looks the thinnest?

A straight vertical line gives a heightening effect and divides the body, making it seem thinner. A gentle curve is feminine and passive. The more exaggerated a curved line becomes, the more time it takes to view the contour and so it will seem fussy, as in a circular ruffle that decorates a

The figures in the center and at the right appear more slender than the one at the left because the added vertical lines divide the space and because the eye interprets this division as a smaller whole. The uninterrupted vertical lines quickly draw the eye upward and make the rectangles seem longer and slimmer. Vertical divisions in garments are called *gores*. Because gores form an unbroken line from end to end, they are more slimming than darts.

scooped neckline and exaggerates femininity. A diagonal line will slim the figure if the angle is not too abrupt. The slim V neckline formed by an open shirt or jacket will make the figure seem slimmer and taller. This neckline will also lengthen a round or square face. If the shape is reinforced by contrast when wearing a light-colored blouse under a dark suit, the effect will be even stronger. When a line is thickened and contrasted to the rest of the garment by using a braid or trim, the line becomes visually stronger. French designer Coco Chanel was famous for suits with braid trim outlining the front edges of the jacket. The jackets were very slenderizing and have become a classic style because they are so flattering.

A contrasting coat worn over a dress is a very slimming illusion. The viewer's eye reads the central panel as the width of the figure, a portion much slimmer than the whole space. A similar illusion occurs with the skirted suit worn with a contrasting blouse. The light color of the top attracts attention to the rectangle of the garment.

Which rectangle looks the widest?

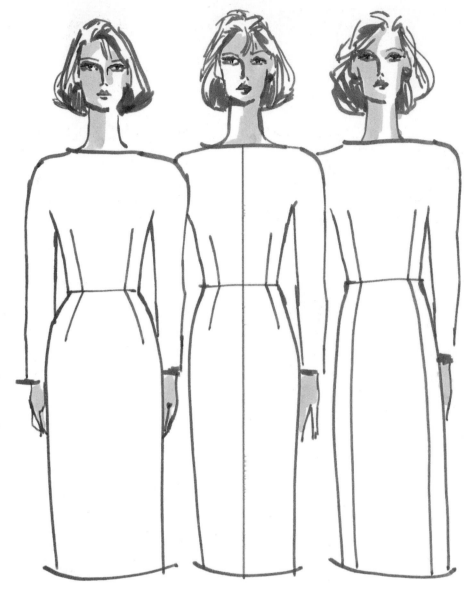

The second and third rectangles look thinner than the first because the vertical lines are interrupted less frequently. Too many horizontal lines with several inches between them add width to a space. Notice how the darts, which look like short lines, do not carry the eye through the whole composition. This adds width to the rectangle of the garment.

Which rectangle looks the most slender?

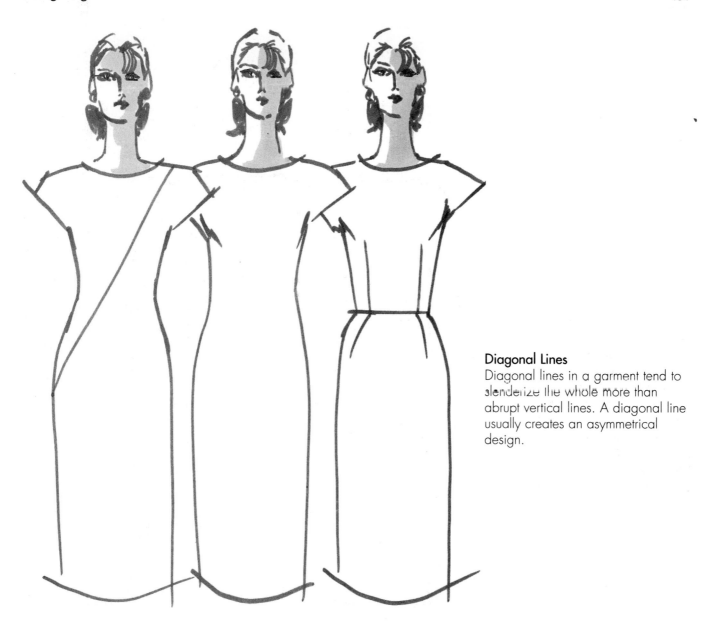

Diagonal Lines
Diagonal lines in a garment tend to slenderize the whole more than abrupt vertical lines. A diagonal line usually creates an asymmetrical design.

Which rectangle looks the most slender?
Which rectangle looks the tallest?

Diagonal lines combined with vertical lines, as illustrated in the figure on the right, create the most slenderizing effect and make the figure seem the tallest. The eye follows the center from the seam up through the skirt and the asymmetrically divided bodice. This style emphasizes and enlarges the bust and shoulder areas.

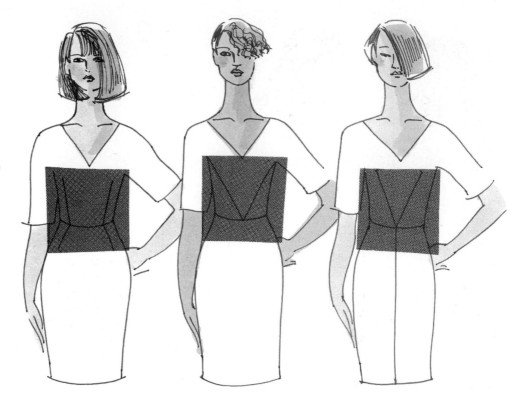

Which rectangle looks the longest?
Which rectangle looks the broadest?

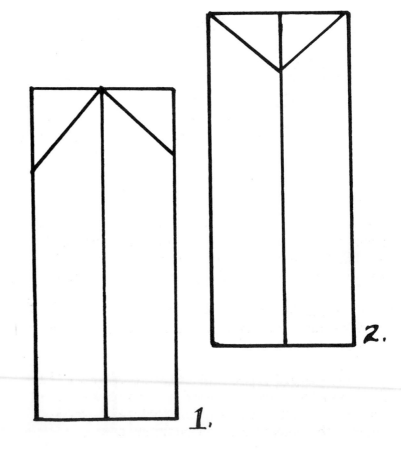

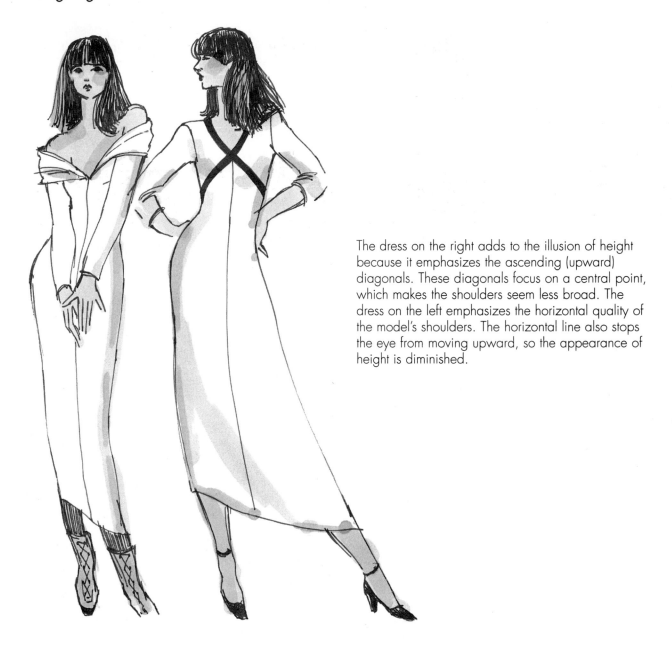

The dress on the right adds to the illusion of height because it emphasizes the ascending (upward) diagonals. These diagonals focus on a central point, which makes the shoulders seem less broad. The dress on the left emphasizes the horizontal quality of the model's shoulders. The horizontal line also stops the eye from moving upward, so the appearance of height is diminished.

Color

Color is the first thing that a customer notices about a garment: It costs a manufacturer very little to change colors, and new colors stimulate sales. Two factors influence a designer's choice of colors:

1. Commercial color predictions
2. Whether a color is appropriate and flattering for a specific customer

The commercial aspects of selecting color will be discussed in Chapter 5. Aesthetic color decisions are based on selecting flattering colors and applying color to the body to create visual illusions.

There are two basic complexion types, warm-toned skin with yellow undertones and cool-toned skin with blue-pink undertones. Colors that complement the basic color characteristics of the wearers' skin tones will flatter them and make them appear healthier and prettier. Warm skin tones look best wearing colors with a yellow undertone; cool skin tones will be most flattered by colors with a blue base. Using red as an example, a rich tomato red would be most flattering to a warm skin tone. The cool version would be a blued red to a magenta. Some lucky persons are able to wear both color palettes. Complexion color can be changed by using a foundation toner, but the best rule is to research your colors and select clothes in your color palette.

During the 1980s, U.S. consumers were fascinated with color research, and many women had their "colors done" by a professional fashion consultant. The commercial designer must be aware of this trend and make sure to select seasonal colors that will be appropriate for both color palettes.

People tend to select colors that are compatible with their complexions, even though they may not consult with color experts. Color-prediction services often ignore the fact that colors should flatter people. Today's designer should study professional color-service information, like that presented by the Ameritone Color Key system,[1] and use this information as a guide to selecting flattering colors for all complexion types. Environment also affects the use of color. People who live in warm climates tend to have more pigment in their skin, which protects them from overexposure to the sun. Warm climates encourage people to wear bright colors that complement darker complexions. Light colors reflect heat and contrast nicely with darker skin and hair tones, making them popular warm-weather colors too.

Color applied to the body will create a variety of illusions. Designers should be aware of how color can highlight parts of the body and minimize figure problems, especially if designing for a special-size woman. Some examples of color illusions follow:

1. A garment in one color (or tones of that color) adds to the illusion of height, especially in a floor-length garment (long skirts and pants).

[1]The Color Key Corporation, P.O. Box 190, Long Beach, CA 90813. Teaching aids including a slide/cassette lesson are available from this address.

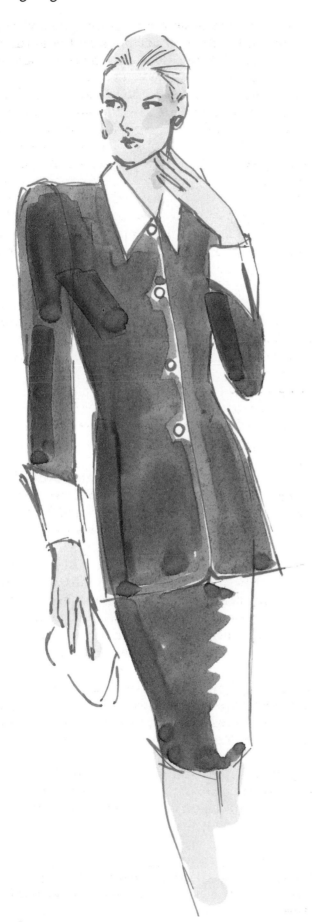

Light colors are flattering around the
face and focus attention to it.

Space filled with a pattern appears larger than a solid garment.

2. Darker colors worn above the hipline with lighter bottoms tend to shorten a figure.

3. Darker colors recede visually, and light, bright colors pop out. A woman with a large bust and slender hips can equalize her figure by wearing light-colored pants and a dark top.

4. Light colors are flattering around the face. The eye seeks out light colors when they contrast with a dark garment. A white collar on a dark dress emphasizes the face.

5. Bright colors focus on an area of the body. Wear them to highlight a positive feature, like a bright belt on a slim waist.

6. Bright colors (like red, bright purple, chrome yellow, and hot pink) against a plain, neutral background will visually "pop" the shape.

7. Space filled with pattern will seem larger than plain space. A boldly patterned blouse worn with a pair of dark pants will make the bust and torso area seem much larger than the hips.

Which rectangle seems the thinnest?

To acquire an eye for color illusions, study clothing on various figure types, making mental notes about how different colors and patterns flatter the wearer.

Value

The contrast between light and dark is used frequently to create effective illusions that disguise figure problems. Contrasts accent different parts of the body and create subtle illusions. Dark areas recede visually, so an area of the body that is disproportionately large can be balanced by covering it with a dark garment. Light colors stand out, which make light areas seem larger than they are, especially when contrasted with dark areas. Look at the illustrations here and on page 158 to see the effects of value.

In the illustration above, the first garment looks the thinnest because the eye "sees" only half the garment, the dark half being less noticeable.

Now study the rectangles and examples on the next page. When the bodice is darker than the skirt or pants, the shoulders and size of the bust are minimized. The figure will appear shorter because the dark value dominates the light bottom. A dark pants or skirt minimizes the hips and makes the person seem taller.

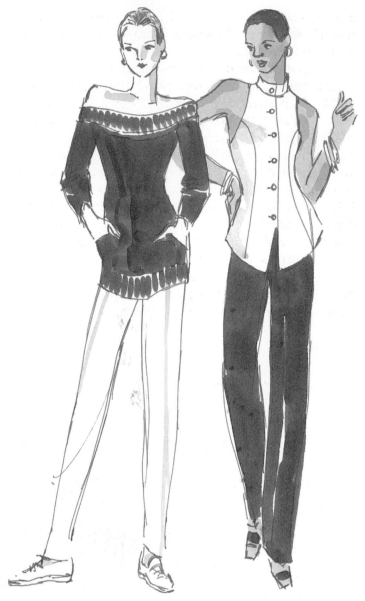

These examples are simple illustrations of the principles of value, principles that can be extended to many other kinds of garments.

Pattern

Developing an eye for selecting patterns that appeal to a great many customers is a special talent. It is important to expose yourself to a great variety of fabrics and to try to imagine how a pattern will look made up in a specific garment. The fabric that carries the pattern is extremely important. A beautiful fabric like silk crêpe de chine makes rather somber or dull prints look elegant because of the quality

and luster of the fabric. The same print on a flat, lusterless fabric will lose a great deal of its beauty and sophistication.

Extremes of pattern will accentuate extremes of the figure. A very large print on a small woman will tend to dwarf her. A moderately sized pattern or a small motif would be more appropriate. A huge print on a very large woman will accent the size of her figure, especially if the patterns are widely spaced, because the eye unconsciously counts the number of patterns needed to span her girth. Widely spaced, huge prints tend to fall unpredictably on the figure and may land on the bust, tummy, or derriere and accentuate these areas. Overall prints with low contrast motifs camouflage a large figure most effectively. Tall, slender women can best carry bold designs. Small prints and florals tend to be dainty and feminine.

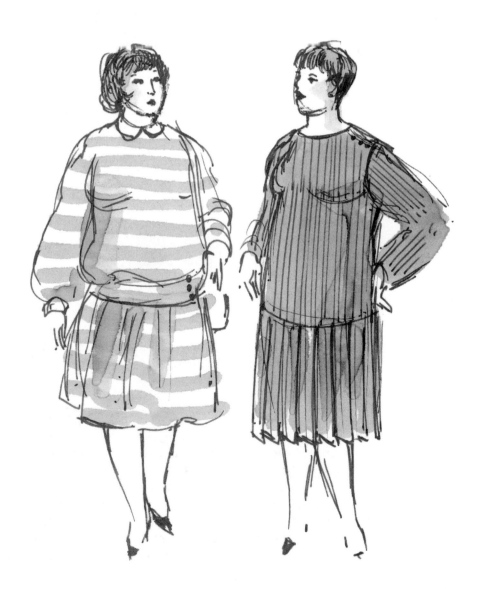

Directional patterns emphasize the figure because the eye follows the direction in which they flow. A vertical stripe will carry the eye from the hem of the garment to the wearer's face in a quick, uninterrupted glance that makes a person seem more slender. Plaids on the bias are flattering because they create a diagonal and lead the eye to the face. Geometrics are more versatile than specific images.

A good rule of thumb is to use simple styles for complicated prints because the print has a lot of intrinsic interest. This lets the fabric carry the style of the dress without diminishing the impact of the print with small structural details. Select a variety of sizes and ground colors when selecting a print group. Include one bold print, one geometric or dot, and a third print that is currently fashionable. Trends in print size and styling have cycles like fashion silhouettes and are often closely linked to them. When full silhouettes are popular, many large prints will be offered. When feminine styling

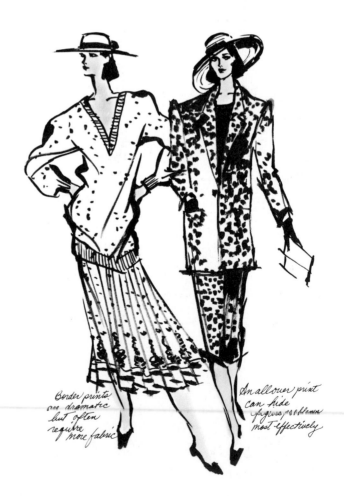

Border prints
are dramatic
but often
require
more fabric

An allover print
can hide
figures problems
most effectively

is popular, look for florals and tiny prints. Conversational prints have an amusing motif and are often popular in the junior market and for casual sportswear.

The designer must evaluate the practicality of each print as well as its aesthetics. Border prints, for example, usually require additional yardage to lay out the pattern pieces effectively. One-way prints have a motif that cannot be reversed and must be laid out with all pattern pieces going in the same direction. Two-way prints are much easier and more economical to work with. Unbalanced plaids are very difficult to cut and match and require special styling. Linear geometric patterns, like stripes and plaids, must be finished carefully and woven or printed exactly on the grain or the patterns will appear bowed.

Light affects the way we perceive colors. When a designer matches a print to a base goods, the two fabrics should be examined in natural light as well as under cool, fluorescent store lighting. The colors

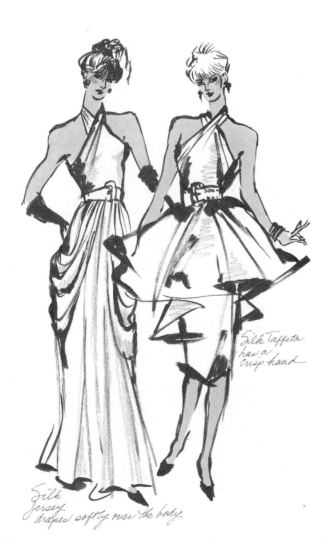

Silk Taffeta has a crisp hand

Silk Jersey drapes softly over the body

must match in all conditions so that the consumer does not buy a blouse only to find that it does not match the coordinates in daylight. A light box for testing colors is standard equipment for any sportswear house where combining fabrics is important. This tool provides fluorescent, incandescent, and daylight to compare fabric swatches for color compatibility.

Texture

Texture means the hand—that is, the way the fabric feels; texture also refers to the appearance of the fabric. Hand and appearance dictate the silhouette and kind of garment that can be made. A soft fabric that drapes cannot be made into a stiff, structured garment without using interlinings or a stiff lining. A thin organza is not appropriate for a coat, nor is a thick wool appropriate for a clinging evening gown. These are exaggerated examples of inappropriate fabrications. The professional designer must consider subtle differences between fabrics and style them accordingly.

Four components determine the texture of a fabric:

1. *Fiber*—the building blocks of fabrics are short strands of raw materials that are spun into yarns.
2. *Yarns*—fibers are twisted or combined to form yarns. The methods of combining yarns and the actual fibers used determine their texture and appearance.
3. *Construction*—yarns are woven, knitted, or felted into a great variety of fabrics. Construction alters the hand of the yarn, and the same yarn used in different fabrics can vary tremendously.
4. *Finish*—the fabric is treated with chemicals to stabilize or change the texture of the base goods. A firm finish will make the fabric crisp, but the same base goods can also be finished with a soft hand.

Every person experiences the texture of garments from birth. The designer develops this vague awareness of how fabric feels (the tactile sense) into a conscious knowledge of the appropriate texture for specific garments. A designer uses tactile evaluation of fabric just as a sculptor or potter experiences the basic stone or clay with hands as well as eyes.

The design student should begin to develop a tactile sense by sewing and draping fabric. Observation is a valuable tool. Look at fabrics and feel textures. Experiment with fabrics to see how they cover the body. Notice that shiny fabrics reflect light, making the body seem larger, especially in a tightly fitted garment. Shiny surfaces also look dressier than matte (dull) surfaces. Feel matte fabrics. Decide which fabrics look appropriate for casual wear. Relate the fabric's hand to the season. Feel a soft, spongy, thick fabric with your hand and decide in which climate a garment made of this fabric would be worn. Sense why a thin, crisp, absorbent, plain weave is appropriate for a warm climate. You have experienced these sensations subconsciously many times. Now you must begin to develop on a conscious level your understanding of fabric uses.

Feel, look, and experiment. Developing these skills will expand your ability to judge what a fabric can be made into and when it can be worn.

Proportion

Proportion, or *scale,* is the relationship of various spaces to the whole shape. Greek artists and mathematicians analyzed buildings and the art of earlier civilizations and formulated the Golden Mean. This proportion standard determined that ratios of 3:5:8 or 5:8:13 are the most pleasing to Western civilizations, a standard of design that has survived for centuries. Applying the Golden Mean to the human figure establishes classic figure divisions. Fashion often breaks these expected rules to create illusions that exaggerate the figure.

The size of the head, width of the figure, length of the waist and torso, and leg length of an individual figure may differ greatly from the classic ideal. Clothing can be worn to visually balance awkward body proportion.

Designers modify proportion to achieve different ideals of beauty. These design evolutions tend to last longer than simple style changes. A good example of extreme proportion modification was the minidress that was popular in the late sixties and again in the nineties. The ideal of beauty is a slender, youthful girl. Dresses that are so short that they divide the figure approximately in half make the person seem young. Leg length seems longer because of the small dress and makes the wearer look tall. Details like narrow shoulders, rounded collars, flat shoes, and small trims emphasized the youthful

The Golden Mean

Which rectangle looks the longest?

The greater the difference between the size of the bodice and the size of the skirt, the taller the figure will look. The eye automatically compares the two areas and concludes that the longer skirt indicates a taller figure. Also, a high waist and small bodice look more youthful. The high-waisted bodice is used in children's wear. It is also used in maternity clothes to camouflage the fuller stomach and emphasize height.

silhouette. Traditional Golden Mean proportions tend to make a person look taller and slimmer, and this proportion achieves the standard of beauty of the period. The following variations in proportion use the Golden Mean as a basis and examine the optical illusions that can be created by modifying expected proportion. Color, used in bold contrasts, will emphasize variations in proportion. Texture and patterns should be consistent with the illusion that the designer wishes to create.

Balance

Balance involves equaling the visual weight or space of different parts of a garment design. There are two

Which rectangle looks the thinnest and the longest?

Evenly divided spaces emphasize the squareness of a shape. Equal divisions make a person seem wider and shorter. Uneven horizontal divisions make the whole shape seem thinner. When a dark top is worn, the illusion is even greater.

Which rectangle looks the longest?

Normal Waist

1.

Empire Sheath

2.

Exaggerated Proportions

The more exaggerated the difference between the bodice and the skirt, the taller and more slender the figure will seem. Thus, the long dress with a raised waistline is popular for brides. The floor-length gown can also conceal high-heeled shoes, which add to a person's height. This proportion was very popular after the French Revolution and retains the name *empire* after the court Napoleon established. The empire is a good proportion for an overweight, small woman if her bust is not too large.

Empire *Normal Waist* *Drop Waist*

Which shape looks younger?

Normal

Mini

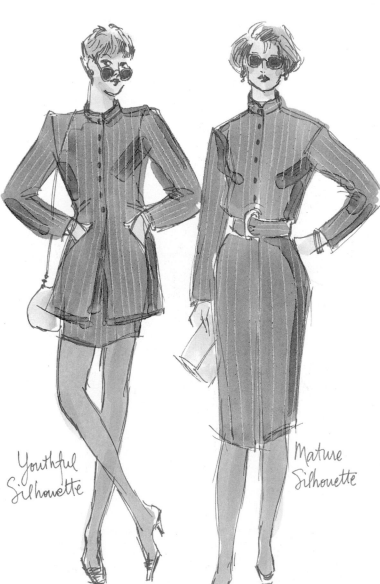

Youthful Silhouette

Mature Silhouette

Exaggerated Proportions

The miniskirt (very short, several inches above the knee) can make a person look taller. So much leg is exposed that the legs become a major factor in the proportion of the entire garment. The waistline is often raised to accentuate the youthful look. Note that accessories, such as tall boots, stockings the same color as the shoes, and high hairstyles, enhance the whole image of height.

Which rectangle looks the longest?

1.

2.

3.

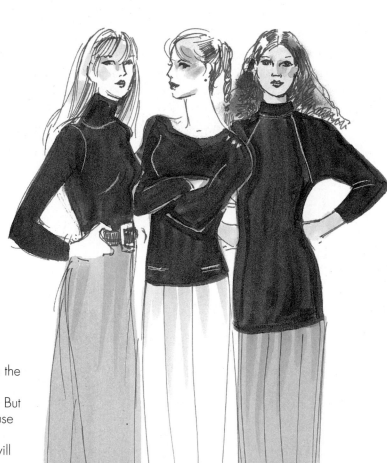

Exaggerated Proportions

Unequal proportions, even when they are reversed and the emphasis is placed on the thighs, enhance the illusion of height. The second rectangle looks the shortest because the proportion is almost the same. But elongating the torso presents some problems because many women have hips that are larger than their busts. If a fitted garment is designed, a low torso will overemphasize the bulges in the hip area.

Note how width at the shoulder and hemline affects the visual size of the waistline and the size of the silhouette.

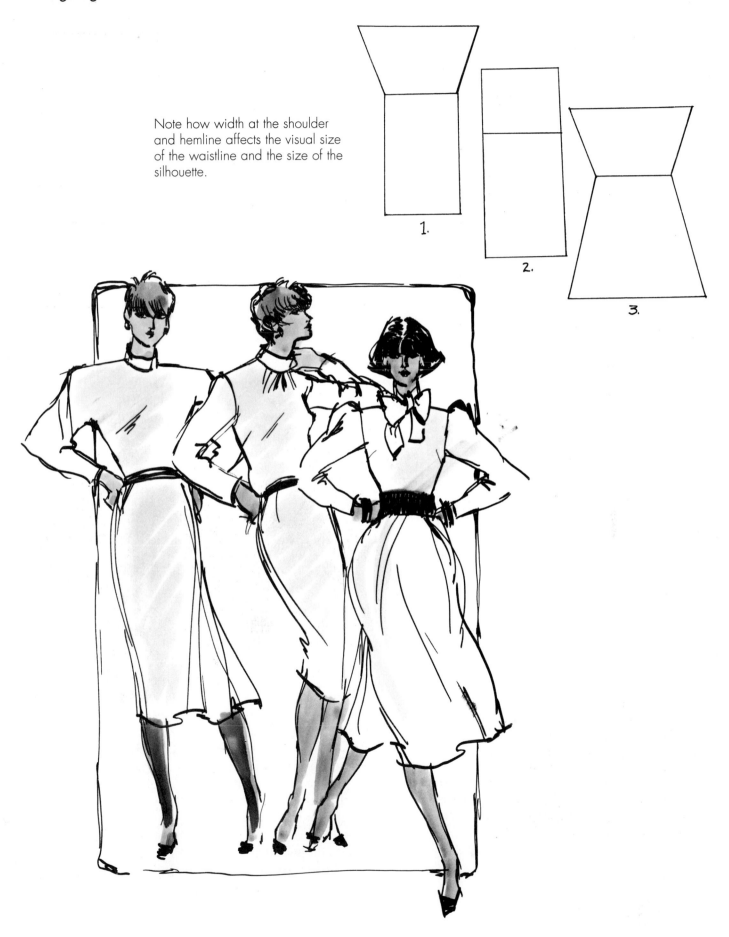

kinds of balance, formal and informal. Formal balance is achieved when a design has equal elements on both sides of a vertical or horizontal division. Formal balance tends to be dignified and static. Informal balance has varying elements and spaces on both sides of a division and tends to be casual and creative in a successful design.

Vertical Balance

The vertical structure of the human body is balanced. The average human body is visually symmetrical, which means the body appears to be the same on each side of a central vertical line. Two arms, two eyes, and two legs are balanced one on either side of a central axis. Actually, if a picture of one-half of a face were duplicated and reversed to produce a picture of a whole face, the picture would look quite different from the face as it exists in reality. In the same way, the body image is slightly different on each side. The eye corrects minor discrepancies in size and shape, so when an object is close to being symmetrical, the eye sees it as equal on both sides. When a person's body differs noticeably on one side, carefully designed clothes can minimize the difference.

Now look at the jacket in the accompanying drawing. Is it a symmetrical design? Actually, the jacket is asymmetrical. If you thought it was symmetrical, it was because your eye ignored the one asymmetrical detail and concluded that the design was balanced. This illustrates the natural tendency to ignore small asymmetrical differences in the dominantly balanced human figure. The lap and leading edge of the jacket closing extend beyond the center line, but the eye follows the buttons up the center front and this dominant design element camouflages the asymmetry of the lap. The design lines, collars, pockets emphasize the formal balance. Formal vertical balance is the least expensive and most expected type of design and so is often found on less expensive garments. Look at the next blazer for an example of asymmetrical design.

Designing a well-balanced, attractive, vertically asymmetrical garment requires more thought and experimentation than designing a symmetrical one. Separate pattern pieces must be made for the right and left sides. These pieces cannot be reversed during cutting because they must fasten right over left, as symmetrical garments do. Balance and proportion are more experimental in an asymmetrical garment because there are fewer formulas for the

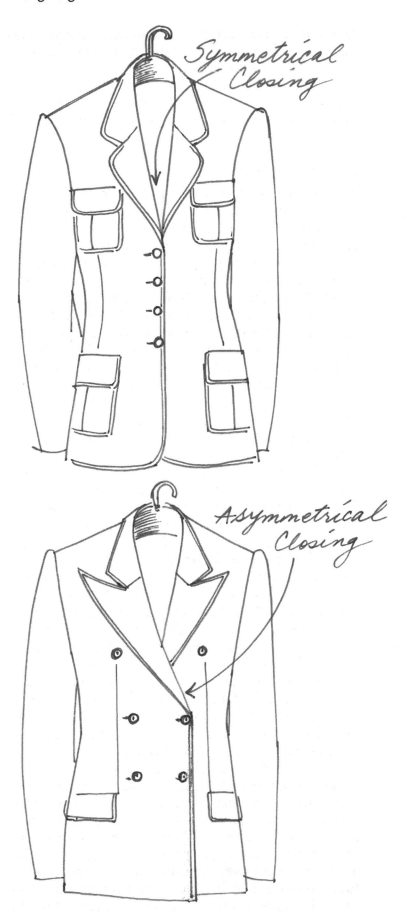

Symmetrical
Closing

Asymmetrical
Closing

Which rectangle looks the thinnest? Which rectangle looks the tallest? The rectangle at the left tends to make the figure look taller and more slender because the eye does not compare the discrepancy between the large and small sides of the asymmetrical garment. The dress at the left in the accompanying illustration is symmetrically balanced; that is, the garment is the same on each side of the center front line.

placement of style lines. For these reasons, fewer asymmetrical garments are designed, and they tend to be more expensive. Evaluate these rectangles and the accompanying illustration to learn another lesson about vertical formal and informal balance. Some figure problems can be camouflaged by wearing an asymmetrical garment. Figures that are unequal can be corrected visually by emphasizing one side to balance the discrepancy. A high hip or shoulder is a typical example that can be corrected by wearing an asymmetrical garment as shown.

Horizontal Balance

An analysis of the figure above and below the natural waistline quickly suggests that only asymmetrical balance is applicable. Visual horizontal balance is especially important when correcting figure problems. There are three types of figures: the balanced figure, with equal hips and bust; the pear-shaped figure, with larger hips than bust; and the full-busted figure, with bust larger than hips. The last two visu-

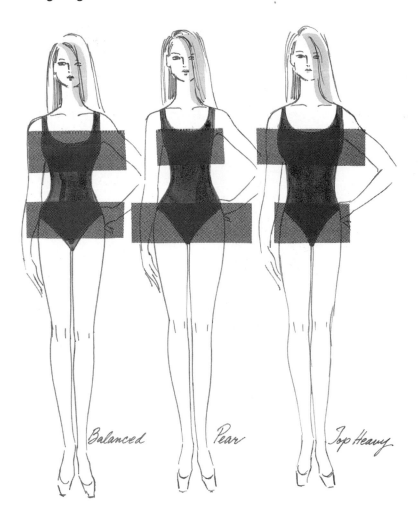

Balanced Pear Top Heavy

ally imbalanced figures can be balanced by wearing colors or style lines that maximize the smaller part of the body and minimize the larger area.

Remember our discussion of dark and light values to balance a problem figure on pages 157–158. Dark areas tend to make a space look smaller and white or bright colors attract the eye and make the space look larger. The same formula works with design elements. The eye is attracted to detail or pattern. The person wishing to balance either a pear-shaped or full-busted figure should wear details and ornaments at the place on the body that needs to be visually enlarged and dress the larger area with a simple garment.

Radial Balance

A third type of balance is occasionally used in garment design. Radial balance has a central focal point with design elements radiating out from it in a sunburst pattern. This is a very costly type of design because of the technical process required to creat the pattern. It is used mainly for novelty effects.

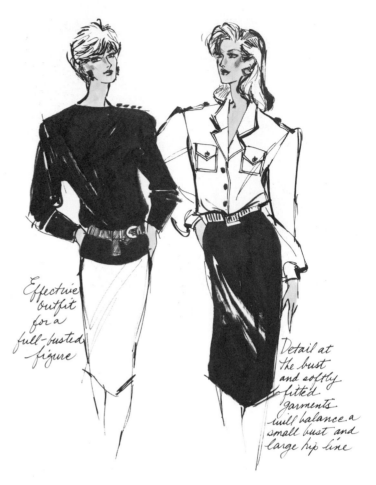

Effective outfit for a full-busted figure

Detail at the bust and softly fitted garments will balance a small bust and large hip line

Radial Balance

4.54

Unity

Unity means that all elements of a design work together to produce a successful visual effect. Study the following six examples of simple garments, and see if you can find the elements that are not combined successfully.

The following six examples point out basic principles of unity in design.

Principle 1. Style lines should be consistent on every area of the garment and on separate garments that are sold as coordinates.

Principle 2. All areas of the garment should reflect the same shapes. In the incorrect example, the collar, cuffs, and hem are curved, so the square pockets interrupt the continuity of design. Curved lines are most compatible with the shape of the body. Geometric lines and shapes must be more carefully designed because they are less compatible with body curves.

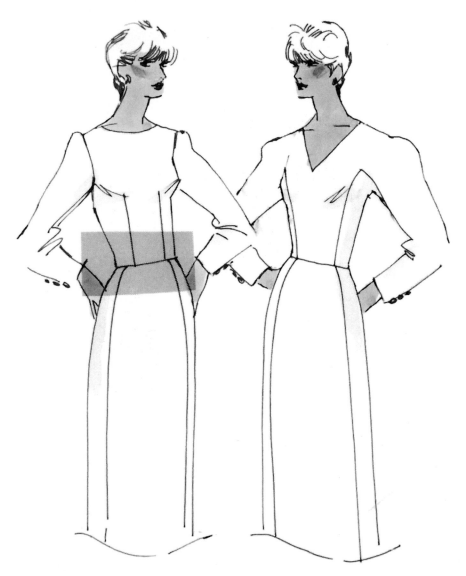

In this illustration, notice how the design devices attract your eye to the bust, stomach, and hips.

Principle 3. Avoid small differences in the hem lengths of sleeves and the garment bottom. A small jog interferes with the horizontal flow of the hemline. This does not mean that all sleeves must be the same length as the jacket: The difference between the sleeves and the jacket should be significant enough to look planned, or the sleeves should be aligned with the jacket hem.

Principle 4. Stripes and plaids used on the straight grain should match, particularly on sleeves that hang parallel to the bodice. Stripes and plaids cut on the bias can be combined effectively with garment pieces cut on the straight grain, but the pattern on bias pieces must be matched with other bias pieces.

Principle 5. Seam lines and trim details on sleeves should align with similar lines on the body of the garment. Small jogs are visual interruptions of the horizontal design.

Principle 6. Style lines on all areas of the garment should have compatible angles and complement each other.

Train your eye to analyze garments that are pleasing to you and recognize how the designer has unified all elements to create a successful garment. When you see an awkward-looking garment, check carefully to see whether the elements are in competition rather than in harmony.

Conflicting Style Lines Compatable Style Lines

Rhythm

Rhythm is the repeated use of lines or shapes to create a pattern. Rhythmic use of design elements leads the eye through a design, giving the garment continuity. The first example uses lace trims and contrasting collar and cuffs to lead the eye through the design with a successful rhythm.

Garments will appear spotty or disconnected when they lack rhythm or are overburdened with details that do not work together harmoniously. Repeating the print motif of the skirt on a sweater ties the two units together and gives them a visual unity.

Emphasis

Emphasis creates a center of interest by focusing the viewer's attention on a specific area of the garment. The designer uses the principles of emphasis to direct the eye. Details that focus on the face are particularly effective because the face is a focal point of beauty in our culture. One of the most successful design formulas is the contrast blouse worn

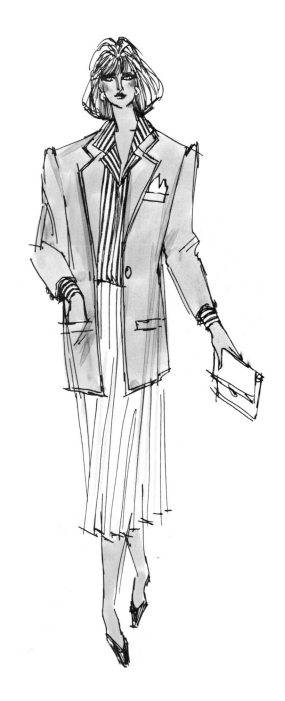

with a jacket. Color forms the visual pathway to the face. A spot of bright color, like a red handkerchief worn with a navy suit and white blouse, further emphasizes the face.

People with figure problems should emphasize the positive parts of their bodies with a bright color or design accent. Garments with little design detail in a dark or neutral color will camouflage the problem areas of a figure without calling attention to them. For example, a woman with a small waist who wears a bright contrasting belt will emphasize the most positive area of her figure.

Designers creating for the mass market should be careful not to emphasize typical figure problems. For example, many women have large hips, so hip belts and other design details like contrasting stripes at the hip area will have a limited audience.

The placement of dark spots in prints, contrasting pockets, and appliques is an important consideration. Dark spots on a light-colored garment and white spots on a dark background emphasize the body part they are placed over. Avoid the placements shown in illustrations 1 to 3. Consider the back of each garment and do not place design elements on the derriere. Generally, these parts of the body are not emphasized when designing streetwear. A costume designer may reverse this rule of emphasis to create a special effect.

Beware of selecting prints with large, spotty motifs. The designer sample can be carefully planned, but stock is a different matter. A designer of mass merchandise cannot predict where each spot will fall when hundreds of garments are being cut together.

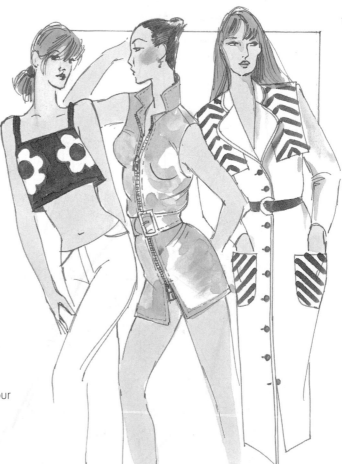

In this illustration, notice how the design devices attract your eye to the bust, stomach, and hips.

Summary

The successful commercial designer interprets fashion trends for a specific customer. The designer studies what the customer does and where he or she lives as well as the occasion for which a garment will be worn and its novelty and value.

A designer creates a garment as an engineer would a building. The cost of the fabric, the make of the garment, and the total look must represent a value to the consumer or the garment will not sell. The quality of the fabric is a major factor in garment design, and the designer must evaluate aesthetics, price, and performance when selecting fabrics.

A garment must look appropriate for the consumer. A designer works with the elements and principles of design to create garments. These are:

ELEMENTS	PRINCIPLES
Silhouette	Proportion
Line	Balance
Color/Value	Unity
Texture	Rhythm
	Emphasis

The category of merchandise often dictates the basic silhouette as does the influence of current fashion. The basic silhouettes are the slim-line silhouette; soft dressing, which has a fuller, easier line; the shoulder wedge; the hourglass; and extreme-volume silhouettes.

Line refers to the edge or outline of the garment and the style lines that divide the space within the design. Line can be used to camouflage figure problems. Vertical lines lengthen the figure and diagonal lines slim it. Horizontal lines broaden the figure. Color is the first thing a customer notices. Color in relation to complexion is an important factor for a consumer. Color can also be applied to the body to create illusions and correct figure problems.

Value is contrast between light and dark and is used frequently to create effective illusions. Pattern is an important element in garment design. The designer must consider the personality of the print and also the technical demands of cutting a patterned garment.

Texture refers to the hand—the way a fabric feels. The texture of a fabric is determined by the fiber, yarn, and construction of the knit or weave. The finish can greatly alter the basic structure of a fabric and give similar basic textiles a great variety of hand.

Proportion is the relationship of various spaces to the whole shape. Western cultures use the Golden Mean, developed in ancient times, as their criteria of beautiful proportion.

Balance is equaling the visual weight or space of a garment. There are two kinds of balance, formal (symmetrical) and informal (asymmetrical). When applying principles of balance to the human figure, a designer must consider vertical and horizontal balance.

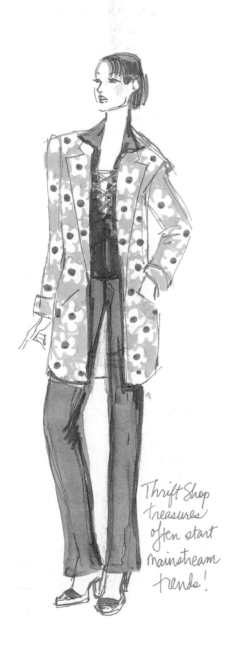

Thrift Shop treasures often start mainstream trends!

Radial balance is used primarily in novelty garment design. Unity means that all elements of a design work together to produce a successful visual effect. Rhythm is the repeated use of lines or shapes to create a pattern.

Emphasis creates a center of interest by focusing the viewer's attention on a specific area of the garment. The face is the usual focal point of a garment in our culture. Figure problems can be camouflaged by emphasizing the positive elements of the body and deemphasizing the negative ones.

Review

WORD FINDERS

Define the following words from the chapter you have just read:

1. Asymmetrical
2. Balance
3. Bodysuit
4. Design
5. Diagonal style lines
6. Elements
7. Emphasis
8. Fashion
9. Golden Mean
10. Hand (fabric)
11. Hourglass
12. Line
13. Man-tailored
14. Proportion
15. Principles
16. Rhythm
17. Symmetrical
18. Silhouette
19. Tactile
20. Texture
21. Value
22. Vertical balance

Don't become a Fashion Victim!

FIGURE PROBLEMS

Using the principles from the chapter, design garments for the following situations and figure problems.

1. Design an evening gown and a garment for spectator sports that will make a small woman with large hips and a small bust seem tall and slender.

2. Design a day dress for a very tall woman who wants to minimize her height.

3. Imagine you are a costume designer dressing an actress who is of average height and wears a size 10. Her parts calls for a mature person, 20 pounds overweight. The actress needs two costumes, one for daytime wear and the other for an evening occasion.

4. A short woman with a very large bust and narrow hips will be having dinner at a restaurant. Design a garment that will make her look as tall as possible.

CHAPTER **5**
Organization of a Line

Organizing a line is one of the designer's most important functions. Most designers style a group based on a theme. Actually, the designer's organizing of groups is very similar to the buyer's selecting merchandise for the store. The buyer must consider a variety of customer likes and dislikes and offer customers a range of colors, sizes, and styles. This range or selection is called an *assortment*. The designer does the same thing as the buyer when he or she plans a line by the group method. Generally the designer offers more selections than the average buyer will buy. The designer realizes that because of price and style considerations, some pieces will fall out (not be sold in sufficient quantity to be cut), so the goal is to design enough pieces to give buyers a choice. Sometimes a designer tries out a styling idea just to get buyers' reactions. Although the experiment may be a failure, many are successful and a new trend is started.

There are several ways of organizing a line of merchandise. The most typical are (1) item lines and (2) groups of styles constructed from one fabric or the same combinations of fabrics. Some manufacturers combine the two approaches.

ITEM LINES

These lines are the simplest to define and understand. They consist of hot items—that is, items that have checked out in the stores or sold well at the buyer level for other manufacturers. The item house will sell each item alone, without a coordinated group, and try to sell a large volume so the

When you have read this chapter, you will understand:

1. Why organizing the line is one of the designer's most important jobs.

2. How item lines are organized.

3. The advantages of designing lines around fabric groups.

4. How to plan a color story.

5. The importance of fabric and workboards.

6. How fabric groups are coordinated to form a line.

7. How garments are costed.

8. Working in a foreign production situation.

manufacturer can order enough fabric to get a good price and delivery date. Many times the fabric is already proved a proven seller.

Often, the item manufacturer is a *knock-off* house and makes direct copies of other garments. A knock-off house can offer a lower-priced garment because it reduces overhead. One way to reduce overhead is to shop the stores for hot items and eliminate a designer. The item house may purchase designs from freelance designers who are paid a commission. The advantages of buying from an item house are lower prices and usually rapid delivery. Often, a store buyer will find a good item at a high price and buy it in small quantity. Then the buyer will have the high-priced garment copied by an item house or a private label vendor who manufacturers a garment to order at a lower price.

An item house has to produce and market the knock-off quickly. The person who selects items for the line must be aware of current best-sellers, so he or she constantly shops the stores. Speed is essential in this kind of operation because usually the manufacturer continues the item for as long as it continues to sell at retail. Item and private label manufacturers sell merchandise in large volume, most often to discount stores, catalog and mail-order houses, and large chain retailers.

Specialized item houses can also sell expensive garments. Usually higher-priced manufactures specialize in one or two items or categories that are interesting enough to be used as attention-getting garments in a department store or boutique. Manufacturers who import handmade garments from countries with *cottage workers* (people who work on garments in their own homes) are typical of item houses that handle expensive and unique items.

GROUP LINES

Group lines are organized around fabric groups. Depending on the type of line and the importance of a fabric, some garments are designed for each fabric. This type of organization has the following advantages:

1. The most seasonable fabric groups can be cut first and shipped to the stores before late-season fabrics. For example, a dress house tries to ship heavyweight cottons for early spring selling because the weather is still quite cool in February and March. The dress house follows this group with mid-

weight fabrications and then lightweight sheer fabrics for early summer selling.

2. If several styles in a group do not sell, other styles will usually be strong enough to carry the fabric. Often, the designer will fill in groups after they have been shown to buyers for a few weeks. The styles that have not sold will be dropped and new numbers will be added to strengthen the group.

3. Several garments can be offered to a buyer for multiitem newspaper advertisements and window and floor displays. When a sportswear or coordinate manufacturer uses the group-line method, hot items can be added to the basic units to generate sales.

4. When a line is unique, a buyer will frequently buy enough garments from different groups by the same manufacturer to fill an area of the store or department. This creates visual impact, and the "department within a department" draws the customer who seeks a special look and is loyal to the line. The customer will find preferred merchandise stocked in depth and will not be forced to search through racks of less exciting garments.

5. Because several items in each group probably will be good sellers, the manufacturer can order the fabric in quantity. With sufficient quantity, a manufacturer can recolor prints, create unique colors, and often bargain for a better price per yard. Some manufacturers order enough yardage to confine a print, type of fabric, or special color to their price and style category.

6. By varying the type and cost of the groups, greater variety of price and styling can be incorporated in the line. The less expensive fabrics can be made into more complicated garments and be more lavishly trimmed.

7. A *story* or styling theme is best developed by designing similar items in one fabric. A strong style story is easy to advertise, and advertising money can be solicited from fiber companies on the basis of fashion-right garments and large fabric purchases.

8. A good body with a strong sales record can be offered in several different fabrics at various prices to cover a range of shipping dates. The overhead for reorders and previously developed styles is much less because the patternmaking and grading have already been done.

9. Well-developed groups, consistent in color story and styling, will look as if they have been created by one person—they will have an image and

identity. You must remember this point when you consider merchandising single-unit items such as dresses, coats, and suits, which do not have to coordinate within a group. A manufacturer strives to create a strong identity because many lines are so similar. When a buyer walks into a showroom, he or she should feel the strong visual presence of a well-developed theme.

Merchandise must be presented to many people before it reaches the individual consumer, and a well-organized line is easy to sell at each level of the merchandising process. The designer must present the line to the boss and salespeople and motivate them to sell the product. If the salespeople understand the designer's motivation, they can incorporate the fashion research and theme development into their sales pitch when they present the line to buyers. In turn, buyers can repeat the information to salespeople in their stores, which may help motivate store personnel to sell the merchandise to the consumer. The consumer must be stimulated to take the garments to the fitting room, try them on, and finally purchase them.

The designer should plan a line so that all styles have a consistent visual image. The colors should be seasonal and fashion-right and offer enough diversity to encourage buyers to purchase many items from the line. The styling within each group should have variety; yet each piece should develop the same theme. A *theme* is a styling detail, trim, or color story that is used consistently throughout the group. Variety of styling means that there should be, for example, different sleeve treatments or a selection of details and necklines. No piece should be so similar to another that the second piece "steals" a share of the first piece's potential sales. The group may have a *price leader,* a garment slightly less expensive than the others. This garment might be a repeat of a proved body, in which case the garment is less expensive because the production pattern and grading phase of production have already been paid for. Then again, the price leader may take less yardage or be easier to sew than other styles in the group. Often, the price leader becomes the best-seller just because it is the least expensive style in the group.

The designer cannot accompany each garment to the stores and explain the theme to salespeople and customers, so the garments must speak for themselves. As mentioned, the garment must stimulate the customer to take it off the rack and

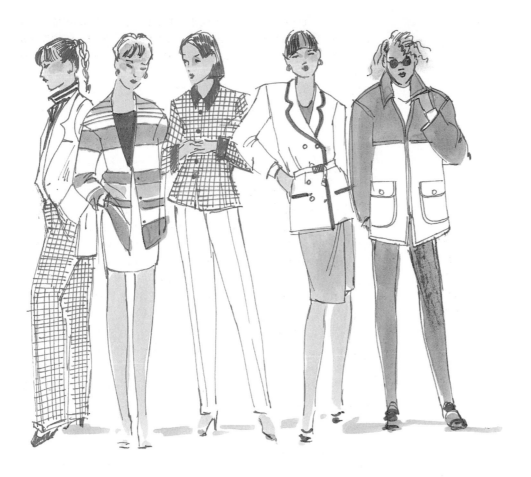

into the fitting rooms. Garments that are not single-unit items should suggest coordination visually because this is the only way to bypass an uncreative salesperson and stimulate an unimaginative customer. If the individual garments make a strong visual statement and combine well with other pieces from the group, the customer will find it easier to coordinate them. For example, the consumer should be able to add a shirt and jacket to a pair of pants to create an outfit.

Developing a Group: Coordinated Sportswear

Category: Junior contemporary

Price range: Moderate

Theme: Men's wear fabric and styling in gray and black flannel combined with a gray pinstripe and accented with a Fair Isle sweater group

Season: Early fall (delivery to stores—July 30 complete; selling time—August through October)

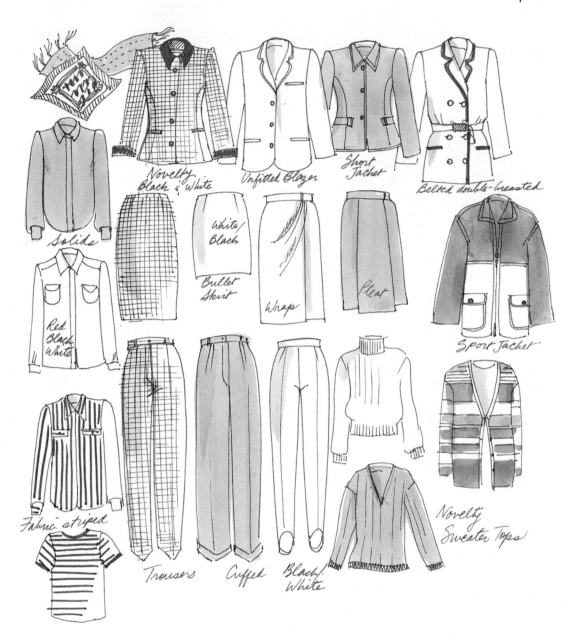

Novelty Black & White

Unfitted Blazer

Short Jacket

Belted double-breasted

Solids

White/Black

Bullet Skirt

Wrap

Pleat

Sport Jacket

Red Black White

Fabric striped

Trousers

Cuffed

Black/White

Novelty Sweater Tops

Coordinated Group

This styling demonstrates organization, not current fashion. Trends, hot items, and fashion change constantly vary the type, size, and price range of a line. The number of items in a group depends on the size of the line and the importance of the fabric as predicted by the manufacturer. The availability of fabric and the shipping date in relation to the season will influence how many pieces are made.

This group has been designed in smaller coordinated units that may be worn as mixed or matched outfits. The matched outfits will have a

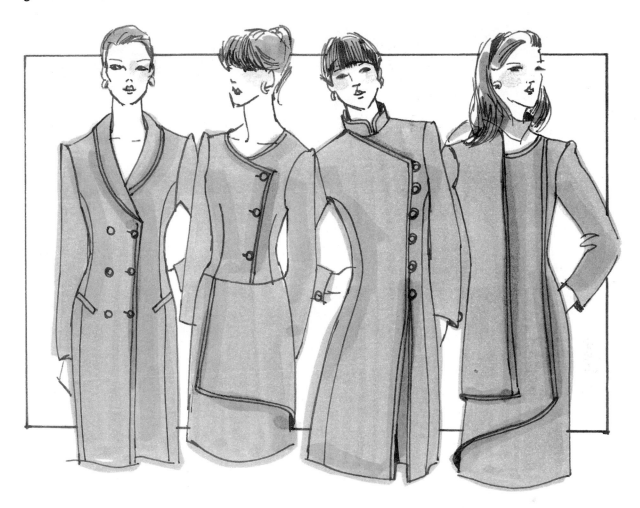

formal, dressier look that will be easily understood by the more conservative customer. Mixed, or mismatched, outfits have a trendier look for a more experimental customer. Study how the garments may be combined; then look at the diagram on page 190, which shows how the group has been planned. When a group has many optional combinations and appeals to both conservative and innovative customers, sales can be increased.

Developing a Group: Dresses

Category: Missy
Price range: Moderate
Theme: Asymmetrical tailored dresses
Season: Fall (delivery—August 30 through September)

A dress group does not require the coordination that a sportswear group does. The dresses should have variety and a loose theme, making

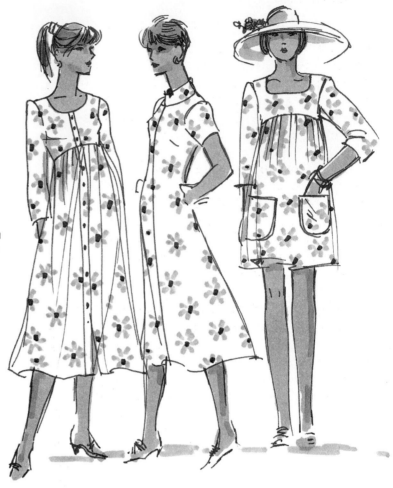

Print-Dress Group
A print dress depends on a strong silhouette and a few details of trims. A group should offer a variety of sleeves and neckline styles.

them easy to display and advertise together. For example, a buyer could advertise the two-piece style with any of the one-piece dresses.

Often a selection of "print bodies" (styles simple enough to be made in a variety of prints) are grouped together. These print groups may be sold assorted—that is, the buyer selects bodies, and then various prints from a specific group are randomly cut in the bodies. A specific body in a specific print may also be sold.

PLANNING THE COLOR STORY

The master colors selected for a line should include

1. Some fashion colors
2. Some staple colors (typically a shade of blue and a shade of pink, neutrals like black and white, and so on)
3. Warm colors
4. Cool colors
5. Neutrals and darks

The colors should reflect

1. *The season.* They should be appropriate but differ from last season's colors.
2. *The market they are designed for.* For example, Texas and California colors typically are lighter and brighter than colors selected for New York lines and sell well in the Sunbelt states (those bordering the Gulf of Mexico and Caribbean Sea).
3. *The type of merchandise.* Specialized apparel, like bathing suits or bridal gowns, will differ radically from other RTW (ready-to-wear) areas.
4. *A sufficient variety of choice.* The color groups should be varied enough to offer the buyer a range of appropriate and attractive colors throughout the shipping season.

Usually, the designer chooses 8 to 12 colors for the master seasonal color story. Each color is not used in each group, but each color is used at least once in the line. Frequently staple fabrics are offered in three or more colors, and novelty fabrics and prints are offered in two. The actual color selection depends on the individual designer's taste and the history of previous seasons' best-sellers. The designer will review all color predictions for the coming season and choose colors that are appropriate for the line. Review the discussion of sources of color information in Chapter 3 and the color insert.

Occasionally a designer will ignore the market's general trend and make a very personal statement through the use of unusual colors. This plan usually succeeds only in a better-priced line, where a strong designer image appeals to a fashion-conscious customer. The designer will have to recruit fabric converters who are willing to work with special colors. But the extra trouble is worth it if the color story is unusual and used consistently in exciting, well-designed garments.

When choosing colors, the best guide is: *Whatever choice you make, be consistent, offer enough variety, and develop the color theme in all groups.*

Fabric Boards

The designer should organize all fabrics chosen for each group on a *fabric board* and record all the necessary style information beside each swatch. This will become the central reference for fabric and styling decisions as the line develops. Use white illustration

board or foam core, and tape the fabric samples to it as they are selected. A sportswear fabric board should be about 20 by 30 inches because of the many components required in each group. A dress board can be smaller; 10 by 15 inches is usually adequate. After the fabrications (textiles selected for each component of a line) are approved by management, all the fabric and trim information can be transferred to a list and given to the stock fabric purchasing person. Manufacturers who computerize production information begin the process in the design room. As changes in the components of the garment occur, the designer updates the information that is electronically transferred to the spec sheets, cutting tickets, and other production documents.

The designer records the following information on each board:

1. Season and year group is planned for; name of the group.
2. Name of the mill; name and phone number of both the regional and the New York (or principal) salesperson.
3. Style and quality number, pattern and color name and number, width of the fabric, fiber content and fiber mill, and price (you may wish to code the fabric price if the board is used to discuss the line with buyers).
4. Trims and their style numbers, sources, and prices.
5. *Croquis* (the painted swatch of a print before it is printed on the fabric) and the finished swatch of the print.
6. *Lab dips* (small patches of colored fabric submitted to the designer to establish a match with other fabrics in the group) and their color numbers.
7. Clip or tape duplicate fabric orders to the back of the board. As you check on duplicate delivery, note the shipping date on the order. Check regularly with the fabric supplier to make sure the duplicate yardage will be delivered in time to produce and ship the duplicates.

Fabric boards should be used when discussing the line with other members of the merchandise development team so that they are aware of what has been planned and purchased for each group. Fabric boards can also be used when discussing future fabrications with buyers prior to the completion of the line. They form a valuable record of how each season was planned and what colors and fabrics were run, and they should be kept as a reference.

COUNTRY CLOTH

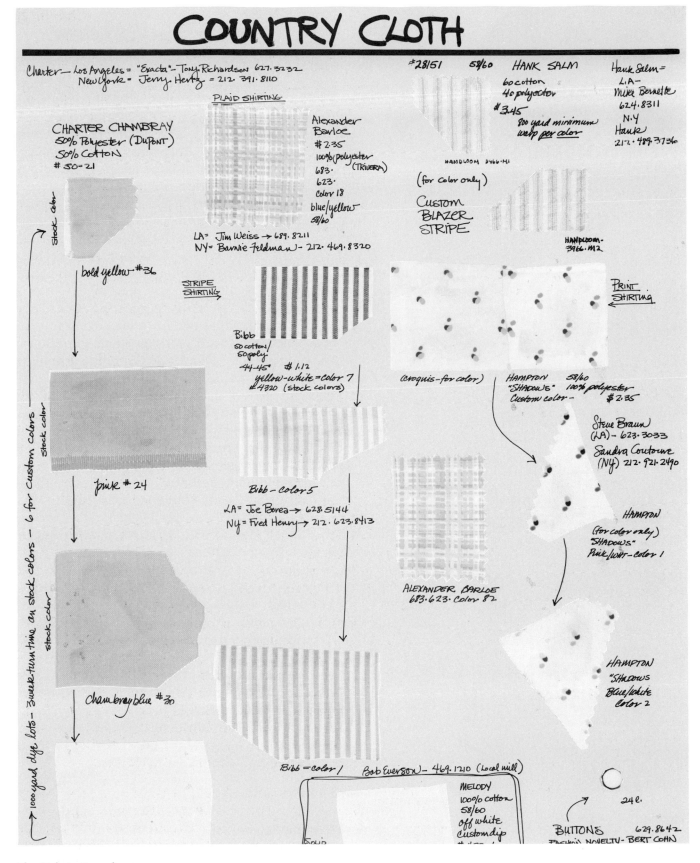

Charter — Los Angeles = "Exacta" — Tony Richardson 627·3232
New York = Jerry Hertz = 212· 391· 8110

#28151 58/60 HANK SALM Hank Salm =
 60 cotton LA —
 40 polyester Mike Bernette
 #345 624·8311
PLAID SHIRTING 800 yard minimum N.Y
 warp per color Hank
 212· 489· 3736

CHARTER CHAMBRAY Alexander
50% Polyester (DuPont) Barloe
50% Cotton #2·35
#50-21 100% polyester
 (TRIVERA)
 683· HANDLOOM 3966·M1
 623·
Stock Color Color 18 (for color only)
 blue/yellow CUSTOM
 58/60 BLAZER
 STRIPE
 LA= Jim Weiss → 689·8211
 NY= Barnie Feldman - 212·469·8320 HANDLOOM-
 3966·M2
bold yellow #36
 STRIPE PRINT
 SHIRTING → SHIRTING →

 Bibb
 50 cotton/
 50 poly
 44-45" #1·12
 yellow-white = color 7
 #4320 (stock colors)
Stock color (croquis-for color) HAMPTON 58/60
 "SHADOWS" 100% polyester
 Custom color — $2·35

 Steve Braun
 (LA) - 623·3033

 Sandra Couture
 (NY) 212· 921· 2490
pink #24
 Bibb — color 5 HAMPTON

 LA= Joe Borea → 628·5144 (for color only)
 NY= Fred Henry → 212·623·8413 "SHADOWS"
 Pink/wht — color 1
Stock color

 ALEXANDER BARLOE
 683·623·Color 82

 HAMPTON
 "SHADOWS
chambray blue #30 Blue/white
 Color 2

 Bibb = color 1 Bob Everson — 469·1210 (local mill)

 MELODY
 100% cotton
 58/60
 off white BUTTONS 629·8642
 custom dip FASHION NOVELTY - BERT COHN

1000 yard dye lots — Sweep turn time on stock colors — 6 for custom colors

The Fabric Board

Swatches of all fabrics that comprise the group should be taped to the fabric board. Often, the designer will have to cut small pieces of the base-goods colors off the swatches and leave them with other fabric resources to match the colors of the base goods to the shirting prints and solids. If all the phone numbers of the resources are included on this master board, follow-up is easy. Often, a designer will take these boards to New York from a regional market to complete the fabric story.

Designer Workboards

A designer creates many garments for each group that are discarded before the group is finalized and sold to the stores. To keep track of all the styles, the designer should develop a *style board* for each group. Again, use white illustration board or foam core, a large size for coordinated sports-wear and a smaller size for item lines. Divide the board into small boxes by categories when doing a sportswear board. Jackets, skirts, pants, blouses, and novelty items such as sweaters would be typical categories. Sketch all the items you design for the group and want to present at the merchandising meeting. Use the board as a guide during the meeting to record changes that are to be made to pieces that are accepted in the line. Cross out rejected garments. Use this board as a guide in the design room so pattern-makers and sample makers can remember the garments have been made into a pattern and cut and sewn. Keep track of all the items in each group by numbering the styles selected for each group. The workboard is a handy tool to use when deciding specific colors to use in duplicating the samples that go to the salespeople. Some designers prefer to pin small individual sketches or computer renderings of each sample on a bulletin board. Additions and subtractions can be made easily. Pin fabric swatches up to identify each group. As more design rooms become computerized, the sketches of each style in a group can be created and stored in the computer.

The fabric board and the style workboard are the reference sources for all the necessary information to write up the cost sheets on each item in the line. Use them to compile all the details, like number and size of buttons, special trim prices and sources, description of the sample, and its style number.

ORGANIZING THE GROUPS TO FORM A LINE

The number of groups in a line depends on the size of the manufacturer, the season, and other considerations. The fabrics should vary in price so that the manufacturer can produce a variety of garments in a general price range, although the firm will want to emphasize its strong price point. The higher the fabric price, the less complicated the garment must be. Garments requiring more yardage than average

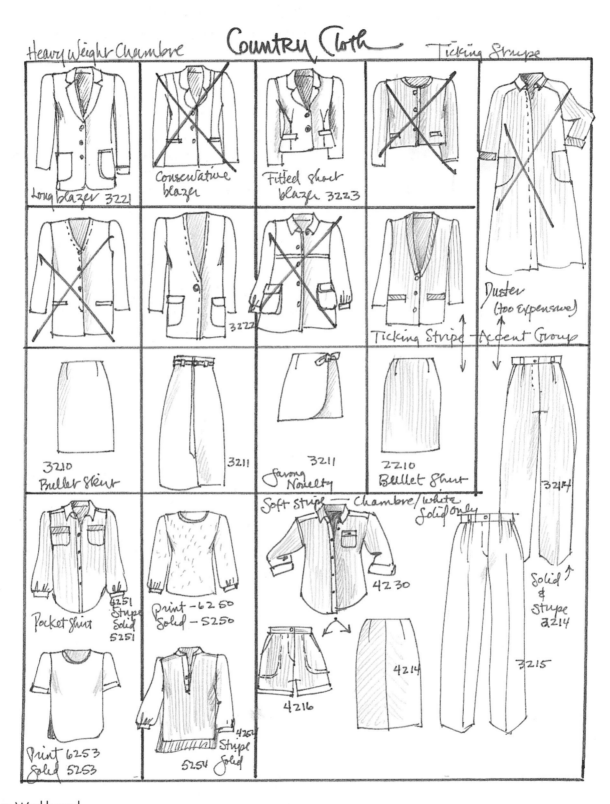

Heavy Weight Chambre Country Cloth Ticking Stripe

Long blazer 3221
Conservative blazer
Fitted short blazer 3223
Duster (too Expensive)

3222

Ticking Stripe Accent Group

3210 Bullet Skirt
3211
3211 Sarong Novelty
2210 Bullet Skirt
3214

Soft Stripe — Chambre/white Solid Only

Pocket shirt
4251 Stripe Solid 5251
Print – 6250 Solid – 5250
4230
4214
Solid & Stripe 3214

3215

Print 6253 Solid 5253
4252 Stripe 5254 Solid
4216

Designer Workboard

All workers in the design room use the board to guide them through the cutting, patternmaking, and sewing of samples. In this way, no pieces are lost. The designer can take this board to the merchandising meeting and note corrections that must be made on the first samples before they are duplicated. Then the line can be numbered and the duplicates worked out from the master sheet. Preparations and anticipation of problems will save a designer a great deal of time in reworking the sample line.

must be cut from less expensive fabrics so that no garment will exceed the price range of the line.

The fabric groups should vary in weight and type as well as in price. Just as similar styles can steal sales from one another, similar fabric groups will share sales and detract from one another. Competing fabrics can be made to work in the same line if the designer offers separate color ranges and groups with completely different themes.

Staple fabrics, also called *base goods* (solid colors or classical patterns), are usually offered in a large range of colors and styling, unlike novelty groups, which are typically offered in two or three colors. Many considerations may alter the conventional organization of a line, so flexibility in planning is important. Very small lines may offer only two or three fabric groups and more styles within the groups. They try to capture a segment of the market in depth, thereby creating an impact, rather than selling random styles that will be scattered throughout a store or department. Small manufacturers may decide to offer only one or two kinds of fabric. This method is particularly successful with prints. One or two fabric groups and many prints can be expanded into an entire line.

EVOLUTION OF A GROUP

Trace the evolution of the styles in the group illustrated. Notice the styles that drop out when the group is weeded. Best-sellers develop after the line has been shown for several weeks. During the first week or two of selling, fill-in styles may be added and weak styles dropped. From this final group, the best-sellers will emerge, but they must be proved in the store to become reorders. This process usually takes several months, depending on the time needed to produce the garments, ship them to the store, and analyze customer reaction. Because of this time lag, best-sellers are frequently prefabricated and offered in the next line.

COSTING A GARMENT

When a sample goes into production, the designer must complete a cost sheet that provides basic information on the sample. The designer should carefully fill in the information about fabric, interfacing, trims, and so on. Then the same sheet will be reworked by the production person to determine labor costs and the amount of fabric the garment will require when it is cut from the production

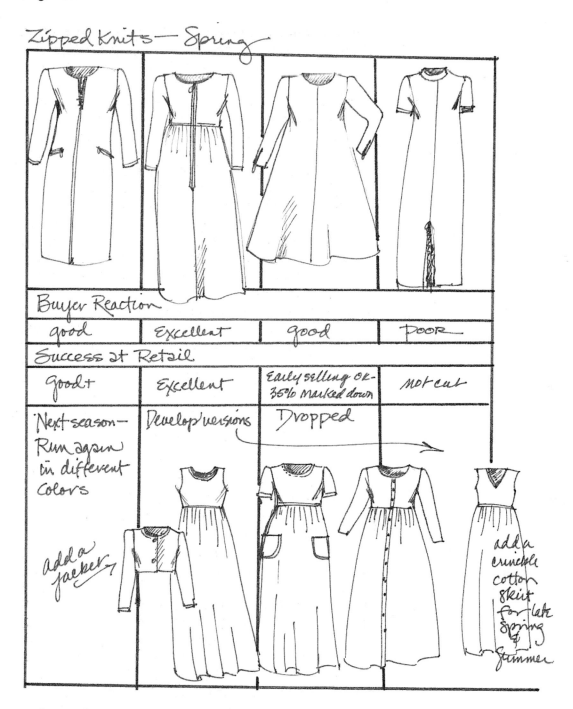

Zipped Knits — Spring

Buyer Reaction			
good	Excellent	good	Poor

Success at Retail			
good +	Excellent	Early selling OK—35% marked down	not cut
Next season— Run again in different colors / add a jacket	Develop versions	Dropped	

add a crinkle cotton skirt for late Spring & Summer

Evolution of a Group

marker. The production person usually completes the cost sheet and works with management to determine the final cost of the garment.

Manufacturers who have computerized the production process begin documenting individual styles when a group is finalized. The styles are numbered, and the design department enters the basic information on fabrication, trims, and so forth into the computerized cost sheet. Updates are added

DATE _8·8·88_ STYLE No. _8074_

DESCRIPTION _Float with shirred sleeve_ SEASON _Fall '89_
detail, 3/4 sleeves SELLING PRICE: _41.00_

SIZE RANGE _6-14_ COLORS _Red, Black, Natural_

MARKERS _58/60_

MARKER YARDAGE: ALLOWANCE: _-0- Import goods_

1. MATERIAL	YARDS	PRICE	AMT.
Merry Mary "Cultured Knit"	_2½y_	_3.90_	_9.75_
Base = 3.75 + .05 delivery +			
.10 inspection			
Inter Lining Pellon TD47	_1/5y_	_.55_	_.11_
TOTAL MATERIAL COST			_9.86_

2. TRIMMINGS	QUANT.	PRICE	AMT.
Fashion Novelty Buttons _#410 24 line ½ ball_	_4_	_2.00 gr_	_.06_
Pads			
Embroidery			
Belts			
Zippers _10"_	_1_		
Pleating, Tucking			
Fusing			
Elastic Shirring "Mr. Pleat"	_1_	_.55_	_.55_
		1	
TOTAL TRIMMINGS COST			_.74_

FPO SCANS
F 5.10
TATE.5509.0182

10.60
(Total Material)

3. LABOR			
Cutting _#75 - (based on 200 unit minimum)_			_.38_
Labor _(Mr. So)_			_7.00_
Marking _$45-_			_.23_
Grading _$70-_			_.35_
Payroll Taxes & Health Fund			
Trucking			
TOTAL LABOR COST			_7.96_

4. TOTAL COST _18.56_

REMARKS

SKETCH

MATERIAL SWATCH

when substitutions or alterations in the basic specifications are made during the sales or production process.

Analyzing a Cost Sheet
Information Area

1. *Date.* Important in determining if the fabric price on the cost sheet is still accurate. The cost of piece goods fluctuates with supply and demand. The cost of sample yardage may differ from the cost of stock yardage if a larger quantity is being purchased. Often, a larger purchase means a lower price.
2. *Description.* A word description of the style. Sometimes, a dress will be given a nickname by the designer or salesperson.
3. *Size range.* Sizes in which the style will be offered.
4. *Colors.* Colors in which the style will be offered.
5. *Style number.* For each garment, manufacturers develop a numbering code that represents the season, fabric, and pattern. For example, a manufacturer will choose the 8000 series for the fall season and break down the style number as follows:

Fall season ⟶ <u>8074</u>

8000 = basic fabric group designates
(gauze in this example) the number
 of the pattern

The same body in a different fabric would be numbered like this:

Holiday season ⟶ <u>9074</u>

9000 series = brocade same body as above

6. *Season.* The *selling* season of the garment (not when the garment was designed).
7. *Selling price.* The garment's selling price is usually determined before production costs.
8. *Marker.* Specifies the width of the marker, which is usually 1 inch narrower than the fabric to compensate for slight variations in fabric width.
9. *Marker yardage and allowance.* The total marker length is averaged to determine the amount of fabric needed to cut all sizes. Fabrics with damages and the end cut fallout (small lengths of fabric not long enough for another garment piece) will generally add 5 percent

SnapFashun Inc.

Cost Sheet

STYLE #: 2371a SIZES: s*m*l*xl SCALE: [] PATTERN #: 123

FABRIC	ESTM YDS	PRICE	EXTEND	ACTUAL YDS	PRICE	EXTEND
wool pin stripe	4.00	2.00	8.00	4.00	4.00	16.00

FUSING						
lapel	2.00	1.50	3.00	2.50	1.50	3.75

TOTAL FABRIC COST	ESTM	11.00	ACTUAL	19.75

TRIM	ESTM YDS	PRICE	EXTEND	ACTUAL YDS	PRICE	EXTEND
buttons						
Pellon 442	0.30	0.45	0.14	0.25	0.65	0.16

BUTTONS

TOTAL TRIM COST	ESTM	0.14	ACTUAL	0.16

LABOR	CUT ...		
	SEW ...		
	SHIP ...		

TOTAL LABOR COST	ESTM	ACTUAL

MISC []

TOTAL COST	ESTM	11.14	ACTUAL	19.91

Remarks

o Lay marker face up

Computerized cost sheets can be edited easily when textile and trim specifications change.

allowance to the marker yardage. This allowance is added to the marker yardage when estimating the order for piece goods and when calculating the final amount of fabric used for each garment. Manufacturers with computer systems can run very accurate computerized markers that give more specific estimates than possible when a manual marker process is in place.

The width of the fabric is a critical component in utilization. Garments that have large pieces, such as pants, are more economically cut from fabric at least 60 inches wide.

Materials Section

1. *Base goods.* An additional amount must be added to the base price of the fabric to cover yardage shipping fees. This amount can be as high as 10 cents per yard if the fabric is being shipped from coast to coast. Fabric that is being imported from the orient or Europe will often have to be shipped air freight. This adds 15 to 20 cents per yard, depending on the source of the fabric. Many manufacturers add a fee per yard to cover inspection and storage of the fabric.

2. *Accessory fabrics.* Linings and interlinings are included here as well as descriptions of the quality and amount required. These fabrics are usually stocked locally, so no freight charge is necessary.

TRIMMINGS

Trims include fabric treatments such as applied trims, pleating, topstitching, and added elements such as zippers, belts, and snaps. Usually, the thread is supplied by the sewing contractor, but this custom may vary with the individual factory. The cost of thread is greater when highly stressed seams or embroidery or appliques are used. The total for trimmings is added to the basic material cost.

LABOR

This area of a cost sheet is most often completed by a production person with current knowledge of production costs. The production person analyzes the methods that will be used to construct the garment and assigns time values to each operation. The Standard Allowed Minutes (SAM) for each operation is calculated, and this establishes the cost of sewing the garment. Some components may be produced outside the factory, and these will be added to the labor cost of the garment. A production person can manipulate the labor factor to increase the per-unit profit.

1. *Cutting.* The manufacturer sets a minimum cut figure. This is the smallest number of garments the firm will cut. If the number of orders for a style is less than the minimum cut figure, the style is dropped from the line. Generally, the lower the garment's cost, the higher the minimum cut figure will be. A volume cutter of budget blouses may set the minimum cut at 300 units. A manufacturer of expensive evening garments may set the minimum cut at 50 or 60 units and set the prices high enough to compensate for the higher per-unit cutting cost.
Use this formula to determine the per-unit cutting price:

$$\$75 \div 100 = .75$$
price of cutting ÷ units cut = price per unit

2. *Production pattern.* Some manufacturers figure the production pattern as a direct cost instead of as overhead, especially if the production pattern is contracted out. If the pattern is done in-house, the cost is difficult to determine. But a contractor is paid

a specific amount for patternmaking. This is a variable in costing a garment.

3. *Grading and marking.* These costs are similar to the production pattern cost because they are paid only once. The cost will not be duplicated if the style is recut. Grading and marking can be contracted out or done in-house. Therefore, the cost per garment depends on whether the manufacturer figures these expenses as overhead or direct costs. Frequently, a manufacturer will consider these as direct costs. Then when a style becomes a reorder, these costs become "earned" profit. Another manufacturer may choose to ignore these costs on a first cut, especially when the firm feels the garment could develop into a hot item if the price is kept as low as possible. The per-unit profit would be smaller, but the firm might be able to cut more garments and make a larger profit because of volume sales.

4. *Labor.* This figure includes all direct labor on the garment. Besides the sewing process, labor costs include bundling, pressing, hemming, trimming, and sewing on buttons, snaps, and loops.

On any garment, a wide variety of construction details must be controlled. The production person must set standards for construction that are compatible with the garment's final price and the construction standards established by the buyer. The production person must find contractors who can meet production standards at a competitive price. If a contractor accustomed to sewing inexpensive garments is given a complicated, high-priced garment, the production standards will usually not be acceptable. The good production manager carefully matches the contractor's skills with the standards necessary for production at a competitive price. To ensure that the contractor is doing a good job, the production person must inspect the garments (or lot) during construction. When the garments have been completed, a final inspection is made. The contractor is expected to correct any sewing mistakes made by the factory workers.

Sewing costs are figured in two ways:

a. *By using sewing costs for similar garments.* Generally, the more garments a factory makes, the lower the cost per unit. The operators become used to a style and work out difficulties after the first lot is completed. Often, the best sewers in the factory are given a few garments of the new style. With the help of the floor supervisor, a methods analysis determines the fastest and most ef-

ficient way to sew the garment. Then the test operators teach other sewers how to construct the garment quickly.

b. *Determining the Standard Allowed Minutes.* The floor supervisor does a detailed methods analysis of the construction elements. The supervisor may suggest less-expensive construction methods to the production person. A trial garment is made, and the sewing cost is computed based on the "gets and puts," the time it takes to pick up the garment piece and put it in the machine for the sewing process. If the factory is a union shop, the union representative may join the supervisor and contractor in determining the price to be paid for the garment. The total minutes to perform all construction details will be calculated and multiplied by the basic cost of employing a sewer. Once the construction cost has been determined, both the manufacturer's production person and the contractor should agree on the price and construction standards before a lot goes into production.

5. *Trucking and Warehousing.* The cost of warehousing the garment and then shipping each garment to the retail store. A retailer may ask the manufacturer to pay a distribution fee, an allowance given the store because the whole order is shipped to one place, saving the manufacturer the expense of shipping orders to branch stores, which the retailer will do. If many branch stores are involved, paying the distribution fee may save the manufacturer high shipping costs.

TOTAL COST

A final, total cost can be calculated in two ways. The first way is this:

Total cost + mark-on desired = wholesale price

The mark-on percentage for moderate garments ranges from 45 to 60 percent. Budget cutters may figure a lower mark-on, whereas manufacturers of expensive garments may take a higher mark-on to cover higher production, design, and advertising costs. **Mark-on** is the amount added to the garment's basic cost that covers a company's overhead. Overhead includes the sales commission (which ranges from 7 to 10 percent) and terms. The traditional terms in apparel are 8/10 EOM—that is, 8 percent of the selling price is refunded to the purchasing store if the goods

are received in a given month and the invoice is paid within 10 days of the end of the billing month. Also included in overhead are rent, machinery depreciation, salaries of personnel not directly involved with construction, taxes, insurance, billing, bookkeeping and accounting, advertising, and profit. In other words, overhead is the cost of running a business.

Many large retailers no longer use 8/10 EOM terms. Net–30 or Net–60 are currently used. *Net–30* means the manufacturer is paid 30 days after the end of the month in which goods were received. Allowances for freight, mark-downs and advertising are deducted from the total purchase price. These allowances must be negotiated at the time of sale.

Another way of figuring the final price is to use the reciprocal formula. Divide the total cost figure by the reciprocal percentage:

Total cost ÷ reciprocal figure = wholesale cost

To determine the reciprocal, subtract the desired mark-on percentage from 100; the result is the *reciprocal percentage*. For example, suppose you have a 55 percent mark-on a $18.56 item. Subtract 55 from 100 to get 45, which is your reciprocal figure. You are dealing in percentages, so the reciprocal percentage in the formula is .45. Now insert your reciprocal percentage into the formula to get the wholesale cost:

Total cost ÷ reciprocal figure = wholesale cost

$$\$18.56 \div .45 = X$$

$$\frac{\$18.56}{1} \div \frac{.45}{100} = X$$

$$\frac{\$18.56}{1} \times \frac{100}{45} = \$41.24$$

Thus $41.24 would be rounded to $41.00 or $41.50.

Many companies will refigure a garment several times because of the savings that are realized during each phase of the manufacturing life of the style. The garment yardage and cost are first estimated at the sample stage. Then the yardage is firmly established when the production pattern is made and graded for the first marker, and the labor price is set and tested as the garment is manufactured. If the garment sells well and is reordered, it is again refigured, eliminating the start-up costs of pattern-making, grading, and marker making. Finally, if the garment continues to a new season or is refabricated, the cost of the new fabric will affect the final cost.

MERCHANDISING THE COST OF A GARMENT

A manufacturer will always cost a garment before establishing the wholesale price. But another factor is as important as the dollar cost of the garment: *Does it look the money?* A garment must compete in an established marketplace. If it does not look as if it is worth its price, the garment's sales appeal will diminish. For example, if two basic shirts made in a similar fabric and style are placed on a rack together and they differ in price by a dollar, the less-expensive shirt is more likely to sell. In particular, basic items must be carefully priced to be competitive. Innovative styling can often be the major factor that allows a manufacturer to get more money for an item. The customer may resist an inexpensive item if there is a more fashionable or more carefully constructed alternative.

Another reason for merchandising the cost of a garment (that is, lowering or raising the wholesale price to affect the sale) is to create a good seller. When the manufacturer sees a garment that is stylish and fairly easy to produce, he may use a lower mark-on when figuring the cost or manipulate the fixed costs as described above (see the section on grading and marking). The manufacturer is gambling that the lower cost will stimulate sales and the added volume will generate the needed profit to make the item worth reordering.

In addition to all these price considerations, the manufacturer must continually be aware of how its items fit into the price structure of the stores and departments that sell the merchandise. To maintain a constant retail customer, the manufacturer's line should display a consistent price structure and visual image.

FOREIGN LABOR MARKETS

The elements of costing a garment are fairly constant for both domestic and foreign apparel. The foreign manufacturer must consider the cost of materials, labor, and overhead. Unlike the domestic manufacturer, the foreign manufacturer must add freight, customs duties, import agent's fees and availability of import quota to the basic components of the garment's cost. An inexpensive labor force is the primary reason to manufacture abroad.

Foreign manufacturing often entails hidden costs and issues. These include travel costs and time to inspect and troubleshoot problems, pay-

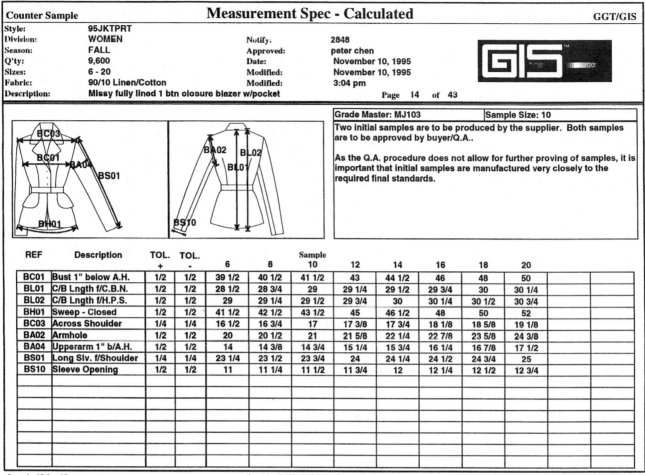

Counter Sample		**Measurement Spec - Calculated**						GGT/GIS

Style:	95JKTPRT				
Division:	WOMEN	Notify:	2848		
Season:	FALL	Approved:	peter chen		
Q'ty:	9,600	Date:	November 10, 1995		GIS
Sizes:	6 - 20	Modified:	November 10, 1995		
Fabric:	90/10 Linen/Cotton	Modified:	3:04 pm		
Description:	Missy fully lined 1 btn closure blazer w/pocket		Page 14 of 43		

Grade Master: MJ103	Sample Size: 10

Two initial samples are to be produced by the supplier. Both samples are to be approved by buyer/Q.A..

As the Q.A. procedure does not allow for further proving of samples, it is important that initial samples are manufactured very closely to the required final standards.

REF	Description	TOL. +	TOL. -	6	8	Sample 10	12	14	16	18	20		
BC01	Bust 1" below A.H.	1/2	1/2	39 1/2	40 1/2	41 1/2	43	44 1/2	46	48	50		
BL01	C/B Lngth f/C.B.N.	1/2	1/2	28 1/2	28 3/4	29	29 1/4	29 1/2	29 3/4	30	30 1/4		
BL02	C/B Lngth f/H.P.S.	1/2	1/2	29	29 1/4	29 1/2	29 3/4	30	30 1/4	30 1/2	30 3/4		
BH01	Sweep - Closed	1/2	1/2	41 1/2	42 1/2	43 1/2	45	46 1/2	48	50	52		
BC03	Across Shoulder	1/4	1/4	16 1/2	16 3/4	17	17 3/8	17 3/4	18 1/8	18 5/8	19 1/8		
BA02	Armhole	1/2	1/2	20	20 1/2	21	21 5/8	22 1/4	22 7/8	23 5/8	24 3/8		
BA04	Upperarm 1" b/A.H.	1/2	1/2	14	14 3/8	14 3/4	15 1/4	15 3/4	16 1/4	16 7/8	17 1/2		
BS01	Long Slv. f/Shoulder	1/4	1/4	23 1/4	23 1/2	23 3/4	24	24 1/4	24 1/2	24 3/4	25		
BS10	Sleeve Opening	1/2	1/2	11	11 1/4	11 1/2	11 3/4	12	12 1/4	12 1/2	12 3/4		

allmeasb 05 Apr 95 Copyright (C) 1990-1995 Gerber Garment Technology, Inc.

Measurement Specification Sheet

Exact measurements are a critical component of quality control. Personnel must know exactly how to measure each garment. The computer is indispensable for recording these details.
Courtesy: Gerber Garment Technology, Inc.

ments to foreign officials, capital investments and training, and so forth. In addition, U.S. consumers are becoming aware foreign countries may abuse child-labor laws, use political prisoner labor to sew garments, and ignore other human rights abuses. These factors are critical to evaluating the worth of manufacturing abroad.

Frequently the designer is an important element in the success of foreign manufacturing. The U.S. designer should have the ability to design garments that will appeal to the domestic consumer. The foreign manufacturer, however, may fail to grasp the subtleties of construction, styling, and fabrication necessary to sell garments in the United States.

To design foreign-made garments successfully, a designer should analyze the strengths and weaknesses of the foreign country—for example, the

Computerized Quality Control
Gerber Garment Technology Production Design System (PDS) provides quality control specialists with exact examples detailing the measurement of each garment.
Courtesy: Gerber Garment Technology, Inc.

material supply and the quality of labor. Things that are difficult to do in the U.S.'s mass-production-oriented industry may be easy to do in a foreign country where small manufacturers dominate the market. India, for example, is geared to custom-dyeing and printing of cotton goods. Hand detailing, such as embroidery and beading, is done inexpensively by cottage laborers.

Duty and quota are two additional cost factors that must be considered when importing garments. *Duty* is the fee that must be paid to United States Customs to import an item. The amount of the duty for each specific item is set by the government in an attempt to balance the cost of inexpensive labor abroad with the higher wages paid in the United States. This is a way of protecting U.S. industry and making domestic prices more comparable with those of garments made offshore. Duty is highest on items that have a competing domestic industry. Additional restrictive duty is added to garments that are ornamented. The manufacturer pays approximately 32 percent more for any decoration that is not functional. A designer has to have a good understanding of current duty regulations to avoid inadvertently adding to the cost of the garment.

Quota refers to the type and number of garments that are allowed to be imported into the United States from each foreign country during the calendar year. The amount allocated to each country depends on the kind of quotas applied and the domestic production that must be protected by the U.S. government. Quota is assigned to the foreign government, which in turn assigns it to manufacturers who request it. Quota is usually not a cost factor for a garment unless there is a limited amount of a hot category available. Then the quotas may be sold by a factory producing less of an item

to another factory that has many orders. This will
increase the price. Quotas are usually assigned to
individual manufacturers based on what they have
shipped in previous years. Thus it is very easy for a
manufacturer that goes out of business or reduces
its production to earn a great deal of money by sell-
ing its quota to another manufacturer that is pro-
ducing a great deal and does not have enough quota
to send all its products to the United States.

A foreign market may be desirable because
labor is inexpensive, but it can also be worthwhile
because highly developed technicians and sophisti-
cated machinery are available abroad. Areas of the
Orient have cornered the full-fashion knitwear in-
dustry. U.S. manufacturers design lines of sweaters
and knit apparel to be manufactured in Asia because
the factories are so excellent and the costs so low.

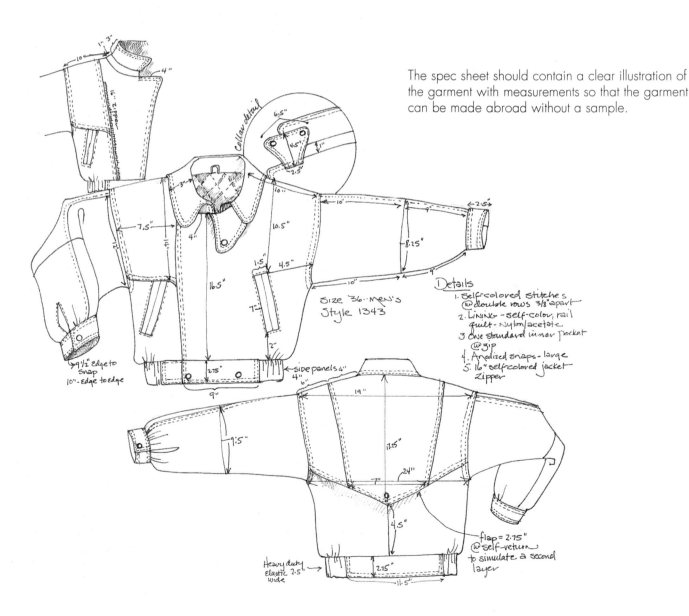

The spec sheet should contain a clear illustration of
the garment with measurements so that the garment
can be made abroad without a sample.

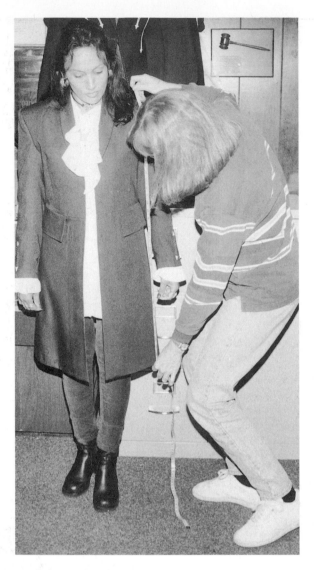

Production Fitting
Constant attention to detail and specifications is critical to the success of a garment through all phases of production.
Courtesy: Frank Walter Sportswear.

Free trade areas exist in North America and Europe. Member countries can import and export each other's goods without paying customs fees. The free trade agreement that the United States has with Mexico has encouraged Asian nationals to set up factories and distribution centers for goods that can be shipped to the United States without paying import fees.

Garments and accessories are imported from Europe because European lines have prestige, not because they are inexpensive. The customer who is seeking an unusual high-fashion garment often prefers to wear a European designer label. High-priced shoes and leather goods are imported from Italy and France. Spain and Portugal export less-expensive shoes, often of Italian design. France and Italy are both noted for high-fashion designer labels. England and Ireland are noted for fine woolens, hand-knit sweaters, and linens. U.S. buyers attend the large prêt-à-porter shows in France and select merchandise for the affluent U.S. customer, and European manufacturers such as Gucci and Hermes sell directly to the customer through branch stores. Design is the forte of the European manufacturer, so fashions are sold directly to the retailer. Hong Kong lacks well-known design talent and depends on U.S. and European designers for guidance in styling merchandise; Hong Kong greatly needs manufacturers to export merchandise successfully on a large scale.

Countries tend to specialize in a specific quality and type of merchandise. The specialty evolves gradually as a market begins to experiment with a product, usually at a fairly inexpensive level. Factories develop, employees are trained, and gradually more sophisticated machinery and production techniques are introduced. Wages may increase as employees acquire skills. Buyers will take their business to the foreign market that produces a garment to U.S. specifications, has adequate production capacities, and delivers the garments on schedule at a price lower than the domestic price.

Constant supervision and creative design guidance are the two vital ingredients in successful dealings with foreign production. Often, language and business customs are so radically different from general U.S. practices that many mistakes are made. For this reason, manufacturers will take a higher mark-on when producing in a foreign country. The mark-on covers any problems that may arise.

Summary

Organizing the line is one of the designer's most important functions. The kind of merchandise and to whom it will be sold determine how the line will be organized. Item lines tend to contain low-priced knockoffs of more expensive garments or high-priced boutique.

Group organization is typical of sportswear and dress lines. Groups of complementary styles are offered in one fabric or in a series of fabrics that is color coordinated. There are many advantages to designing with fabric groups. Retail continuity and impact in the store are important. In addition, the strong styles in a group usually will carry the fabric purchase when the weak styles fall out. Advertisements and displays can be planned around several styles in a similar color and fabric story. Fabric may be purchased in quantity to save money and ensure delivery. Various price zones can be represented by groups designed in different-priced fabrics. A hot item may be sold in several fabrics to get the most mileage out of a good style. Lines based on group organization have a consistent, well-developed look. Organization of a line begins with the selection of the color story. Research and personal taste determine the designer's choice of color. The season, type of merchandise, and current market trends are factors that influence the color trends promoted by fiber companies and textile firms.

Fabric boards are helpful to keep track of the textiles selected for each group. They contain individual swatches of the base goods and accessory fabrics chosen for a group. Workboards show the samples created for each group and assist the designer in numbering and selecting colors for the samples.

Groups that form a line should look as if they were designed for the same store or customer but have enough variety within the selection to allow buyers a choice of fabrics, colors, and styles. The good designer analyzes how much change the customer is willing to accept in new styles and reinterprets past styles that have been successful sellers.

A cost sheet is used to organize all the information relevant to the production of a garment. Usually the designer originates the cost sheets and lists the resource information necessary to purchase all fabrics and trims. The production department figures the labor cost, and the cutting department is responsible for estimating marker yardages. Merchandising the cost of the garment is important to ensure that the final price is compatible with current market activity.

A designer is often the first contact in foreign manufacturing and forms the vital link in creating merchandise that is producible in offshore locations and yet salable in the United States. Duty is the fee that must be paid to United States Customs to import an item, and quota refers to the type and number of garments allowed to be imported during a year from a specific country. These are two additional cost factors—along with the costs of shipping, clearing customs, and supervising offshore production—that must be considered when importing apparel.

Review

WORD FINDERS

Define the following words from the chapter you have just read:

1. Cottage labor
2. Designer worksheet
3. Direct labor cost
4. Duty
5. 8/10 EOM
6. Fall out
7. Group line
8. Item line
9. Knock off
10. Mark-on
11. Master color story
12. Merchandising
13. Novelty fabric
14. Price leader
15. Quota
16. Reciprocal
17. Staple fabric
18. Style theme
19. Supervisor
20. Volume cutter

DISCUSSION QUESTIONS

1. Describe the merits of organizing a line by the group method.
2. Plan a fall color story for a junior sportswear manufacturer. Keep the following points in mind: be consistent, offer enough variety, develop the color theme in all groups.
3. Describe two types of item houses.
4. Working from an actual garment, fill in a cost sheet. Estimate yardage, trims, and labor costs.

Unit 2

Materials

CHAPTER 6
Fabricating a Line

This chapter discusses the business of selecting fabrics and how the textile producer and manufacturer must work together to get textiles into the marketplace in appropriate garments. *Textile science*—the identification of fibers and textile constructions, dyestuffs, and printing techniques, and so on—is discussed only as it relates to the actual ordering of fabrics. Textile science is a complicated subject that should be covered in a class separate from one on garment design. Many fine textbooks are available on textile science and may be used as a reference to clarify technical questions.

The designer's responsibility in choosing fabrics for the line can vary quite a bit, depending on the manufacturer. For example, a designer can be assigned fabrics to work on after management has selected all the piece goods for the season. Other manufacturers require the designer to select and purchase both sample and stock yardage. Generally, the designer's responsibility will fall between these two extremes. Sometimes, the designer will review lines with either a stylist or the owner of the house, but most manufacturers encourage the designer to make aesthetic decisions about fabric. Frequently, the manufacturer will have a bad relationship with some textile firms, and the designer will be discouraged from ordering their samples. Similarly, manufacturers with poor credit ratings will be unable to purchase piece goods unless they pay cash.

Timing yardage purchases is an important aspect of apparel manufacturing. Generally, piece-goods salespeople encourage manufacturers who

When you have read this chapter, you will understand:

1. How a designer selects appropriate fabrics for a line.

2. The timing of fabric purchases and terms of sale.

3. How a textile salesperson works with a manufacturer.

4. Where to get information on fabric trends and resources.

5. How fabric aesthetic relate to garment styling.

are buying substantial amounts of yardage to commit (buy a specific amount or a particular fabric) early in the season to ensure delivery at the promised time. Manufacturers of fashion items try to wait for early sales results before purchasing fabric. The pressure from both directions—the salespeople wanting commitments for fabric and the production supervisor or owner wanting salable garments—often falls on the designer.

A very small manufacturer who has no credit history must purchase fabrics COD (collect on delivery) from a textile manufacturer or jobber. A jobber is a middleman who purchases large amounts of fabric from a mill or other manufacturers and sells them in smaller lots at a slightly higher price. When a company is large enough to establish credit with its fabric suppliers, terms for stock yardage purchases are 60–net. This means that manufacturers do not have to pay for fabric that they have purchased until 60 days after the shipping date. This allows the manufacturer to work with the textile company's money for two months. A well-organized manufacturer can cut, sew, ship garments to a store, and often receive payment during this time period. A manufacturer can ask a textile manufacturer for "dating," which is an additional time period in which to pay a bill, to allow the manufacturer time to collect before payment of the principal amount is due. Interest is usually charged on the amount outstanding. Fabric costs are approximately one-third the cost of a garment. Contractors and factory workers that cut and sew the garment must be paid immediately. The money "float" afforded by 60–net payment terms for fabric makes it easier for a manufacturer to finance the business.

The designer usually reviews all fabric lines which have any relevance to the product, even lines that are above or below the typical price range. This wide sampling is important because the designer must know what competitors and other firms in the market are choosing. In other words, when designers thoroughly research all fabrics offered during a season, they will have an overview of all textile trends and innovations. Fabrics beyond the usual price range are important because the designer can use an inexpensive fabric as a lining or an expensive fabric as a trim in a limited area.

Occasionally, the designer will find a new fabric that promises to be a good seller, in which case he will sample it and test the most suitable sewing methods by making it into a stock garment. When a new product is satisfactory, management will com-

Fabric Mixes
Rudi Gernreich designed innovative geometric knits and styled them into sportswear and dresses for Harmon Knitwear. The kimono dress was a best-seller in the 1960s.

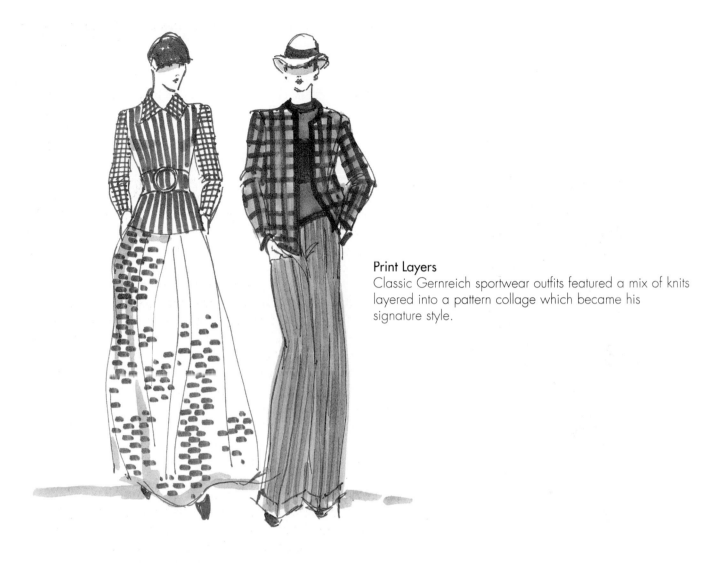

Print Layers
Classic Gernreich sportwear outfits featured a mix of knits layered into a pattern collage which became his signature style.

mit itself immediately for some amount of yardage but specify (assort) colors and prints at a later time. New fabrics are usually in short supply at first, so an early order ensures that a manufacturer will have the first chance to ship that fabric to stores in his product area.

A designer needs to know who else has sampled a fabric and will try to avoid fabrics that have been chosen by competitors or those used in lower-priced lines. This is especially true for novelty and print fabrics. Staple fabrics may be used in competitive lines where styling determines success.

When a designer finds a fabric to sample, a *sample cut* of 3 to 5 yards is ordered. The salesman provides a color card and information on delivery dates for duplicate and stock yardage. *Stock yardage* is the large amount of fabric needed to cut garments ordered by stores. Stock yardage is usually purchased by a purchasing agent specializing in fabrics. If the designer anticipates dyeing or printing a

MILL NAME **COLLINS + AIKMAN**

New York Contact _**JIM THOMPSON**_ Phone_**212·953·4309**_
Los Angeles Rep _**LES WEINGARD**_ Phone_**213·683·1960**_
Season_____

NAME OF PATTERN #	FIBER CONTENT	PRICE	WIDTH	DELIVERY & COMMENT
VEL·DU·YORK	100/COT.	5.50	60"	SWATCH CARD ENCLOSED
FANCIES: {	all priced @ $6.25 all 60"			SWATCHS TO COME: SAMPLES ATTACHED
HEATHER	100% COT	6.25	60"	
	flannel here - also in a faded denim blue velvet.			
SPACE FLORAL	due in January →			
VEL CHECK	more in January → Colours on white ground due			
coming:	PIN STRIPE, ½" spaced stripe, paisley, bouquet + fleur de lis - I will send you my samples			

Textile Information Sheet
The designer should keep a record of the lines reviewed. If it is possible to keep swatches of fabrics that are potentially interesting, they should be included in this record. If a special fabric request develops during the season, the designer can review the notes and source the fabric. This sheet is an example of a form that organizes the information a fabric salesperson presents to a designer.
Courtesy: Grayce Baldwin Consults.

special color, it is important to negotiate minimum yardage requirements.

A designer should see as many lines as possible. The piece-goods salespeople are well acquainted with events in the marketplace, and they often have information that can aid a designer in the choice of a fabric or print. One well-known designer in the California swimwear market saw each salesperson who called on her at least once a season. She sampled what she thought would be appropriate for her product. Because she saw everyone and rarely turned a person away, this designer was called first whenever a salesperson had a new or different fabric. This gave her a tremendous edge over other local designers, who had discouraged salespeople at one time or another. The cardinal rule for a designer should be this: *See all the textile representatives you possibly can during a season. Judge their products' relevance to the designs you are planning. Be flexible, yet practical.*

FABRIC SELECTION

The designer selects samples on the basis of price, aesthetics, fashion, and the fabric's suitability for the line. Frequently, a beautiful fabric cannot be used because it is too similar to another fabric in the line. The designer should look for different weights and textures, crisp fabrics and goods for draping, thin blouse weights and heavier "bottom" weights (suitable for skirts and pants). The fabrics in the line should be balanced between novelty goods and base goods. *Novelty fabrics* include prints, fancy woven patterns, textured and fancy knits, and textured wovens. *Base goods* are fabrics in solid colors and traditional patterns that can be used in many different styles.

The fabrics in a line should have a price range. The lower-priced fabrics can be made into more complicated styles. Higher-priced goods should be reserved for simple silhouettes.

When a sample fabric works well when it is made into a garment and is accepted as an item or group in the line, the sample garment must be duplicated. *Duplicates (dupes)* are extra sample garments that are sent to road salespeople and showrooms in other markets. In many companies, the designer is responsible for ordering the duplicate yardage and supervising the construction of the dupes. Extra yardage is also needed to make production samples. Each time the designer orders the fabric, he or she should check delivery date and

price of stock yardage. The delivery date is determined by the turn-time of the fabric producer. *Turn-time* includes the time it takes to knit or weave the fabric, dye and finish it, and ship it to the manufacturer. Turn-time depends on many factors and can range from immediate delivery for yardage that is on hand in the producer's warehouse to several months. The designer should inquire about turn-time and relate it to the cycle the manufacturer can work with.

Ordering of piece goods for stock cutting is usually handled by the manufacturer after the number of confirmed sales and the number of projected sales for the item have been calculated. A contract for the yardage purchase is drawn up between the fabric company and the manufacturer.

Designers based in regional design centers frequently travel to New York to preview new fabric developments. They can discuss their ideas and color schemes directly with textile designers and technicians. Textile designers and principals also visit regional manufacturing areas to meet and work with designers.

Many textile firms are located on the West Coast to give first-hand service to the California market. Knit manufacturers dominate, followed by finishing plants that process denim and other

Fabric Inspiration
Designer Tadashi Shoji sketches print bodies based on the fabric groups he has selected for the season.
Courtesy: Tadashi.

woven fabrics so they look worn. The Los Angeles textile market has grown considerably in the last decade, but the total amount of yardage produced in California is still less than the amount produced on the east coast. Regional textile plants tend to sell the most yardage in their local market to capitalize on lower freight rates, quick turn-time, and custom fabrics.

THE TEXTILE FIRMS

There are two major types of textile firms. The first is the vertical textile firm. The company owns the mill or knitting factory that produces the *greige goods* (unstyled and unfinished base fabric, also spelled *gray* or *greig*), converts (styles, prints, and finishes) this yardage into fashion fabric, and then markets it. The converter is the second type of fabric firm. The converter buys greige goods from large mills, employs designers and technicians to style the goods, and rents facilities where the greige goods are printed, dyed, and finished. Then the converter markets the finished fabric. The vertical textile firm owns the physical plant and the styling and marketing facilities. The converter owns people (that is, pays their salaries) and yardage. All other functions are contracted out.

The Textile Salesperson

The main contact between the textile firm and the manufacturer is the textile salesperson. Textile firms vary greatly in the size and complexity of their marketing operations, and textile sales-people vary accordingly. A salesperson may:

1. work for one division of a large firm that services only one kind of manufacturer (largest textile firms),
2. handle an entire medium-size textile house and sell to a variety of manufacturers, probably in one geographic area (medium-size textile firm),
3. handle several smaller converters and cover the entire market for goods in a particular price range. Usually, this person will work in a limited geographic area and choose nonconflicting lines whose base goods differ in price or type (small firm with a specialized product).

Most textile firms try to specialize in one type of fabric and gear their product to a specific market—for example, women's wear in one price range.

Even larger companies with a diversified product tend to group similar fabrics under one division to concentrate selling activities. Fashion can affect this grouping, however. Currently, men's wear designers are using many fabrics formerly thought to be suitable for women's wear and women's wear designers are using men's fabrics.

Among textile manufacturers, the trend is toward larger companies. Larger firms create divisions that specialize in one type of fiber, one price range, a particular type of base goods, or a specific market. A division is broken down further into marketing areas based on price of the final product, manufacturer's geographical location, category of merchandise, and retail divisions.

Servicing accounts (manufacturers) is the textile salesperson's first job. The first step is to show designers the line at the beginning of each season and whenever a new fabric or print is added. The designer should make every effort to see the line without interruption. Most designers review lines outside the workroom to avoid distractions and keep current designs confidential.

The textile salesperson should not edit the line or prejudge a designer's selection. Often, a designer is looking for a specific item and should see all available fabrics. The designer should select sample cuts of fabrics to experiment with and judge realistically how the fabric will adapt to the line.

Customizing Textiles

Designers who can create unique prints or fabric colors will give their lines an edge in the marketplace because competitors cannot duplicate the styling. Customizing textiles usually requires a large purchase at the sampling or duplicating phase of the textile ordering. More and more textile producers are requiring manufacturers to commit (place a minimum order) once they have decided to duplicate the yardage. Minimum yardage requirements for custom colors depend on the method of dyeing or printing. Yarn-dyed and solution-dyed fabrics require the most yardage if a color is to be dyed to order. The yarn is dyed and then woven in the yarn-dyed fabric method. Solution-dyed fabrics are synthetics that are dyed in the liquid state before the liquid is made into yarn. Piece-dyed goods have a lower requirement for a special color because the piece (usually several hundred yards) is dyed after weaving. The designer approves the colors from

"lab dips," small swatches of fabric dyed to match a given color. Each textile manufacturer will have different minimum yardage requirements for special colors, depending on what production facilities are available, the fabric blend, and the fabric price. The fabric printing method is important when a designer is considering recoloring a print; for example, to recolor a roller print requires a very large run or the price will increase. Machine screens are more flexible: They can be recolored if the minimum yardage ordered is somewhere between 1,500 to 2,000 yards. Heat-transfer prints usually can be recolored at a minimum of 1,000 yards per color.

When a designer wants a special color combination in a print, the textile salesperson requests the textile firm's art department make a painting or *croquis* of the new color way. Traditionally, the croquis was rendered in paint on paper, and it showed the print in the new color combination. The apparel designer may give the salesperson swatches of the desired colors, describe the colors, or adapt colors from another print.

Today, the computer has radically changed the way textiles are colored and designed. The outline of the print is scanned into the computer, inputting the colors of the base goods into the "color way" (number of colors used in the print) and programming the mix of colors in each position. The computer can also randomly mix the colors on the screen, and the designer can select the most appealing.

A designer may design a custom print on the computer and print a small amount of goods on a digital printer, resolving the problem of ordering stock yardage before seeing the garment made up in a new color way. Eventually, this technology will allow consumers to customize the color of a print to their individual taste, have it printed on the garment pieces, cut a single ply of fabric, a sew a custom printed garment.

Traditionally, a *strike-off* is made; that is, the textile company produces on base goods a short run of the new color, usually no more than 1 yard. Usually the strike-off is not finished because the manufacturer's main concern is what the pattern will look like when it is printed on fabric. Generally, the purchase will have to be made before the manufacturer can receive yardage in the new color range. Just as in dyeing goods, the typical minimum yardage will vary according to market conditions and the textile firm.

Croquis
A painting, or croquis, is made if a customer requests a color change in a pattern and the designer is not using a CAD system. Then the croquis is approved by the manufacturer and printed in the form of a strike-off.

Some textile firms specialize in flexible production, styling the product to meet the demands of the individual customer; usually, they receive a higher price for their product. Other firms specialize in a standard product at a competitive price; they require large fabric commitments if they are to do a special fabric work. Some companies have a division that supplies the designer market that does special prints and colors that for one season are confined to one designer. The textile firm absorbs some production costs in these cases because it offers the fabrics to the general market at a lower price the following season. This method benefits both the designer firm and the textile manufacturer: The former has a unique product, a new and personal fabrication unlike any other on the market; the textile manufacturer gains prestige by selling to a high-priced resource, tests the product at the consumer level without making huge yardage commitments, and advertises the "exclusive" designer quality of the fabric and styling.

Innovative apparel designers start by designing the fabric. Computerized textile design is allowing this to become more widespread. The first to use the computer were knitwear designers. High-end jacquard knitting machines allow the designer great flexibility to design stitches and patterns that can be knit down for individual garments or short runs of customized fabric. Brenda French of French Rags and St. John Knits are two customized knit houses that feature unique, in-house knit fabrications.

Jhane Barnes is well known for her unique men's wear fabrications. She designs geometric weaves and knits on the computer, which allows her to develop complicated patterns based on mathematical coordinates of the loom or knitting machines' stitch patterns. Woven fabrics patterns (twills, basket weaves, and so forth) can be simulated on computer in a great variety of color ways, repeats, and sizes. A miniloom is programmed from the computerized design and weaves down a sample swatch. The weaving or knitting program can be sent on a computer network to other locations for stock weaving. Barnes also translates her apparel into home furnishing fabrics.

Ordering Duplicate and Stock Yardage

After the designer has sampled the fabric and made it into garments for the line, duplicate yardage must be ordered. In some firms, the designer will be re-

sponsible for this order; in other firms, it is the responsibility of the production department. After the duplicate yardage order, the designer has little to do with fabric ordering unless he or she works for a very small shop or is a principal of the house. Most often, the head of production and the fabric salesperson set up delivery dates, damage allowances, shipping terms, and the final price per yard.

Negotiations for advertising allowances usually begin at this point. Advertising allowances are given by the textile mill or the company that provides the converter with the fiber. The money is for advertisements that feature the name of the mill or the fiber. Generally, the manufacturer will also contribute some money and the retailer will make up the difference. The larger textile firms and fiber companies also run ads on the trade level.

There are several reasons why a designer may be called back into conference with the manufacturer and the textile representative:

1. to review the fabric line if additional patterns and colors must be selected,
2. if problems develop with sewing methods on a particular fabric or if the samplemaker is unable to solve a construction problem,

Cooperative Fiber Advertisement

Hoechst Fiber promotes its fiber by advertising in trade newspapers to encourage other manufactureres to use the fabric.
Courtesy: Hoechst Fibers Industries.

3. to refabricate styles when yardage commitments cannot be met and substitutions must be made.

Many times, a designer is working on two lines at once—preparing a future line while solving the problems of the line about to be shipped.

Frequently, the designer is called upon to choose promotional patterns. These are off-priced goods offered to manufacturers near the end of the season. Often, they are print goods that the textile firm has not been able to sell. The designer will select a group of prints that will be offered in "assorted" proven bodies. The manufacturer cuts the chosen fabrics and sells them at a lower price than the regular stock.

A good textile salesperson will attempt to develop a working rapport with many designers. He or she knows that each person may change jobs many times. If the salesperson has developed a good working record with a designer and has a good product to sell, the salesperson will have a successful future no matter where the designer is working.

The designer should always be open to the products and information a textile salesperson has to offer. The designer should consider the product's suitability to the line he or she is creating. By taking notes on available textile products, the designer will have information for future reference. Although the designer should be open to suggestion, she or he should not be motivated unrealistically by a good sales pitch or by the fabric representative's friendship.

INFORMATION ON FABRIC SOURCES

Fabric Libraries

At the beginning of the season, a designer may find it helpful to get an overview of the fabric market. Some excellent sources are the fabric libraries compiled each season by large fiber companies. If a designer requests a specific type of fabric, these libraries can help find it. Most companies have market representatives who interpret the general color and fashion trends in each apparel area. The fiber companies recommend that every converter and mill using their fibers send them *types* (swatches large enough to feel) to include in the library. Seeing the fabrics in a library is advantageous because the designer is not pressured to buy a fabric and may compare in one place the products and prices of many converters.

Step One: Research

FALL COLOR PREDICTIONS: WOMEN'S WEAR

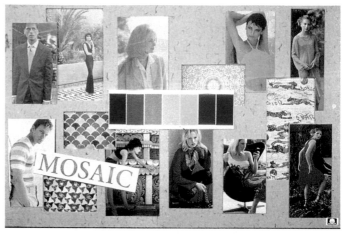

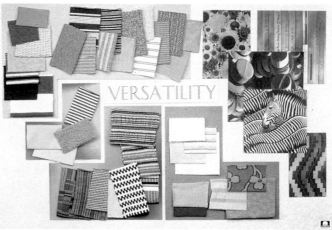

Commercial color predictions are developed by fiber companies, fabric converters and manufacturers, fashion magazines and predictive services, and professional color experts. At the beginning of each season, the apparel designer begins researching as many of these resources as possible. In large apparel markets, seasonal color, fabric, and trend/silhouette seminars are presented to designers, manufacturers, and retailers. Building a collection of color swatches is the first step. Analysis of different

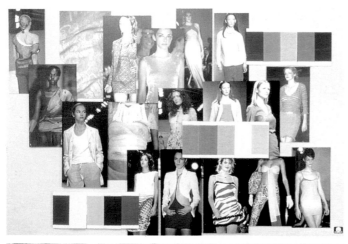

markets and an awareness of what colors sold well the previous fall in domestic designer lines, European prêt-à-porter, and to the specific customer, are all important to research.

Color reports are usually organized in families that provide designers with possible combinations to develop group themes for their lines. Upscale designers research commercial color predictions to determine general color direction, but combine color in unusual ways or invent their own color direction.

Courtesy of Cotton Incorporated

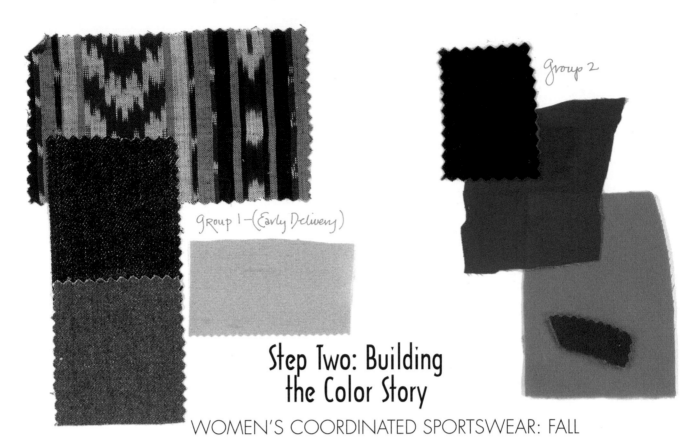

Group 1 – (Early Delivery)

Group 2

Step Two: Building the Color Story

WOMEN'S COORDINATED SPORTSWEAR: FALL

Coordinated sportswear is the most complicated type of merchandise to design because of the diverse types of garments, fabrics, and accessories that must be developed, coordinated, and produced for delivery at the same time.

A coordinated sportswear designer begins with delivery dates for each fabric group. The selling periods dictate color ways, fabric, and styling. Next, the designer selects color stories for each delivery group and works with the sales people and merchandisers to determine the size of the group and a selling strategy. Some groups are targeted for a very short delivery period. Others have several different sub-groups that refresh the selection of the basic pieces.

A group has a minimum of three colors. Usually a neutral is coordinated with two accent colors. Each group should be different to encourage a buyer to select several groups each season. Large sportswear companies may have two or three main color stories in a group to allow sales to competing retailers located in one area. The same styles can be purchased in different colors.

Group 4

Group 3

(late delivery — into holiday)

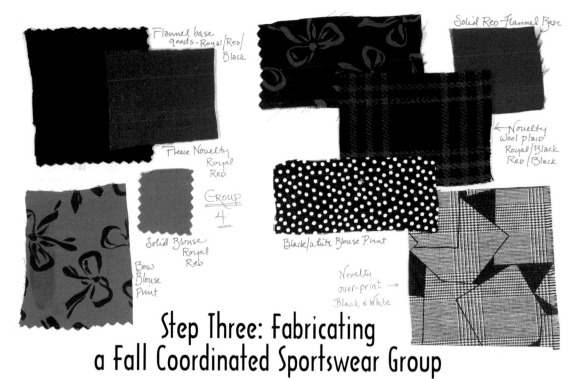

Flannel base goods - Royal/Red/Black

Solid Red Flannel Base

Fleece Novelty Royal Red

Novelty Wool plaid Royal/Black Red/Black

Group 4

Solid Blouse Royal Red

Bow Blouse Print

Black/White Blouse Print

Novelty over-print → Black & White

Step Three: Fabricating a Fall Coordinated Sportswear Group

Sportswear firms often repeat base goods that have sold well and can be dyed in new colors once they have been selected. New fabrics must be tested to make sure they tailor well, can be washed or dry cleaned, and are attractive in a garment. The designer reviews many textile lines to look for accessory fabrics. Existing prints may be recolored and novelty sweater knits and fabrics can be developed to match the base goods. Sometimes the process begins with a novelty fabric which suggests the color range for the solid fabrics in the group.

Once fabrics are selected, the designer begins to style the garments mixing novelty fabrics with base goods to create as many ensembles as possible.

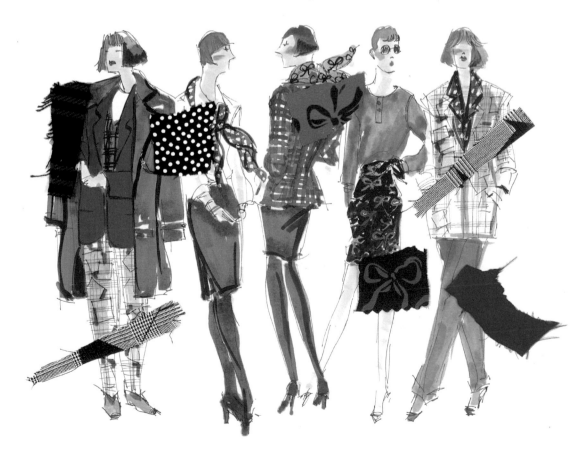

Courtesy of Cotton Incorporated

Red　　Mustard

Rust　　Maise

Green　　Black

Cobalt Blue　　Purple

Navy　　Brown

Neutrals

Forest Green

Rust

← Olive Drab

Brown

Denim

Kakhi

Fall Children's Wear Color Stories

Children's wear designers are less influenced by fashion trends than women's wear. Classic color selections are the primary and secondary brights for all but the youngest children. Dark, rich fall classics like rust, crimson, royal blue, and a full range of greens from hunter through teal, are perennial favorites. Yellow and gold are often used as accents. Plaid flannels are traditionally popular for fall and blend well with the classic colors used for pants and skirts. Denim and khaki are classic neutral bottom weights. Black is less frequently used in children's wear than for adults.

Classic Color Stories

#1

#2

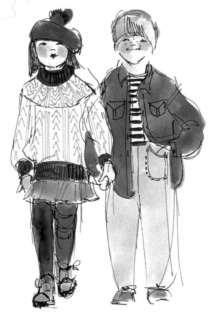

Classic Color Stories

#4

#3

Red Teal Off White

Rust Blue Camel

Cinnamon Forest Green Kakhi

Purple Navy Olive Drap

Black Dark gray grey

Black & gray

Fall Men's Wear Color Stories: Casual Apparel

Typical fall men's wear color stories include primary brights and bold, rich, traditional fall colors accenting neutral pant and jacket colors. Casual apparel is influenced by cold weather sports like skiing, rugby, football, and winter equestrian sports, such as fox hunting. Formal color stories include a light shirting weight fabric, in bright colors (red, rust, burgundy, gold, or royal blue) contrasted with dark plaids, solids, tweeds, and flannels. A dark shirt teamed with a dark tie and suit makes a trendy color story.

Courtesy of Cotton Incorporated

Camel + Navy

Navy + Burgandy

Brown + Rust + Mustard

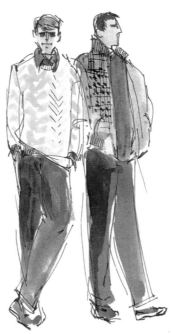

Rust

Kaaki

Brown

Typical Fall Color Range for Item Lines

Color stories for an item line usually include several selections. Individual colors within a group should relate to one another and provide variety including some basic colors, warm and cool hues, and some fashion accents. Selecting colors for an item line involves considering the coordinates that will be worn with the item. For example, jacket colors should relate to seasonal fall basic bottom weight fabric colors to ensure the greatest possible combinations for the customer. Red and bright "taxi-cab yellow" are two fashion colors that mix well with almost all neutral bottom weights, and have become favorites for jackets and sweaters.

The number of colors selected depends on the kind of item. Very basic items, like a turtle neck or high volume style, may be offered in eight to ten colors.

Researching large catalog retailers such as *L.L. Bean, Lands End, Victoria's Secret* and *Clifford and Wills* is an excellent way to identify seasonal color stories for a great variety of item lines. Advertisers group the color range to make each color appealing.

Typical Brown Bottom Colors

Grey/Black family

Green Bottom Colors

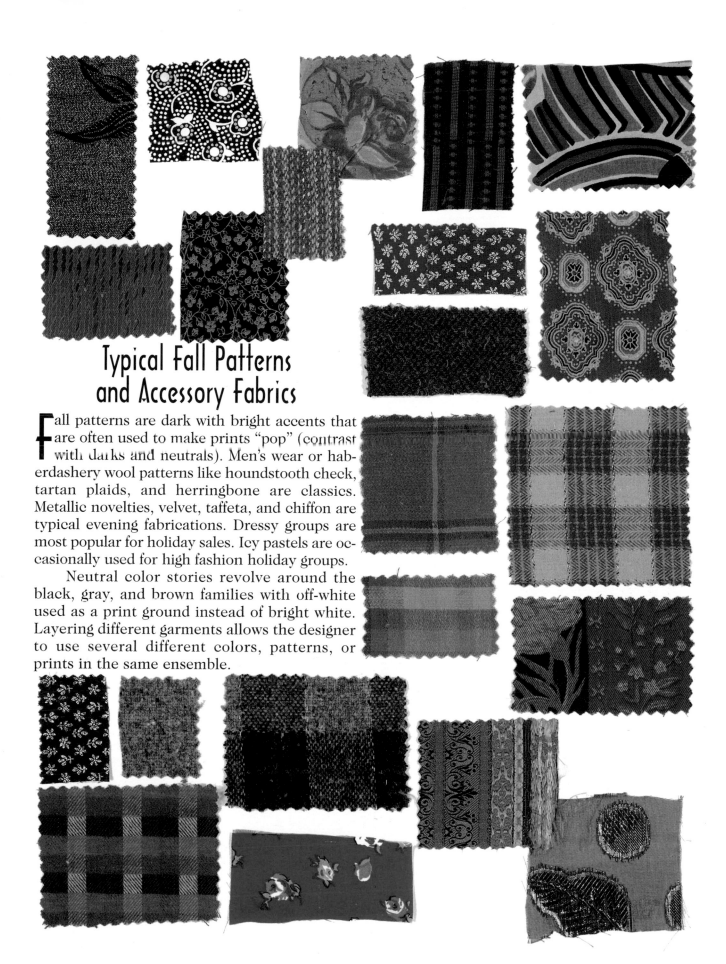

Typical Fall Patterns and Accessory Fabrics

Fall patterns are dark with bright accents that are often used to make prints "pop" (contrast with darks and neutrals). Men's wear or haberdashery wool patterns like houndstooth check, tartan plaids, and herringbone are classics. Metallic novelties, velvet, taffeta, and chiffon are typical evening fabrications. Dressy groups are most popular for holiday sales. Icy pastels are occasionally used for high fashion holiday groups.

Neutral color stories revolve around the black, gray, and brown families with off-white used as a print ground instead of bright white. Layering different garments allows the designer to use several different colors, patterns, or prints in the same ensemble.

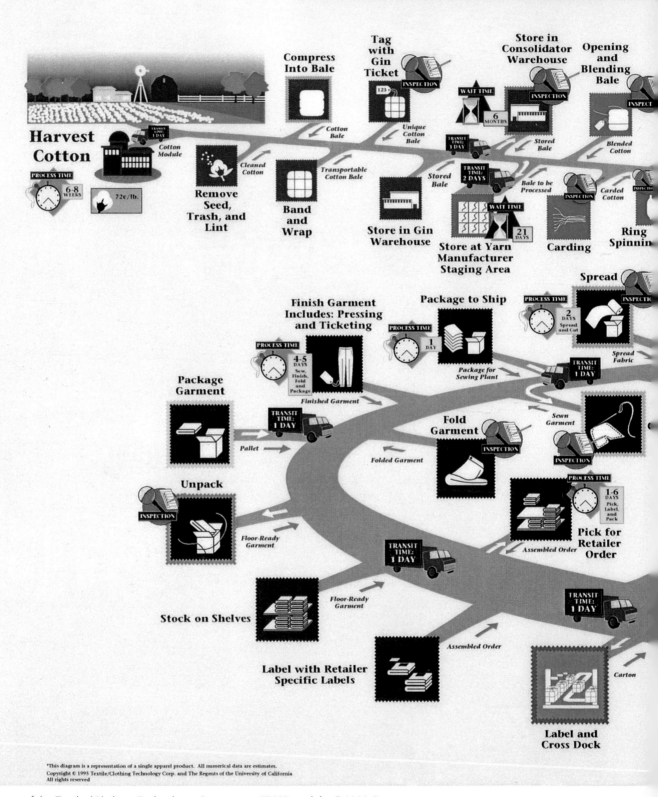

Courtesy of the Textile/Clothing Technology Corporation [TC]2 and the DAMA Project.

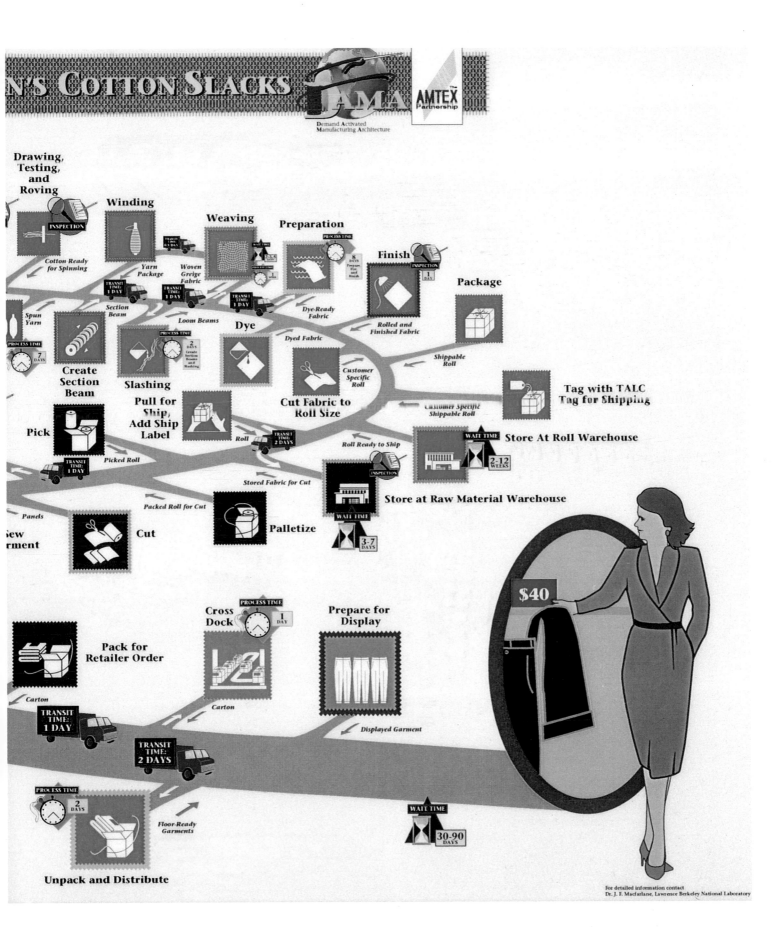

Step One: Research Spring/Summer Predictions: Women's Wear

Spring color ranges play brights, medium brights, and black and navy against neutral and light colored basics. Pure white is most often used as a ground color for prints. Cotton and linen fabrications are seasonal favorites, and both accept a wide range of colors.

Denim is an important classic in all shades from deep, unwashed navy and black, through all the distressed shades of blue to white canvas. Classic color stories are influenced by summer sports. Nautical color themes (navy plus red and white, gold plus royal blue and white) are classic spring color stories. Other warm weather sports influencing spring color stories are polo, tennis, baseball, rock climbing, cycling, and water sports.

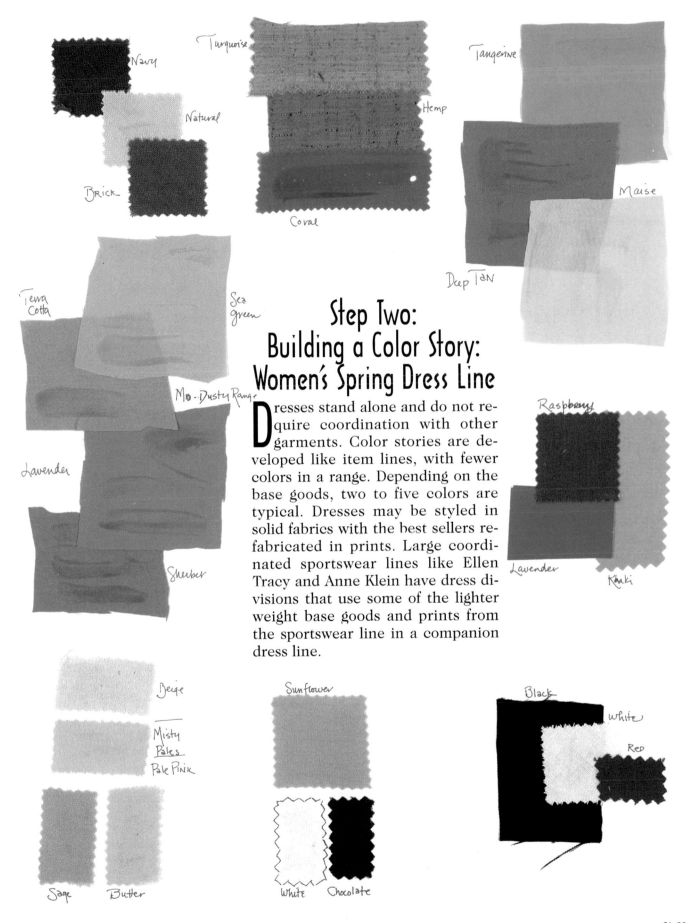

Navy

Natural

Brick

Turquoise

Hemp

Coral

Tangerine

Maise

Deep Tan

Terra Cotta

Sea green

Mid-Dusty Range

Lavender

Sherbet

Raspberry

Lavender

Khaki

Step Two:
Building a Color Story:
Women's Spring Dress Line

Dresses stand alone and do not require coordination with other garments. Color stories are developed like item lines, with fewer colors in a range. Depending on the base goods, two to five colors are typical. Dresses may be styled in solid fabrics with the best sellers refabricated in prints. Large coordinated sportswear lines like Ellen Tracy and Anne Klein have dress divisions that use some of the lighter weight base goods and prints from the sportswear line in a companion dress line.

Beige

Misty Pales
Pale Pink

Sage

Butter

Sunflower

White

Chocolate

Black

White

Red

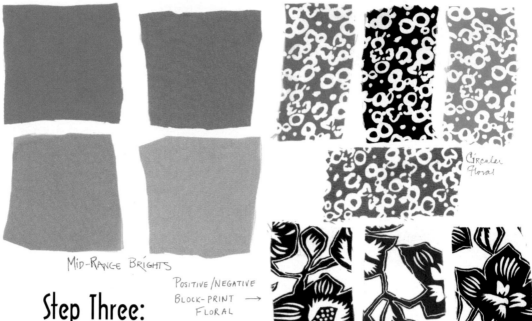

MID-RANGE BRIGHTS

Circular Floral

POSITIVE / NEGATIVE
BLOCK-PRINT →
FLORAL

Step Three:
Developing the Groups:
Women's Spring Dress Line

Dress manufacturers often present a wide range of styles early in the season and quickly narrow down their lines to the best sellers. These can be repeated in a variety of fabrics and prints. Best selling dresses are easier to repeat because they are not integrated into a large group of other pieces like a sportwear line.

Dress designers are not pressured to develop prints that match base goods and often select from a range designed by the textile converter. Large manufacturers may customize prints to develop unique products and then require an exclusive for the first season. Two or three colors-ways are typically offered in a print group. More colors-ways may be purchased by manufacturers who specialize in print dresses and sold as an assorted range instead of in specific colors and sizes.

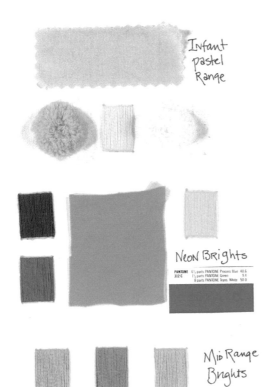

Infant pastel Range

Neon Brights

PANTONE
312 C
6½ parts PANTONE Process Blue 40.6
1½ parts PANTONE Green 9.4
8 parts PANTONE Trans White 50.0

Mid Range Brights

Spring Children's Wear Color Stories

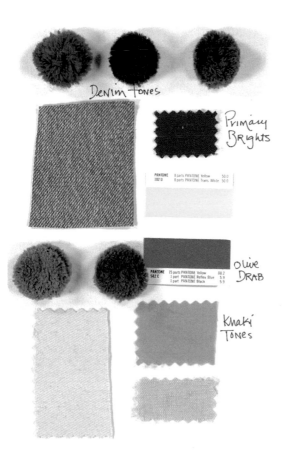

Denim Tones

Primary Brights

PANTONE
102 U
8 parts PANTONE Yellow 50.0
8 parts PANTONE Trans White 50.0

Olive Drab

PANTONE
582 C
15 parts PANTONE Yellow 88.2
1 part PANTONE Reflex Blue 5.9
1 part PANTONE Black 5.9

Khaki Tones

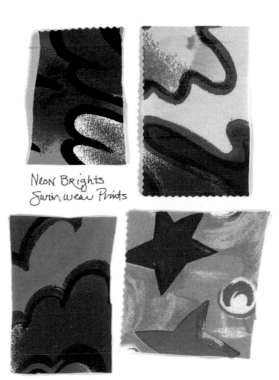

Neon Brights Swimwear Prints

Children's wear follows hot colors and trends developed for the junior market. Infant apparel is often colored in pale shades of pink, blue, and yellow. Classic color stories for sizes 3–6x and 7–14 include primary and secondary brights (hot pink, aqua, royal, and so forth), colors that coordinate with denim, the most important base goods fabrication. Other neutrals include khaki, white, navy, and olive drab.

Boys and girls in the 3–6x range have very similar color stories. More color differentiation occurs in the 7–14 range. Boys apparel is rarely offered in pastel ranges and black is less popular for children than adults.

PANTONE® Basic Colors 1 XR

PANTONE Yellow C

PANTONE Warm Red C

PANTONE Rubine Red C

PANTONE Rhodamine Red C

PANTONE Purple C

PANTONE Violet C

PANTONE Reflex Blue C

PANTONE Process Blue C

PANTONE Green C

→ Novelty mid-BRIGHTS

PASTELS/Top Colors

Spring/Summer Men's Wear Color Stories

Warm weather sport themes are the traditional source of color stories for men's sportswear. A full range of color stories, including pastels, is typical. Neutral bottom weight colors in the brown, gray, blue, and green families coordinate with tops of all colors. Woven stripes, plaids, and checks are classic shirting fabrications. Cotton is the dominant fiber used in spring/summer men's wear, and it may be dyed in a full range of colors, from brights and rich dark tones, to the most subtle pastels.

White and off-white are popular for prints, base goods, and woven novelties. Classic color stories include nautical combinations, soft pastels typical of washed Madras plaids, and bright accents teamed with white.

Top Colors / BRIGHTS

Vegetable Dye Top Colors

PANT Colors

Bottom Colors

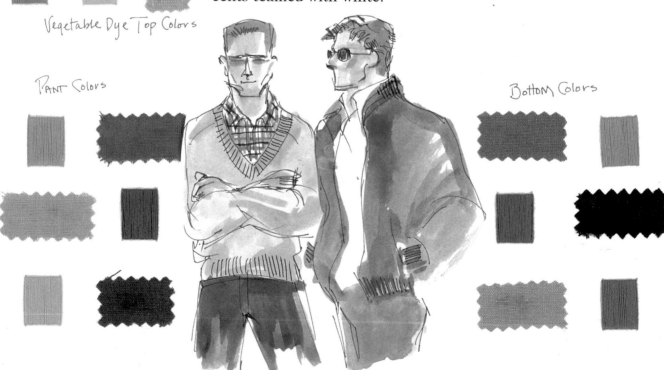

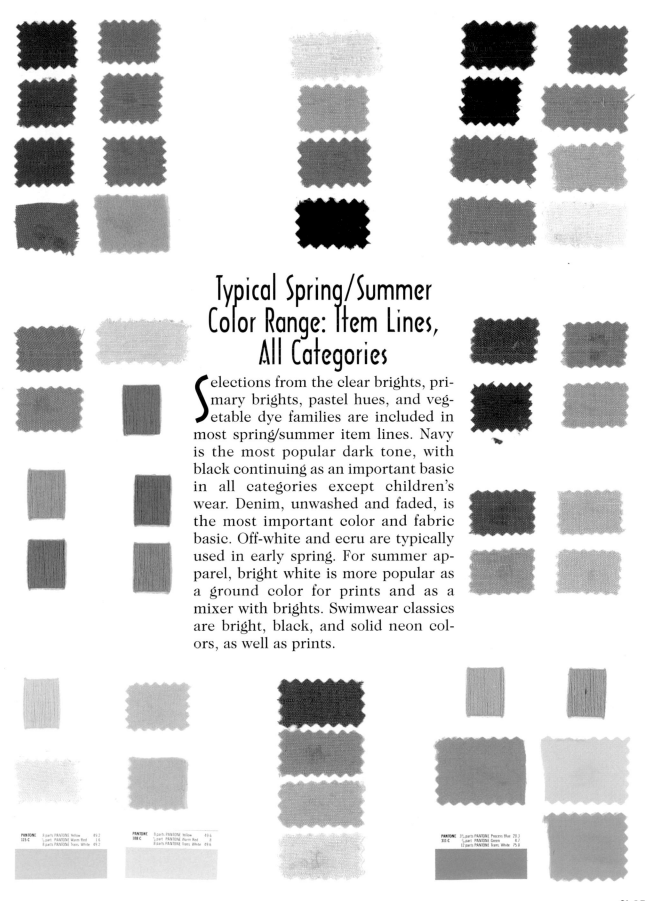

Typical Spring/Summer Color Range: Item Lines, All Categories

Selections from the clear brights, primary brights, pastel hues, and vegetable dye families are included in most spring/summer item lines. Navy is the most popular dark tone, with black continuing as an important basic in all categories except children's wear. Denim, unwashed and faded, is the most important color and fabric basic. Off-white and ecru are typically used in early spring. For summer apparel, bright white is more popular as a ground color for prints and as a mixer with brights. Swimwear classics are bright, black, and solid neon colors, as well as prints.

PANTONE 115 C 8 parts PANTONE Yellow 49.2
⅓ part PANTONE Warm Red 1.6
8 parts PANTONE Trans. White 49.2

PANTONE 108 C 8 parts PANTONE Yellow 49.6
⅓ part PANTONE Warm Red .8
8 parts PANTONE Trans. White 49.6

PANTONE 311 C 3½ parts PANTONE Process Blue 20.3
¾ part PANTONE Green 4.7
12 parts PANTONE Trans. White 75.0

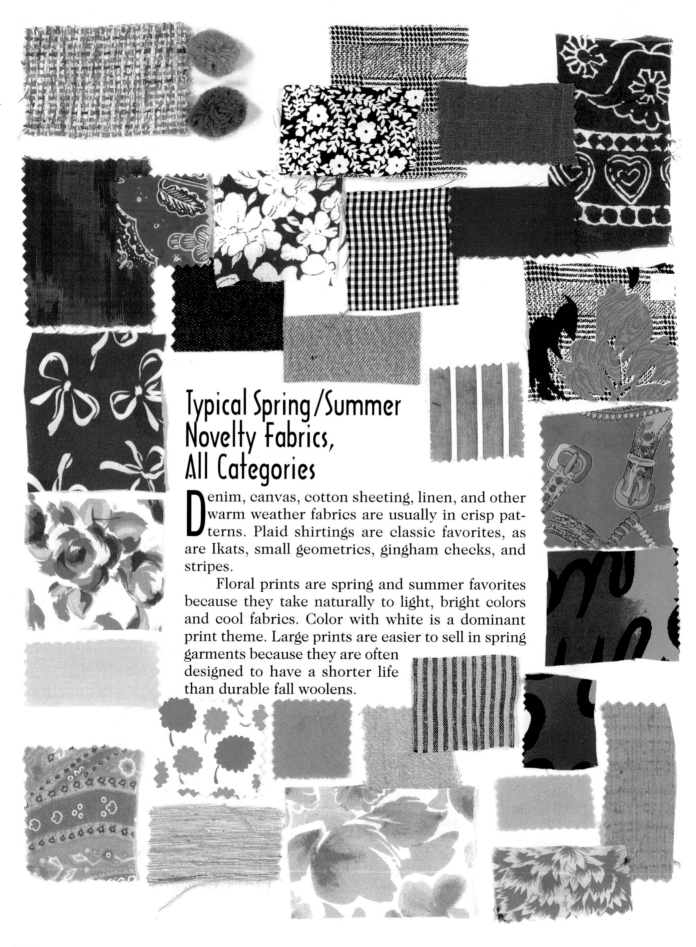

Typical Spring/Summer Novelty Fabrics, All Categories

Denim, canvas, cotton sheeting, linen, and other warm weather fabrics are usually in crisp patterns. Plaid shirtings are classic favorites, as are Ikats, small geometrics, gingham checks, and stripes.

Floral prints are spring and summer favorites because they take naturally to light, bright colors and cool fabrics. Color with white is a dominant print theme. Large prints are easier to sell in spring garments because they are often designed to have a shorter life than durable fall woolens.

The large companies that maintain fabric libraries are listed below. Most of the libraries are located in New York.

Natural fibers:
Wool Bureau
Cotton, Incorporated

Synthetic fibers:
DuPont (E. I. du Pont de Nemours and Company)
Monsanto
Hoechst/Celanese

Textile Library

Elanore Kennedy of DuPont Fibers discusses available fabrics with many designers and manufacturers. Specific types of fabrics and prints are displayed on large panels to assist designers.

Textile Directories

Major markets have directories for textile firms and salespeople. The New York textile market changes so rapidly that a directory is published several times a year in the form of a magazine called *The New York Connection*. Articles that feature news of the industry, new styling developments, and textile business news are combined with an updated directory of firms.

In Los Angeles, textile salespeople have formed an association called the Textile Association of Los Angeles (TALA). One of their most important functions is the compilation of their annual directory of manufacturers, textile firms and sales reps, and other manufacturing support services. In addition, the public may call and request information about member textiles sales representatives and resources.

The sources mentioned may be contacted at:

The New York Connection
516 Fifth Avenue
New York, NY 10036
(212) 221–1050

Textile Association of Los Angeles (TALA)
110 East Ninth Street, Suite C 765
Los Angeles, CA 90079
(213) 627–6173

Textile Trade Shows

The major textile trade show is held twice annually in Paris, France, and is called Premier Vision. Most important European textile companies show their lines at this show. U.S. manufacturers and mill representatives also attend. Ideacomo and Indigo, Italian fabric shows, feature more-expensive fabric houses and prints. Interstoff is the textile show held twice annually in Frankfurt, Germany.

The New York textile associations present several textile shows annually that feature domestic mills and manufacturers. Various foreign textile associations present periodic shows in New York so that designers can review fabrics and order from foreign mills.

Color Services

Color services predict seasonal color trends 18 months before the customer sees the merchandise in the stores. Most services divide their information into colors for men's wear and ladies' and children's

autumn-winter *color*

NEW BRIGHTS IN COMBINATION

COLOR:

Darkened or washed brights in unexpected mixes for an exciting approach to stripings, prints and patterns.

FORMULA:

The Prospectors + The Settlers or The Adventurers = NEW BRIGHTS in combination.

MOOD:

- Lively contrasts offer a strong basis for important autumn/winter prints and patterns.

- The color mix is essential to achieve print coordination and pattern "blocking" in layered looks

PRINT & PATTERN IDEA

Oriental scenics and figuratives as all-overs and borders.

PRAIRIE GREEN

TIMBER

CLARET

CRYSTAL BLUE

Textile Trade Information

Subscription fashion reports have many fabrication suggestions.

THE EASY TUNIC DRESS FOR JUNIORS

apparel. These color services are used by fiber producers, textile converters and print stylists, manufacturers, and retailers. They are sold on a private subscription basis twice a year. Color prediction services are discussed in Chapter 3. Also refer to the color boards from Cotton, Incorporated in the color insert.

FABRICATION

Fabrication means selecting or creating a style for a fabric. The fabric that is suitable for a specific style depends on the characteristics of the fabric.

1. *Surface interest.* Color, aesthetics, pattern, texture.

2. *Weight.* Correct weight for wear requirements, season, and construction details.
3. *Texture or hand.* Correct stiffness for silhouette; fabric feels pleasant and drapes well.
4. *Fiber.* Suited to the season, good performance and easy care; allergic reactions rare.

These four elements form the character of the fabric. They also dictate many of the limits on styling. The designer should be familiar with all types of fabric, just as a potter is familiar with the properties of many types of clay. The designer is a fabric sculptor and the human body is the frame of reference.

The experienced designer can look at a piece of fabric or feel it and envision the type of garment it can be made into. This ability is developed by experimenting with many different fabrics and a great variety of styles. Usually, the designer has a working knowledge of basic textile construction, dyeing, and finishing and is familiar with natural and synthetic fibers. This basic knowledge should be expanded constantly by listening to textile salespeople and reading trade papers. Innovations in the textile industry are constant, and fabric mills are eager to keep manufacturers and designers up-to-date on developments. Many textile and fiber firms will attempt to solve construction problems that arise with a new fiber or method of construction.

The designer must evaluate the performance of a piece of fabric as well as the aesthetic aspects before electing to use it in a line. A shrinking test under the pressing buck of the Hoffman press is the first step. Cut a 12- by 12-inch piece of fabric and a corresponding piece of paper. Press the fabric and line it up with the paper pattern standard. If steam, heat, and pressure have made the fabric shrink more than a half-inch in a 12-inch span, problems will occur when the garment is pressed. The average length of a jacket is 26 inches. A fabric that shrinks a half-inch on the pressing buck will shorten the jacket by 1 inch. Interfacing and lining will not usually shrink, so the jacket would be very difficult to construct in this fabric.

Some designers wash or dry-clean a fabric once it has been made into a sample to see how it performs. Trims should also be tested to make sure they can withstand the same care instructions as the base-goods fabrics. The designer may elect to send questionable fabrics to a professional testing laboratory that will run tests for colorfastness, washability, and abrasion. These professional tests

are especially important for garments that must stand up to the rigid quality control inspections of mass merchandisers such as Sears, JC Penney, and Montgomery Ward.

Working with fabrics is an excellent background for a beginning designer. Often, a design student can sell fabrics over the counter, and this exposure to a variety of fabrics is good training. Home sewing is another good way to learn about fabrics. Experimentation and observation are the keys to developing a sense of fabrication.

Surface Interest

The way a fabric looks is the most important factor in choosing it for a style. In most firms, decision making in fabrication is the designer's exclusive domain. Selection of colors and prints should be based on research and observation of the latest fashion trends. But the designer with taste and personal discrimination should rely on instinct, as well as background information, when searching for a new fashion direction.

Technical considerations are even more important when choosing a print. The repeat of the print must be suitable for the garment. The repeat is the amount of material taken for a pattern to duplicate itself. A very large repeat is unsuitable for trims or children's garments. Fabrics with large repeats work best in styles with few seams.

The scale of the pattern must complement the garment. When a very small pattern is used, such as a classic houndstooth or herringbone, the scale of the pattern is less important than when the pattern is large and bold. The pattern should complement the silhouette and style. A bold pattern on a small, delicate garment will detract from the style. A medium stripe on a large woman will make her look larger because the eye will compare the pattern size with the bulk of the garment.

The designer should recognize a pattern that requires special matching. *Matching* is designing and cutting a garment so the fabric pattern in each piece matches when the garment is sewed together. This is particularly important with bold plaids, checks, and stripes. The placement of the bold print is also an important consideration: A dark spot placed at the bustline, stomach, or crotch will call undesirable attention to these areas. Sometimes, the print is arranged so that there are no flattering possibilities for placement; the experienced designer will avoid these problem prints. Matching

Cutting one-way prints requires laying up all the fabric in the same direction. All motifs in the print should face in the same direction.

and placement problems generally require extra yardage.

One-way prints also present technical problems. A one-way print has all motifs printed in one direction. When these prints are cut, all garment pieces must be facing in the same direction, so more yardage is needed. (The same problem occurs with pile fabrics.) A two-way print features a motif that faces in both directions, so the print is simpler and more economical to work with. The way a fabric is printed will affect the look of the print and the quantities that may be ordered in special colors or exclusive patterns. The four ways of printing fabric are

1. *Screen printing with wet dyestuffs (wet printing)*. Wet dyestuffs are applied directly to the surface of greige goods that are prepared for printing (PFP). Flatbed screens or rotary screens may be used to apply the dyes. The design is created by porous areas left in the otherwise impervious screen or roller that allow the dye to come through in the pattern desired. Flatbed screen prints are most often used for bathing suit panels because there is a limited area that can be printed without leaving a break line. Each color requires another screen in both printing methods. Rotary screens print a length of fabric without a join line. Dye and discharge is another way of using screens to create a design. This method is excellent for spaced prints that have a colored ground because the fabric is dyed first and printed with a caustic solution that removes the dye in certain areas when it is washed. Then the design is printed on the fabric with rotary screens in the areas where the color has been removed. All these methods may be used on natural or synthetic fibers to produce a print that has good dye penetration. Minimum yardage for a special color and a confined print (*confined* means that only the originator may use the pattern for the first season) is usually 3,000 yards for the pattern and 1,000 yards for each color combination.

2. *Engraved roller printing*. In this process, a large metal drum is engraved with the design. The roller is inked and run over the surface of the greige goods. Each color requires a different roller. This method is used for small motifs on a light color ground. It may be used to print both synthetic and natural fabrics. Usually, large runs are needed for special colors and minimum yardages. Six thousand yards would be a typical minimum yardage because of the cost of engraving the rollers. Many small cot-

ton prints are roller printed; these are often classical designs that are used for many years.

3. *Heat-transfer printing (dry printing).* In this process, the design is printed on a specially treated paper, much like a color magazine. The print can be transferred only to a heat-sensitive fabric such as polyester, some nylons, and acrylics. Heat and pressure are applied to the fabric and paper as it passes through hot rollers. This method leaves the dyestuffs on the surface of the fabric, but there is little penetration of the base goods. This is an economical way to print a design with many colors and to achieve a very detailed design. Heat-transfer printing is less expensive than wet printing because the machinery is less elaborate. The heat-transfer paper is often printed abroad and imported into the United States, where it is transferred to the PFP fabric. Minimum yardage requirements depend on how much paper the printer must print to change the color and design. Occasionally, a minimum of 500 yards is available from a printer that makes its own paper. One thousand yards per color and 3,000 yards per pattern are standard minimums for a new design that must be engraved and printed.

4. *Digital printing.* Digital printing is in its infancy but has great promise for textile applications. As mentioned before, a process similar to that used for paper copies is being developed for textiles that will allow short-run printing. The cost per yard is expensive but can be used in certain applications to preview stock yardage printed by other methods and customizing one-of-a-kind garments. The print is created on the computer and transferred digitally to the printer with no intermediate steps (cutting screens, matching dyes, and so forth).

Basic prints and surface patterns are the foundations of a designer's knowledge. Many prints are developed as novelties and become classics when they are used season after season. To increase your knowledge of fabric patterns, study the pictures and definitions in the textile dictionary.

Weight

The weight of a fabric is an important consideration, especially when a durable garment is being designed. Heavier fabrics suitable for pants, skirts, and jackets are called *bottom weights.* Blouse weights are lighter fabrics, best for bodices and blouses.

The fabric weight should be compatible with the style of the garment and the season for which it

Flatbed screens are often used to print bathing-suit panels because of the many possible colors in each print and the stretch factor of Lycra® fabrics.

is intended. Winter-weight fabrics are usually heavier to add warmth. Spring merchandise requires a medium-weight fabric and colors that are lighter and brighter than fall colors. Summer fabrics have the lightest weight of all.

Tailored garments, such as jackets and coats, must be made in a fabric heavy enough to support the tailored details. If the fabric is too thin, the seams will show through when they are pressed. Also, the pockets will show as ridges in the top fabric and bound buttonholes will be lumpy.

Light, transparent fabrics often require a lining, which makes the garment more expensive. Light-weight fabrics can be bonded to give them greater bulk and substance. *Bonded fabrics* have a thin layer of fabric or foam that is laminated (glued with heat and pressure) to the wrong side. If the bonding process is poorly done or the proper glue is not used, the fabric and the bonding material may separate during cleaning or washing.

Fabric Hand

Hand refers to the feel of a fabric. Hand can be altered greatly by the kind of finish applied to the fabric. A crisp finish may give a fabric enough body so that it can be used as a bottom weight. The same fabric with a dress finish will be soft and more easily draped. Finishes break down when pressed, cleaned, or worn. Generally, less-expensive fabrics are finished to create a crisper hand and more body.

A fabric's hand greatly influences the way it can be styled. A fabric that is fluid and soft cannot be used for a crisp, well-tailored garment such as a blazer. The silhouette will reflect the body shape if a fabric with a soft hand is used. A fabric that drapes will fall gracefully and cling to the figure. More gathering can be used with a soft fabric and the garment will not become bulky or awkward.

A crisp fabric, such as linen or sailcloth, can be used for a well-defined, tailored silhouette. Interfacing—a stiff, plain fabric added to a garment's inner construction—is used to further stiffen tailored areas. Most often, interfacing is used in the collar, cuffs, and placket. Interfacing may be used in soft, draped garments, but a very lightweight interfacing is appropriate. This will be compatible with the hand of a soft fabric. *A primary rule of design is to style garments in a fabric that is compatible with the silhouette desired.*

The texture of the fabric is an important aspect to consider when fabricating a line. The customer

usually touches a fabric that attracts the eye. If the hand is appealing, the customer will consider the potential purchase more carefully. Most designers have developed their tactile sense and evaluate the visual aspects and the hand of a fabric before sampling it.

Some adjectives used to describe fabric hand and texture are:

Dry: Grainy, resilient texture, typical of linen

Slick, or wet: Slippery texture, typical of acetate surah

Crisp: Characteristic of a sized (starched) fabric, such as organdy or silk organza

Boardy: Stiff fabric; derogatory term for a cheap fabric with too much sizing

Gutsy: Fabric with a great deal of body

Lofty: Fabric with a high pile or nap, such as velvet

Flat: Weave with low surface interest, such as poplin

Rough: Heavily textured surface, such as raw silk

Smooth: Slick surface, such as taffeta

Crepe: Light-textured surface, typical of crêpe de chine

Fiber

Traditionally, natural fibers have been considered appropriate for a specific season. Wool is a typical fall fiber because it is warm and usually has a bulky weave. Linen and cotton are warm-weather fibers because they are cool, absorbent, and easily washed. The widespread use of synthetics and blends has altered the seasonal use of specific fibers. Now hand, bulk, and color are more important than the fiber when a fabric is being selected for a specific season. Cotton woven as a bulky corduroy can be used for a fall line. Cotton and polyester blends are appropriate for spring and summer wear. Wools woven as gauze (light crepes) are used for expensive spring garments.

The choice of fiber is important when the designer considers how the fabric will perform. Wash-and-wear characteristics are generally built into polyester blends. Easy care is particularly important for garments that will be laundered in a washing machine at high temperatures, such as children's wear, work clothes, and uniforms. Lurex blends are delicate and react to pressure and heat; therefore, these blends are used for garments that can be made with few seams, which eliminates

pressing, and garments that will not receive much wear. The designer must understand many other fiber characteristics before she or he is ready to design a line. Through experimentation and observation, the designer will add continually to his or her knowledge of fibers and how they react to styling and sewing.

Fibers have fashion cycles just as silhouettes and colors do. Consumer preference changes, reflecting different lifestyles and values, though this is an evolutionary change that often spans a decade or more. Technical innovations also create changes in fiber demands. Polyester became popular in the early 1960s. High-fashion designers, such as Halston and Bill Blass, used the innovation Ultrasuede and polyester jerseys to create expensive garments. At the same time, the younger generation discovered denim jeans and jackets. Polyester continued in great demand for more than two decades, especially with the middle class, who valued performance and the easy-care characteristics of the synthetic fibers. Natural fibers were considered appropriate for the young, and denim was a counter cultural fabric.

Gradually, the market for natural fibers grew and polyester declined in popularity. Many manufacturers did not identify these changes and went out of business. Finally, after decades of being relatively unpopular, polyester is returning to the fashion scene as microfilament and is high fashion once again. Evolutionary changes are often more difficult for businesses to adapt to because they happen over a long period of time and the urge to resist fundamental changes in a formula that has been successful for several years is great.

Frequently fiber companies offer advertising money to manufacturers who use substantial amounts of their fiber. The fiber company may contribute to an advertisement placed in a trade newspaper or magazine. Fiber money is also given to the manufacturer to be passed on to the retailer who advertises a specific garment to the public. The manufacturer may contribute money to the retailer because the manufacturer will gain if sales improve. These advertisements must carry the names of the fiber company and the manufacturer. Because advertising sells the product directly to the consumer, the advertising allowance is good for all three parties.

Fabric Hand
Similar styles will look quite different when made in soft and crisp fabrics.

Summary

The designer must understand the business of manufacturing apparel and producing textiles to coordinate a selection of fabric that can be delivered in the proper time frame to manufacture seasonal merchandise. A designer begins by sampling a fabric and testing it to see if it can be sewn and pressed. An aware designer reviews all fabric lines to gain an overview of the market and avoid missing an appropriate fabric. The actual selection depends on the price range, aesthetics, and fabric mix appropriate to each line.

The textile salesperson may work for one house as an in-house representative, may represent several converters, or may be an independent sales agent for a textile house. Jobbers purchase fabric from a mill and resell it in smaller lots for a slightly higher price. The textile salesperson works closely with the manufacturer on sample, duplicate, and stock yardage shipments.

Custom fabrics allow the manufacturer to offer unique merchandise but require prepurchase of a minimum amount of fabric before it is shown to the buyer. A designer works from first a croquis and then a strike-off of a print and must be able to imagine the finished product. Custom solid goods are purchased from lab dips of the colors the designer has specified. Computerized textile and print design is speeding up the design process, and digital printing will influence future printing techniques.

After the fabric has been sampled and selected for the line, duplicate yardage must be purchased. If a custom fabric has been selected, a significant amount must be purchased at this point.

The excess fabric is saved and cut into stock garments. Stock fabric is purchased throughout the manufacturing season as needed.

The designer may find information on fabric resources from textile libraries, which are located in New York and Los Angeles. These are run by fiber companies who forecast fashion trends and promote textiles made from their fibers. Textile directories are also available in New York and the regional markets. Trade shows, both domestic and abroad, focus on innovations and textile resources. Color services sell predictions of important colors for the coming seasons.

Fabricating a line depends on the aesthetics of the fabric and the type of garments to be manufactured. The weight of a fabric designates it as a bottom weight that can be tailored into jackets, pants, and skirts; a lighter weight that is appropriate for dresses; or a blouse weight, the lightest of all. The texture, or hand, of a fabric is dependent upon several factors, but the finish can alter a fabric's hand and must be carefully selected to be appropriate for the end use. The fiber used to make a fabric will determine the resulting garment's season, care, and market.

Review

WORD FINDERS

Define the following words from the chapter you have just read:

1. Base goods
2. Blouse weight
3. Bonded
4. Bottom weight
5. Crepe
6. Converter
7. Croquis
8. Delivery date
9. Dress finish
10. Greige goods
11. Heat-transfer printing
12. Interfacing
13. Matching
14. Machine screen
15. Novelty fabric
16. One-way print
17. Piece-dyed
18. Piece goods
19. Roller print
20. Repeat
21. Scale
22. Solution-dyed
23. Strike-off
24. Type
25. Vertical textile mill
26. Wet printing

DISCUSSION QUESTIONS

1. What are the four characteristics of a fabric? Define these terms.
2. What are the designer's responsibilities when fabricating a line?
3. What are the salesperson's responsibilities when selling piece goods to a manufacturer?
4. Name and discuss the two main kinds of textile firms.

Textile Dictionary

The following textile dictionary identifies and defines basic types of fabrics and prints used frequently by designers. The photographs are arranged in groups according to related prints or surface treatments. The contents lists all photographs alphabetically.

Fabric Groupings

Alphabetical Contents

Jacquard (p. 249)
Jersey (p. 249)
Knit brocade (p. 248)
Knit, seven cut (p. 248)
Knot novelty, woven (p. 256)
Lamé (p. 242)
Leno (p. 250)
Liberty print (p. 246)
Linen (p. 255)
Lisle (p. 248)
Lofty surface (p. 253)
Marble print (p. 257)
Matelassé (p. 256)
Men's wear stripe (p. 251)
Mesh (p. 243)
Metallic knit, lurex (p. 248)
Moiré (p. 242)
Mock suede (p. 249)
Monk's cloth (p. 242)
Muslin (p. 242)
Novelty knit, 7 cut (p. 248)
Novelty woven dot (p. 244)
Ombre (p. 257)
Osnaburg (p. 242)
Ottoman (p. 250)
Outing flannel (p. 253)
Painter's drill (p. 242)
Paisley (p. 245)
Panne velvet (p. 253)
Patchwork (p. 245)
Pilou, French (p. 253)
Pin dot (p. 244)
Pinstripe (p. 251)

Plissé (p. 256)
Pointillist floral (p. 247)
Ponte de Roma (p. 249)
Poplin (p. 243)
Quilt, novelty (p. 245)
Raschel knit (p. 249)
Realistic floral (p. 247)
Reverse twill (p. 243)
Rib pique (p. 251)
Satin stripe (p. 251)
Schiffli embroidery (p. 245)
Seersucker (p. 256)
Seersucker, novelty (p. 256)
Shepherd's check (p. 252)
Silk shantung (p. 255)
Stylized floral (p. 247)
Suede cloth (p. 254)
Tartan plaid (p. 252)
Terry cloth (p. 254)
Ticking stripe (p. 251)
Tie-dye (p. 245)
Tricot (p. 249)
Toile (p. 246)
Tweed (p. 256)
Twill (p. 243)
Velour (p. 254)
Waffle pique (p. 255)
Wallpaper floral stripe (p. 247)
Wild silk (p. 256)
Windowpane plaid (p. 253)
Wrinkle cotton (p. 256)
Wrinkled sheeting (p. 243)

Woven Base Goods

1 2 3 4 5 6

1. **Alaskine:** A blend of silk and wool woven in a variety of weights suitable for dresses and suitings. Slight luster makes this a dressy fabric. Wrinkles and is rather fragile. Now also woven in synthetic blends.

2. **Chambray:** Colored warp yarns and natural filling yarns are woven to create a heathered look. Usually a shirting-weight cotton. A blend of two fabrics can be cross-dyed after weaving, with one of the fibers resisting the dye that the other absorbs.

3. **Crepe:** Crepe yarns are crimped and twisted and then woven in a plain weave. The surface of crepe is pebbly or slightly crinkled. Crepe drapes well and is made from many fibers. Often printed and available with a satin back.

4. **Muslin, osnaburg, painter's drill, canvas:** Plain-weave cotton or cotton blends made up of waste and low-grade cotton yarns. When unbleached, the natural dark flecks in the yarns give this fabric its typical character. Many slubs are also characteristic. Drill and canvas are heavier weights of the muslin base cloth.

5. **Heather:** A mixture of a color and several lighter shades of the same color to give the fabric a frosted appearance. This coloration is typical of wool, although it is currently used also for many synthetic base cloths.

6. **Lamé:** Metallic threads woven into a wide variety of base goods. The metallic glint gives the fabric a shiny, dressy look. Metallic threads are often heat sensitive, making pressing difficult.

7 8 9

7. **Moiré:** A small-rib-weave fabric that has watermark designs embossed on the surface. Has a luster that gives it a dressy appearance. Woven in a variety of silk-like blends.

8. **Monk's cloth:** Rough, variegated threads are woven like a basket to form this textured base goods. A very soft, limp hand is characteristic of this weave, which is often of cotton and cotton-blended yarns.

9. **Indigo denim, prewashed:** A durable twill fabric woven with a colored warp over a natural or white filler. Indigo is a traditional dye that gradually fades as it is washed. Denim is often washed before manufacturing to break down the crisp hand and soften the color of the fabric. Woven in cotton and blends in a wide variety of weights.

10. **Crinkle cloth:** A textured surface created by the tension of some threads woven tighter than others. Often, this cloth is woven as a smooth cloth and crinkled in the finishing process. Crinkle can be added to many different weights of fabric.

11. **Flannel:** A plain or twill-weave fabric classically made in wool with a slightly napped surface. Contemporary fabrications include synthetic fibers and blends. This is a classic winter suiting fabric, often colored with a heather surface. Cotton flannels are classic winter shirtings.

12. **Gabardine:** A firm twill fabric, classically made from wool but currently woven in polyester and blends. The surface is smooth and slick with a low luster unless it has been brushed. This fabric is a suiting base goods.

13. **Georgette:** Georgettes made in polyester are lightweight shirtings that can be a plain weave or novelties such as this crinkle georgette with a leno woven design. This is often a print cloth and is woven in the Orient.

14. **Mesh:** A woven, open-weave fabric with a fishnet look woven in cotton and blended fibers. Typically a sportswear fabric.

15. **Poplin:** Firm, plain-weave cloth of a light to medium weight. Fine warp ribs are visible upon close examination because the warp threads are finer than the filling threads. Made of cotton, wool, or synthetic fibers.

16. **Reverse twill:** The direction of the twills is reversed in a regular pattern to create this base goods with a herringbone effect.

17. **Twill:** A weave that has a diagonal line or rib because the filling yarns pass over one warp yarn and under two warp yarns. This is the strongest weave. Twills can be woven in cotton, wool, and blended fibers.

18. **Wrinkled sheeting:** Sheeting is a lightweight, plain-weave cotton that has been permanently wrinkled in the finishing process to give it a casual sportswear look.

Dots and Spots

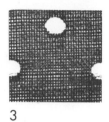

1

2

3

4

5

6

1. **Dotted Swiss, clipped dot:** A traditional fabric usually in cotton and cotton blends, with a separate thread woven into the face of the fabric and then clipped to form a small thread dot. Contrast dots or all one color.

2. **Dotted Swiss, flock dot:** A voile or lawn ground printed with a bonding agent in dots (patterns are also possible). Flock is then secured to the surface of the fabric with bonding (glue) agent. Colored flock may be used, and the ground can also be colored. Often printed as well.

3. **Duco dot, painted dot:** The dots are printed on base goods with a paintlike surface. Dots are slightly stiff, so this process is most successful for a small dot. May be printed in colors or white on a wide variety of base goods.

4. **Aspirin dot, white ground:** A polka dot about the size of an aspirin, which can be printed on a large variety of base goods in many color combinations. The dark dot on a white ground has the most impact of any polka-dot color combination.

5. **Pin dot, dark ground:** Small dots are spaced at regular intervals for an allover effect. These patterns are easy to use because no matching or special engineering is necessary. These classical dots may be printed or woven into any base goods.

6. **Novelty woven graduated dot:** The graduated dot is a novelty fabrication that is appropriate for both woven and printed patterns on many base cloths and fibers. Also used for knits. Numerous variations possible.

7

8

9

7. **Coin dot:** An arrangement of large dots that are about the size of a nickel. This example is on a dark ground, but many color combinations are possible. May be printed on a wide variety of base goods.

8. **Confetti dot:** Random placement of dots gives a confetti look to the print. A concentration of dots forms a horizontal strip banding called a *biadier.*

9. **Foulard:** A print typical of men's ties and linings and popular as an accessory for blouses. Often printed on a surah or silk-type fabric. Available in many pattern variations on a range of base cloths.

1

2

3

1. **Schiffli embroidery:** Embroidery done by a Schiffli machine, which is capable of embroidering a limitless variety of novelty patterns in multicolored threads. May be embroidered on many base goods but most typically done on cotton and cotton blends. The pattern design is governed by a punch-card system similar to that used on a Jacquard loom.

2. **Eyelet:** Schiffli embroidery that covers the entire ground. Holes are often punched out of the base goods and reembroidered to give the fabric a lacelike effect. Most often done on a white or natural cotton or cotton blend. May be dyed and overprinted. Border patterns are also available. A typical summer fabrication.

3. **Novelty quilt:** Quilt formed by stitching a base goods (usually a thin cotton base goods) to a backing with a thin polyester fiber filler to give a puffy appearance to the unstitched areas. Quilting makes a lightweight fabric warm. Many varieties of quilting are available.

1

2

3

4

5

1. **Paisley:** Printed patterns derived from East Indian shawls, first imported to Europe during the early nineteenth century. Typically including a stylized pine-cone or tree-of-life motif. Printed on a wide variety of base goods in many pattern variations.

2. **French provincial:** Small stylized floral prints often surrounded by a spot of color that contrasts with the ground. Frequently printed in primary colors. Typical of country prints on cotton and cotton blends from the southern part of France.

3. **Patchwork pattern:** Combinations of prints in compatible color and size ranges. Often a fabric company will team patchworks with pullout patterns from individual patches. Many variations, from random patches to typical Americana patterns, are designed.

4. **Block print:** Rustic-looking print with the unclear borders and surfaces typical of the hand-printed block (usually made of wood and metal) used to print ethnic patterns. Often done on cotton base goods but also available on many other cloths.

5. **Tie-dye:** Circular designs formed by knotted areas of fabric that resist dye. Gradations and random taking of the dye are typical of this hand-dyeing technique. May be done on a variety of base cloths. Typical ethnic dyeing method used by many cultures.

Ethnic Prints, continued

6

7

8

9

6. **American Indian pattern:** Native American rug, basket, and fabric patterns have inspired many contemporary fabric prints. Geometrics and stripes are most typical, with many variations possible.

7. **Liberty print:** English print firm that specializes in florals and intricately printed fine cottons and silks. Prints are so typical that small florals printed by other firms are often called liberty-type prints.

8. **Austrian provincial print (Lanz):** Typically a small print, with many variations possible. Most often printed on cotton and cotton-type base goods with small folk art motifs. Popularized in the United States by the Lanz line of junior clothes. This example is quilted.

9. **Bandanna print:** These prints are adapted from traditional bandanna scarf patterns. They are often printed in primary colors on cotton and cotton blends.

10

11

12

10. **Batik:** An ethnic print usually printed on a plain-weave cotton broadcloth. Many variations on the traditional wax-resistant, hand-printed and dyed technique that originated in Java. Typical batiks often have a softly cracked color that results from the dye partially penetrating the cracked wax surface. Many commercial variations now available.

11. **Ikat:** An ethnic printing technique that prints the pattern on the warp threads before weaving. When filler is added, the pattern gets a fragmented edge. This technique has been adapted to prints characterized by an irregular print outline. A generic name is *fractured print*.

12. **Toile:** Traditional French scenic print usually printed as a dark line drawing on natural or white cotton base goods. Often used in home furnishings as well as apparel. Many variations possible.

1 2 3 4

1. **Chintz:** Chintz technically describes the glazed surface added to plain or printed cotton. The term is also used to describe colorful cotton prints of stylized floral and natural motifs. Popular as a home-furnishing fabric. Many varieties of patterns possible.

2. **Art nouveau floral:** Floral patterns emphasizing curving, flowing lines, and subtle colorations. Developed from patterns popular during the art nouveau period of the first quarter of the twentieth century. Many variations possible.

3. **Calico:** Small florals printed on basic cotton-type base goods and other base goods. Many prints fall into this category. Calico prints were used in early American garments and quilts.

4. **Pointillist floral:** The pattern is formed by a concentration of dots. Can be done in several colors or one color and white. May be done in many variations on any base cloth.

5 6 7 8

5. **Stylized floral (two-way design):** An abstract floral pattern that has a stylized image of a floral. A two-way print because the motifs face both directions in a random placement. Many variations are available because this is a basic textile design pattern. Two-way prints are economical to cut because they do not need special matching or pattern placement.

6. **Challis:** Challis may be solid or printed and was once woven of fine wool. Now, it is available in many fibers. Challis is a soft dress- and blouse-weight fabric with a slightly napped surface. Typical prints are paisleys and small, stylized florals.

7. **Realistic (naturalistic) floral:** Print based on a realistic rendering of a flower. Many variations possible; can be printed on numerous base cloths.

8. **Wallpaper floral stripe:** A string of flowers separated by a decorative stripe typical of Victorian wallpaper patterns. Often printed on cotton-type fabrics but may be used on other base goods. Many variations and sizes popular.

Knit-Base Goods

1

2

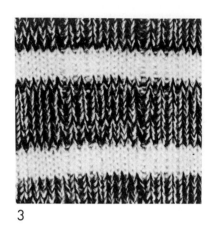

3

1. **Lisle:** A lightweight, single-knit, fine-gauge fabric, traditionally made in cotton. Now available in synthetics that have a soft hand and a slight sheen to the surface. Also fabricated in a 1-by-1 rib, which has a slightly ribbed effect created by a knit-one, purl-one pattern.

2. **Knit brocade:** Knits often have a novelty face with a design formed by raised portions of the knit to add dimension to the fabric. Many design variations possible. Frequently done in polyester.

3. **Novelty knit, seven cut:** Cut refers to the number of stitches per inch (horizontal) that comprise the fabric. Vast variations of ribs and patterns are possible, with vertical stripings being a favorite design theme. Other weights from very bulky knits (3-cut) to jersey-weight (22-cut) knits are available.

4

5

6

7

4. **Metallic knit, lurex:** Metallic threads may be combined with many yarns to form numerous knitted patterns. The shiny addition of the lurex tends to make the fabric dressy.

5. **Bouclé:** A woven or knitted fabric that uses a looped yarn to create a looped or knotted appearance.

6. **Double knit, quilt effect:** A double knit using a basic surface stitch and a catch stitch to the underlayer in a pattern that simulates quilting.

7. **Double-knit tweed:** A blending of basic and novelty yarns in a stitch pattern that resembles woven tweed suitings. Many color and pattern variations are possible.

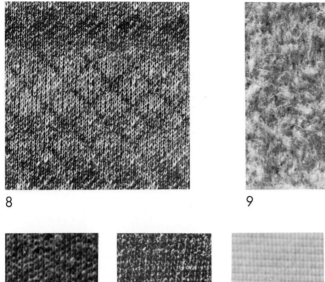

8

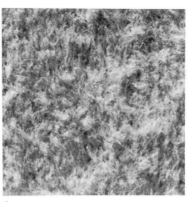

9

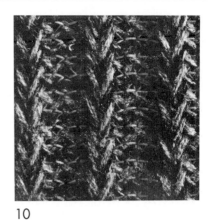

10

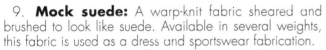

11 12 13

10. **Raschel knit:** A rigid knit typically used to make lace, nettings, power net, and elaborate sweater-knit fabrics made of novelty yarns in innovative stitches.

11. **Jersey:** A plain-knit rib fabric that is very stretchy. May be knitted in cotton, wool, or blended fibers. Used for soft garments such as dresses and blouses. May have a slightly napped surface when knitted in spun yarns.

12. **Ponte de Roma double knit:** A basic double-knit stitch used for sportswear and dresses in wool, blends, and synthetic fibers. Sportswear weights are usually 10 ounces and above in weight.

13. **Tricot, warp knit:** Synthetic knit on a warp knitting system available in many patterns and finishes. Classic tricot knits are often used for lingerie and have a smooth, silky surface.

8. **Jacquard:** Double or single-knit fabrics with the designs in multicolored yarns worked directly into the weft knitting. Used in sportswear and dresses.

9. **Mock suede:** A warp-knit fabric sheared and brushed to look like suede. Available in several weights, this fabric is used as a dress and sportswear fabrication.

1 2 3 4

1. **Bedford cord:** A small vertical cord that is formed by using a two-ply warp to create the ridges. Usually woven in cotton and cotton blends and often printed and brushed (also called sanded or napped).

2. **Bengaline:** Horizontal small ribs woven in a lustrous fiber. The surface resembles grosgrain ribbon and has a dressy look.

3. **Baby wale corduroy:** This example is 14 wales per inch, which usually runs 7 ounces per yard. This ribbed pile fabric is woven by cutting an extra surface filler and brushing it to form the wale. Most often woven in cotton and blends.

4. **Medium wale corduroy:** A 7-wale-per-inch corduroy is a medium wale that is also called a thick set. Often used for printed corduroys.

Linear Patterns, continued

5

6

7

8

5. **Wide wale corduroy:** This example is 5 wales per inch, which generally ranges from 10 to 14 ounces per yard. The wider wales are suitable as bottom weights and for jackets and coats. This corduroy is woven in the same manner as the narrower wales, with wider floats that, when cut, form fatter wales.

6. **Ribless corduroy:** A shallow-wale corduroy that is finished to look like a sueded cord. There are no defined ribs. Often printed.

7. **Thick and thin corduroy:** A novelty corduroy that is woven with wales of various widths and spacings. Great variety is possible. Most often woven in cotton and cotton blends.

8. **Printed corduroy:** Many patterns may be printed on all weights and wales of corduroy. The smaller wales are more popular for prints because they are less expensive and more readily available.

9

10

11

9. **Awning stripe:** Bold, wide stripes named after the canvas used for window awnings. Most typical when woven in cotton-base goods. Particularly effective when woven or printed in bold primary colors.

10. **Leno:** A woven pattern created by spacing threads to achieve an open look. Most typical of cottons and cotton blends but also woven into other base goods.

11. **Ottoman:** A heavy woven ribbed fabric with a wide crosswise rib created by a heavy warp at spaced intervals. Often woven from cotton, wool, silk, and synthetic fibers.

12

13

14

15

16

12. **Pinstripe, gangster stripe, men's wear stripe:** A finely woven or printed stripe on a wide variety of base goods. Typically used in tailored clothing, both for men and women, and shirtings.

13. **Satin stripe:** Plain-weave stripes are combined with a satin-weave stripe, which is best when woven in a combination of dull or textured yarns and shiny contrasting satin-weave yarns.

14. **Ticking stripe:** Originally used as a covering for pillows and mattresses. Real ticking is so densely woven that feathers cannot poke through it. First woven in black and natural or navy and natural, but now many novelty variations, often printed instead of woven, in a wide variety of colors. A typical summer fabrication.

15. **Rib piqué:** Heavier yarns are added to the warp at regular intervals at the back and secured with filling yarns. Ribs may be in a contrast color or the same as the background. Typically woven from cotton and cotton blends.

16. **French knot:** A light- to medium-weight cotton or cotton blend that has a woven novelty boucle (looped) pinstripe. This fabric is often overprinted.

1

2

1. **Bias plaid:** For a novelty effect, plaid pattern may be printed or knitted on a 90-degree angle to the salvages. Typical of an argyle plaid pattern. A bias-printed plaid avoids the problem of bowing (bowing occurs when the straight lines in a pattern are printed off grain, which makes construction difficult).

2. **Geometric print:** Many printed geometric patterns are possible, and the geometric elements may be printed on the diagonal, a motif not possible with many plain-woven geometrics. Many combinations of regular motifs are classical components of fabric design.

Plaids and Checks, continued

3 4 6 7

3. **Glen plaid:** A traditional woven plaid pattern originally done in wool or wool blends. Now available as a woven and a print in either a color and white or in beige or in several colors. Suitable for many base goods.

4. **Woven geometric plaid:** Formed by different-color threads arranged into a geometric pattern within the weave. Numerous patterns and combinations are available. May be woven from most fibers.

5. **Gingham, ⅛-inch check:** A classical plaid formed by the crossing of two colors of thread in the warp and filler at even intervals. Classic colorations are white

and color. Woven in tiny checks (1/32 inch) to squares of several inches. Also may be a printed version that can be printed on the straight or the bias. Typical of cotton and cotton blends.

6. **Gingham, ¼-inch check:** This version shows the very popular ¼-inch check.

7. **Gingham, 1-inch check:** This typical gingham is woven in 1-inch checks and larger, although these larger checks are usually less popular than the smaller ones. Gingham plaids larger than 1 inch are called "Buffalo Plaids."

8 9 10 11

8. **Herringbone:** Stripes of reverse twills in alternating colors. Traditionally woven in wool, although now available in many fabrications and as a print.

9. **Houndstooth:** A traditional woven pattern for wool. Often done in white with a strong color-contrast check. Typical shape of the pattern is now interpreted as a weave in many fibers and frequently printed on many base goods. May be done in two or three colors.

10. **Shepherd's check:** A woven wool plaid that resembles cotton gingham. Now also duplicated in synthetics with a woollike surface and hand.

11. **Tartan plaid (quilted example):** Woven and printed plaids derived from the traditional Scottish-clan plaids are printed on numerous base goods. Originally the tartan plaids were woven in wools. Modern interpretations include color and scale changes.

12

13

12. **Windowpane plaid:** Widely spaced plaid that resembles a windowpane. May be printed or woven on numerous base goods.

13. **End-on-end shirting:** Yarn-dyed plaid woven into a vast variety of plaids typically used for men's shirtings.

Piled, Looped, and Napped Surfaces

1

2

3

4

5

1. **Lofty surface:** Thick, furry, or napped surface used to describe both knits and wovens with a brushed face. Descriptive term for many lofty base goods.

2. **Felt:** Nonwoven fabric created by applying heat, pressure, and a bonding agent (glue) to different fibers. This fabric will not ravel and takes dye vividly. Because the fibers are not woven together, this fabric is fragile and thus used for special garments.

3. **Camel's hair:** A coat- or dress-weight fabric usually made from a blend of camel hair and wool because pure camel's hair fabric is very expensive. Very lightweight,

warm, and naturally water repellent. The fabric is usually softly napped and has a characteristic light-tan color.

4. **Cotton outing flannel: pilou (French):** A twill or plain-weave, lightweight, cotton or cotton blend fabric that has a napped, sanded, and brushed surface. Both sides may be brushed. Often printed. This traditional sleepwear fabric may be flameproofed. After washing and wearing, the napped surface has a tendency to pill.

5. **Panné velvet:** A finish is applied to the pile of a napped fabric. This lays the pile in one direction. Can be applied to knitted or woven pile fabrics in many fibers.

Piled, Looped, and Napped Surfaces, continued

6

7

8

6. **Suede cloth:** A sueded surface may be found on knitted, woven, and nonwoven fabrics. Sueded surfaces vary greatly in character. Price range is from expensive to inexpensive. Various weights and hands are available, depending on the fiber and construction method used.

7. **Terry cloth:** Uncut loops, on one or both sides of this fabric, make terry cloth very absorbent. Practical for towels and casual wear, especially in water-related sports clothing. Many print, woven, and knit variations, including stretch terry knits. Most often woven or knit from cotton or cotton blends.

8. **Velour:** Knit with a pile face that may be printed or embellished with woven stripes. Often knitted in cottons and blends. Soft, drapable hand.

Woven Patterns

1

2

3

1. **Bouclé linen:** Loopy yarns woven into a window-pane plaid. The bouclé yarns can be a blend of several fibers and can be woven into many base goods and novelties. Also used in knits.

2. **Damask, satin type:** The design is woven on a Jacquard loom on both sides of the fabric. Raised surface is created by a combination of satin and twill stitches. Woven in numerous fibers.

3. **Bird's-eye piqué:** A classic fabrication woven in cotton and cotton blends. Made in the typical piqué method of a large filler yarn that is held with a larger filler to make the standard pattern. Can be printed and dyed, although white is the traditional color. A knit stitch emulates the surface texture of this woven fabric.

4

5

4. **Waffle piqué:** A cotton or cotton blend woven with a dobby look; pattern formed by a heavy stuffer yarn on the back of the cloth that is caught at intervals by a filling thread. Many pattern variations possible. Often overprinted and dyed.

5. **Eyelash novelty:** A woven plaid shirting in cotton or cotton blends; may be woven with a novelty stripe, accented with a woven dot that is trimmed to a small fringed spot that resembles an eyelash. Many pattern variations are possible.

Woven Textures

1

2

3

4

5

6

1. **Burlap:** Rough, stiff fabric often used for sacking. Also available in colors with an apparel finish. Used for novelty garments.

2. **Duppioni silk:** Slubbed and textured silk threads are woven into dress-and suiting-weight base goods. Dyed and finished with a crisp hand and often duplicated in synthetic fibers to resemble the original silk.

3. **Hopsacking:** Rough, slubby yarns are combined in a plain weave to give a coarse-textured fabric. Many variations of this basic look are available in numerous fibers.

4. **Indian gauze, cheesecloth, cotton crepe:** Textured crepe yarns of cotton that may be hand- or ma-

chine-loomed. Soft, drapy fabric with much stretch. This semitransparent fabric is cool and dyes brilliantly. Woven in novelties and duplicated domestically.

5. **Linen:** Originally woven in flax fibers. Traditionally the finest qualities were imported from Ireland. A typical summer fabric noted for brilliant color range. Now, many synthetic fibers are used to simulate linen and improve its tendency to wrinkle.

6. **Silk shantung:** A blouse weight, lighter than Duppioni silk, woven from lustrous, slubbed silk yarns. Now also available in synthetic fabrications to simulate silks. Dyed and finished with a crisp hand.

Woven Textures, continued

7 8 9 10

7. **Tweed:** Traditionally, tweed has been a sturdy wool cloth made from coarse woolen yarns with characteristic contrast slubs and knots. Now, tweeds are woven in many yarns and blends to simulate the original wool. Tweed patterns are even printed on numerous base goods.

8. **Wrinkle cotton:** Bottom weight of gauze, woven with a permanently wrinkled surface. The finish further accentuates the wrinkled effect. Cotton or a cotton-polyester blend available in many weights.

9. **Wild silk:** Silk fiber is collected from cocoons of wild silkworms and woven into a rough, slubby, textured fabric suitable for coating. Difficult to tailor because fabric is spongy and ravels easily. Usually in natural tan, with many natural shades.

10. **Knot novelty, woven:** Soft cotton and blended yarns are woven with a shiny warp and weft to secure the large untwisted yarns. This fabric has a zigzag effect, but many other variations are possible. Resembles a cotton dishcloth.

Puckered Surfaces

1 2 3 4

1. **Matelassé:** A blistered-surface fabric that is created from a double warp-faced fabric which has interlaced yarns in the warp and filling. Contrast metallic threads may be used, as in this example. Tends to be dressy in appearance.

2. **Plissé:** This print simulates the warp-print technique in a floral print. When the traditional technique is used only the warp is printed and the filler is added, giving a fragmented, softened look to the pattern. The base goods is a plissé cotton. The plissé effect is created by printing the base goods with a gum and passing it through a soda bath. The soda crinkles the fabric where the gum is not protecting the surface. Typical summer fabrication.

3. **Seersucker:** A medium-weight cotton or cotton blend with a woven crinkled stripe or novelty geometric pattern. The crinkle is created by alternating slack tension in the warp yarns. The stripe is yarn-dyed. The classic pattern is usually colored with a white and contrasting color ⅛-inch stripe.

4. **Novelty seersucker:** A medium-weight cotton with alternating smooth stripes and crinkled bands woven with alternating tension to give the crinkled effect. Many patterns and variations are possible.

1

3

2

4

5

6

1. **Clay print:** A print technique that simulates the ornate endpapers used to finish quality books. Most of these patterns are hand-made in France and Italy. Patterns may be printed on many base goods. Usually printed by the heat-transfer method because of the many colors and fine quality of printing required.

2. **Heat-transfer print, photographic print:** The image is printed first on a specially treated paper that can be printed with many colors. The image is transferred from the paper to a suitable base goods by a heat-transfer process. Many colors and designs are possible.

3. **Marble print:** A print that simulates the veins and colorations of marble. This example is printed on velveteen, but marble print can be printed on numerous base goods.

4. **Ombre:** A shaded print that graduates from light to dark tones of a color. Available on many base goods.

5. **Border print:** One edge of the fabric (or both in a double border) has an added design. Borders require careful designing and may take more yardage than an average fabric. Many border print patterns are printed on various base goods.

6. **Engineered print:** The motif is usually designed to be placed on the garment before the sample is made. Bathing suit prints are designed in this manner. Stock engineered prints include scarf prints, large block designs which must be carefully designed so little fabric is wasted.

CHAPTER **7**
Kinds of Trims and Their Uses

rimming means decorating a garment with functional or decorative accessory parts or details. *Accessory parts* are components of a garment that are not part of its basic structure, such as buttons, collars, cuffs, or shaped edges. *Details* are trims added to the basic garment, such as appliqué, topstitching, ribbons, pleats, and ruffles.

When a designer selects a trim for a garment, many of the same factors that govern fabric selection must be considered.

1. The trim must enhance the garment or make it unusual, thereby increasing its sales potential.
2. The trim cost must be within the framework of the garment's price.
3. The process of trimming should not delay production.
4. The trim's color and scale should complement the design and enhance the garment's proportion.
5. The trim should have care instructions that are compatible with the fabric it decorates.

A designer has two options when selecting a trim to add to a garment. Trim lines can be reviewed and a ready-made trim selected just as a fabric would be selected. The second option is to create a trim design and then search for a contractor to make the design. (Actually, most designers use both options.) It is worthwhile to review trim lines, if only to get an idea of available techniques. Generally, a trim contractor will hire designers to invent new applications for its machines' techniques. The contractor will

When you have read this chapter, you will understand:

1. The criteria a designer uses when selecting trims.

2. How belts can enhance a garment.

3. The types and placement of pockets.

4. The variety of fastenings available for garments.

5. The kinds and uses of linear trims.

6. How area trims can enhance a garment.

7. The names of the parts of a collar.

8. Basic collar and neckline shapes and names.

Trim can enhance a garment and make it more salable.

compile a reference library of trim sketches and examples and encourage designers to use the library.

Designers who can create their own trim have an edge on competitors because imaginative trims are increasingly important in the moderate and inexpensive markets. Fabric companies selling popular-priced goods are no longer able to confine prints and fabrics to a single manufacturer. Even special colors require large yardage orders. Therefore, many manufacturers in the same market are limited in their choice of piece goods, and style duplication results. To complicate the design situation further, when a fabric company has hot base goods, other converters in the same price range try to duplicate items that are selling well. Therefore, many fabric firms offer a similar product for the same price. The designer who makes a garment unique by adding an innovative trim will be in a superior position to competitors who may be using the same fabric.

Two design areas that use applied trims frequently are children's wear and lingerie. Children's clothing is often appliquéd. Lace and ribbons on small girls' dresses are appropriate, as are nonfunctional buttons. Lingerie items, both intimate apparel (garments worn close to the body such as bras, girdles, slips, and panties) and at-home garments, use a wealth of special machine edgings, lace insets, and appliqués. Often, so many special edgings are used that a lingerie factory will have its own edging machines with interchangeable attachments.

A third kind of trim is produced by a fabric converter who embroiders designs on base goods and then sells the goods by the yard. This converter develops a line and shows it in the same way a regular piece-goods firm would. Usually, these converter firms are flexible enough to adapt the designer's ideas and combine or invent special motifs. Often, the patterns can be embroidered on a variety of base goods. These firms maintain reference libraries of samples to stimulate new ideas and combinations.

A manufacturer usually works with one or two contractors who supply all of its buttons and belts. It is advantageous to have an ongoing relationship with such suppliers so that they can adjust their production standards to the manufacturer's specifications. The salespeople for these contractors usually service an account individually and make up samples quickly because they can count on a large order.

Most garments shown in this chapter illustrate classical applications of trims. Because fashion changes so rapidly, the design student should recognize traditional trims and traditional uses. Then, armed with good taste, the classical methods of trimming, and knowledge of available trims, a designer can create unique trims that are in step with current fashion.

Classifying trims by kind and method of application is handy for a person who is trying to organize information, but this organization is not particularly useful to the working designer. Some trims fall into several categories; for example, buttons and zippers can be functional or decorative—they can be carefully hidden or boldly displayed. In practice, the merit of a trim is determined by this question: "Does this trim make the garment more attractive and salable?"

COLLARS

A collar is an added piece of fabric that surrounds the neck and is attached to the neckline of a garment. The collar is an important part of the garment because it frames and directs the eye towards the face and finishes the neckline of the garment. The edge of the garment that surrounds the neck or shoulders is the neckline.

The four styling factors that determine how a collar looks are the following:

1. Distance between the neckline and the base of the neck.
2. Height of the stand (that is, how far the collar stands up).
3. Shape and depth of the fall.
4. Revere or lapel, if included, and its size and shape (this is an optional styling device).

Collar Shapes

The shape of the collar and the neckline seam determine how the collar lies.

1. Collars with the same shape as the neckline will lie flat with no stand. The outer edge of the collar and the neck edge of the garment are exactly the same size at this point, so the collar falls flat over the garment.

2. As the neckline curve of the collar becomes straighter (it can be a straight piece of fabric if it is

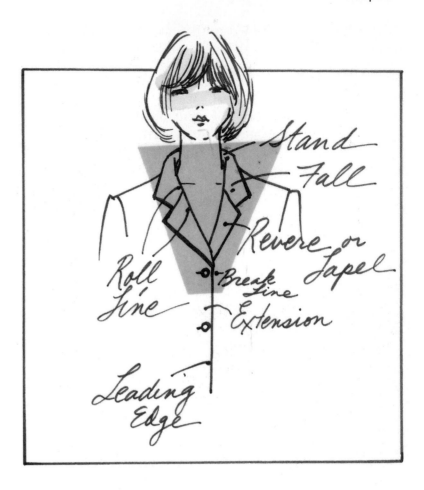

cut on the bias), the stand becomes taller. Fabric is added to the neckline curve of the collar to build the stand. The outer edge of the collar is much smaller than the garment, so the collar stands up higher on the shoulder.

3. The greater the outside curve on a collar piece the fuller the collar will be, almost like a ruffle. The expanded outside edge allows for ripples or ruffles. The surface area of the collar is much larger than the area of the bodice it covers. This type of collar does not have a stand and the height is at the outer edge. Gathering this type of collar gives it more fullness.

There are many types of collars. Each type can be modified by varying the four principles that govern collar styling. The possibilities of varying a collar by using these modifications can be illustrated by changes in a simple bias band collar. Many of these modifications can be used for any of the following collar illustrations, and others can be made if trims or contrast fabric are introduced into collar styling.

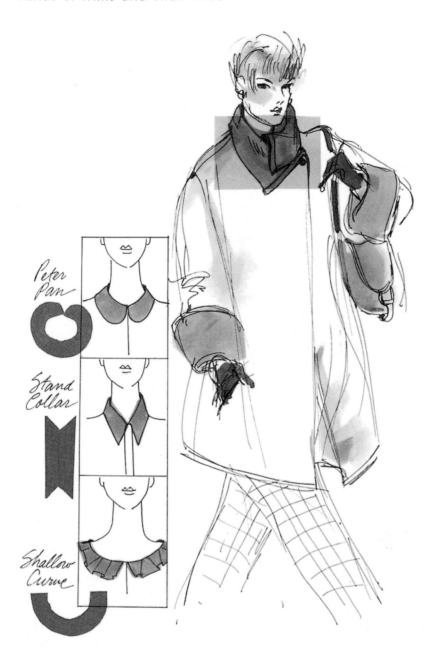

Peter
Pan

Stand
Collar

Shallow
Curve

Straight-Band Collars

A straight-band collar may be cut on the straight
grain line. It has a slightly curved neckline, stands
straight, and has no fall. Usually, this collar is quite
narrow because a high band would be uncomfortable.
The lower right and left examples on the following
page show classic band collars. The mandarin collar
is a shaped band that is typical of Chinese costume.

An example of a man-tailored shirt with a me-
chanical stand can be seen in the following illustra-
tion. The band and the top collar are made separately

and then sewn together. The stand holds the collar rigidly in place, which is particularly desirable if the shirt will be worn with a tie or if it is made in a soft fabric. The top collar may have any shape.

The band collar is usually interfaced with a fabric that is stiffer than the outer fabric, further reinforcing the stand. Most collars are interfaced. The designer can select from a wide variety of woven and nonwoven interfacings that vary in firmness and weight. To make the collar pieces easier to handle, interfacings are often fused (bonded to the outer fabric by a machine that applies heat and pressure to both fabric layers). The interfacing reinforces the drape and shape of the collar. It is essential if the garment is to preserve its original look after washing or cleaning.

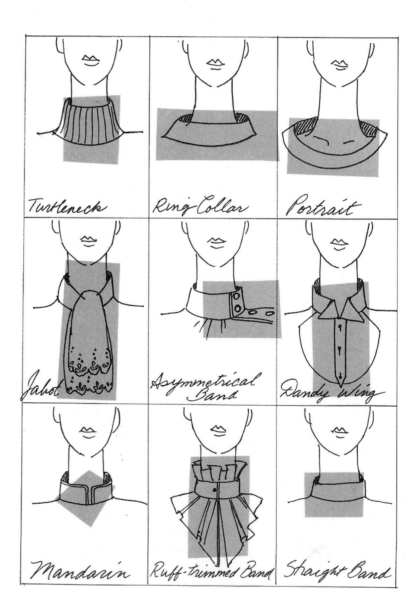

Turtleneck	Ring Collar	Portrait
Jabot	Asymmetrical Band	Dandy Wing
Mandarin	Ruff-trimmed Band	Straight Band

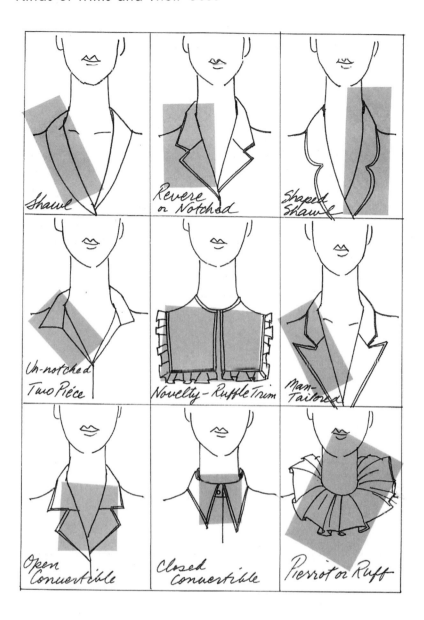

Bias Straight Band

A soft bow at the neckline is a popular collar for blouses and dresses. Generally, this collar is cut on the bias to give it maximum softness and drape. The ends of the tie can be finished in a variety of shapes. Separate bows are often tied under shirt collars. The ties can also be set into the shoulder seams so the ties cannot be detached from the garment.

Revere Collars

A revere collar has part of the bodice fabric incorporated into the lapel or underlapel. The jacket front facing is an extra facing piece that can be extended to incorporate the back collar as well as the revere (as in the Italian collar).

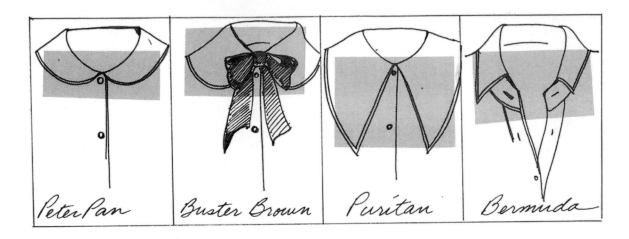

Peter Pan Collars

Peter Pan collars are youthful and casual. Like the bias-band collar, Peter Pan collars can be varied in many ways. When a Peter Pan collar is worn close to the neck, it is particularly youthful. This collar is used most often in children's wear. The Buster Brown collar has the look of an old-fashioned school uniform or an artist's smock. The tie is characteristic of this collar. The Buster Brown collar varies in size from medium to large, depending on the size of the bow.

The Puritan collar has its ancestry in the cartwheel ruffs worn during the sixteenth century. Gradually, the ruff softened, and the lace trim often used as decoration became less elaborate. During the seventeenth century, the sober "fallen collar" became the fashion among Protestants. Early settlers carried the collar to America, where it was firmly associated with the Puritans and early Americans. This type of collar is generally quite large. One modification of the Peter Pan collar is the Bermuda collar, which is used mostly on casual garments. It can be made with a band placket, which holds the collar firmly away from the neck in a slight V. The Bermuda collar may be shaped like the Peter Pan collar.

Cowl Necklines and Collars

A cowl neckline is draped on the bias fabric grain. It is a graceful, soft neckline that resembles the drape of a Greek chiton but is named after the priest's robe, which also has a draped neckline. When the designer is planning a cowl, draping it in the garment fabric rather than muslin is necessary to determine precisely how the cowl will drape and how

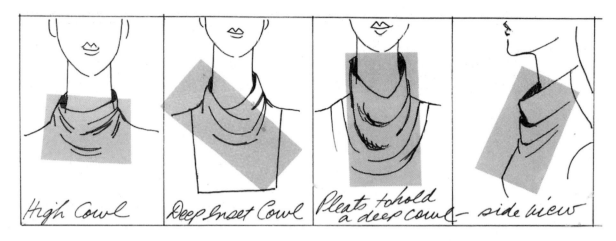

High Cowl | Deep Inset Cowl | Pleats to hold a deep cowl | side view

much fabric will be required for the perfect look. Soft, pliable knits and wovens are best suited to this style because they fall naturally into graceful folds. A cowl can be draped high on the neck with only one fold, or more ease can be added to create a deep cowl with several folds. A cowl can also be draped at the armseye.

A cowl collar can be draped in soft pliable fabric as well. The collar is a separate piece of fabric attached to the garment that is draped instead of part of the bodice being draped into the cowl.

Middy or Sailor Collars

Traditionally, a sailor collar is used on a seafarer's uniform. Typical trim would be two bands of soutache braid sewn around the eges and two stars at the back corners. When authentically duplicated, this collar is worn with a tie. Nautical colors of white, navy blue, and red are particularly effective. This is an ageless collar, appropriate for both young and old. The size and shape of the collar can be altered for novelty variations.

Bertha or Cape Collars

The Bertha collar resembles a small cape and can be designed in several novelty styles. This collar tends to be bulky, so this style may not be appropriate for heavy fabrics. The pelerine, a cape sleeve, is closely related to this collar (see the illustration of the Inverness cloak in Chapter 10).

Mitered Corners

A mitered corner is two pieces of straight fabric sewn together at a 45-degree angle. This effect produces a

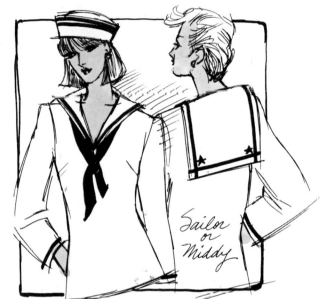

Sailor or Middy

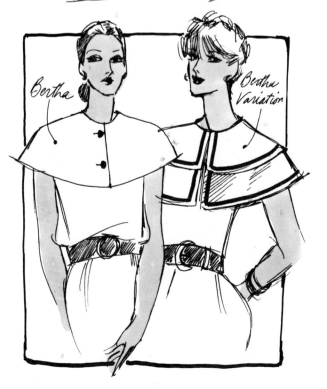

Bertha

Bertha Variation

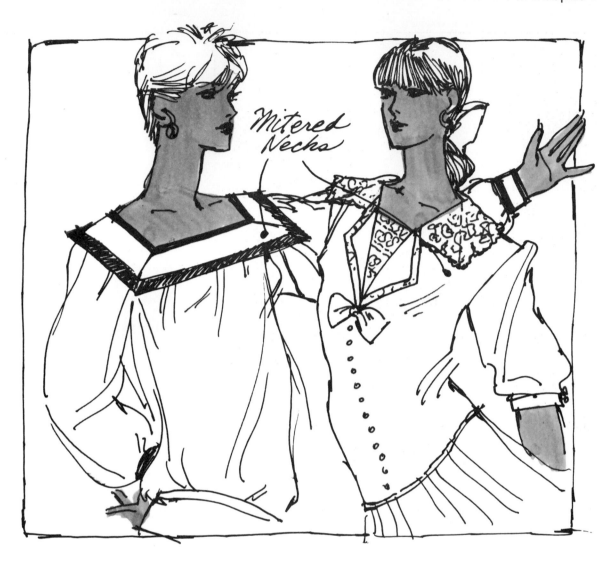

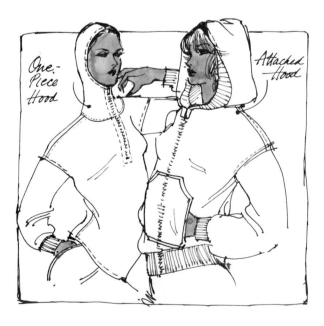

square neckline. The mitered pieces may be sewn to the garment like a band, or they can be a separate collar. This is the most effective way of adding a straight stripe or band to a garment.

Hoods

Hoods are effective as outerwear collars. Many times, they are as attractive when worn down around the shoulders as they are when worn over the head. A soft knit makes the most successful one-piece hood. When a stiffer, bulkier outerwear fabric is used, the hood should be fitted to the head and should lie gracefully on the back when not covering the head. The parka almost always is styled with a hood.

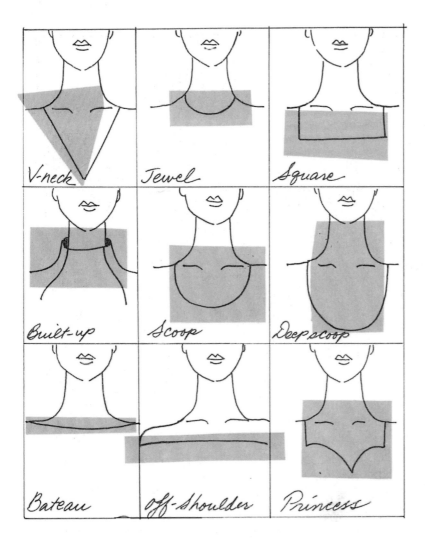

NECKLINES

The neckline does not have to be finished with a collar. It can be faced. A *facing* is a piece of fabric that corresponds exactly to the shape of the neckline and is sewn on to finish the neckline's raw edge. Then the facing is secured to the interior of the garment so that the facing is not visible. Necklines may also be finished with piping or bias binding. Knits are often finished with ribbed bands. Many neckline shapes and variations are possible. Some basic necklines are illustrated here.

BELTS

A belt can be a big help in selling a garment. For example, if the waist is slightly too large, the belt will pull the fabric to the body and make the garment look better, or if a dress with a full silhouette has a belt, the customer can belt the dress or let it fall loosely.

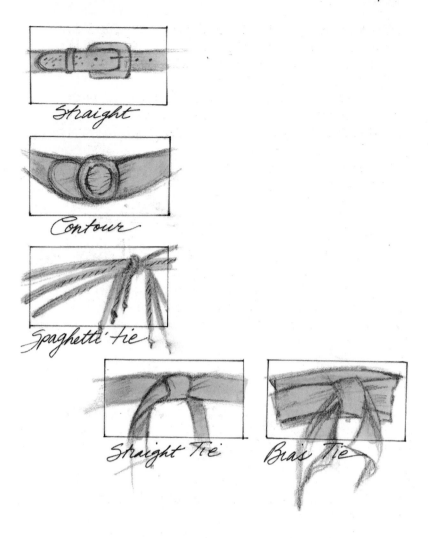

Defining the waist with a belt goes in and out of fashion. During the 1940s and 1950s, a small waist was very fashionable. From childhood through adulthood, women wore waist-cinching undergarments and belts. The average waist measurement for a size 10 was 24 inches. During the early 1960s, the chemise (a loose dress with no waist definition) and the overblouse dominated the fashion scene. These shapes were unfitted at the waist and women abandoned their corsets and tight belts. When belts reappeared after an eight-year absence, manufacturers found that women's waistlines were larger. A size 10 waistline had increased by 2 inches to 26 inches. Women were not larger overall, but the waist returned to its natural dimensions when it was unconfined.

There are three main shapes for belts:

1. *Straight.* Worn at the waist, rib cage, or hip; a long, straight strip of fabric that can be stiffened with interfacing.

2. *Contour.* Shaped in a long curve to conform to the hipline or give shape to the waist. This kind of belt is almost always stiffened with interfacing.
3. *Tie.* There are several varieties:
 a. *Spaghetti.* Long, narrow cords covered with the garment fabric or made of leather or plastic. The ends can be finished with a knot or a novelty finish.
 b. *Straight.* Usually, a tie belt that is cut on the straight grain (cut parallel to the selvage); cannot be too wide unless the fabric is very soft. This belt may have a light interfacing. It makes a crisp knot when tied.
 c. *Bias.* This belt, cut on the most flexible grain of the fabric, can be wider than a straight belt. It will have a soft bow, rather like a scarf. Because of its ability to drape, a bias belt can be wrapped around the waist several times for a dramatic effect.

As with any trim the designer selects, the belt must be compatible with the garment's price. Therefore, more-expensive belt fabrications must be avoided in moderate- and low-priced garments. Generally, this cost restriction eliminates leather as a material (unless the belt is narrow). Leather has been copied in an inexpensive plastic material. In fact, almost all expensive belts can be knocked off in less-expensive fabrics.

Many belts must be made outside the manufacturer's factory. Two methods are used. In the first method, the backing and belt material are glued to a stiff interfacing, producing a smooth, elegant belt. Unfortunately, prolonged exposure to pressure and body heat may cause the backing to separate from the core of the belt. In the second method, the belt material, interfacing, and backing are sewn together on a sewing machine. This type of belt will have stitching around the edge but is sturdier than a glued belt.

Several kinds of belts can be made in the factory. Tie belts are often made in-house. If the designer wants buckles, they can be sampled from the button supplier. Generally, a belt with a soft core (interfacing) or a belt made of the garment fabric can be constructed in the factory. Belts made in-house are more likely to be ready when the garments are shipped and are generally less expensive.

A bow with interfacing can be used as an ornament on a belt. The belt will snap shut. Snap belts do not allow much room for adjustment, as tie and buckle belts do, but they can look dressier. When a

A. The pretied bow in a crisp fabric looks formal.
B. The self-tied bow is softer looking and more flexible than a pretied bow, but it has to be tied each time.

nonadjustable type of fastening is used, the belt can be made of stretch braid or garment fabric covering an elastic core. Either will make the belt more adaptable.

Often, the designer will have an idea for a unique belt and will sketch it for the belt contractor to make up. The belt should be as inexpensive as possible without losing its distinctive look. If the designer is planning a sophisticated garment but cannot justify the high cost of a leather belt, there are three alternatives: (1) substitute a plastic fabric that looks like leather, (2) select a novelty material like chain or braid, or (3) use a self-fabric belt that will match the garment fabric exactly and give the customer a belt that cannot be duplicated. Besides being a fashionable choice, a self-fabric belt is usually less expensive than novelty selections.

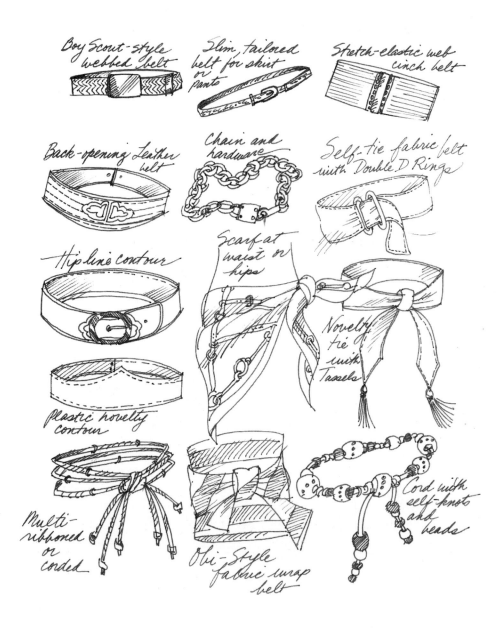

Boy Scout-style webbed belt

Slim, tailored belt for shirt or pants

Stretch-elastic web cinch belt

Back-opening leather belt

Chain and hardware

Self-tie fabric belt with Double D Rings

Hip line contour

Scarf at waist or hips

Novelty tie with Tassels

Plastic novelty contour

Multi-ribboned or corded

Obi-Style fabric wrap belt

Cord with self-knots and beads

POCKETS

Pockets are the most important trim for functional clothing. Frequently, sportswear has pockets because people wear this clothing for everyday life and they like to carry things or have a place to put their hands. Well-designed pockets will enhance many other kinds of garments. When using pockets on a garment, follow these guidelines:

1. Make the pocket reflect the shape of the garment's details. If a soft, rounded collar is used, geometric pockets will destroy the unity of the design.
2. Pockets that require precise geometric shapes should not be designed for a garment made of a soft fabric that drapes because the pockets will sag.
3. Place the pockets where they are both functional and attractive. Consider the normal reach of the arm and a comfortable resting place for the hand.
4. Pockets used in pairs should have a related shape and be carefully placed. Avoid contrast

Left: Square pockets teamed with a round collar are discordant. Right: Pockets that are compatible with other garment details are more attractive.

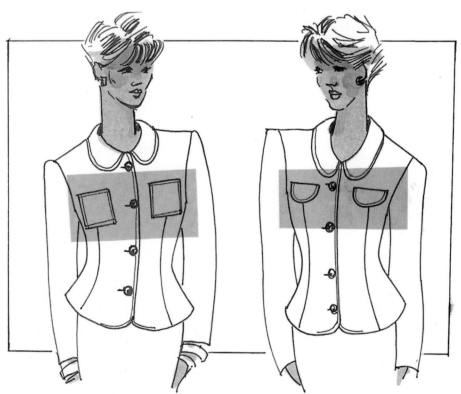

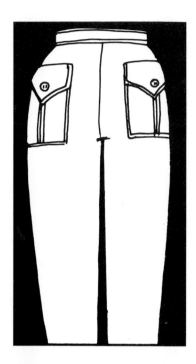

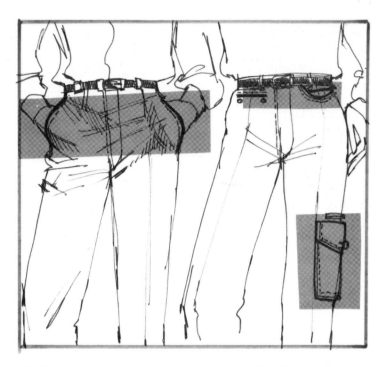

Left: Functional pockets. Right: Nonfunctional pockets.

pockets at the bustline or hipline because they will call attention to these areas and make the design look spotty. Buttons on pocket flaps will look awkward if the buttons are placed over the bust.

5. Remember that, visually, pockets add bulk. When designing for a person with heavy hips or a large bust, placing pockets over these areas will emphasize the figure problem, especially if the garment is fitted.

6. Scale the size of the pocket to the garment it will be used on. A small pocket on a large woman emphasizes her size by contrasting the large expanse of fabric with the small pocket size. The reverse happens if a large pocket is used on a small garment. A pocket at the hipline should be large enough to contain a hand. Pockets on the upper part of the garment can be smaller.

The best way to experiment with shape and placement of pockets is to drape muslin on a dress form. Cut out several potential pocket designs in various sizes and shapes. Pin these samples on the garment. Step back and consider the garment from a distance. Look at the garment in a mirror. The mirror gives you a different perspective on the style because the image is reversed. In fact, this

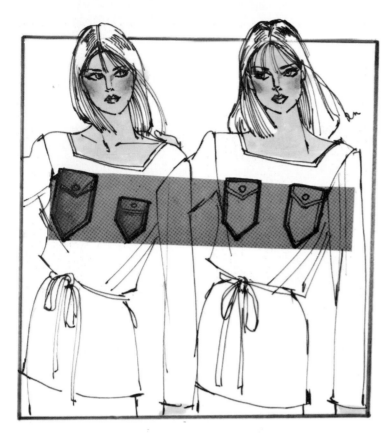

Left: Spotty pockets. Right: Related pockets.

method is excellent for judging your drape when it is completed. When you work steadily on a muslin, your eye tends to adjust to unbalanced lines and awkward proportions. Looking at the reverse image helps you to see what corrections the drape requires.

Pockets tend to be used in pairs. Two equally spaced pockets give the garment a symmetrical design; that is, the design is the same on both sides of the center front line. Symmetrical designs are appropriate for the human body because, ideally, it is equal on both sides. The eye readily accepts a balanced or symmetrical design. When only one pocket is used, the design is asymmetrical and emphasizes one side of the garment. Asymmetrical designs are used in more expensive garments, probably because the design requires a more subtle balance to succeed.

There are three major kinds of pockets, with many possible variations on each kind:

1. *Patch pocket.* A pocket applied to the outside of the garment. A great variety of shapes and details is possible. It may have a flap closing.

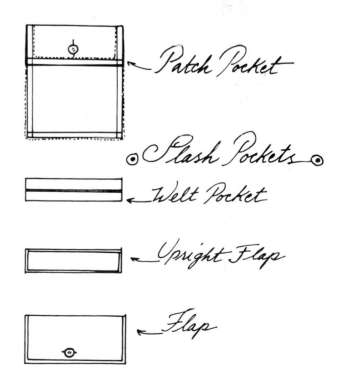

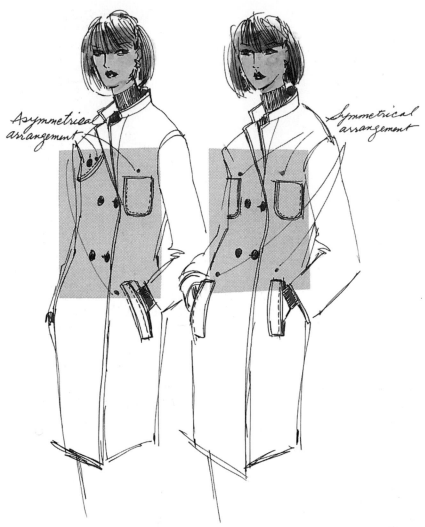

Asymmetrical arrangement

Symmetrical arrangement

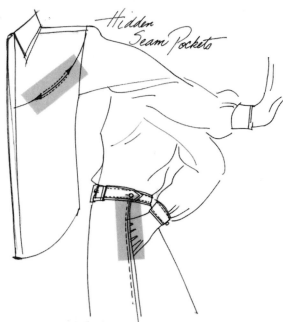

Hidden Seam Pockets

2. *Slashed pocket.* This pocket's functional pouch is hidden inside the garment. A decorative finish is used on the opening.

 a. *Welt or buttonhole pocket.* May have a variety of shapes; also called a *bound or slot pocket.* Specialized contractors are often used to add this detail.

 b. *Upright flap.* Characteristic of men's suits. The flap may have novelty shapes.

 c. *Flap.* When the flap is secured with a button, the pocket is practical because its contents are secure.

3. *Pockets hidden in a seam.* These pockets can be sewn into a side seam, a princess seam, or a yokeline seam. A tremendous variety of pocket stylings can be achieved by combining kinds of pockets, using several pockets on top of each other, or adding various trims.

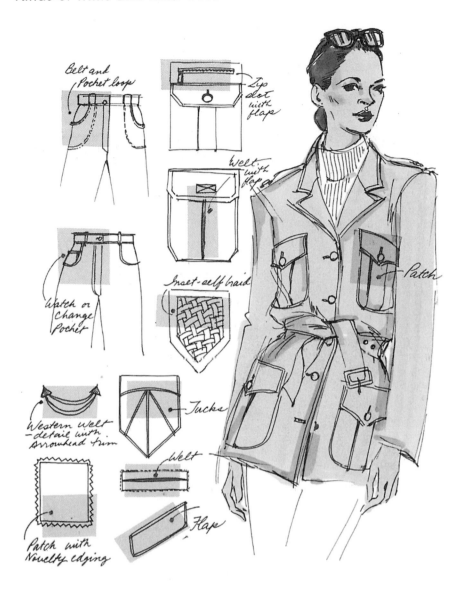

Belt and Pocket loop

Zip slot with flap

Welt with flap

Watch or Change Pocket

Inset-self braid

Western welt-detail with Arrowhead trim

Tucks

Welt

Flap

Patch with Novelty edging

Patch

FASTENINGS

Buttons

Buttons were invented in the late thirteenth century. People who wore buttons were considered morally loose because they could undress more rapidly than people who wore clothing that was laced or sewn closed. Soon, buttons became the fashion rage. During the fourteenth century, buttons were used both ornamentally and functionally, just as they are today.

A designer usually selects buttons before a style is made up. He may sample a range of buttons and have them ready for the garment when it is finished. Many times, the designer will have to order new buttons and have them dyed to match the fabric, or he may find a novelty or antique button and ask the supplier to copy it. The relationship between the

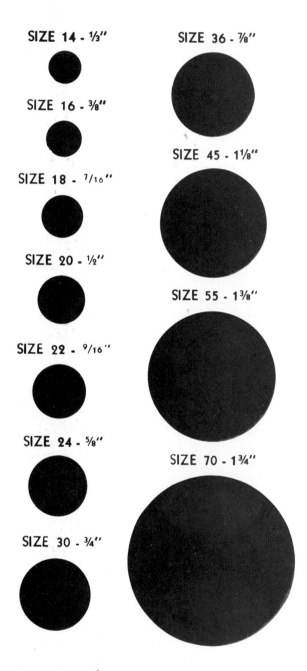

SIZE 14 - 1/3"

SIZE 16 - 3/8"

SIZE 18 - 7/16"

SIZE 20 - 1/2"

SIZE 22 - 9/16"

SIZE 24 - 5/8"

SIZE 30 - 3/4"

SIZE 36 - 7/8"

SIZE 45 - 1 1/8"

SIZE 55 - 1 3/8"

SIZE 70 - 1 3/4"

Button Ligne Chart
This convenient chart shows the ligne (pronounced "line") size of a range of buttons and the equivalent size in fractions of an inch.
Courtesy: Lidz Brothers, Inc.

button supplier and the designer is constant. Because a designer requires continuous service, he will use one or two button companies regularly. The button supplier is more likely to give good service when asked for samples if he is reasonably sure of receiving a stock order. For the supplier, making up samples is time consuming and unprofitable, but it is necessary if he is bidding for a large quantity order.

The designer must consider the following things when selecting buttons:

1. *Price.* As always, price is a primary consideration. The unit price of a single button must be extended (multiplied) by the number of buttons on the entire garment. The cost may be less if buttons are ordered in quantity for stock production.
2. *Aesthetics.* A button can be a simple fastening or a major ornament.
 a. *Shape.* Should reflect the garment's styling and the fabric. Several kinds of surfaces are available (including shiny or matte), depending on the material and method of producing the button.
 b. *Color.* Buttons will stand out if a contrasting color is chosen. The most subtle and inconspicuous button is self-covered. Beware of too many contrasting spots on a garment.
3. *Weight.* On a light, delicate fabric, a heavy button causes the placket to droop and look unattractive. A small, lightweight button on a bulky fabric will not secure the placket.
4. *Durability.* A sturdy button should be used if the garment will be washed often. Many buttons must be covered with aluminum foil before a garment is dry-cleaned. On an inexpensive garment, a fragile button that requires expensive special handling is inappropriate. Beware of buttons with jeweled insets because the jewels often fall out.
5. *Size.* The size of the button should be appropriate to the function of the garment and the visual effect of the total design. Frequently, the same button in several sizes will be used on the same garment. For example, the front placket of a shirt requires a larger button than the cuff. Buttons are measured by "ligne" across their diameter. Forty lignes equal 1 inch. Check the ligne chart to identify some familiar sizes.

What Are Buttons Made Of?

1. *Mother-of-pearl (or other shells, such as abalone).* This is a classic material for buttons on

men's shirts. These buttons are made in novelty sizes as well as small sizes for shirts and children's wear. Real shell buttons are fragile, especially when subjected to heat during washing or ironing. These buttons are expensive, and they are not always available in a range of styles. They are difficult to dye to match when purchased domestically because the dye required to tint them is toxic and not allowed in the United States.

2. *Plastic.* Plastic is the most versatile of all button materials. It has been used to copy the classic pearl button. Any surface can be produced, from matte (dull) to shiny, and plastic can be dyed any color. Also, it can be clear or opaque. Prices may be high or low, depending on the styling.

3. *Wood (or pressed wood).* This type of button is generally used for casual or sporty clothing. It can have many different shapes and be stained, painted, or have a natural finish. Generally, this button will have holes or a metal shank (a loop through which thread is passed to attach the button to the fabric). Usually, wood is more expensive than plastic.

4. *Cloth.* Self-covered buttons can be made in many styles and shapes. They can be subtle, yet elegant, but an extra should be included because they are hard to replace. Price depends on style and fabric cost but they are usually inexpensive.

5. *Metal.* Casting metal is used for many metal buttons. They can be solid or hollow, dull, antiqued (a darker metal), or very shiny. Gold, brass, and silver are the usual finishes, and medals and coins are popular designs. Metal may be enameled to match a fabric color. Prices vary.

6. *Leather.* Good for a sporty look. Often tied in a knot (a style that has been copied in plastic).

7. *Jeweled.* Rhinestones, jet, or any other stone can be set in plastic or metal for a dressy look. Stones often fall out. Usually more expensive than plastic.

8. *Bone and horn.* Rarely used because the materials are expensive and can be duplicated in plastic. Bone and horn are hard to get domestically because of ecological restrictions, but they can sometimes be found as imports.

Buttonholes

The most common kind of buttonholes are worked on one side of the placket. By tradition, women's garments button right side over left, so the buttonholes are made in the right side of the placket. The

Buttons

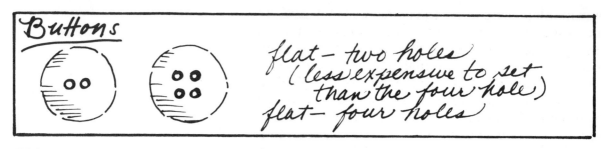

flat – two holes
(less expensive to set than the four hole)
flat – four holes

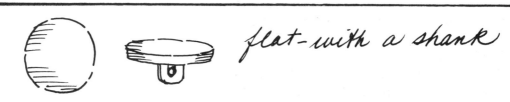

flat – with a shank

quarter ball

half ball

full ball – metal shank

full ball – built-in shank

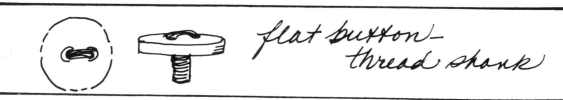

flat button – thread shank

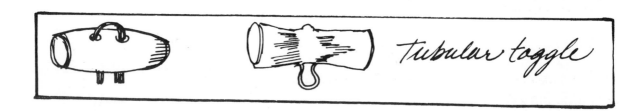

tubular toggle

buttonholes are placed so the buttons will fall on the exact center front of the garment (unless it is an asymmetrical closing or the garment is double-breasted). An extension remains between the end of the buttonhole and the leading edge of the placket. The size of the extension depends on the size of the button and the weight of the fabric. Usually, a larger button or a heavier fabric requires a bigger extension. The extension can be ½ to 2 inches beyond the center front line. It should be large enough to balance visually the size of the button.

Three kinds of buttonholes may be used on a garment. The most widely used is the machine-made buttonhole because it is inexpensive and suitable for almost every fabric. Machines automatically space, make, and cut the buttonholes.

The second, a bound buttonhole, is used on well-tailored garments, particularly coats and suits. There is a machine that makes this bound or corded buttonhole. A bound buttonhole is more expensive than a machine-made one because the back facing must be sewn by hand to the back of the finished buttonhole. Any area requiring hand sewing adds considerably to the cost of the garment.

The third kind of buttonhole is used rarely. It resembles the bound buttonhole and is often used in conjunction with it. When a yoke seam crosses the front placket, a space large enough for a buttonhole is left in the seam and facing. The ends of this opening are secured and the sides are slipstitched together to form a buttonhole.

Loop Fastenings

Loops that extend from the leading edge (the outside placket edge that is not stitched to the garment front) may also be used to secure the front of the garment. Loops must be spaced more closely than buttons, and the placket size differs from a buttonhole placket. A half- or full-ball button is usually used with a loop fastening so the loop will fit over the button more easily. This type of fastening is

Machine-Made Buttonhole

Bound Buttonhole

Slot Buttonhole

popular for bridal and evening styling. The loops are more difficult to button, so they are not used regularly in day wear.

Placement of Buttons and Buttonholes

Buttons should be functional. When buttons and buttonholes are decorative, costs increase because a functional opening must be constructed too. Also, a front-opening collar is used for dresses with buttons down the front, and dividing the collar at the center back for the functional opening spoils the collar's drape. Many times, a beginner will design a dress that buttons down the front to the waistline

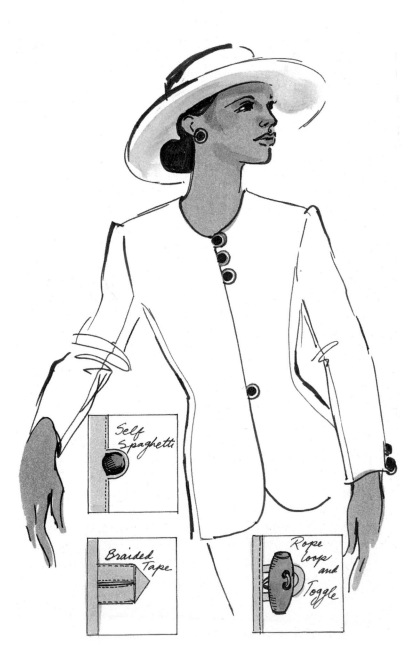

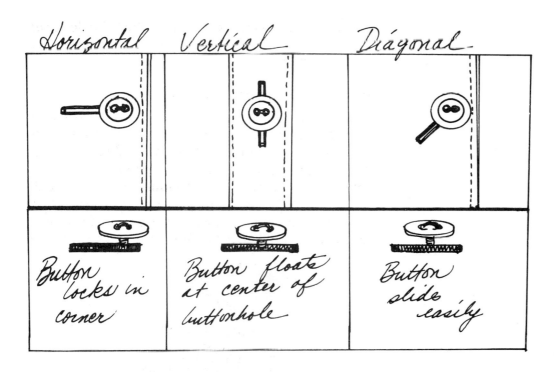

but will forget to carry the placket into the skirt, which makes it impossible to get the dress on or off.

Buttonholes should be placed horizontal to the leading edge. In this way, the button is held on the center front line by the reinforced end of the buttonhole. A vertical buttonhole may be used if the stress on it will be light, as in a loosely fitted shirt. Vertical buttonholes are also used on a narrow placket. For a novelty effect, buttonholes can be placed on the diagonal, but the button is not secured at the end of the hole, so the garment cannot withstand much stress on the placket.

Buttons should be placed where they can control the stress on the garment. Stress areas on a jacket or bodice are as follows:

1. *Top of the neck.* To hold the neck of the garment closed or to establish the roll of the collar.
2. *Bust.* Place a button parallel to the bust apex point.
3. *Waistline.* Secure at the waist.
4. *Hipline.* Placement may vary, depending on the length and fit of the garment. The other buttons should be equally spaced between the buttons at these stress points.

Button companies sell other accessories—for example, ornamental pins and buckles.

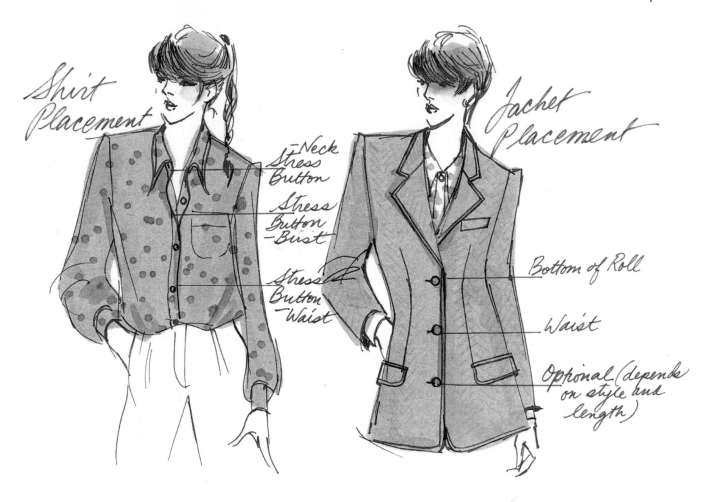

Shirt Placement

Neck
Stress Button

Stress Button - Bust

Stress Button - Waist

Jacket Placement

Bottom of Roll

Waist

Optional (depends on style and length)

Zippers

Zippers can be used decoratively or functionally. Heavy-duty industrial closings with contrasting tape and novelty pulls are used for casual wear, loungewear, and children's garments. Zippers are available in almost every length and color, and they can be dyed to match an odd shade. Furthermore, zippers can be used to accent design lines or pocket areas. A zipper may be hidden in a seam so that a lower panel can be zipped off to give the garment an optional shorter length. Other novelty effects are possible with hidden or decorative zippers.

Velcro Fasteners

Velcro fasteners were first used in industrial applications and for military uniforms. Velcro is formed of two tapes composed of tiny plastic fibers that grip each other on contact. The tapes can be easily stitched to fabric and are most effectively used in relatively short lengths. The product is made in several widths and colors and is found in a great variety of apparel and cloth accessories.

Velcro

Snaps

Two kinds of snaps are commonly used, most often on Western wear and work clothes. The decorative snap looks like a button and is attached to the fabric with a pointed gripper. The head of the snap has a mother-of-pearl inset or another kind of decorative element. The second type of snap is functional and is sewn to the garment through holes at its edge. In expensive garments, the designer will cover the snap with a piece of lining fabric.

Hardware

Various kinds of hardware are used for garment closings. Perhaps the most inventive designer who uses hardware for fasteners is Bonnie Cashin. Her clothes have anything from a dog-leash clip to a hardware snap. Hardware closings are particularly appropriate for outerwear that is made of bulky fabrics with enough weight to support the metal fastenings. Hardware closings are also used on belts in place of buckles.

Lacings

Lacings are another novelty fastening. The laces can be threaded through metal eyelets set into each side of a placket. Fabric loops are an alternative to eyelets.

Ties

Ties, either in the garment fabric or in contrasting novelty braids, are used to secure garments. They are adaptable to both casual and dressy styles. Ties are particularly popular on ethnic garments.

Hardware Fastenings

LINEAR TRIMS

Linear trims accent seam lines and garment edges. The simplest kinds (which are usually the least expensive) are stitched trims. They include the following:

1. *Slot seam.* A good tailored look.
2. *Welt seam.* Particularly good for suiting.

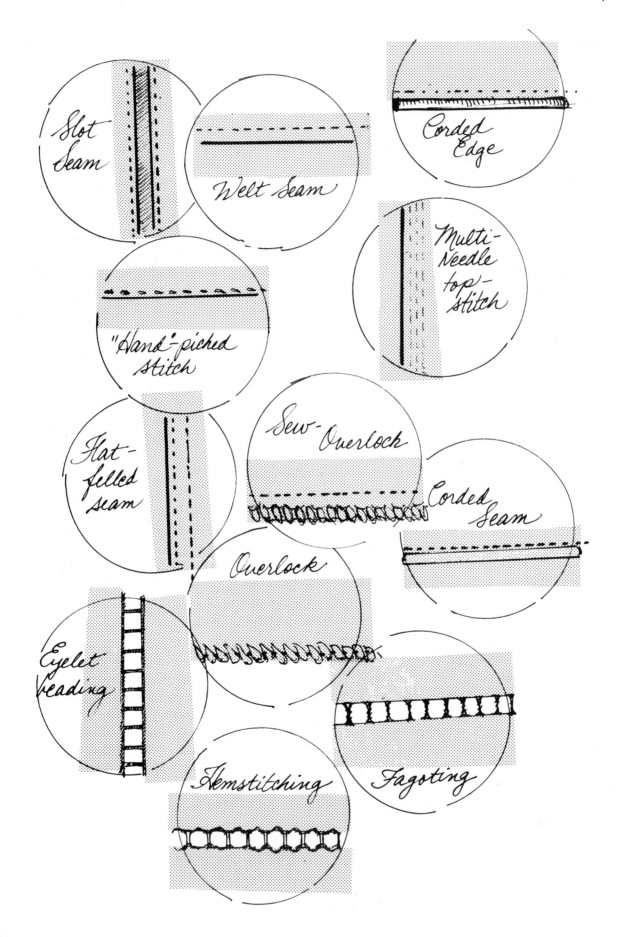

3. *Multineedle topstitch.* Can be used with novelty threads and colors.
4. *Corded edge.* Outlines and defines a shape.
5. *Corded seam.*
6. *"Hand" picked trim.* Really a machine trim that simulates hand-stitched detailing.
7. *Flat-fell seam.* The classic seam for jeans; appropriate for shirts and sporty clothes.
8. *Fagoting.* Openwork (linear), most effective for straight lines.
9. *Hem stitching.*
10. *Eyelet beading.* An inset of open lace.
11. *Sew-overlock seam.* Mostly an internal seam finish.
12. *Overlock.* Can be used as a hem, to decorate a seam, or as an internal seam finish.

These stitched trims can be varied by using contrasting threads or by alternating colors. Many linear trims are completed on special machines by specialty contractors.

Elastic Multineedle Techniques

Multineedle techniques are frequently used with elastic yarns. This style of trim is most successful when it is used on light-weight fabrics that drape well. Several rows of elastic linear trim are usually used to form an area trim. The elastic yarn causes the fabric to conform to the body shape without the use of darts or seams. This is called *elastic shirring*.

Smocking

Hand smocking was a favorite trim for children's dresses early in the century. Smocking creates a raised pattern when small stitches gather the fabric in geometric shapes. Contrasting thread enhances the pattern. The fabric gathers naturally below the smocking in a soft ruffle or skirt. Hand smocking is still done commercially in expensive children's garments that are made in countries with a low pay scale.

Machine smocking lacks the beauty of the handmade product but is available domestically at a much lower price. Children's wear designers still use this trim often.

Binding and Piping

A bias strip can be used to edge a piece of fabric, eliminating the need for a hem or other finish.

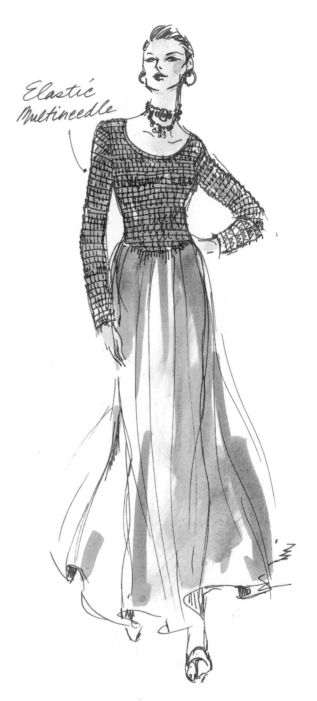

Elastic Multineedle Techniques

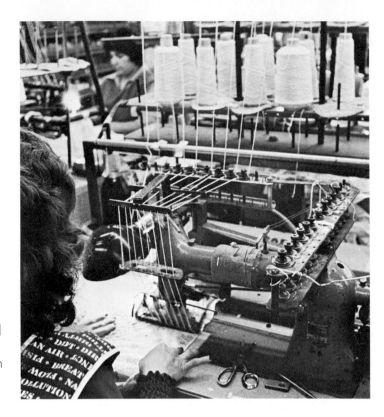

Elastic Multineedle Machine
This machine is sewing elastic threads in eight parallel rows on a precut strip of fabric. This shirred fabric will cling to a body without the use of darts or gores when it is sewing into a tube.
Courtesy: Mr. Pleat.

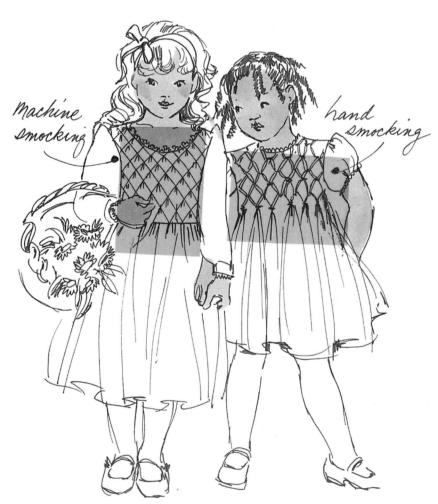

Piping is made by filling a bias strip with a cord and then sewing it to an edge or seam of a garment. Both trims can be made economically on commercial machines. Contrast bindings and pipings are very decorative. Depending on the fabric selected, these can be used in designing all kinds of apparel.

Shaped Edges

Shaped edges were fashionable during the fourteenth century and for several hundred years thereafter. Shaped edges are still used today but sparingly: They are expensive and pose some technical problems. For example, decorative effects on skirt and pants hemlines prevent alterations. If the hem is raised or lowered, part of the design impact is lost. Shaped edges are most successful when the garment will not have to be shortened or lengthened.

Piping

Braid

Binding and Piping

Shaped Edges

Some examples of shaped edges are:

1. Scallops
2. Fagoting
3. Lettuce edge (merrow edge)
4. Bias cording
5. Crochet edging
6. Wired edge
7. Picot edge—one of the many edges used for lingerie and intimate apparel

Ruffles

Ruffles are shaped in two ways: as a straight piece of fabric gathered along one edge or as a circular shape (or a complete circle resembling the shape of a doughnut). Ruffles must be set into a seam, bound at one edge, or gathered in the center to control

Neck Ruffle
—gathered wrist Ruffle

Area Ruffle

Graduated Ruffle

Lace Ruffle

Straight Hem Ruffle

Crystal Pleat Ruffle

their fullness. Both circular and straight ruffles can be used at a hem, on the edge of a garment, or as an area trim.

Straight-Ruffle Variations

The following are seven basic variations of the straight ruffle:

1. Simple straight ruffle
2. Bias ruffle
3. Pleated ruffle
4. Centrally gathered ruffle
5. Edge finished with a ruffle
6. Lace ruffle
7. Area ruffle

Ruffles can be finished with a "baby hem" (a stitch to hold two tiny folds of fabric) or a merrow stitch, which covers the raw edge of the ruffle with a cover stitch similar to a buttonhole stitch. The merrow finish causes the ruffle to twist and turn, giving it the name "lettuce edging." Some fabrics do not need to be hemmed when made into ruffles because they do not ravel. Examples are fine cut Lycra© knits, Ultra-suede,© and felt.

Circular Ruffles

The closer the curved shape of the ruffle resembles a complete doughnut shape, the fuller the ruffle will be. The curved edge of the ruffle limits the kinds of edge finishing that can be used. The ruffle can be made double if the fabric is fine. Otherwise, it can be hemmed with an overlock stitch or edged with a fancy finishing stitch. A circular ruffle usually has a smooth, ungathered edge attached to the seam, and the ruffle makes a graceful, curved edge. The four most common circular ruffles are:

1. Large ruffles at hem
2. Cascade
3. Ruffle set into a seam
4. Circular ruffle with wired edge

Passementerie, Braids, Ribbons, Ricrac

Passementerie trim is a broad term for most kinds of braided and corded trim. Ribbons and braids are available in a wide variety of colors, styles, and prices. They range from elaborate and sometimes very wide metallic fancies (usually imported from France and Switzerland) to the inexpensive and

classic narrow soutache braid. An important characteristic to consider when choosing a ribbon or braid trim is its flexibility. A braid or ribbon woven on the straight grain must be sewn to the garment in a straight line. A straight trim may be used on a square neckline if the corners of the trim are mitered (matched at a 45-degree angle).

Straight Trims

The following are general types; many novelties are available:

1. Grosgrain ribbons (available in narrow and wide widths)
2. Satin ribbons
3. Novelty wovens

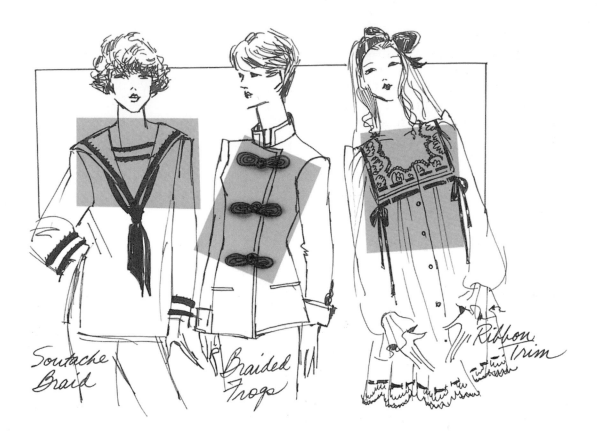

Soutache
Braid

Braided
Frogs

Ribbon
Trim

Flexible Trims

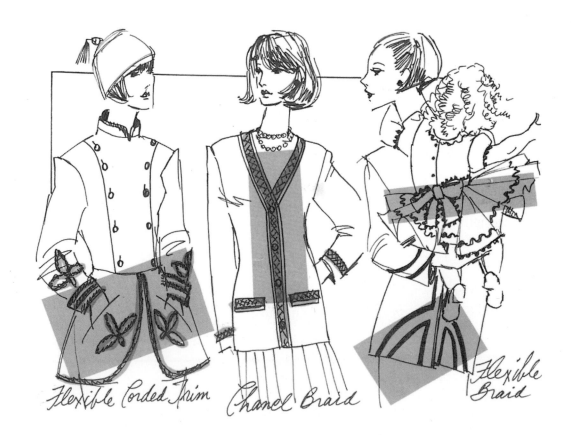

Flexible Corded Trim Chanel Braid Flexible
 Braid

Flexible Trims

Flexible trims are easy to sew around curved edges. Often, they are woven on the bias or knitted. Sometimes, these trims are flexible because they are narrow. To determine if a trim is flexible, lay it on a flat surface and try to shape it into a curve. If it forms a smooth curve with no gathers in the edges of the trim, it is flexible. Flexible trims can be sewn in a straight line. The accompanying illustration shows four kinds of flexible trims. Note that many of these examples have ethnic origins. Generally, ethnic costumes are basic in cut but are elaborately embellished with distinctive handwork.

AREA TRIMS

Area trims cover a larger expanse than linear or spot trims. Many times, the area trim can be applied to the yardage before the garment is cut out. An area trim is usually added to inexpensive piece goods because the trim greatly increases the cost of the yardage. The actual price depends on the number of stitches and the time required to apply the trim to a yard of fabric. Area trims can also be applied to a garment section after the section has been cut out. There are three major area trims:

1. *Quilting.* Fabric can be quilted with filler (a light stuffing) or without.
 a. Rail quilt
 b. Chicken wire
 c. Novelty patterns
2. *Trapunto.* A stitched design in one area of the garment that is padded for added dimension.
3. *Tucking.*
 a. Pin tucking
 b. Vertical
 c. Diagonal
 d. Horizontal
 e. Heat
 f. Side

Contrast Fabric Trim

Combining several fabrics in a single garment is another effective method of trimming. The contrasting color or print can be used as a lining or facing. The contrast will show the customer the possible combinations he or she can use to accessorize the garment. When combining prints is popular, fabric converters often design twin prints. These prints are intended

Trapunto

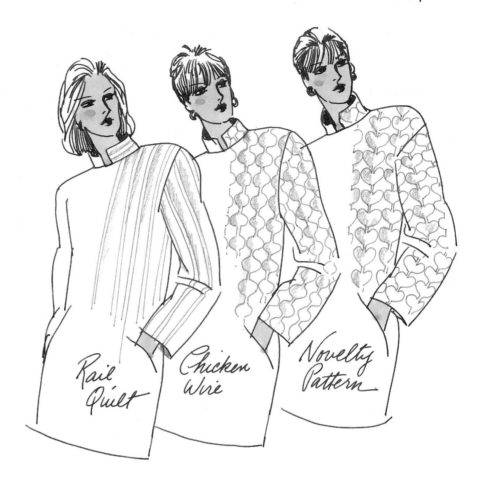

Rail
Quilt

Chicken
Wire

Novelty
Pattern

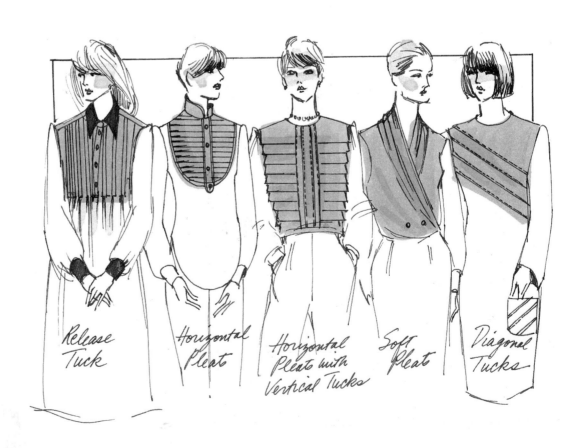

Release
Tuck

Horizontal
Pleats

Horizontal
Pleats with
Vertical Tucks

Soft
Pleats

Diagonal
Tucks

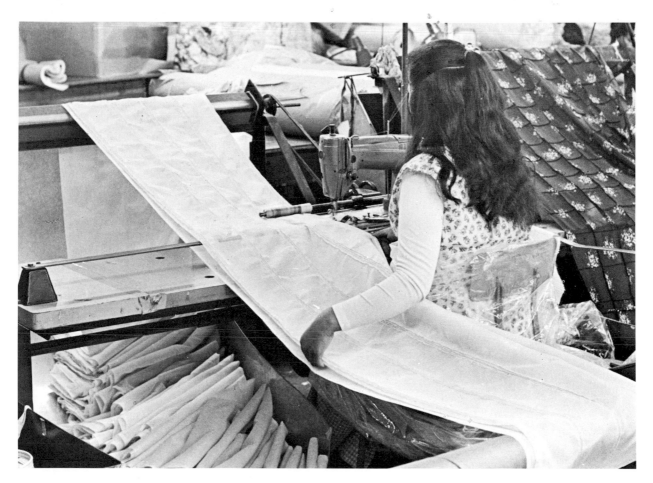

Heat Tucking
The fabric is run through a heating element that sets small tucks. A windowpane effect, like the dark fabric to the right of the operator, is also possible with this machine.
Courtesy: Mr. Pleat.

for use together, and they feature a common design motif or color theme. Two main problems may arise when several patterns are combined in one style. First, stock yardage must match the original sample. Sometimes, dye lots in stock yardage are different, so the stock yardage cannot be matched to the sample goods. Second, all fabrics used in one garment must have similar delivery schedules so the cutting will not be delayed if one pattern arrives later. A separate marker must be made for each print or pattern used. Therefore, the cost of cutting a garment that uses several fabrics is higher.

Embroidery

Embroidery may be added to uncut yardage or to a garment piece after it is cut. Each of the three types of embroidery comes from a different source. The embroidered yardage is available by the yard from converters. A specialty contractor adds the spot

embroidery trim to the garment piece after the manufacturer has purchased the fabric and cut it. Three important kinds of embroidery are:

1. *Schiffli.* A versatile embroidery technique that can cover the whole fabric or can be confined to a border or edging. The process is named for the Swiss manufacturer who invented the embroidery machines for the technique. Elaborate patterns are possible. The cost is based on the stitch count and the time needed to embroider a yard of fabric.

2. *Gross.* A spot-embroidery technique that is less expensive than Schiffli if the pattern is confined to a small space. In one design, several colors and a variety of yarns and threads may be used. The process is named after the machines that originated this type of design, though many other companies now manufacture similar machines.

3. *Eyelet.* An overall pattern (a border is optional) that is embroidered on a Schiffli machine

Classic Black Velvet Collar and Cuffs

Pile Fabric lining, Corduroy Jacket

Dressy Crepe with Satin Trim

Contrast Jacket stripe exaggerates Proportion

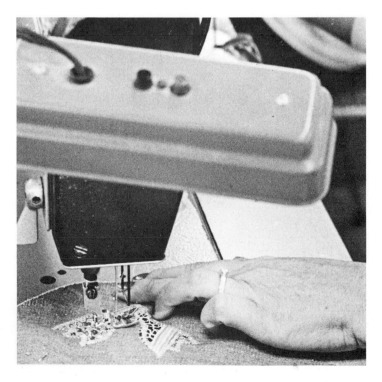

Appliqué
Decorative calico flowers have been stamped out with a die (a metal stamp in the shape of the design). Then the design is attached to the precut garment piece with an edge stitch that prevents the appliqué fabric from raveling.
Courtesy: Mr. Pleat.

with the following added characteristics (see the textile dictionary in Chapter 6 for example):

a. The classic look features white thread on white cotton-base goods (or a cotton blend).
b. Some areas of the design may be stamped out and the holes embroidered around the edge to give a lace effect.
c. Eyelet is almost always purchased as yardage. Because eyelet is a classic type of embroidery, comes in one color, and has set patterns, it is the most inexpensive fabric with allover embroidery. Typically, this fabric is used in the spring and summer.

Appliqués and Patches

Appliqués are pieces of fabric in decorative shapes that are sewn to a garment with an ornamental finishing stitch. The most effective appliqués are simple, graphic shapes that are scaled to complement the garment to which they are applied. Appliqués can be made three dimensional by stuffing tiny "pillows" and stitching them to the garment. This type of trim is particularly suitable for children's wear, but it is used in many other kinds of garments. Patches of embroidery can also be sewn on garments.

Pleating

Fabric is pleated by putting a garment piece into a manila paper pattern that has been scored with the desired pleat dimensions. The paper pattern is folded tightly along the guidelines and securely tied. Then the bundle is baked in an oven. Almost any fabric can be pleated, but unless there is some heat-sensitive fiber in the fabric, the pleats will come out when the garment is cleaned or washed. An outside contractor is almost always used for pleating. Because pleats are most frequently employed for skirts, there is a complete discussion of pleat types in Chapter 11.

Studding

Studding was first used by Levi Strauss as a means of reinforcing the seams on work pants designed for miners in the California goldfields. Strauss patented the process in the nineteenth century, but when the patent ran out, many other manufacturers used the

Appliqués
Appliqués are particularly suited to children's wear.

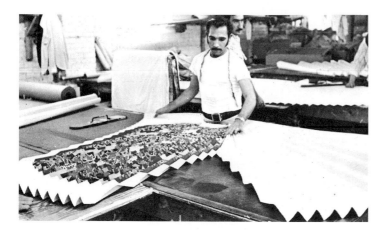

Pleating
The pleated piece is taken from the paper pattern after being baked in an oven that sets the pleats. While one piece is opened, another unpleated piece is placed in the vacated pattern and wrapped to baked in the oven that sets the pleats. *Courtesy: Mr. Pleat.*

riveting process. These early rivets fastened pockets securely and reinforced stress points, making the early denim pants very durable. Today, studding is decorative as well as functional. Types of studs include rivetlike nailheads and rhinestones. Depending on the type of stud, the garment can be sporty or dressy.

Beading

Hand beading is professionally done by using a crochetlike stitch on the backside of the fabric to attach beads and sequins to the front. The pattern shape is lightly chalk marked on the piece of fabric and stretched between two stretcher bars. A beading needle pushes the thread through the fabric to pick up a bead or sequins strung on a thread on the right side of the fabric. A professional can bead the front of a bodice in a fairly complicated design in about 10 hours.

A completely beaded dress costs several thousand dollars because of the time required to decorate it. The garment will be very heavy because of the weight of the beads and must be folded when stored. Many different fabrics can be used as the base goods, but chiffon and silks are most popular.

Several offshore resources for beaded garments have been developed. Natives have been trained to bead, and the garments they produce cost much less than a domestic garment because of lower wages.

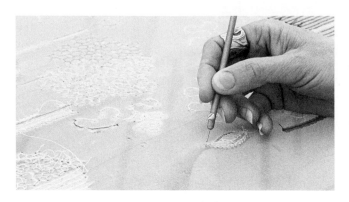

The fabric to be beaded is stretched to a frame. A crochetlike stitch fastens the bead to the fabric.

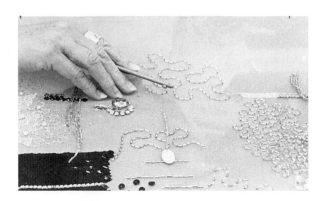

A great variety of beads and sequins can be used to decorate a garment.

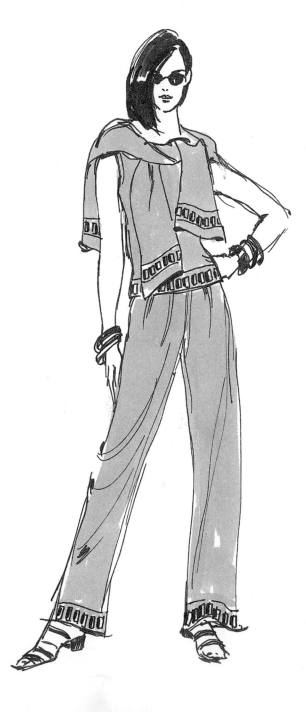

Openwork

Openwork is a design that is cut out of the fabric and edged with an overlock stitch or a corded detail. Sometimes, lace insets or transparent fabric replace the opaque top fabric.

Airbrush and Hand Painting

Airbrush designs are painted freehand or stenciled on a garment. The paint or dye is sprayed on by air pressure to achieve a subtle effect or a more commercial look. Depending on the design and technique, the garments can be dressy or very casual. Hand-painted garments are usually quite expensive. Some manufacturers have turned to the Orient for cheaper hand-painted fabric. Quality is high and the price is lower because wages are lower.

Silk Screening

A design of one or more colors can be silk-screened onto a garment. This technique resembles hand painting but without the subtle variations in shades and textures possible with hand-painted designs. The garment can be silk-screened before being constructed. The pieces to carry the design are sent to a contractor who applies the motif; then they are made into a garment. Silk-screen designs can be added to the fronts and backs of such simple garments as sweatshirts and T-shirts after they have been constructed.

Novelty inks and treatments are constantly being invented. "Puff," a thick, raised, rubberlike substance that stays on the surface of a fabric, is an example. Puff is often used to decorate novelty sweatshirts.

Heat-Transfer Prints

Heat-transfer prints are a more commercial method for putting an image on a garment. Many colors may be used. The fabric that prints most successfully with this system is polyester. First, the image is printed on a specially treated paper. Then it is transferred to the fabric by a machine that applies heat to the paper and fabric. This inexpensive method is often used on T-shirts.

Summary

The trim selected for a garment should make it more salable. The trim must be of an appropriate price and applying or buying the trim should not delay production of the garment. Some apparel categories, like children's wear and loungewear, utilize trims more than other apparel.

A collar is an added piece of fabric that surrounds the neck and is attached to the neckline of a garment. Four styling factors determine how a collar looks: distance from the base of the neck, height of the stand, shape and depth of the fall, and shape and size of the refer, if used.

The shape of the collar determines the height of the stand. Curved collars conform to

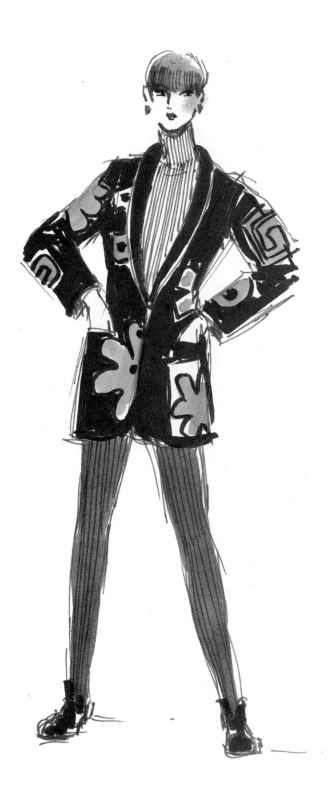

the neckline and lie flat on the shoulders. Straight collars tend to stand up and frame the face. Band collars stand straight up from the neck and may be detailed or plain. Soft band collars are often tied to form neckline bows or ascots. Revere collars incorporate part of the bodice as a turn back. Peter Pan collars are youthful and may be enlarged to form Buster Brown or Puritan collars. Cowl necklines and collars are formed by a bias drape at the neckline. Middy, Bertha and hoods are additional ways of finishing the neckline. Necklines accent the shape of the face and focus attention on it.

Belts are popular when fashion defines the waist. Belts can be placed under the bust or at the waist or hip. Belts are usually made by an outside contractor, and a large variety of belts is available. The garment designer collaborates with the belt sales-person or designer to create a belt appropriate for the garment.

Pockets can be functional or decorative. The placement of pockets is crucial to the look of a garment. Pockets can be used symmetrically or asymmetrically, and the size and placement should complement the scale and design of the garment.

A great variety of fastenings is available for garments. Buttons are decorative and available in an infinite variety of styles, shapes, and sizes. Zippers are functional fastenings and are most often used as hidden closings. Snaps and hardware closings are appropriate for sportswear and casual garments.

Linear trims accent edges and seam lines of a garment. Topstitching is the most subtle of these. Binding, passementerie braids, cording, and ricrac (a trim woven in a zigzag pattern) are typical linear trims. Elastic multineedle stitching and smocking are used to shape a garment and add fullness.

Area trims change the look of the fabric. Quilting, especially when a heavy filler is used, creates a warm garment that insulates the body well. Trapunto is an area application of quilting technique. Contrasting fabric, appliques, and patches are effective trims. Embroidery can be applied to the fabric before purchase or added to a garment or cut piece by an outside contractor. Pleating is an effective way to style heat-sensitive fabrics. A great variety of patterns is available. Beading is the most expen-

sive trim, and professional beaders use the crochet method to attach sequins or beads to fabric. Inexpensive sequined fabric is machine stitched before a manufacturer purchases it. Airbrush and hand-painting techniques are art trims that can be simulated by the less-expensive silk-screen process.

Review

WORD FINDERS

Define the following words from the chapter you have just read:

1. Beading
2. Bertha Collar
3. Bias belt
4. Boat neck
5. Bound buttonholes
6. Break line
7. Buster Brown collar
8. Contour belt
9. Cowl
10. Extension
11. Flap pocket
12. Full-ball button
13. Hardware
14. Interfacing
15. Intimate apparel
16. Jewel neckline
17. Lacing
18. Lettuce edge
19. Leading edge
20. Line
21. Loop button fastening
22. Mandarin collar
23. Mitered collar
24. Mother-of-pearl
25. Passementerie
26. Patch pockets
27. Peter Pan collar
28. Placket
29. Revere collar
30. Schiffli embroidery
31. Shank
32. Silk screening
33. Slashed pockets
34. Soutache braid
35. Spaghetti
36. Stand
37. Twin print
38. Welt pocket

DISCUSSION QUESTIONS

1. What factors must a designer consider when selecting a trim?
2. What are the three belt shapes? What materials can be used to make a belt?
3. Name and sketch 10 pocket details.
4. What are the most common materials buttons are made from?
5. What stress points on a jacket require a button?

Unit 3

Specialty Design Categories

CHAPTER **8**
Children's Wear

Until the late nineteenth century, children were dressed like miniature adults, with little thought given to designing flattering or comfortable garments for them. Children's clothes were usually made by a family member or dressmaker. Mass production of children's clothing began in the 1870s, but these early garments were simple basics with little style or imagination. During the 1920s, the children's wear industry began to create innovative, stylish garments and found a ready market for these among parents in the middle and upper classes.

This enthusiastic response for well-designed children's wear has continued during the twentieth century. Styles evolve more slowly than those for women's wear and often reflect general fashion trends but also undergo developments unique to the children's wear industry.

Children's wear is divided into four large categories: practical and dressy, price conscious and upscale. Practical clothes for daily living is the largest-selling category. These clothes must be sturdy, relatively inexpensive, and easy to wash. Another important customer has developed during the 1990s: affluent parents and grandparents, devoted to purchasing upscale designer children's wear. Manufacturers such as OshKosh B'Gosh, Esprit, and Guess? Kids have opened retail outlets. Specialty stores focus on high-fashion merchandise, while the department store carries more traditional styles.

Parallel to this development is the popularity of budget children's wear including recycling apparel. Resale and recycling of children's wear flourishes because children outgrow apparel more often than

When you have read this chapter, you will understand:

1. Commercial seasons used in children's wear.

2. Sources of children's wear inspiration.

3. Fabric most appropriate for children's wear.

4. How trims are used to decorate children's wear.

5. Size ranges for each category of children's wear.

6. How to utilize proportion to design the most flattering garments for each age.

7. Classic garment styles for children.

they wear it out. Budget children's wear is fashionable, well made, and quickly emulates more-expensive merchandise. A large percentage of all children's wear is made offshore.

Children's wear separates are very practical because they can be interchanged to allow for growth and combined to make many different outfits. Comfortable, durable fabric, sturdy construction details, and functional trims are the hallmarks of practical playwear, outerwear, sleepwear, and active sportswear that make up the bulk of this category.

Dressy garments and specialty items are the second category of children's wear. This merchandise is often designed for gift giving and must appeal to a grown-up customer as well as to the small fry. Practicality is second to eye appeal. Customers tend to be less price conscious when purchasing fancy clothes, but practical considerations cannot be ignored. Handmade details, fancy trims, and luxury fabrics are typical of dressy garments.

CHILDREN'S WEAR SELLING SEASONS
Fall/Back-to-School

This is the largest shipping season in the 7 to 14 size range, featuring sportswear and dresses appropriate for school-age children. More working mothers with toddlers and preschool children in child care or nursery schools are making this a more-important season for the smaller sizes also. Sleeves are long for both boys' and girls' casual tops. Outerwear manufacturers plan their largest lines for fall. This merchandise is received in the stores in July, and sales continue through October.

The most important items during the fall season are:

> Tailored dresses and spectator sportswear
> School uniforms
> Outerwear, including casual styles and the dressy coats
> Some dressy goods for formal occasions
> Shoes and accessories
> Sweaters and warm tops
> Turtleneck T-shirts and long-sleeved knit tops

Typical fabrications are:

> Corduroy, denim, washable poly/cotton wovens
> Flannels, dark cotton prints
> Fleecy knits, cotton knits, and blends

Washable woolens, plaids, and coating fabrics
Full-fashioned knit sweaters and yardage in
wool blends and acrylics
Quilted and bonded fabrics

Holiday

This season features dressy garments and attractive
novelty items for gift giving. Catalog business is im-
portant for the item manufacturer during this sea-
son. Merchandise is shipped to the stores in
October–November and is marked down by the first
of the year. Color palettes are typically primary,
with emphasis on bright red and black, blue, or
dusty (muted shades) pastels, previewing coming
cruise wear.

Typical garments for this season include:

Dressy dresses and suits for boys
Sweaters, fleecy sweatshirts, and novelty tops
Sleepwear and robes
Active sportswear, especially for cold climates
Outerwear items such as coats, car coats, and
duffels
Unusual items, such as rabbit-fur jackets and
other novelties

Typical fabrications include:

Velveteen, velour knits
Acrylics and acrylic blends, winter-theme knits
Wool and wool blends, especially colorful tartans
Sheers for party looks
Taffeta, voile organdy, cotton chintzes, and
other fancies for party dresses and tops

Cruise/Spring

A small percentage of merchandise is designed for
early delivery, often testing the market to deter-
mine the best-sellers that will continue through late
spring deliveries. Some cruise merchandise is
shipped to the store for holiday catalog selling, but
the bulk of merchandise arrives in late January and
deliveries continue through April. The color palette
changes radically, with emphasis on softer brights
and pastels. White and navy combinations are typi-
cal of early spring. Bright pastels and floral cotton
dresses begin to sell and continue selling through
Easter. Party merchandise for Easter is an impor-
tant category for both boys and girls. White dressy
dresses sell for June confirmations.

*Holiday Item
line feature
upscale gift
items for
children.*

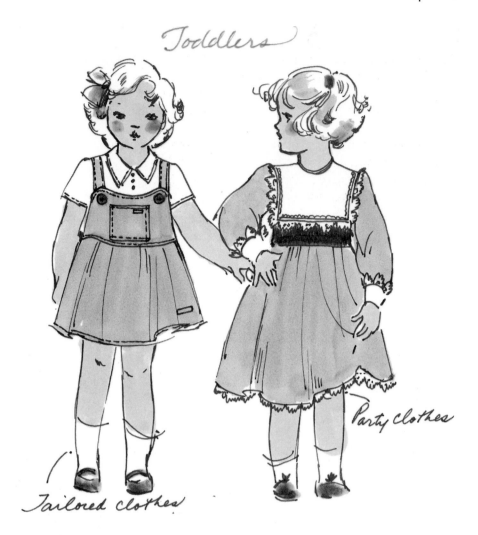

Toddlers

Tailored clothes

Party clothes

Typical garments for this season include:

Swimwear and active sportswear for warm-weather activities

Sportswear in lightweight fabrics with short-sleeved shirts

Party looks, sometimes a duster and dress combination as well as fancy sheers, cotton prints, and pastels

Tailored dresses

Lightweight jackets

Sweaters in acrylic or cotton

Typical fabrics for this season are:

Base goods in lighter-weight woven cottons and blends

Denim, poplin, and sailcloth

Cotton prints in woven and knits

Pastel acrylics and washable wools

Novelty cottons like eyelet, seersucker, and so forth

Summer

This is a small line for most manufacturers. This is the time to capitalize on successful spring styles by recoloring them into summer colors and recutting them. Hot-weather items such as sunsuits, halters, and shorts are added to the line. White is an important color, often mixed with brights. Summer apparel is shipped to the stores in April and is often marked down by June. Swimsuits usually go on sale in July and are promoted through August.

Typical new garments for the summer season are:

> Sunsuits, shorts, rompers, and bare sundresses
> Beach cover-ups and bathing suits in the early summer

Typical fabrics added to the spring lines are:

> Terry cloth, cotton single knit, and jersey
> Gingham, cotton prints, pique

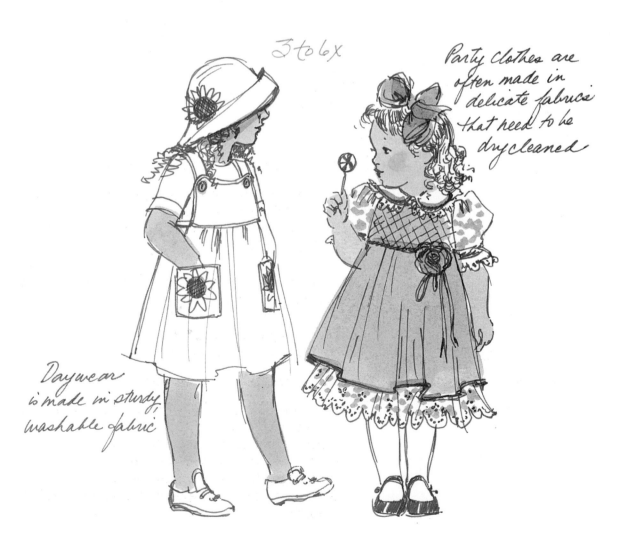

3 to 6x

Party clothes are often made in delicate fabrics that need to be drycleaned

Daywear is made in sturdy washable fabric

FIBERS MOST OFTEN USED IN CHILDREN'S WEAR

Natural Fibers

Cotton

Cotton and cotton blends are the fibers most widely used in children's wear because they are inexpensive, colorful, comfortable, and available in a great variety of styles and weights in both woven fabrics and knits. Pure cotton worn next to the skin is soft and absorbent, ideal for T-shirts and underwear. Cottons can be layered or quilted for greater warmth during the fall and winter. Heavyweight, durable twills, denims, and plain weaves are made into sturdy sportswear. Cottons can be woven into fine lawn, voile, and organdy for dressy goods. Technology has improved many of the problems inherent in the fiber. Blends, most often 50/50 or 65/35 polyester/cottons, resist wrinkling. Fading and shrinkage can be controlled with special finishes. The importance of washability cannot be overstressed when selecting fabrics for children's wear. Cottons are easy to wash and iron, reducing maintenance costs to a minimum. Finally, they are easy to sew, with few construction problems.

Wool

Wool is a versatile fiber that can be woven into warm, colorful fabrics appropriate for coats, dresses, and sportswear. Wool tends to be more expensive than other fibers and can be scratchy for delicate skins. Most woolens must be dry-cleaned, which is an impractical and expensive way to maintain children's clothing. Blending wool with synthetic fibers solves many of these problems. Blends of acrylic, wool, and polyester are less expensive and are woven into attractive plaids appropriate for back-to-school clothes. Several mills have developed washable wools, which are the most acceptable wool fabric for children's wear. Specialty knit sweaters are often worn as outerwear, over a T-shirt to eliminate the itchy surface, or blended with acrylics or furs to create a softer yarn. Some wool blends are washable. Wool is still used for expensive children's wear but is much less popular than cotton.

Synthetic Fibers

Acrylics

Acrylics have a woollike look and hand. They can be woven or knitted into a great variety of fabrications appropriate for children's wear. Acrylics are

less expensive than wools and wash well. The main drawback to this fiber is a tendency to pill and to have a stiff hand if wovens are not finished properly. This fiber is the most substituted for wool looks.

Rayon

Rayon is a cellulose fiber that can be woven into colorful, soft, absorbent fabrics. New finishes have improved the washability of rayons. Rayon is blended with cotton to create a less-expensive-base goods. Rayon has limited acceptance in children's wear because it loses its body when washed. Rayon is used most frequently for girls' wear that imitates junior styling, where it is a highly accepted fiber.

Polyester

Textiles that are made of 100 percent polyester have several drawbacks that make them less desirable for children's wear. Many are nonabsorbent and do not breathe. Polyester is highly desirable when blended with natural fibers because blends have the positive properties of both fibers used.

Cotton knits are durable and comfortable

Poly/cotton blends wash well, resist wrinkles, are comfortable, and can be dyed bright colors. Poly/cotton blends do not have to be ironed when finished properly, a great asset to the busy mother.

Polyester fleece fabrics are popular outerwear fabrics because they are light weight, washable, warm, and can be dyed into clear, bright colors. PolarTec®, a fleece fabrication from Malden Mills, is recycled from plastic soft-drink containers. Polyester knits blended with Lycra are the most widely used children's swimwear fabrication. These knits stretch easily and can be dyed and printed in bright colors. They dry quickly and are resistant to chlorine and salt water. Their major drawback is a tendency to pill after hard use. Stretch fabrics are also popular for children's active and dance wear.

Nylon

Nylon is used for cold-weather clothes and ski suits. Nylon wovens are impervious to moisture and can be worn over several layers of cotton or wool clothes to keep warm air close to the body. Nylon quilted with a polyester fiber or down filling and a lining layer creates the warmest clothes. Nylon garments are machine washable. Nylon is inappropriate for warm-weather clothing because it does not allow the body to breathe.

TRIMMING CHILDREN'S WEAR

The proportions appropriate for children's garments are quite limited. The same basic bodies are used for seasonal dresses and playwear, and designers must rely on fabric changes and trimming to create a new look. A wide variety of trims is used on children's wear, from simple embroideries to lace edgings and elaborate knit jacquards. *Proportion*—the amount and size of the trim—is crucial to the success of the garment: Too much of a good thing will dwarf the child, and the garment will have limited success.

Trimming garments for infants and toddlers requires special care because infants tend to put everything into their mouths. Fastenings must be firmly attached to the garment, and for this reason gripper snaps are highly desirable—they cannot fall off like buttons. Zippers must be soft and flexible so that they do not irritate delicate skin. Small trims should be embroidered or sewn securely to the garment for this age group.

Durable trims must be used for children of all ages with the exception of christening gowns or spe-

cial-occasion dresses. The size of the trim must be compatible with that of the garment fabric. Elastic should be able to withstand hot-water washings. The motif chosen for appliqués and embroideries should be appropriate for the age and sex of the child. Paint or applied chemicals should be non-toxic when used on infants' or toddlers' clothing. Drawstring ties should be avoided on necklines.

Machine-made trims dominate the domestic budget-to-moderate market, but imports often feature such handmade trims as smocking or embroidery. Generally, the most successful commercial machine-made trims try to imitate expensive

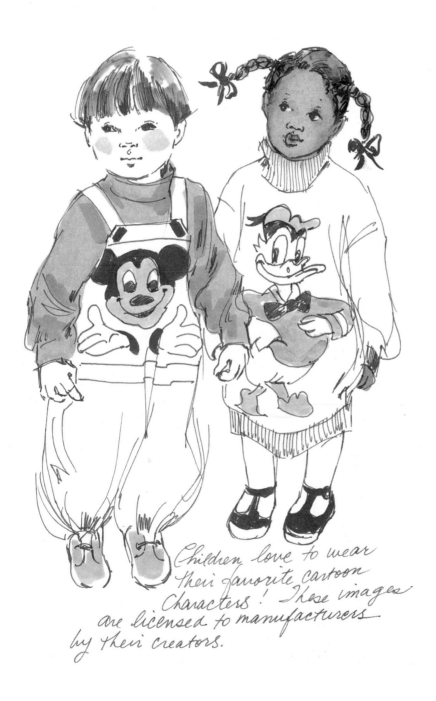

Children love to wear their favorite cartoon characters! These images are licensed to manufacturers by their creators.

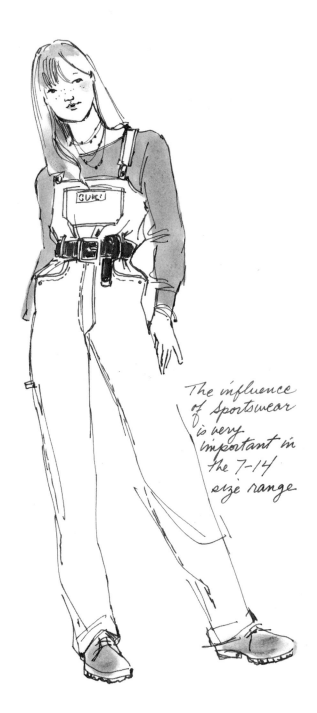

The influence of sportswear is very important in the 7-14 size range

handmade trims. Cost is an important consideration when selecting a trim. The trim cannot raise the cost of the garment to the point where it is too expensive; yet a cheap-looking trim will almost surely detract from salability of the garment.

The two most widely used kinds of trims for children's wear are embroideries and appliqués. Motifs appropriate for the age of the child add color and whimsy to a basic garment. The scale of the motif is important. A tiny garment will be overwhelmed if the embroidery or appliqué is too large or poorly executed. Children love to wear pictures of their favorite cartoon characters. Most famous images, such as the Disney or *Sesame Street* characters, must be licensed by the children's wear manufacturer, who pays a premium to the creator of the cartoon character to use it to sell garments.

Lace of all kinds is used to trim girls' dresses, blouses, and sleepwear and to edge garments as a substitute for hemming. Lace makes beautiful insets. Gallons (double-scalloped lace) is a favorite trim. Eyelets are used for dresses and blouses. Flimsy synthetic laces should be avoided for better garments because they will be destroyed in the first wash. Cotton laces and eyelets are sturdy, attractive, and compatible with many cotton base goods.

Passamenterie trims, in particular ricrac, embroidered tape, and soutache, are popular, especially when peasant fashions are in style.

Combining two prints or compatible colors in one garment is an inexpensive trim technique that is very appropriate for children's wear. The fabric must have compatible care properties. A linear trim is often used to tie the two elements together.

ORGANIZING A CHILDREN'S WEAR LINE

Review Chapter 5 to refresh your memory on organizing a line. Children's items, dress, and sportswear lines are developed in exactly the same way that women's wear lines are. The only difference lies in selecting fabrics appropriate to children's wear and using the typical garments mentioned above to structure the lines.

SOURCES OF INSPIRATION

The junior market greatly influences the children's market in the 4 to 6X and 7 to 14 size ranges.

Members of this group identify with older sisters, brothers, and classmates and definitely want to dress like the group they associate with socially. Heroes, especially music idols and movie stars, often start fads with this age group. Smart designers constantly study their customers at school and leisure to keep up-to-date with the latest fads.

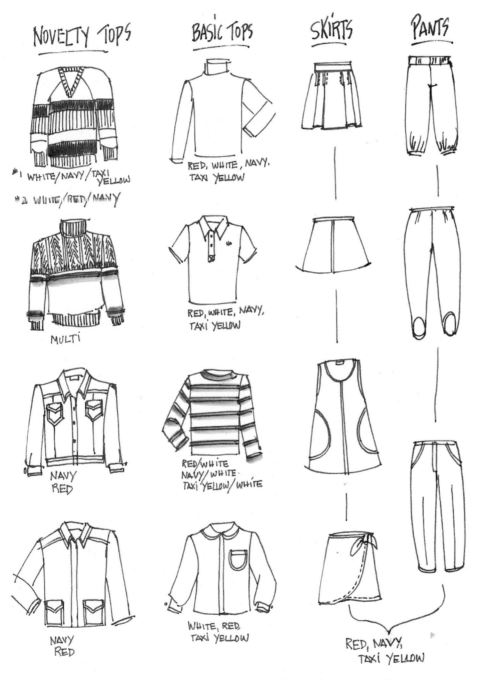

Coordinated sportswear groups have bottoms that can be sold with several tops in the group to encourage multiple purchases.

Younger children are less affected by the junior market. The proportion of their apparel demands a unique approach. Fashion trends tend to change more slowly for the younger child but do echo general fashion trends in the market. For example, when Lacoste shirts were hot for adults, they were for children too.

Some adult firms, for instance Guess? jeans, have had tremendous impact on the children's wear market and have started their own lines for small fry to capitalize on the success of their adult products.

Generally, children's wear designers must stay aware of the whole market by reading fashion magazines, shopping the stores, and constantly observing and researching their customers. Especially relevant periodicals include the following:

WWD and *Apparel News* feature occasional reports on the children's wear market. *Children's*

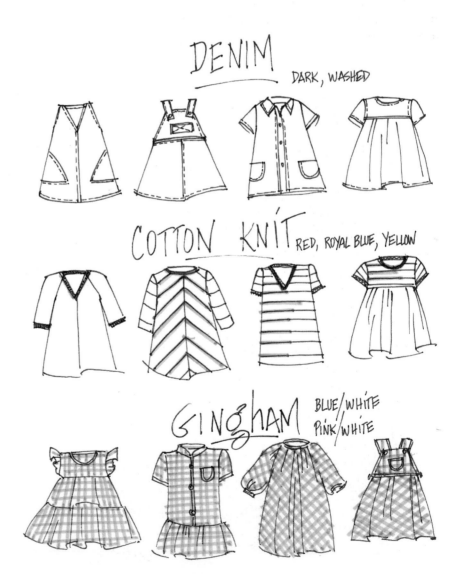

Dress lines should offer enough diversity to sell several items in each group.

Business—published monthly by Fairchild; covers children's apparel, footwear, toys, and licensing

Seventeen, Elle (both domestic and French editions), *Lei,* and occasional children's wear issues in *Town and Country,* feature upscale children's wear from foreign and domestic designers. *Here and There, Report West,* and other select fashion reports—carry information on children's wear

Vogue publishes *Bambini* in Italy, a very influential, high-style children's magazine.

Children's television and movies—offer many clues to current fashion trends and favorite images.

CHILDREN'S WEAR SIZE CATEGORIES

The problems in designing children's wear are very diverse. Consider that the typical infant at birth is approximately 23 inches long and weighs 8 pounds.

Children love to dress up and pretend to be their heroes.

A teenage girl still shopping in the children's wear department can be 5 feet 4 inches and weigh more than 100 pounds. Children's sizes are arranged in groups that are typical of one body type. This makes designing and buying children's wear easier too.

Clothes for boys and girls are remarkably alike for infants and toddlers. The main difference between the sexes is color and trims; also boys have narrower hips than girls, so their pants fit differently. A manufacturer in these size ranges usually makes clothes for both boys and girls, and stores sell the merchandise in the same departments. Separate styles for boys and girls are designed for all size ranges, but unisex apparel is made until the 7 to 14 size range. Boys' apparel resembles men's styling and has similar manufacturing and styling

Boy's wear often adapts classics from men's wear.

problems. Teenage girls grow toward the young or "bubble-gum" junior department, which is imitative of trendy junior apparel.

It is important to consider each of the four size groupings of children's wear separately because the requirements for each age are so diverse and children's figures change so dramatically as they grow from infants to teenagers.

Infants

The size range for this category is:

> 3-month, 6-month, 9-month, 12-month, 18-month or Small (S), Medium (M), Large (L), Extra Large (XL)
>
> Sample size is 12-month or medium.

The parent selects the garment for the infant and looks for the following things when buying practical, everyday garments:

> Soft fabrics to avoid scratching tender skin; cotton knits and soft wovens such as flannel are best. Avoid synthetics next to the skin.

Total washability.

Soft layers of fabric to keep the body warm because babies chill easily and extra care is required to insulate the body properly. Clothes should stretch and not restrict movement.

Clothes should be slightly large to allow for growth but not so bulky that they inhibit movement.

Openings should be large enough to dress the infant with ease, and there should be easy access to the diaper in all garments.

All fastenings and trimmings should be firmly secured to the garment, with no long drawstrings on the garment and none at the neck.

Attractive and colorful garments.

Gift giving is a large category for this size range of apparel. Gifts are often chosen because they are attractive rather than practical. Fine details, delicate lace trims, painstaking hand finishes, and beautiful fabrics sell well to grandmothers and other well-wishers. Career women often are able to buy more-expensive children's garments because they have delayed motherhood to achieve a higher family income.

Typical garments for this size range include:

Gowns, kimonos, wrappers

T-shirt and diaper-cover panties, bibs

Sleepers, blanket sleepers, coveralls in stretch fabric

Pram bags, buntings, crib accessories

Crawlers, sunsuits, and overalls for larger children

Sweaters, knit outerwear T-shirts

Accessories include hats and bonnets, soft shoes, socks

Fancy dresses, suits, and christening gowns

Blue for boys and pink for girls are traditional colors that are often the only distinguishing feature between the sexes, but traditional colors are becoming less important. The variety is great, but pastels are most salable because they complement the baby's delicate complexion.

Embroidery and appliqués are very appropriate trims for this type of clothing because they are compatible with the care of the shell fabric. Small, delicate prints are an attractive choice for infants' clothing.

INFANCY— ONE—SIXTEEN MONTHS

Bib

Sack

Tee Shirts

Diaper Cover

Coverall or Jumper sleeper

Customers look for washable fabrics; small delicate details; delicate colors and baby themes; diaper access; comfortable, stretchy fabrics; and clothes that are easy to put on.

Avoid drawstrings and long ties that could choke a baby, small, hard-to-button details, and necklines that are too small for baby's big head.

The smallest size ranges require a delicate design eye to scale the trims and garments to the infant. The designer must picture the baby on its back or being held. Fit is important so that the edges of the garment do not bind the baby. Trying all garments on an actual child to check the fit is essential to proper fit. Garment forms are rigid and upright and do not reflect the fact that a baby's legs are usually bent. A realistic doll is often used to establish the preliminary fit of a garment and to model the garment in the showroom or store.

Toddlers

The size range for this category is:

1T, 2T, 3T, 4T
Sample size is 3T.

The size does not always conform to the age of a child. Different children experience varied growth rates and may wear a size or two larger than their age. A mother often finds that her child wears a smaller dress size and a larger sportswear size. The toddler size range is designed for the child who is crawling and beginning to walk. Room for the diaper and a snap-crotch pants are still factors, as most children are not toilet trained until the age of 2+ or 3 years.

Basic items may still be unisex, but many garments are specifically designed for boys or girls.

Children need active wear that's durable and colourful!

Boys' pants are cut with a front placket from size 4T on. Boys' clothes are more tailored than girls'.

The parent still dominates the clothing selection early in this period, but by the age of 2 or 3 the child begins to have definite likes and dislikes. Color is very important. Research has determined that children recognize bright colors, especially red, at an early age. Red tends to make them more active. Perhaps this is the reason that toddlers often prefer bright, primary shades. Older toddlers can begin to dress themselves, and the ease of putting on a garment is important to encourage self-confidence. Buttons should be large enough to be grasped by small fingers. Pull-on pants, elastic, and Velcro closings encourage

Designers use small and large contrasting proportions to make a child taller, or garments with no horizontal divisions. Elasticized waist bottoms are comfortable and practical. Overalls and jumpers and layered clothes are comfortable and flattering. Avoid two-piece outfits with tuck-in shirts and natural waistlines that emphasize the tummy.

independence. Sturdy zippers with large pulls are good for sportswear pants.

Typical garments for this size range are:

Unisex overalls and pull-on pants, usually with reinforced knees

T-shirts, woven shirts, and blouses; sweatshirts and sweaters

Dresses, both tailored and dressy, are easier to wear than skirts; sunsuits and sundresses

Eton suits for boys, traditionally worn with short pants

Jackets, ski suits, and tailored coats for special occasions

Accessories, hats

Underwear and sleepwear

Active sportswear, such as bathing suits, leotards, etc.

overalls · Shift · Dropped Torso · Princess · Stretch leggings · Sweatshirts · Shorts · Skorts

The toddler designer must create garments that make the child attractive and emphasize the positive aspects of the typical child's figure. Children between the ages of 2 and 4 have a flexible spine that curves inward, allowing the tummy to protrude. They have narrow shoulders and large heads. Early in this period, the legs are often bowed until walking strengthens and straightens them. Successful garments emphasize the positive aspects of the toddler's figure by making it seem cute instead of awkward.

Proportion is an essential part of designing a successful toddler's garment. The overall is a successful garment for this age because it makes the child seem taller by means of a single color and vertical style lines. Overall and jumpers hang from the shoulder and cover the protruding stomach. Two-piece garments, even with elasticized waistbands, tend to ride below the tummy, allowing a wedge of skin to appear between the top and pant. Longer tops camouflage this but also overwhelm the small

figure. Dresses are most effective when they are shifts, with no horizontal divisions, or when the waistband is raised above the tummy. A yoke shift has a small area contrasted with a larger one and makes the figure seem taller. An unfitted princess dress creates a long expanse of color reinforced with vertical style lines and flatters most little girls' figures. A trickier style is the drop waist. The torso must be two or more times the size of the ruffle to create a pleasing proportion. The common denominators in these styles are a long, uninterrupted garment with horizontal style lines (overall, shift, and princess) or a small area contrasted with a large area to make the child seem taller. The most effective length is mid-to-high thigh. Enough leg is visible to make the child seem taller. Avoid proportions that divide the figure in half. The child will seem heavier and shorter.

There is great latitude in selecting colors for this size range. Bright primaries, medium brights, or pastels are equally effective. Dark colors can be attractive for special-occasion dresses (picture a black velveteen dress with a white lace collar). Even dark neutrals have their place in basic bottoms for boy's wear. Traditional seasons for dressy garments are holidays and Easter. The huge back-to-school rush is softened for this size range but is becoming more important to mothers who work and place their children in day care. Active sportswear begins to be produced for this age range but remains a relatively small business.

Young Children

The size range for this category is:

> 3 to 6X (X means extra large size 6)
> Slims, regular, and husky used for boy's wear
> Sample size is 5.

Young children grow rapidly and are very active in this size range. Practical clothes no longer have to have diaper room. They should be sturdy, with reinforced knees to protect the active child. All clothes should be easy to put on because this is the age of independence and young children want to dress themselves completely. Clothes should have large hems. Shirts should be long to allow for torso growth. Sleeves that have roll cuffs are very practical because they can be lengthened.

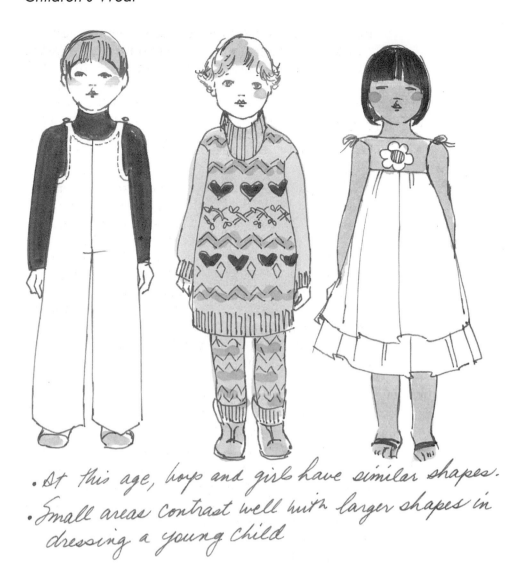

- At this age, boys and girls have similar shapes.
- Small areas contrast well with larger shapes in dressing a young child

Most manufacturers specialize in either boys' or girls' clothing from this stage on. Unisex items such as jeans, overalls, sweats, and T-shirts are worn by both sexes but are sold in different departments.

Young children are usually interested in selecting clothes after the age of 4 or 5. An older sister or brother or older school chums influence clothing purchases. The junior market is an important trend-setter for girls' wear from this period on. Bright colors, favorite cartoon characters and heroes, and peer-group pressure influence the child's selection of clothes. Mothers look for practical, attractive, sturdy play clothes that will fit the child for many months or can be passed on to younger brothers and sisters. Trendy apparel sells well for this size range, especially to two-income, affluent families where the

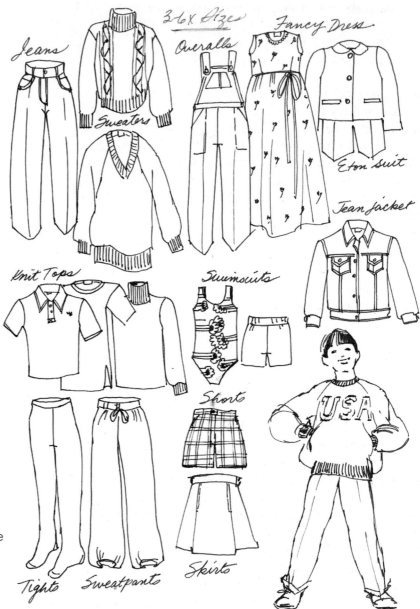

Separates that allow for growth are important so that both boys and girls can mix-and-match their clothes. Protective coverings such as reinforced knee patches lengthen the life of pants. Active sportswear and specialized apparel sell well to this age group.

mother works and the child is enrolled in day care from an early age.

Typical garments for this size range are:

Pants, usually clearly designed for each sex, with front zip plackets and reinforced knees for boys. Girls may wear similar play clothes but with feminine details.

T-shirts, woven shirts and blouses, sweatshirts, sweaters

Dresses, both tailored and dressy

Skirts and jumpers

Suits and sports coats for boys' special occasions

Bathing suits, active sportswear for both sexes

Jackets, ski suits, tailored coats for girls, and
 miniature overcoats for boys
Accessories, hats, purses
Underwear, sleepwear, and robes

Boys' apparel from this age on is very reflective of
trends in general men's wear. Girls' wear must still
be designed to camouflage figure problems by em-
phasizing height with unbroken horizontal lines
and contrasting small proportions with larger
ones. Usually, the stomach slims down and the
spine strengthens as the child grows. Waistlines
become more defined, and two-piece items are
more practical.

Older Girls

The size range for this category is:

7 to 14
Slim and regular are used by some jeans man-
 ufacturers.
Sample size is 10.

This age child loves to dress like older girls, so the
influence of the junior market is vitally important.
Peer pressure is great and fads often sweep through
manufacturers of 7 to 14 apparel. Many children are
very modest and want to dress to camouflage their
newly developing figures until they can get used to
them. For example, the tank bathing suit is the
basic body style for this age range.

The school cycle is very important in the 7 to
14 size range. Dress codes, the school calendar, and
typical school social events influence the variety of
clothes needed. Uniform manufacturers do excellent
volume in this size range, continuing into adult sizes
as the child matures and goes to high school. Public
schools began to require uniforms in an attempt to
curb gang identification and remove social barriers
created by apparel. This practice has been so effec-
tive that it is likely to increase in coming years.

Comfort and practicality continue to be impor-
tant, with special emphasis on easy-care garments
because family life is hectic as children grow and
their activities increase. There is an equal commit-
ment to clothing selection between parents and chil-
dren at this stage, with children beginning to
dominate the aesthetic part of the selection and par-
ents contending with practicality and expense. Peer-
group pressure to wear accepted designer labels

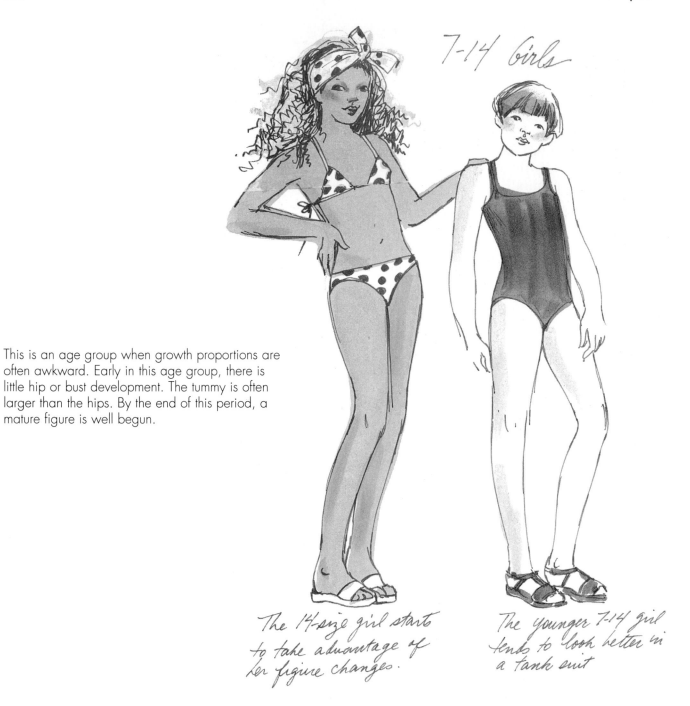

7-14 Girls

This is an age group when growth proportions are often awkward. Early in this age group, there is little hip or bust development. The tummy is often larger than the hips. By the end of this period, a mature figure is well begun.

The 14-size girl starts to take advantage of her figure changes.

The younger 7-14 girl tends to look better in a tank suit

begins to influence children's clothing selection at this age.

Typical garment categories for this age are:

Spectator sportswear, including specialty items like sweaters, related jackets, and so on.
Tailored dresses, skirts, and tops
Dressy garments, dresses for girls and suits for boys
Active sportswear of all types

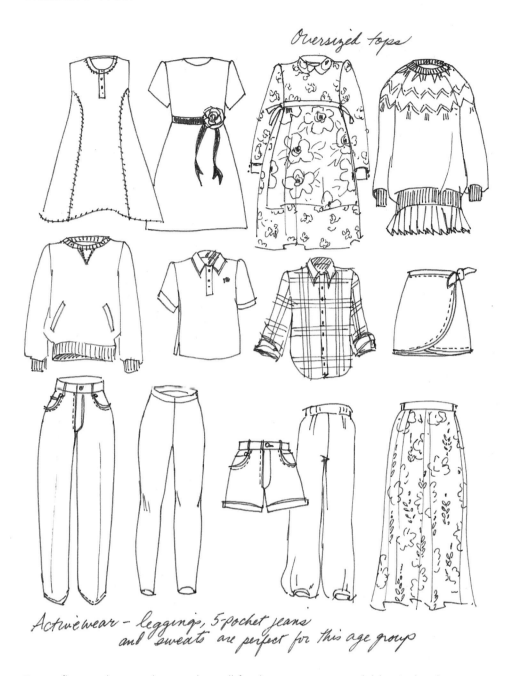

Oversized tops

Activewear – leggings, 5 pocket jeans and sweats are perfect for this age group

Camouflaging the waistline works well for this size range as children's development varies. Slender children are attractive in tuck-in tops but are usually so active that the tops are difficult to keep inside bottoms.

Outerwear, both sporty and dressy
Underwear
Sleep and loungewear
Accessories

Children wearing sizes 7 to 14 often have awkward proportions. Legs usually grow first and the torso lags. Girls begin to develop hips and bust lines as

early as 11 and usually have mature figures as they approach 14. Preteen or "bubble-gum junior" apparel fits a girl better than children's apparel once she begins to develop a mature figure. Clothes for this age range must be flexible so they can camouflage awkward proportions and emphasize the positive aspects of each stage of growth.

Two-piece items, or jumpers layered over tops, are very functional. Simple princess-line dresses and shifts will fit more girls than dresses with a snug waistline. When oversized silhouettes are in fashion, they are very effective in hiding awkward proportions.

During this transition period, the designer must create versatile, attractive, well-proportioned garments that reflect junior styling. Special emphasis on researching fashion trends in teen magazines like *Seventeen* and *Teen* as well as general fashion trends is important.

Summary

Children's well-designed, mass-produced clothing began to be produced early in the twentieth century. The two most important categories are casual, practical play clothes and dressy garments.

Children's wear is designed for fall, or back-to-school; holiday; cruise/spring; and summer. Cotton is the fiber used most in children's wear because it is washable, versatile, practical, comfortable, attractive, and inexpensive. Wool and wool blends have a limited use for fall and outerwear lines. Acrylics are often substituted for wool in children's apparel and sleepwear. Polyester is blended with natural fibers to improve their practicality. Rayon has a limited use in children's wear and is used in cotton/rayon blends as a shirting. Nylon is used in outerwear and active wear.

Trim is an important practical and decorative addition to children's wear. Basic bodies are repeated, and trims are used to give them variety. Trims should be appropriate for the age of the child and must be compatible with the base fabric for washability. The two trims most widely used for toddlers and young children are appliqués and embroidery. The price of the trim must not inflate the final price of the garment too greatly, or it will not be purchased.

There are four main size ranges for children's wear: Infants—3 months to 18 months; Toddlers—1T to 4T; Young children—3 to 6X; and Children—6 to 14. Each size range has unique proportions and practical considerations that the designer must constantly keep in focus in order to design garments appropriate for each stage in the child's development.

Review

WORD FINDERS
Define the following words from the chapter you have just read:

1. Acrylics	8. Lycra© spandex
2. Back-to-school	9. Overalls
3. Bunting	10. Pastels
4. 4 to 6X	11. Polyester blends
5. Gallon lace	12. Sample size
6. Gripper snaps	13. *Seventeen*
7. Jumper	14. Toddler

DISCUSSION QUESTIONS

1. Why are cottons and cotton blends the most widely used fabrics for children's wear?
2. What two classic styling proportions emphasize the positive appearance of children when they are in awkward growth periods?
3. List the most important things a designer must consider when creating practical play clothes for toddlers.

CHAPTER 9
Men's Wear

The elements of a man's business suit were established at the beginning of the twentieth century. The basic components are a tailored jacket covering the torso and hips worn over matching pants with an optional vest and hat. Accessories include a shirt, tie, overcoat for cold weather, appropriate socks, shoes, and undergarments. At the beginning of the century, the suit was a uniform worn by businessmen during the day for most activities. Laborers modified the formula by wearing a work shirt and sturdy pants, covered by a jacket that was usually similar in cut to the business jacket.

During the nineteenth century, the average workweek was 72 hours, and men had little leisure time. The twentieth century brought more free time when the work week was shortened, and the variety of leisure activities increased. The automobile, the railroad, and finally the airplane decreased the size of the world and stimulated travel throughout the United States and to other countries, which encouraged an exchange of ideas and fashions. Men's fashions responded to these changes but still retained the basic elements of the business suit for formal wear. Clothes for leisure were evolved from active sportswear and military uniforms.

A slow evolution of details, quality fabric, and hand-tailored construction characterized men's business wear instead of the rapid changes in silhouette and color that were typical of women's wear. Tradition and quality remain the most important elements of high-fashion men's tailored clothes. It is important to trace the major developments of men's wear during this century to understand how the

When you have read this chapter, you will understand:

1. The evolution of men's wear styling during the twentieth century and how it contributes to current fashion trends.

2. How the relationship between the wholesale manufacturer and retailer shapes the men's wear industry.

3. How a men's wear manufacturing plant differs from one making women's wear.

4. The role of the men's wear designer.

5. How men's wear separates and coordinate lines are organized.

6. Sources of inspiration for men's wear design.

7. Men's wear size and merchandise categories.

8. Style variations in men's business and sportswear.

The basic components of the business suit were established by the beginning of the twentieth century.

business suit has evolved. The padded-shoulder suit with a fitted waist has alternated with the natural-shoulder relaxed-fit Ivy League jacket throughout the decades of this century, and the reinterpretations of these silhouettes form the basis of styling the fashionable business suit. New items have been added from active sportswear and military uniforms that form the basis of sportswear.

HISTORY

1900–1920

The frock coat was abandoned in favor of the "saque" suit. This jacket had less padding and a natural shoulder line that was worn with slim trousers. Jackets were shortened during World War I, and shirt collars shrunk and were starched less. Military costumes, from Army khaki and Navy blue to Marine green, became popular. Formal evening wear was simplified, and the tuxedo was born in New York when a gentleman wore a short black coat instead of tails to a party in Tuxedo, a fashionable resort. The trench coat, a short raincoat, was imported from England. The tank watch was designed by Cartier for the first fighter-airplane pilots.

The 1920s

The business suit became fitted and youth was the fashion ideal. The Ivy League influence, an understated, natural look that lasts to this day, was born. The Ivy League suit had a lightly padded shoulder and a natural fit. Knickers were popular with young men and evolved to "plus fours," which hung 4 inches below the knee and finally became baggy trousers. The Fair Isle sweater and golf socks were imported from Scotland. Popular sports of this decade, such as golf, swimming, and polo, added the windbreaker, short-sleeved sports shirts, button-down and attached collars on casual shirts, sweaters, and the polo shirt to a man's wardrobe.

These styles formed the basis of what we still know as the Ivy League or traditional look. Brooks Brothers is a retailer that is synonymous with the Ivy League style. A second silhouette was popular with older men toward the end of the decade. These suit jackets had very padded shoulders and a fitted waist worn with wider trousers. The tailors of Savile Row in London introduced this style and es-

tablished themselves as fashion leaders for fine tailored garments, a reputation they have retained to this day.

The 1930s

The two major fashion developments of the decade were the tremendous increase in the amount of sportswear worn and the total acceptance of the "English Drape" suit, which had a very fitted waist accented with large shoulders and wide lapels. The sophisticated man replaced the youthful Ivy Leaguer as a fashion leader during this decade. Slacks replaced knickers on the golf course, and crew neck and boat neck T-shirts were imported from the French Riviera as outerwear. The bush jacket was borrowed from the African bwana. California became an important center for innovative sportswear and contributed a flamboyant look to this merchandise, often with a cowboy flavor. The zipper was finally accepted as a closing for the trouser fly.

The 1940s

The war influenced this decade by introducing the concept of dressing in several lightweight layers with a wind- and water-resistant "shell" to provide warmth and freedom of movement. Synthetic fabrics were often used to conserve natural fabrics. The Lounge Suit, a jacket with broad shoulders but a less-fitted waist, was preferred. Military jackets like the waist-length Eisenhower or battle jacket, chino or poplin pants, and the leather bomber or aviator jacket were brought home from the war and worn for leisure.

The 1950s

The natural shoulder suit and Ivy League styling returned as the dominant business-suit silhouette, though most suits still had a small shoulder padding. A typical Ivy League detail, the buckle strap, was found on trousers, shirts, vests, and caps, and the three-button, back-vented suit was resurrected from the 1920s. In the mid-fifties, another style was imported from Italy: The Continental style had a slightly built-up shoulder, slim waist, and straight-leg pant. The blue jean and black leather jackets became symbols of the youthful rebellion to come in the next decade as they were

Formal Wear
The tuxedo.

The 1930s "Gangster Stripe" suit featured exaggerated, padded shoulders.

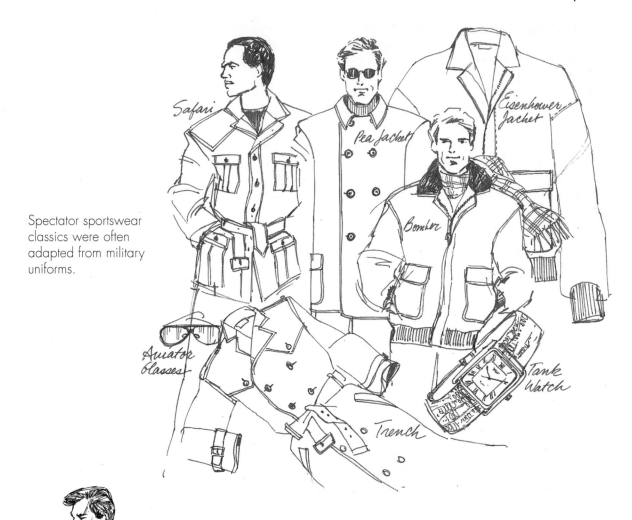

Spectator sportswear classics were often adapted from military uniforms.

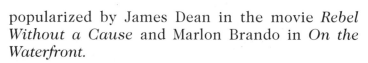

popularized by James Dean in the movie *Rebel Without a Cause* and Marlon Brando in *On the Waterfront*.

The 1960s

A youthful president, John F. Kennedy, reinvigorated Ivy League elegance. The Contemporary Look combined the Ivy League and Continental in a two-button, slim-line suit with narrow lapels and accessories. The Traditional Look was popular with conservative older businessmen: Synthetic fibers and permanent press fabrics were used to create business suits and sportswear that resisted wrinkles and looked pressed, though the comfort of natural fibers was sacrificed. Shiny, bold prints were styled into sports shirts and flared pants and flamboyant colors and designs were imported from London's Carnaby Street. A youthful counterculture rebelled against the traditional and "Peacock Generation" by wearing faded and distressed denim clothes, the badge of the hippie.

The 1970s

The Vietnam War and general world unrest created a resurgence of interest in military garments for sportswear. Designer names designated prestige merchandise and became more important than brand names. Men's suits were divided into two distinct camps: the traditional natural shoulder jacket with a loose fit favored by older, less physically fit men, and the stylized Italian or Continental cut that featured the built-up shoulder, trim waist, and flared pants worn by slim businessmen. Sportswear was worn for active wear and the spectator wore a mismatched sports coat and slacks for leisure and

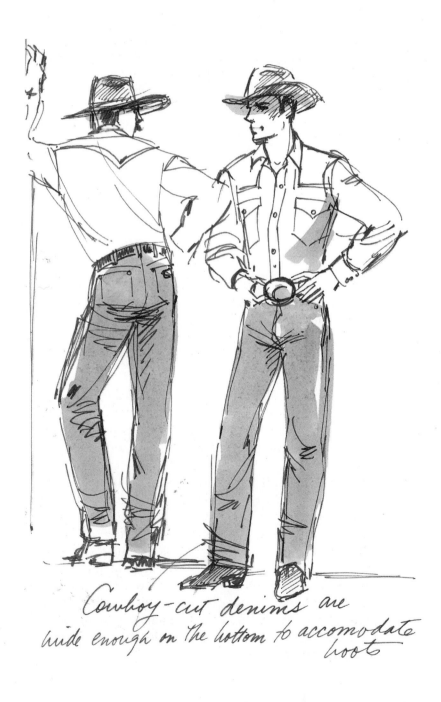

Cowboy-cut denims are wide enough on the bottom to accomodate boots

casual business wear. Lapels on suit and sports jackets grew wider, except for the brief appearance of the Nehru jacket that emulated Indian business costume. The flared pants leg gradually went out of style in favor of a straight leg. Denim, western wear, and active sportswear influenced all leisure wear. Ski and surfing apparel gained new importance. Garments designed for active sportswear began to be worn for leisure activities.

The 1980s

The traditional Ivy League and Continental cuts dominate business wear. The deciding factors in selecting a personal style have become occupation, body type, and geographic and urban location. Designer personalities continue to influence clothing purchases. Nontraditional colors distinguish leisure wear from somber-colored business clothing. New sports are bicycling and aerobics. Sweat clothes, tennis wear, ski jackets, and other active

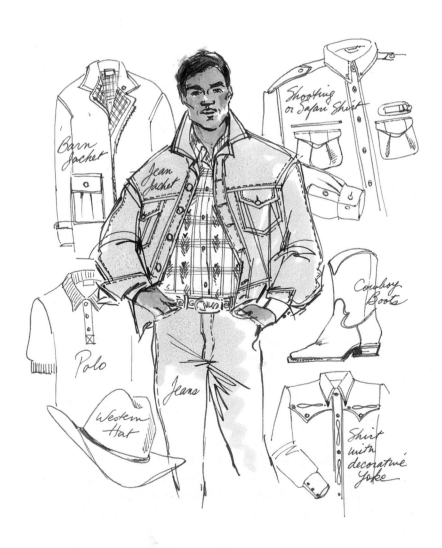

sportswear have become accepted street wear for casual occasions. Natural fibers symbolize better clothing, and synthetics are relegated to less-expensive merchandise or active sportswear. New clothes are prewashed or "distressed" to look worn.

CURRENT MARKET TRENDS

Today's men's wear is grouped in three distinct categories: tailored clothing, spectator sportswear, and active sportswear. Fashions in tailored clothing evolve slowly. Hand tailoring, quality fabric, and excellent fit are the signs of expensive high-fashion suits and outerwear. Men's sportswear is much more experimental and innovative. There is a constant exchange of styling trends between active and spectator sportswear. International trends and styles influence this market, and customers are willing to experiment with new colors and silhouettes for leisure and active wear.

Lifestyle is an important consideration for men's wear designers because living patterns have changed radically for men during the last decades of the twentieth century, and these changes affect clothing purchases. Men's wear is more casual and experimental. For many decades, men have worn prescribed apparel for various activities. During the 1970s, men began to wear active sportswear for leisure activities. The comfort and colorful styling appealed to men who spent the majority of their waking days in formal clothing. Manufacturers and retailers began to realize that tremendous amounts of tennis and golf clothes were being worn off the courts and greens. Such manufacturers as Merona and Gennera began to make casual, colorful apparel with the pull-on pants as the basic component of their lines. The appearance of these manufacturers coincided with the arrival of the baby boomers as young customers in men's wear departments in the 1980s. A father and son no longer wanted to wear the same clothes. The men's wear market began to be segmented like women's sportswear, with departments for young and mature men and casual and formal sportswear.

The popularity of sportswear has been promoted by apparel giant Levi Strauss. "Casual Friday," a marketing strategy designed to promote the Levi's Docker label of casual slacks quickly validated the trend to shed the business suit. Other social developments such as the virtual office that allows employees to work at home and trend towards small entrepreneurial businesses and relaxed

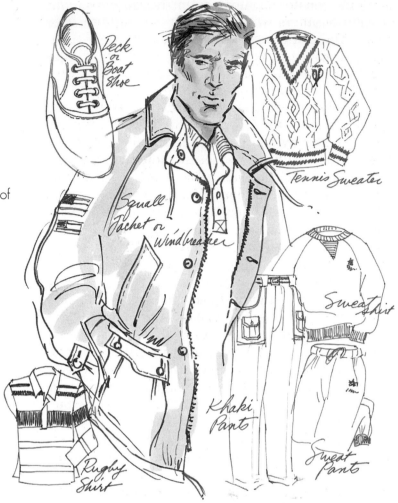

Classic spectator sportswear items also evolve from active sportswear pieces. "Casual Fridays" have promoted the sales of men's sportswear.

dress codes will continue to increase the demand for casual apparel. As the baby boomer generation matures and retires, conservative casual apparel will continue to grow as a market segment.

Private-Label Apparel

Large department, chain, and specialty stores began to manufacture basic men's wear directly and bypass the manufacturer. They purchased apparel from the Orient and used domestic contractors. Private-label merchandise allowed the retailer to make much greater profits on styles that did not need design innovation. This forced manufacturers who were making basics to diversify and produce more creative apparel if they were to survive. In addition, innovative retailers such as the Gap and Banana Republic opened chain stores to sell directly to the consumer. These stores focused on a

particular customer, usually on the huge numbers of baby boomers who were now moving into their most affluent time of life. Specialty stores put further pressure on manufacturers of traditional apparel to become more innovative and style conscious to maintain their market positions.

Smaller manufacturers used this strategy and opened their own stores. Retail stores create a profit center by selling directly to the customer. New styles can be tested and studied before they are released to the general market. A manufacturer's boutique showcases the entire line without a buyer editing the most innovative styles. Advertising can be used to promote the manufacturer's total image as well as to stimulate direct sales to the consumer. The boutique serves as a model to department stores and encourages them to open a "department within a department" to highlight a hot manufacturer, thus allowing a large amount of goods to be sold. The most successful example of this type of merchandising in the men's wear market is the Polo line by Ralph Lauren. Bass, Nautica, Tommy Hilfiger, and Guess? (MGA stores) are other excellent examples of the manufacturer-turned-retailer. All these manufacturers produce men's and women's apparel and accessories. Many manufacturers opened outlet stores to sell overstocks, samples, seconds, and returns at lower prices than found in regular department and specialty stores. Outlet stores are usually located a distance from primary retailers and do not stock a complete selection of the manufacturer's line. These stores are usually clustered in an outlet mall and have been so successful that many manufacturers actually cut additional merchandise to stock their outlet stores.

When shopping in a manufacturer's store or a department within a department, the customer is encouraged to purchase the total look that a designer presents. In reality, many customers just purchase a single item, but the image and prestige the manufacturer has created allows him to sell large volumes of merchandise in basic classifications. The Ralph Lauren Polo shirt is a perfect example.

The Changing Men's Wear Manufacturer

Today's successful manufacturer has found a "niche"—supplying a specific product to stores that can sell it to the customer base they have created. The manufacturer producing basic lines must sell

them to "mom-and-pop" stores, industry slang for the single or small chain of specialty stores that do not have sufficient volume to commission their own private-label merchandise. This is a shrinking market that is costly to sell to because the small store is often a poor credit risk.

Typical men's wear manufacturers create lines that have 80 percent new styles and repeat 20 percent of last season's basics. They must work closer to the market to see what is hot and what the consumer is demanding. This is a dramatic change from 10 years ago when men's wear lines could be created months in advance with little innovation. The pace of men's wear is beginning to match the design frenzy required to create contemporary women's wear.

MEN'S WEAR MANUFACTURING PLANT

The structure of a tailored men's wear manufacturing plant is more labor-intensive than a women's wear plant. Often, a tailor will select the silhouettes and fabrications and direct the fit of the garments manufactured by a suit house. The most-expensive suits are still made by individual tailors who hand-construct every detail and fit the customer several times during the construction of the jacket. Better mass-produced tailored clothes are often made by one sewing operator and various finishing sewers instead of a production line. Popular-priced suits are constructed using the piecework method. Styling trends for this market often originate in Europe.

Men's shirt factories are less labor-intensive than women's wear manufacturers because the styles change slowly, allowing standardization of collars, plackets, and cuffs. These small parts can be dye-cut for greater precision and speed, though automated cutting machines deliver the same accuracy. Sewing machines are set to produce the collars rapidly and set the collar band and placket. Lots are usually larger, allowing a manufacturer to work offshore or domestically at a better price.

Sportswear construction depends on the innovative nature of the item, how much it costs, and the size of the manufacturer. A modified piecework system is usually used. Factory methods are similar to women's sportswear, but a greater emphasis is placed on such sturdy construction details as flat-fell seams and inner construction details.

Dress Shirt Details

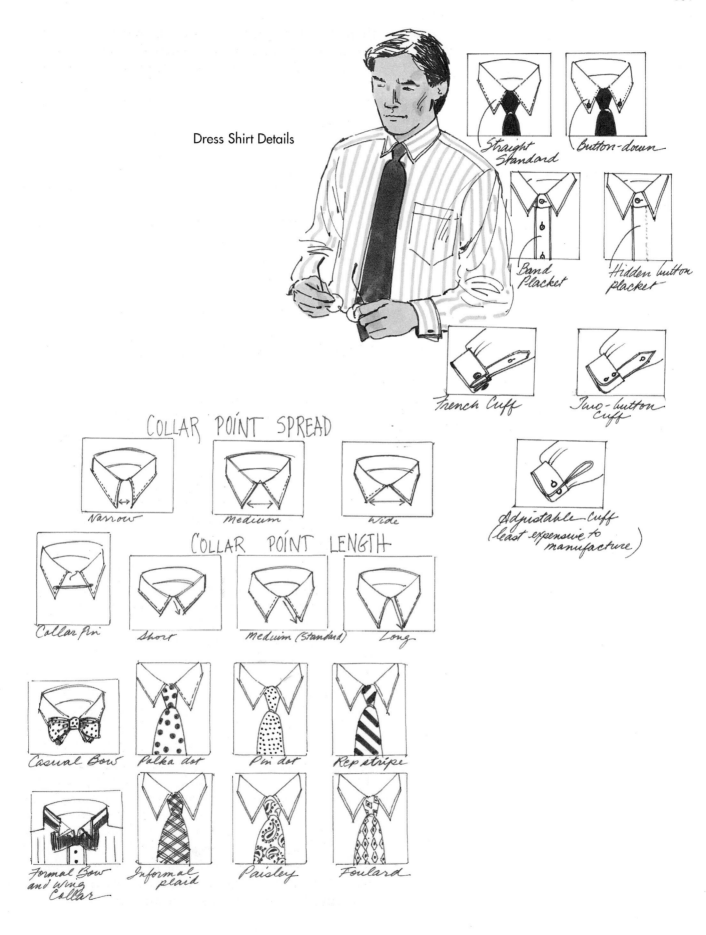

Straight Standard

Button-down

Band Placket

Hidden button placket

French Cuff

Two-button Cuff

COLLAR POINT SPREAD

Narrow

Medium

Wide

Adjustable cuff (least expensive to manufacture)

COLLAR POINT LENGTH

Collar Pin

Short

Medium (Standard)

Long

Casual Bow

Polka dot

Pin dot

Rep stripe

Formal Bow and wing Collar

Informal plaid

Paisley

Foulard

THE MEN'S WEAR DESIGNER

The men's wear market, particularly sportswear, requires the designer to do the same investigation and planning as for women's wear. Designers begin by investigating color and determining the silhouettes and details most appropriate for the lines. In the past, traditional sportswear colors were very limited. Today, the innovative nature of the industry requires constant research to select the correct colors. Designers rely on color predictions from design services, fiber producers and innovative textile producers who specialize in the men's wear market. Designers research what is selling in better lines and in prêt-à-porter in Europe. They study new trends from Japan and Hong Kong and make selections based on their analysis of the market.

Designers and merchandisers select a theme to guide the styling of the group. A typical spring theme is nautical, clothes typically worn for sailing. Then they build the fabric groups with base goods and accessory fabrics and trims just as a women's sportswear designer would. Finally, the groups are styled with a variety of silhouettes, utilizing the best-sellers of the past season as a starting point. Specialized sources of men's wear information are available.

Customer Research

Men's wear designers research the stores that sell expensive men's wear and adapt the styles, colors, and prints exactly as a women's wear designer would. Observing men in various social and leisure activities is important.

Travel is also very important for designers. European men spend a great deal of time coordinating their "look." They are willing to experiment and combine merchandise from many vendors to create a unique outfit. U.S. men's wear designers travel to Europe to see new styles on the streets and in the stores and then use these as a point of departure for designing U.S. ready-to-wear. Japanese designer men's wear is innovative and uses different proportions, colors, and fabrics. The Orient is a constant source of new style trends for sportswear. The U.S. men's wear designer has a task similar to a women's wear designer: to evaluate how much innovation is necessary to make the customer want to buy new styles and how much is too much.

Shaheen Sadeghi, merchandise manager for Jantzen Menswear, discusses spring styles with designers Mari Isono and Kirk Nozaki. *Courtesy: Jantzen.*

Trade Publications

Fairchild publishes *The Daily News Record (DNR)*, the counterpart to *WWD*. This newspaper informs the manufacturer about current trends, business events, and industry news every weekday and is the primary trade publication for men's wear. Special market editions are published for large men's wear markets in New York, and the MAGIC (Men's Apparel Guild in California) Show in Las Vegas.

The *California Apparel News* publishes periodic news and special issues for men's wear market weeks.

Sportswear International features men's and women's sportswear retail and wholesale information. This large glossy magazine is published eight times a year.

Domestic Consumer Publications

Esquire—glossy magazine that features articles of interest to men and a conservative fashion philosophy.

Gentleman's Quarterly—published monthly; features a contemporary report on men's wear and is a leading fashion arbiter.

Playboy, Penthouse, and so on—though these magazines focus primarily on male lifestyle issues, they do have occasional fashion articles.

Vogue, Harper's Bazaar, Town and Country, and so on—women's fashion magazines that occasionally feature men's wear.

Catalogs—designers often explore retail catalogs to get an armchair overview of merchandise. Catalogs from L. L. Bean, Cable Car Clothing Company and Wilkes Bashford in San Francisco, Bullock & Jones, Land's End, Brooks Brothers, and other specialty retailers, as well as the department stores that feature better men's wear, are important.

Foreign Publications

L'Officiel Hommes—features French upscale sportswear and tailored clothing.

Linia Italia Sport focuses on high-fashion apparel worn for active and spectator sports.

Per Lui—is a young man's fashion magazine from Italy.

Vogue publishes two important men's wear magazines, *L'Uomo Vogue* in Italy and *Hommes* in France. Both offer upscale, innovative merchandise and are important fashion trendsetters. In addition, special issues on sports, boating, and other interests often feature men's wear.

Design Reports

Color services that are mentioned in Chapter 3 provide direction for men's wear.

Report West for Men and Men's Photobox is available on disk and in published form from Bill Glazer Associates.

DESIGNING MEN'S WEAR

Traditionally, men's wear was produced for two seasons annually: spring and fall. Current market conditions demand more seasons and market dates closer to the season. Men's wear lines usually produce a large spring line in two or more groups that is delivered to the stores starting with pre-Christmas completion dates and shipping until February. Fall usually has two groups and ships to the stores from April through June. Most manufacturers produce a smaller holiday line that previews spring merchandise and is shipped to the stores from September through November for catalog sales

and gift giving. Lines that feature surfing and swimwear often have an additional summer season and show very small fall lines. Outerwear lines reverse this formula and minimize spring summer sales. Fabric is planned for these seasons, and usually deliveries are scheduled far in advance of production. Men's wear fabric is sold in larger quantity than most women's wear textiles. Manufacturers usually contract for the fabric before a garment is

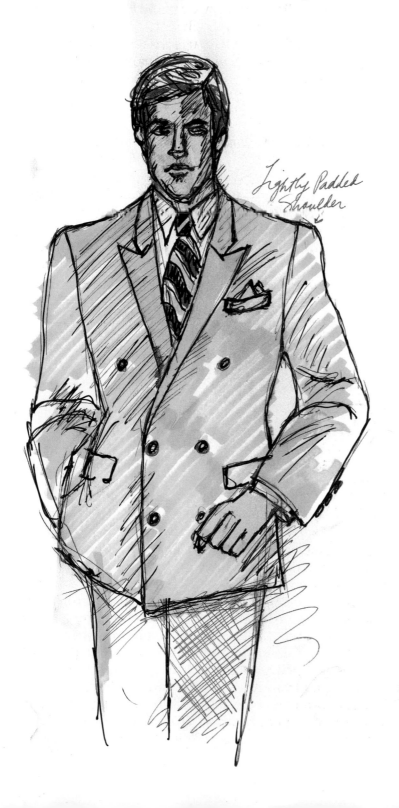

Lightly Padded Shoulder

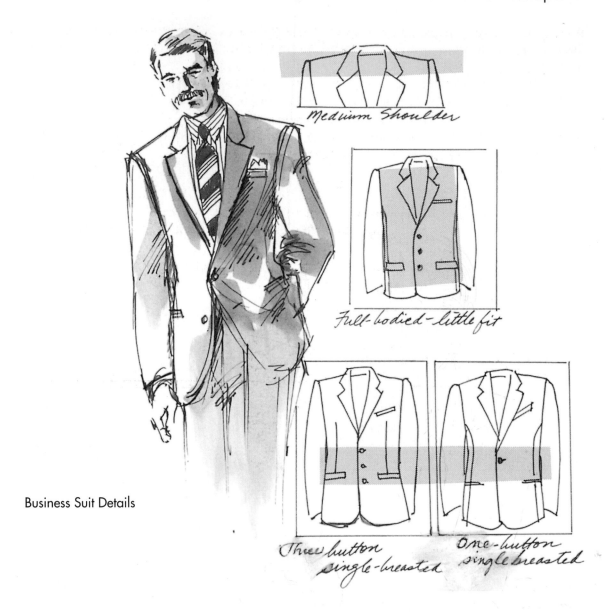

Business Suit Details

produced and request specific colors and patterns because of the large volume they order.

Item lines featuring separates that are designed to be combined with other manufacturers' apparel are typical of the shirt, jacket, pants, and specialty-item producer. Accessories are usually item lines. Coordinated sportswear lines comprise approximately 30 percent of total offerings. Coordinated sportswear manufacturers must plan the purchase of many different kinds of fabric and various types of construction to produce a line. Contractors may be used as they are in women's wear to augment in-house factories. Even designer sportswear manufacturers license the production of many of the accessory areas of their lines while maintaining control of the colors and styles so that all coordinates

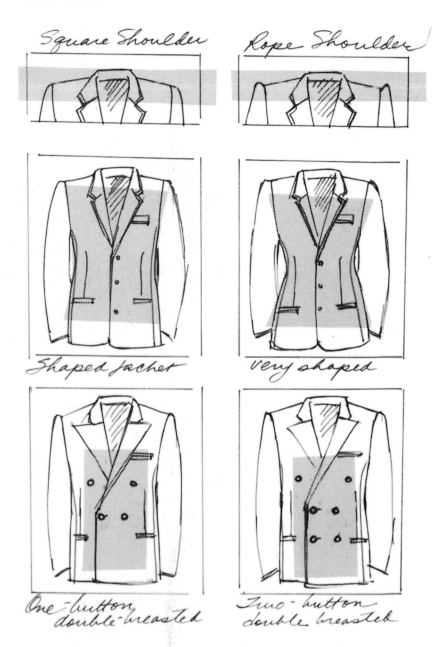

Square Shoulder

Rope Shoulder

Shaped Jacket

Very shaped

One-button double-breasted

Two-button double-breasted

can be sold together. The complexity of setting up a factory that can make structured garments as well as shirts economically tends to discourage manufacturers from making all the items necessary for a coordinated spectator sportswear line in-house.

Casual coordinated sportswear is more practical for one manufacturer to make. These lines are organized around fabric groups to offer several color ways and a variety of styles. Several groups are usually featured, and delivery is spread over a shipping period so that a flow of merchandise will come to the retailer. Typical coordinated sportswear manufacturers are Polo, Nautica, Gennera, Tommy Hilfiger, Jhane Barns, and Liz Claiborne for Men.

Business Suit Details

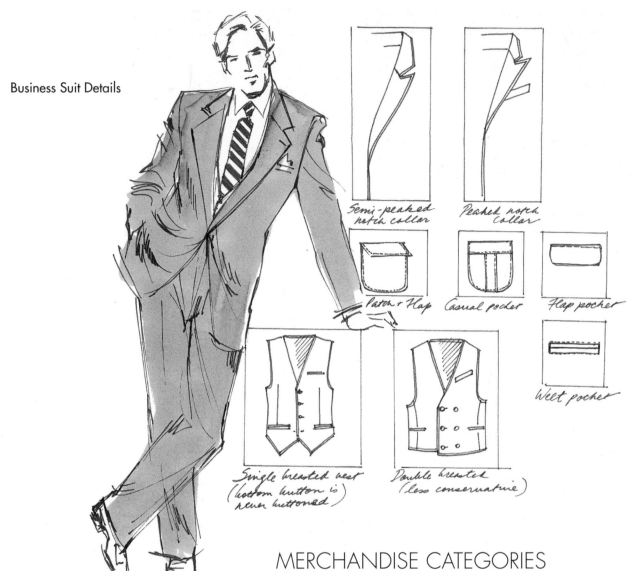

Semi-peaked notch collar

Peaked notch collar

Patch + Flap

Casual pocket

Flap pocket

Welt pocket

Single breasted vest (bottom button is never buttoned)

Double breasted (less conservative)

MERCHANDISE CATEGORIES

Men's wear is offered at many price points, from budget to very expensive. Degrees of fashionability include "Innovative," very trendy, usually youthful styles; "Directional" merchandise for the man who wants a current image; and "Conservative" for the man resisting change.

Tailored suits are manufactured in categories appropriate to price, fashion image, and fit. Barney's is a specialty retailer featuring a wide range of men's wear designers, sizes, and price ranges. This popular retailer has branches in many large cities and offers the best example of the huge variety of tailored men's wear available and the subtle differences that characterize one suit market from another. Other department stores with a similar range of important casual and formal men's wear include Macy's, Bloomingdales, Saks Fifth Avenue, and Neiman Marcus.

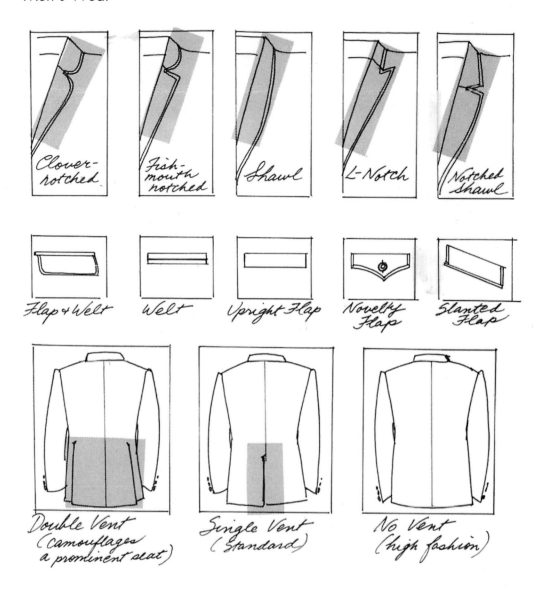

Clover-notched | Fish-mouth notched | Shawl | L-Notch | Notched shawl

Flap + Welt | Welt | Upright Flap | Novelty Flap | Slanted Flap

Double Vent (camouflages a prominent seat) | Single Vent (Standard) | No Vent (high fashion)

Tailored clothing is manufactured in the following categories:

Suits
Natural Shoulder
7-inch Drop (Drop refers to the difference between the waist and jacket size. This category is favored by slim, athletic figures. See the size chart for further clarification.)
European styling
Formal wear
Outerwear, overcoats, and raincoats
Spectator sportswear
Sports coats
Slacks
Furs

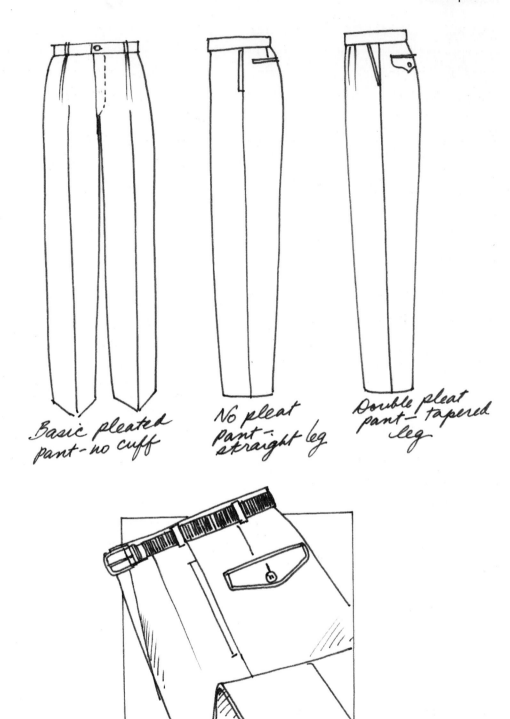

Basic pleated pant – no cuff

No pleat pant – straight leg

Double pleat pant – tapered leg

Slack Details

Nontailored categories include:

Active sportswear
Apparel for skiing, bicycling, mountain climb-
ing, various equestrian activities, boxing,
swimming and surfing, workout and aerobics,
golf, hunting, boating, tennis, and so forth.

Table 9.1

				MEN'S APPAREL SIZE RANGE					
Category	Portly	Small	Short	Medium	Regular	Large	Long	Extra Large	Extra Long
Casual shirts		S (tapered)		M (regular)		L		XL (full cut)	
Dress shirts: Collar		13½–14½		15–15½		16–16½		17–17½	
Sleeve length		32		33–34		34		35	
Sweaters (T-shirts)		S		M		L		XL	
Weight (lb)		110–135		135–165		170–200		over 210	
Slacks—Sold by waist Casual (pants are hemmed to inseam length)		30		32/34		36/38		40/42	
Jackets—Chest measurement		36		38		40–42		44	
Suits— Measuring the difference between chest and waist	Waist is up to 3" less than chest measure	36 chest	Under 5'9"	38 chest	Waist is 6" less than chest measure 5'9"–5'11"	40–42 chest	"Athletic"— Waist 8" less than chest 5'11"–6'3"	44–46 chest	over 6'3"
Pajamas		A		B		C–D		E	
Robes		Small		Medium		Large		X Large	
Undershorts		30		32–34		36–38		40–42	

Spectator sportswear
Leather
Western wear
Shirts: formal and casual; knit and woven
Sweaters
Pants: slacks, jeans, casual pants
Work clothes
Underwear: knit briefs and woven boxer shorts,
 T-shirts, hosiery, suspenders, and garters
Sleepwear, robes, and bathrobes
Accessories, including handkerchiefs, belts,
 suspenders, gloves, ties, and scarves
Hats and caps

Size categories cover all ages, from boys' to large size men's wear. The following chart simplifies the sizes traditionally given to various categories of adult men's wear.

Summary

The elements of a man's business suit were established at the beginning of the twentieth century, and the evolution of fit and detailing throughout the century have formed the basis for restyling the business suit. The 1920s were notable for the introduction of the Ivy League look and the natural shoulder suit. During the 1930s, the "English Drape" suit, characterized by padded shoulders, a fitted waistline, and wide lapels, was popular. The 1940s contributed a modified padded shoulder business suit silhouette and introduced many military garments to civilian use. During the 1950s, the natural shoulder suit and Ivy League details returned to popularity. The 1960s were a decade of experimentation for the young generation, contrasted with conservative, Ivy League business suits for the establishment. Men began to wear active sportswear for leisure activities during the 1970s. Business suits were either conservative, natural shoulder silhouettes, or the fitted and padded Continental look; this trend continued into the last decades of the 20th century. Lifestyle changes have occurred rapidly during the last 25 years, and men's clothing reflects the casual, comfortable, sports-and-fitness orientation that has begun to dominate modern life.

Three categories dominate contemporary men's wear: tailored clothing, spectator sportswear, and active sportswear. Private-label merchandise made by large retail organizations has forced manufacturers to design more-creative merchandise. Innovative manufacturers run their own retail and outlet stores. The role of the manufacturer and retailer has blurred as

Pant Silhouettes

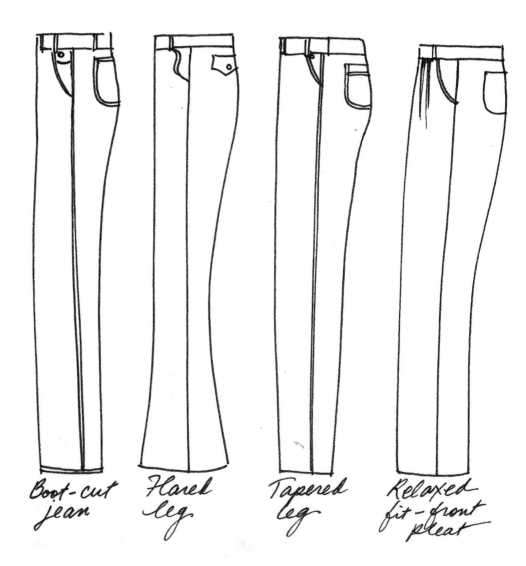

Boot-cut jean Flared leg Tapered leg Relaxed fit - front pleat

each segment alters the traditional methods of presenting goods to the ultimate consumer. This trend is expected to continue through the end of the century.

Manufacturing men's tailored clothing is more labor-intensive than manufacturing women's wear, although production of basic items like shirts is more automated. The manufacturing of sportswear for both men and women is similar.

Men's wear designers research and structure a coordinated sportswear or item line in much the same manner as women's wear designers do, but they use different research material. Customer research, travel, men's wear trade publications, domestic and foreign consumer publications, and design reports are all resources used by the men's wear designer.

Spring, fall, and holiday are the primary markets for most men's wear lines, summer is an added season for surf and beach wear. Fabric purchases are larger than typical women's wear buys and are often custom-made for the manufacturer.

Item lines comprise 70 percent of the sportswear business. The coordinates sportswear manufacturer often uses contractors to produce specialty goods because of the diversity and production schedule necessary to produce and ship merchandise on time.

Men's wear is offered at various price points with many specialized categories and also encompasses teenage boy's apparel. Sizing is different for various apparel categories but is related to height and weight to assist the customer in determining his ideal size.

Review

WORD FINDERS

Define the following words and terms from the chapter you have just read:

1. Barney's
2. Conservative
3. Continental suit
4. Department within a department
5. Directional
6. *DNR*
7. Drop
8. Eisenhower jacket
9. Innovative
10. Ivy League
11. MAGIC
12. Mom-and-pop stores
13. Natural shoulder
14. Niche
15. Plus fours
16. Polo shirt
17. Private label
18. Savile Row
19. Tuxedo

DISCUSSION QUESTIONS

1. Describe the difference between the traditional, natural shoulder suit and the Continental look.
2. What other kinds of activities have generated items now typical of men's sportswear? List four items contributed by each of these sources.
3. Describe current market practices that have led to the blurring of traditional methods of getting apparel into the hands of the ultimate consumer.

Unit 4

Apparel Categories

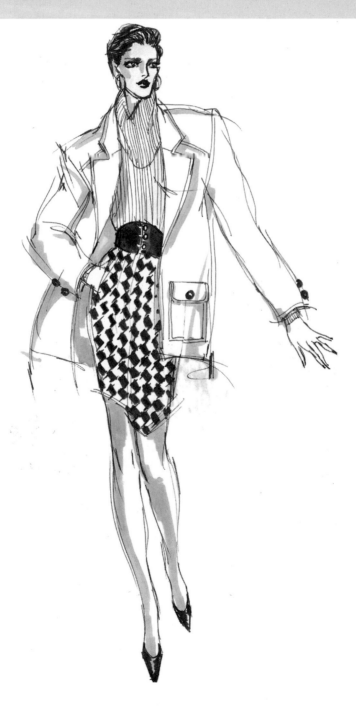

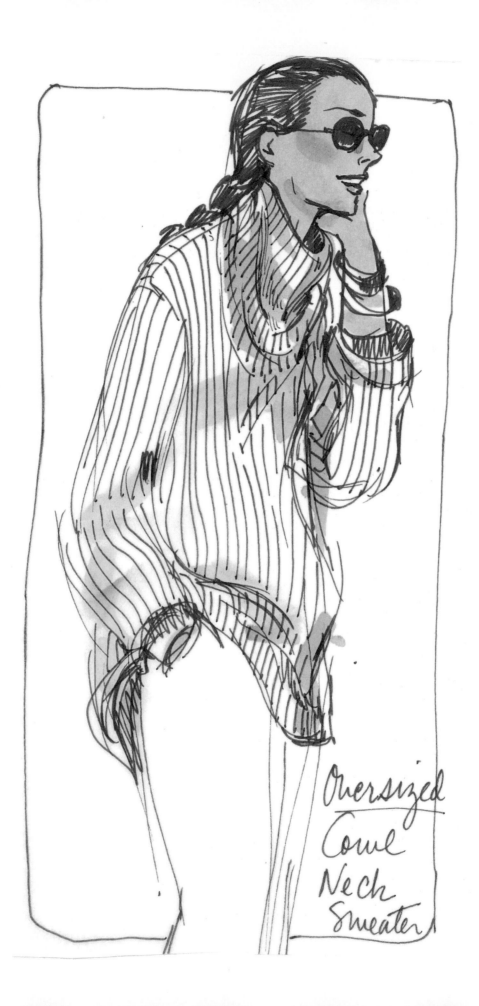

Oversized
Cowl
Neck
Sweater

CHAPTER **10**

Tops and Coats

The bodice is the part of the garment that covers the body from the waist up. The basic bodice has two front darts and two back darts that make the flat piece of fabric fit the body's curves. *Darts* are V-shaped wedges that take in the excess fabric around the outer edge of the pattern and taper to nothing about 1 inch from the point of the bust. The back darts taper to nothing about 1 inch from the fullest part of the back. If the pattern piece extends beyond the waist, the darts may not reach to the edge of the fabric. A dart that starts and ends within the pattern piece without touching the pattern edge is called a *fisheye* or *double-ended dart*.

Basic front and back bodices are used to develop patterns for the shirt, jacket, and coat blocks. Ease is added to the basic pattern, and the darts may be shifted around the point of bust, divided into several style lines, or manipulated into gores or yokes. *Patternmaking for Fashion Design* by Helen Armstrong (Longman Publishers, 1993) is an excellent reference book that explains how the basic bodice can be made into a great variety of styles.

The first pattern outline in the accompanying illustration is a basic bodice front with standard dart placement. To the right is a basic bodice where the shaded portion contains all the ease. The lines show other popular dart positions. The dart can radiate to any area of the bodice's outer edge. The jacket block shows a fisheye dart, and the coat shows a shaped shoulder dart.

When you have read this chapter, you will understand:

1. How the basic bodice evolves into various other tops.

2. The method of styling a top with darts and ease.

3. The ways gores and yokes are used to style tops.

4. How price and category affect the way garments fit.

5. How the set in and sleeves that incorporate part of the bodice fit and are used in garment styling.

6. Various sleeve and placket finishes.

7. Classical bodice, sweater, and coat styles.

MULTIPLE-DARTED BODICES

Darts can be used singly, in pairs, or in multiples (either darts or tucks). The illustrated examples here are the components of many possible styling variations. The variations could be incorporated into tops, blouses, or jackets.

GATHERED OR EASED BODICES

Instead of being sewn into a dart, excess fabric can be gathered into a seam. This is a very flattering way of fitting a garment because ease does not have to fit as precisely as in a dart. Also, ease has a soft look that is particularly appropriate for knits and

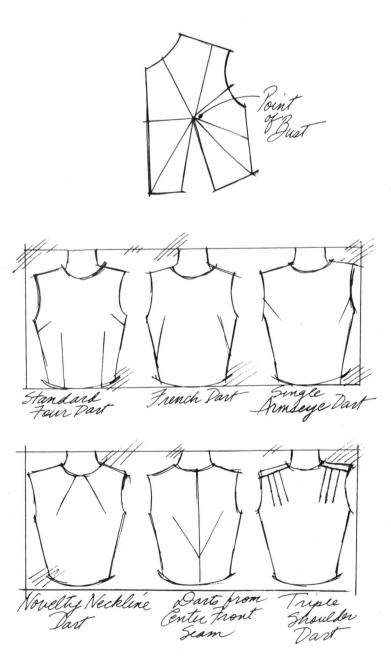

The darts in a bodice make flat fabric fit the three-dimensional dress form and the human body.
Courtesy: Helen Armstrong, Patternmaking for Fashion Design, HarperCollins, 1993.

Point of Bust

Standard Four Dart

French Dart

Single Armseye Dart

Novelty Neckline Dart

Darts from Center Front Seam

Triple Shoulder Dart

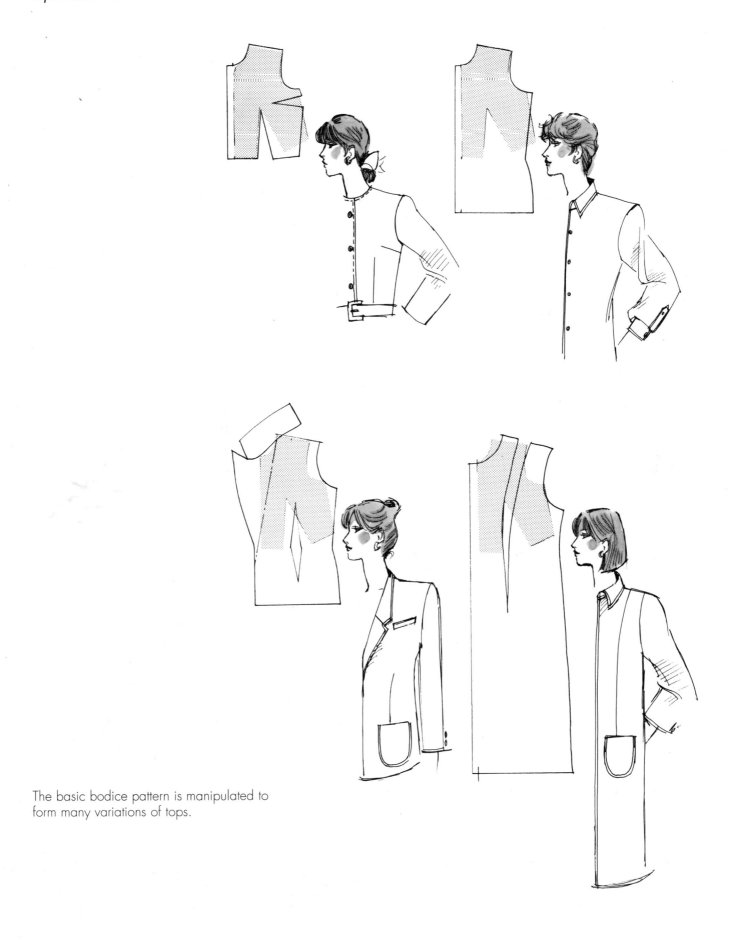

The basic bodice pattern is manipulated to
form many variations of tops.

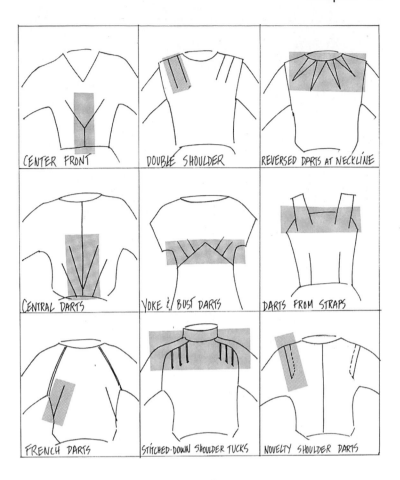

soft wovens. When a dart is used with sheer fabric, the excess fabric taken in by the dart may show through, but no shadow is visible when a fabric is eased. (A fabric that *shadows* means a fabric transparent enough for seams and details to show through.)

YOKED AND GORED BODICES

A garment can be shaped by horizontal divisions (yokes) and vertical divisions (gores) in the pattern pieces. Gores are adaptable because they can be shaped in many ways. A gored garment can fit the exact shape of the body (if this is desired) because it can be shaped to the body's contours at closer intervals than a dart can. Gores and yokes can be combined with ease and darts to achieve the best fit.

FIT

The *fit* of garments is determined by the standard fit for each category of merchandise and by current fashion. A junior garment and a missy garment in a

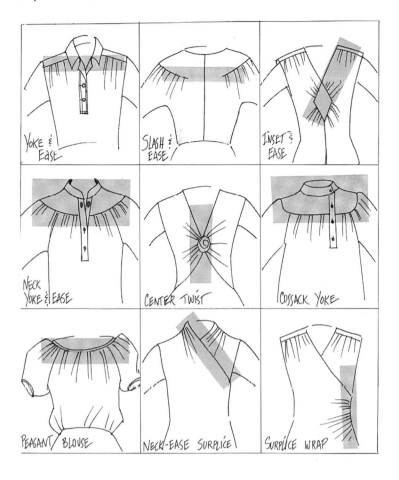

Yoke & Ease

Slash & Ease

Inset & Ease

Neck Yoke & Ease

Center Twist

Cossack Yoke

Peasant Blouse

Neck-Ease Surplice

Surplice Wrap

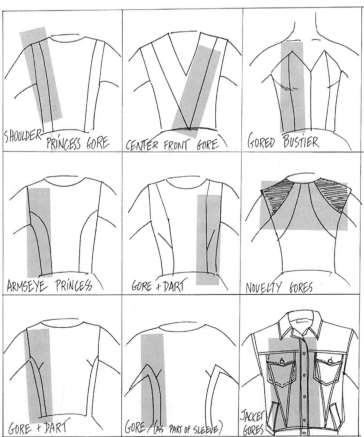

Shoulder Princess Gore

Center Front Gore

Gored Bustier

Armseye Princess

Gore + Dart

Novelty Gores

Gore + Dart

Gore (as part of sleeve)

Jacket Gores

similar style will fit in two different ways. The junior garment will have a shorter back neck-to-waist measurement. Compared with a missy garment, measurements for the shoulders and bust are usually smaller, and the garment fits with less ease. A contemporary garment will fit a youthful figure, and the styles will emphasize the avant-garde in current fashion. For example, if oversized tops are the current style, the contemporary version would be the fullest and most exaggerated on the market. The junior style would modify the oversized top, possibly by taking out some fullness and adjusting the length so that it would look better on a shorter figure. The missy top would be modified to flatter a more mature figure, possibly preserving the look only in a looser top that is belted to slim the waistline.

Price also determines how a garment fits. Inexpensive, "down-stairs" (budget and chain store) manufacturers take out all excess fabric to cut the cost of the garment but use enough yardage to suggest the original silhouette. Often, these garments look skimpy because an inexpensive fabric is substituted for the original and most ease is taken out.

In moderately priced garments too, construction is designed to conserve fabric. Generally, a manufacturer of moderate garments will not remove so much fabric that the garment loses its style. The customer will feel that a garment must look worth the money and will resist purchasing a skimpy-looking or poorly fitted garment, despite its moderate price.

Usually, the appeal of expensive garments is based on styling and construction details. The customer buys these garments because they are the essence of high fashion. Cost is less of a consideration when a garment has the latest nuance of fit and detail. More-expensive garments tend to be closest to forward fashion's current ideal of fit.

SLEEVES

Sleeves are the primary component of the bodice. There are two categories of sleeves:

1. set in sleeves
2. sleeves that are cut in one piece with the bodice or that incorporate part of the bodice into the sleeve

The set-in sleeve is used most often. This sleeve is a separate piece of fabric that joins the bodice at the

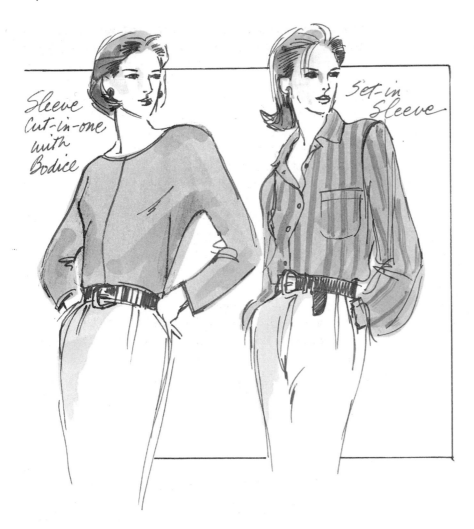

Sleeve
Cut-in-one
with
Bodice

Set-in
Sleeve

armseye. A correctly made set-in sleeve allows enough ease for free arm movements. The arm is the most mobile part of the torso, so free movement is essential.

Usually, the basic sleeve is drafted from standard measurements that are based on the circumference of the armseye. Then this basic sleeve sloper can be divided, expanded or manipulated to make most other sleeve styles. A sleeve can be draped, but this method is time consuming and less accurate then drafting.

Finishing the sleeve end is an important part of sleeve design. There are many ways of finishing a sleeve, and these methods apply to both set-in and bodice-incorporating sleeve styles.

Fit for a Set-In Sleeve

A standard set-in sleeve should smoothly cover the upper arm and shoulder socket. The armhole seam

Parts of the Set-in Sleeve

The shoulder seam is connected to the armseye of the garment. The front and back balance points control the amount of ease and its distribution as the sleeve is sewn into the bodice. The cap covers the top of the arm at the shoulder joint and must have a small amount of ease when cut in rigid fabrics to allow for movement. The bicep line is the measurement of the circumference of the arm at the underarm point. The underarm seams are joined to form the sleeve body. The elbow dart allows for movement of the lower arm in a fitted sleeve cut in rigid fabric. The placket line should follow the wristbone up the arm and can be opened in a fitted sleeve to allow the hand to pass through the wrist area.

should fall on the shoulder where the socket joins the arm. If the sleeve droops, it will look matronly; if it is too snug, it will impede the movement of the arm and the fabric will pull.

The cap of a standard sleeve has from 3/4 inch to 1 1/4 inch of ease. This amount is small enough to be eased into the armseye without gathers or bunches.

The underarm seam should fit comfortably under the armpit. In garments that will be worn over other clothes, the armhole is enlarged and dropped slightly.

The designer may wish to vary the position of the armseye seam at the top of the cap to achieve a certain effect. Modifications in the armseye can be combined with all variations of the set-in sleeve to produce a great variety of sleeve treatments, as the following series of illustrations will show.

Bishop Sleeve and Puff Sleeve Variations

Ease may be added to any area of the sleeve to achieve different effects. The illustrations show the variations possible in a bishop sleeve and a puff set-in sleeve. The bishop is a classic sleeve style often used in all categories of women's apparel. The puff sleeve is used less widely because of its youthful look. Think how these sleeves could be further

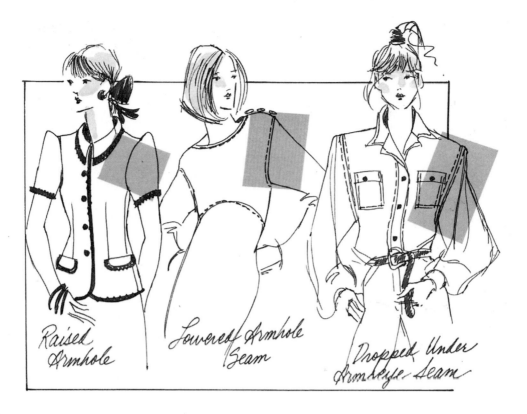

Raised Armhole

Lowered Armhole Seam

Dropped Under Armseye Seam

Raised Armhole
Move the armhole seam toward the neckline, and raise the underarm seam to give the bodice a snug, youthful fit. This device is often used in junior apparel and is especially effective for styling a full or puff sleeve.

Lowered Armhole Seam
Fabric is added to the bodice, and the cap of the sleeve is shortened to give an easy fit, typical of sporty tops. Men's wear shirts are cut this way.

Dropped Under Armseye Seam
The shoulder seam remains fixed, but the armhole is much deeper giving the shirt a very casual look. Extra fabric must be added to the underarm seam or the sleeve will limit arm movement.

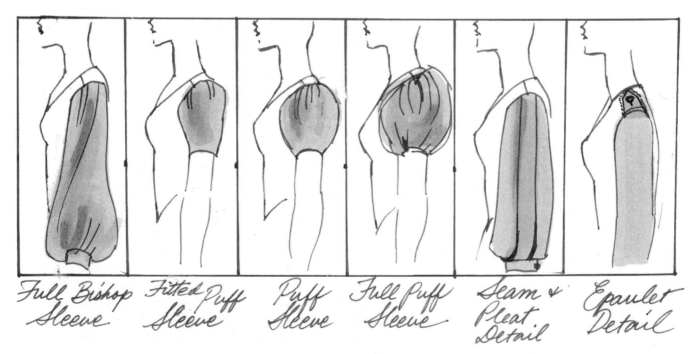

Full Bishop Sleeve

Fitted Puff Sleeve

Puff Sleeve

Full Puff Sleeve

Seam & Pleat Detail

Epaulet Detail

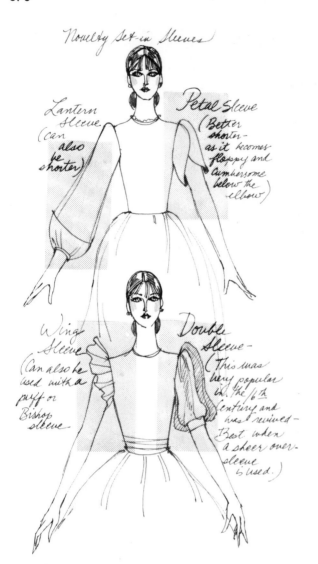

Novelty Set-in Sleeves

Lantern Sleeve (can also be shorter)

Petal Sleeve (Better shorter—as it becomes floppy and cumbersome below the elbow)

Wing Sleeve (Can also be used with a puff or Bishop sleeve.

Double Sleeve—(This was very popular in the 16th century and was revived—Best when a sheer over-sleeve is used.)

modified by varying the finish on the sleeve end or changing the placement of the armhole.

Padded Sleeves

Shoulder pads dramatically change the silhouette of the garment by lifting the shoulder and sleeve area. The shape and thickness of the pad varies depending on the fashion of the period. The shape of the pad should be determined by the style of the sleeve. A set-in sleeve requires a wedge-shaped pad, while a dolman or kimono should be padded with a rounded pad that covers the ball of the shoulder and extends slightly over the top of the arm. The correctly shaped pad will enhance the shape of the sleeves and look most natural.

The size of the pad depends on the effect the designer wants. Norma Kamali is credited with es-

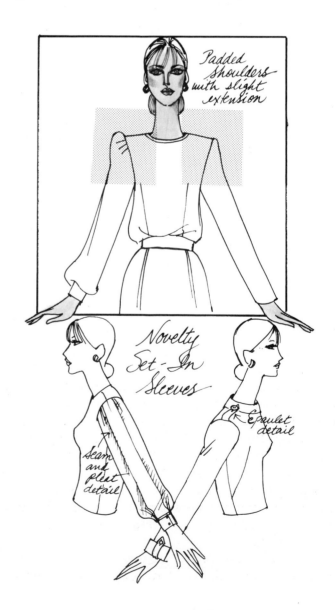

Padded Shoulders with slight extension

Novelty Set-In Sleeves

Seam and pleat detail

Epaulet detail

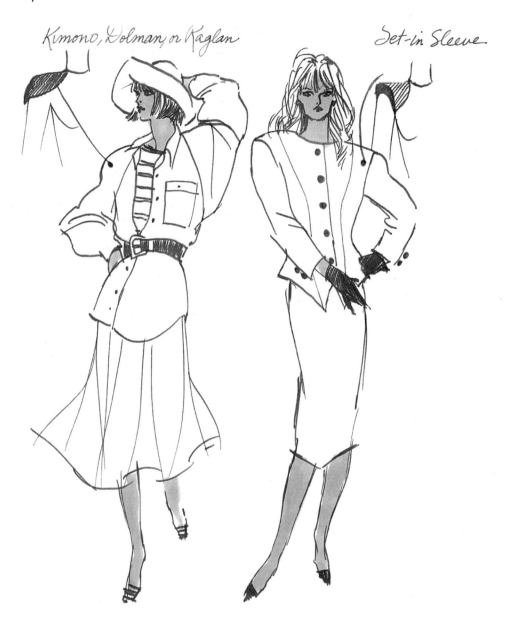

Kimono, Dolman or Raglan

Set-in Sleeve

tablishing the padded shoulder as high fashion in the late 1970s. She was inspired by period clothes from the 1940s and revived the large, square shoulder. The most extreme Kamali styles had 2 inch-thick shoulder pads. A clever innovation was her use of Velcro© fastening strips added to the pad and inside the shoulder seam so that the pads could be removed if the customer did not want to wear them and when the garments had to be cleaned.

Smaller pads are flattering to many figures. Width at the shoulder balances the width of the hipline and makes a person seem slimmer. Shoulder pads that are not too exaggerated also make a person seem taller.

The padded sleeve pattern is quite different from a natural sleeve. The cap of the sleeve is

deeper, and often the underarm seam is dropped. Padded shoulders focus attention on the bodice and usually are accompanied by a period of great variation in sleeve styling.

Two-Piece Set-In Sleeves: Shoulder Seam

This two-piece sleeve has the usual underarm seam, but it also has a seam from the top of the cap to the center of the wrist. Ease can be taken out of the sleeve cap with the upper seam, and a snugly fitted sleeve will be the result. This extra seam is rarely added for fashion styling interest. The two-piece sleeve forms the basic sloper, which is developed into all attached-to-the-bodice sleeve styles.

Tailored Sleeve, Underarm Panel

The tailored two-piece sleeve has no underarm seam. Instead, it has a panel that covers the underarm area. This sleeve is particularly good for coats and jackets made from bulky fabrics because the sleeve can be fitted quite snugly and the elbow dart

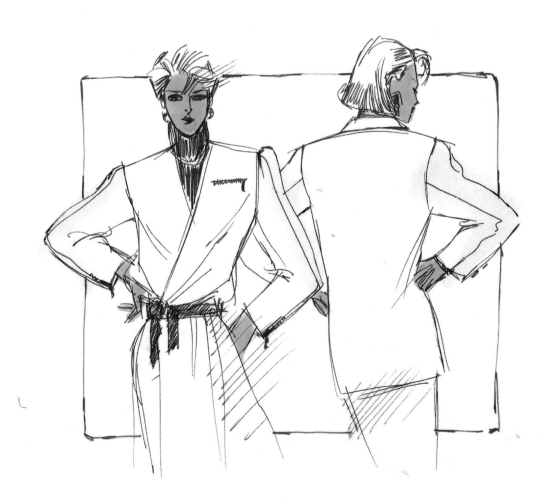

can be eliminated. The underarm panel should be narrow enough to be inconspicuous from both the sleeve front and the sleeve back.

SLEEVES INCORPORATING PART OF THE BODICE

Raglan Sleeve

A raglan sleeve is separate from the bodice and has an underarm seam, like the set-in sleeve. It qualifies as a sleeve cut with the bodice because it fits the shoulder to the neckline as well as covering the arm. When styling a raised neckline, the raglan sleeve is a natural choice because the seams running to the neckline can be curved in many ways. Frequently, the raglan has a slightly deeper armseye so that the arm will not be impeded by the fitted shoulder. The shoulder curve can be shaped by a large dart or by a seam down the center of the sleeve, from shoulder to midwrist.

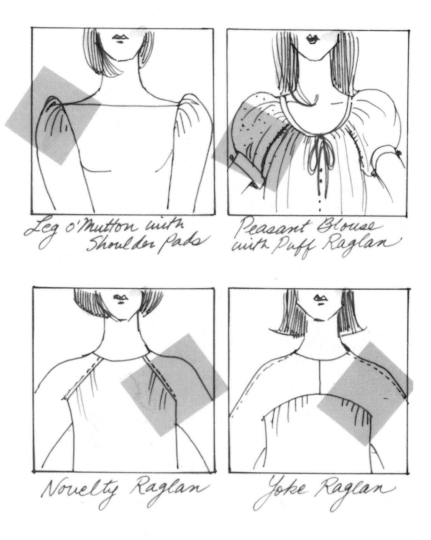

Leg o'Mutton with Shoulder Pads

Peasant Blouse with Puff Raglan

Novelty Raglan

Yoke Raglan

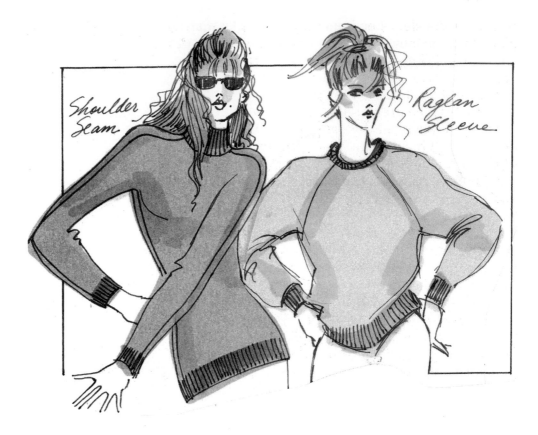

Kimono and Dolman Sleeves

The classic Japanese kimono sleeve is a simple rectangle of fabric. When laid flat, a garment with kimono sleeves forms a T shape. The sleeves fall gracefully from a lowered shoulder line. The underarm seam is also considerably lower than in a set-in sleeve. Garments with kimono sleeves are made in many different styles and fabrics for men, women, and children. Although the fabric and style may differ, the basic shape of the garment and sleeve remains constant. People in many early cultures wore costumes based on the basic T shape.

Western contemporary styling has modified the kimono sleeve, resulting in many variations. Often, the shape of the variation bears little resemblance to the Japanese kimono sleeve. When long kimono or dolman sleeves are styled from fabric 45 to 55 inches wide, there must be openings or seams in the center back and center front of the garment. The pattern pieces would not fit if they were undivided.

Kimono sleeves and dolman sleeves are cut in one piece with the bodice, or they incorporate part of the bodice into the sleeve. Classic dolman and kimono sleeves have an unbroken line from the

bodice to the sleeve end, so they are well suited to plaids and stripes, which can be difficult to work with if a style has too many seams. Underarm seams are sometimes used on a bodice with a kimono shape to save fabric.

The shaded area in the illustration on page 382 represents a typical dolman sleeve pattern. If the arm is raised higher than the shoulder line, the rest of the garment is pulled out of shape. To allow the maximum movement, the underarm seam has been extended. When the arm is in repose, the added fabric at the underarm seam falls in graceful folds. A true dolman sleeve adds bulk to the torso and bust.

The shoulder line may be fitted to conform to the curve of the arm when the arm is in repose. As the angle of the shoulder becomes exaggerated, the movement of the arm is more restrained. To allow for the movement of the sleeves illustrated in positions 2 to 4, a gusset must be added to the underarm seam. A *gusset* is a diamond-shaped piece of fabric, cut on the bias, that is inserted in a slash in

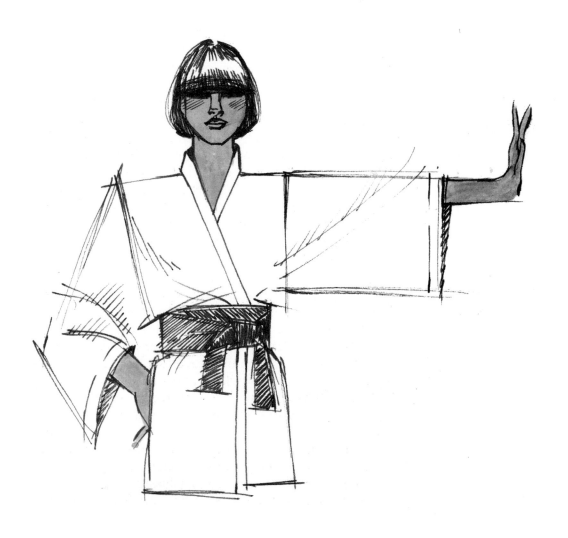

the underarm area that roughly corresponds to the armpit. This fabric should be inconspicuous while the arm is at the side of the body. The gusset compensates for the fabric that was removed when the shoulder was shaped. Some gussets are not a separate piece of fabric. An extension of the bodice may be used to form the gusset.

Styled Kimono Sleeve

Another way to shape the kimono sleeve without using a gusset is to raise the shoulder seam. This automatically allows the underarm seam to grow, increasing the mobility of the sleeve. The underarm

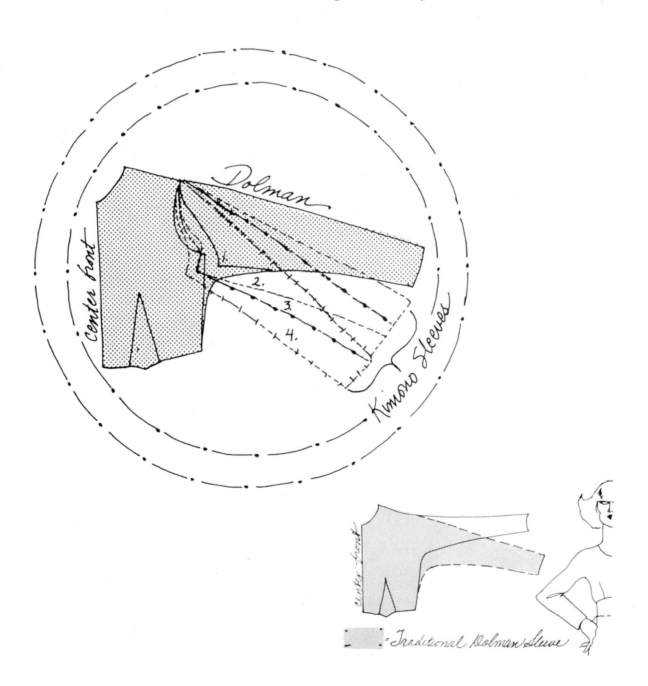

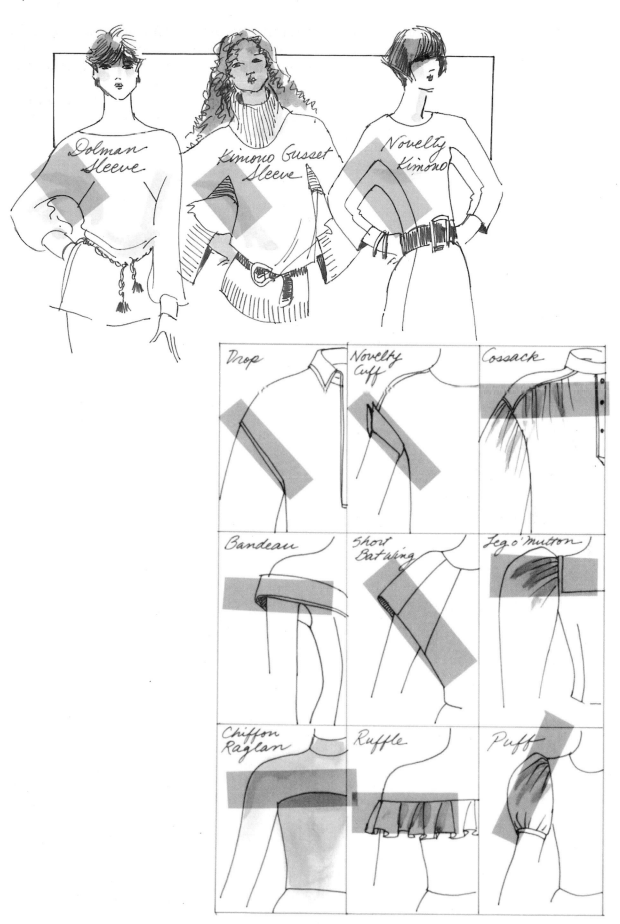

Dolman Sleeve

Kimono Gusset Sleeve

Novelty Kimono

Drop

Novelty Cuff

Cossack

Bandeau

Short Batwing

Leg o'mutton

Chiffon Raglan

Ruffle

Puff

area fits more snugly than in traditional dolman or kimono sleeves. This style is important for two reasons. First, it allows for upward movement of the arm by raising the shoulder slope; second, it increases the length of the underarm seam, also permitting more movement. This was a favorite sleeve of the American sportswear designer Claire McCardell.

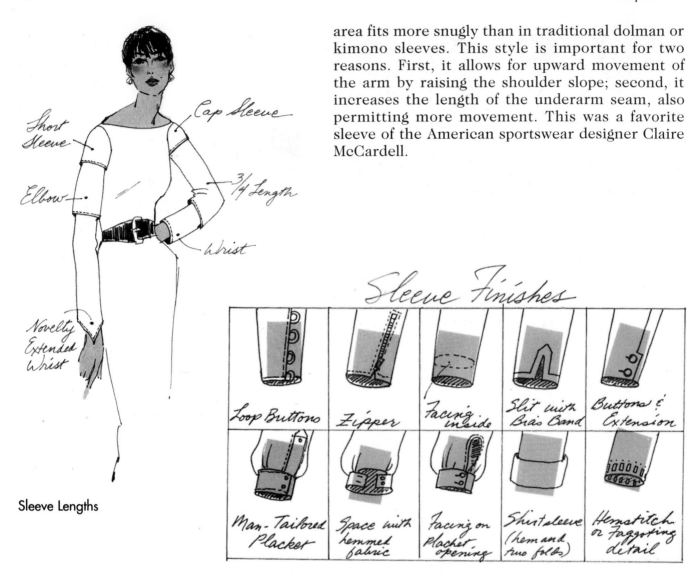

Sleeve Lengths

Sleeve Finishes

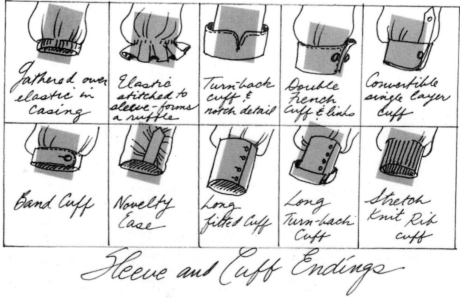

Sleeve and Cuff Endings

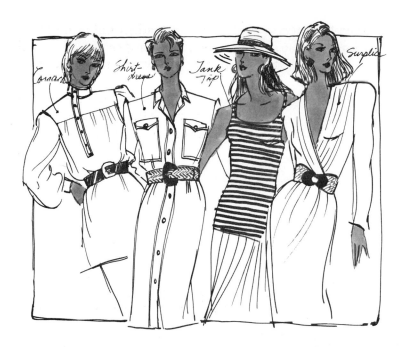

CLASSIC TOP STYLING

Classic styling is a garment that is repeated over and over during different fashion cycles. A particular style may fall from fashion for a period of time, but it is almost always revived. The name

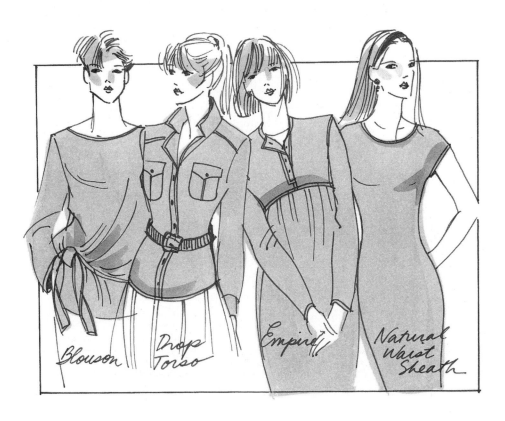

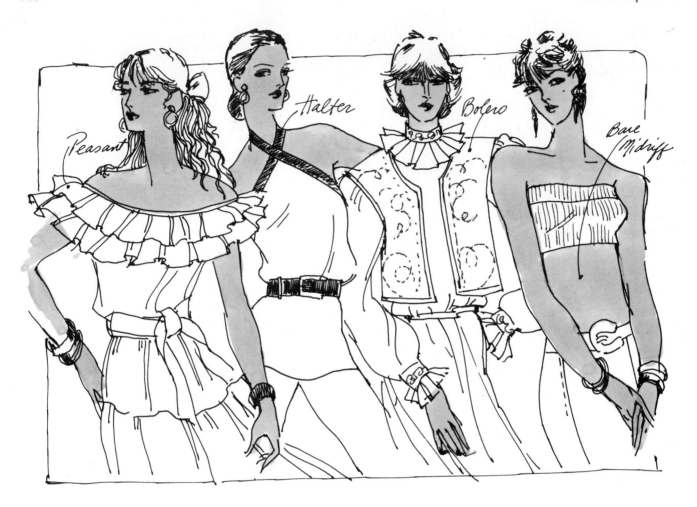

and appearance of each style is part of the basic visual and verbal vocabulary of every person employed in fashion—from the designer and merchant to the copywriter.

Each year, basics are modified slightly. The blazer remains as a classic jacket, but the shape evolves, details are altered, and collars and lapels shrink or enlarge as fashion changes. During periods when ethnic influence is a fashion theme, classic garments from other cultures reappear, always interpreted in the idiom of the period.

The classic dresses, tops, and jackets illustrated here show only one version of each style, but many are possible. The examples are basic, but they should help you to recognize the styling details that occur in current fashion.

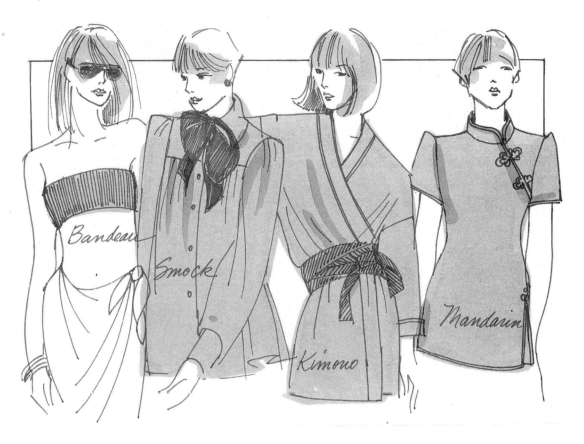

Bandeau

Smock

Kimono

Mandarin

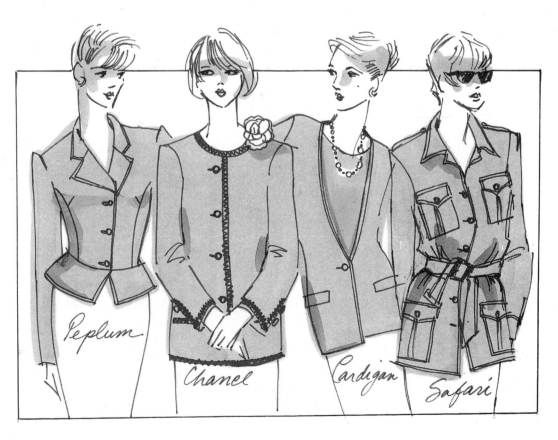

Peplum

Chanel

Cardigan

Safari

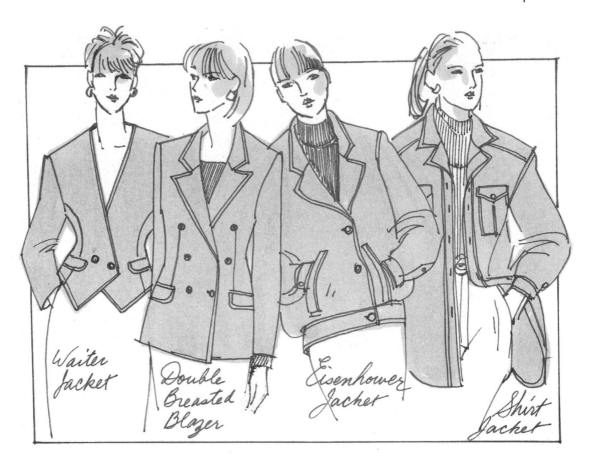

Waiter Jacket

Double Breasted Blazer

Eisenhower Jacket

Shirt Jacket

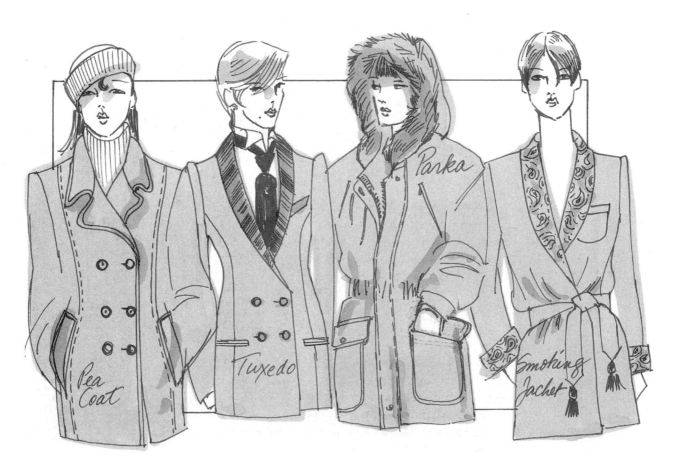

Pea Coat

Tuxedo

Parka

Smoking Jacket

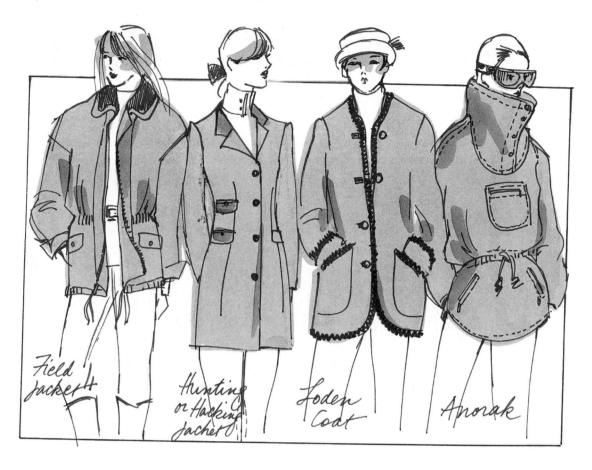

Field Jacket

Hunting or Hacking Jacket

Loden Coat

Anorak

KNIT STYLING

Many classic styles can be made in knit fabric as well as woven fabric. Some styles are made only in knits. There are three main methods of producing knit garments: cut-and-sew, full-fashion, and handknit.

The least expensive cut-and-sew knits are made from yardage from which the garment pieces are cut out exactly as in a woven garment. The pieces are usually overlocked together to allow the knit to stretch. Stabilized knits are finished to react like wovens. This type of knit garment will require fitting and pattern techniques similar to a woven garment, except that the fit will be snugger because the fabric stretch compensates for some ease allowance. Specially designed knit braids and ribbed bands can be purchased to give cut-and-sew garments a sweater look. A second cut-and-sew method that produces a garment that looks more like a sweater is used in domestic sweater mills. Knits are made in coarser gauges (number of stitches per inch) using novelty yarns on sweater machines that knit blocks approximately the size and shape of each garment piece. The blocks are then cut to the exact shape of the sweater piece and

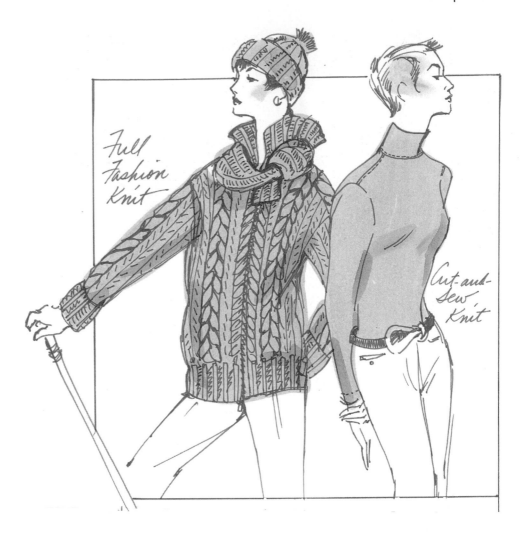

Full Fashion Knit

Cut-and-Sew Knit

assembled. Sweater machines can knit areas of different stitches on one garment piece, and a knitting machine knits fabric in a single pattern. For example, rib bands that finish the hem of a sweater can be knit into each piece, giving the garment more of a true sweater look.

Full-fashion sweaters (also called handloomed) have each piece of the sweater knitted to the proper shape on a hand-knitting machine. There are several handloomed factories in the United States, but these are very labor-intensive and are used mainly to create expensive garments. St. John Knits, located in Los Angeles, is the most famous manufacturer of domestic handloomed sweaters, dresses, and suits. The handloomed pieces are hand assembled and blocked. Hems, trims, and findings are also added by hand.

Full-fashion garments are most often made in the Orient or Europe in specialized factories. Taiwan and Korea produce jacquard, intarsia, and fancy handlooms for the inexpensive-to-moderate market.

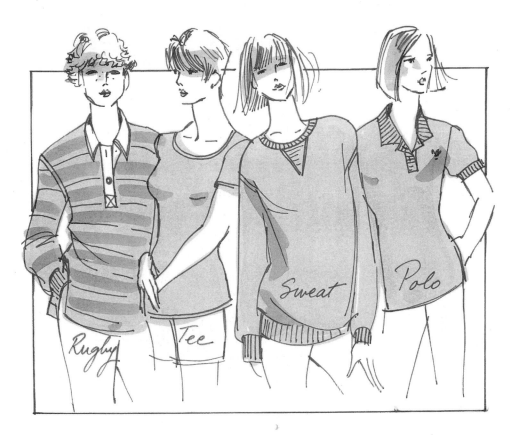

Rugby Tee Sweat Polo

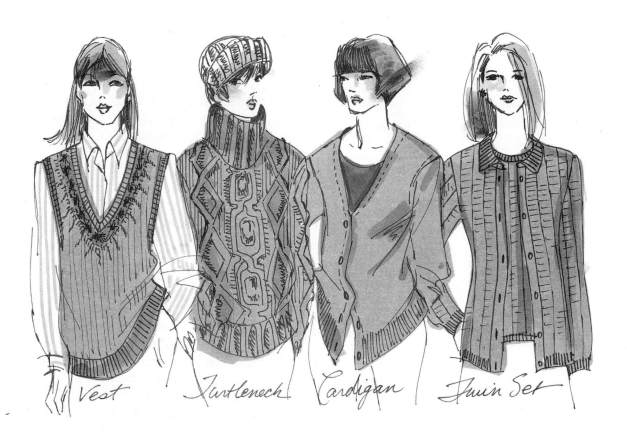

Vest Turtleneck Cardigan Twin Set

Hong Kong produces a wide range of knits for the budget-to-expensive market. Moderate-to-designer full-fashion sweaters are also made in Europe. The price of the garment depends on the price of the yarn and the wage rate of the country it is made in. Fancy yarns of all kinds are available in Hong Kong and Europe, while acrylic and cotton yarns dominate the less-expensive sweaters produced in Taiwan and Korea.

Hand knits are produced in many countries and are usually made in cottage industries. A manufacturer designs a garment, assembles instructions and materials, and contracts the garments out to women who knit in their homes. England, Ireland, and Scandinavia have traditionally produced fine hand-knit garments in this way. Less-expensive sweaters are hand knit in India, the Orient, and the Middle East.

Patterned sweaters are popular fashion items. There are several ways to create patterns. Jacquard knits can be made in cut-and-sew fabric, full-fashion, and hand-knit techniques. Two to four colored yarns are used, and the pattern is created by allowing one color to be knit on the face of the fabric, while the yarns not in use are carried as

The back of a hand-knit jacquard has floats of one-color yarn knitted into the contrasting ground yarn.

The front of a hand-knit jacquard.

floats on the back of the knit. Jacquards are used for allover patterns. Jacquards have all the colored yarns visible throughout the pattern on the back of the fabric. Light-colored patterns with dark accents have a shadow and are less effective than yarns in one-color palette. Modern machine-made jacquards utilize a computer to program punch cards that guide the knitting machine to use the correct color on the face of the fabric. Hand-knitted jacquards are made with bobbins of various colored yarns knitted to the face of the sweater in intricate patterns.

Intarsia is a technique of knitting a design out of several colors of yarn, stitching the pieces together, and then sewing the design into the body of the sweater. This technique can be made on a knitting machine or by hand. The sweater can be further decorated with embroidery. Intarsia is used for spot motifs. To identify it, look at the back of the sweater for telltale stitches where the pattern is joined. There is no bleed-through of colors in this technique.

Embroidery can be added to the basic knit by hand to simulate intarsia techniques. Colors are added to form a pattern following the form of the

The front of a machine-made jacquard has a pattern created by one color of yarn being knitted through to the face of the knit. Notice that the pattern is not as clear as an intarsia pattern because the yarns carried on the back of the sweater shadow through the pattern.

The back of a machine-made jacquard shows several yarn colors carried throughout the pattern.

The back of an intarsia sweater shows how the different-color areas are stitched into the ground to create a pattern.

The front of an intarsia-patterned sweater.

knit stitch. A great variety of colors can be used in this technique, but it can only be done by hand and is therefore expensive.

Dramatic sweater patterns can be created using a combination of techniques, including striping and ribs that can be made by machine. Sweater designers combine jacquard or intarsia on the front or back of a sweater and striped or patterned sleeves knitted by machine to make sweaters less expensive.

CLASSIC COATS

Classic coats are reinterpreted frequently during fashion cycles. Lengths are changed to conform to current hemline trends and collars and details are modified. The fashion cycle for coats is slower than the cycle for dresses or sportswear. The customer invests more money in a coat and wants it to last for several seasons, so she will buy a more classic garment.

Coats must fit with more ease if they are to accommodate clothes worn underneath. Often, coats are made of bulky fabric, so a looser fit, especially in the sleeves and chest, is essential for freedom of movement.

Many times, raincoats are made from a lightweight fabric, such as poplin, that has a water-resistant finish. These coats should be roomy because they are not warm and underlayers must be added

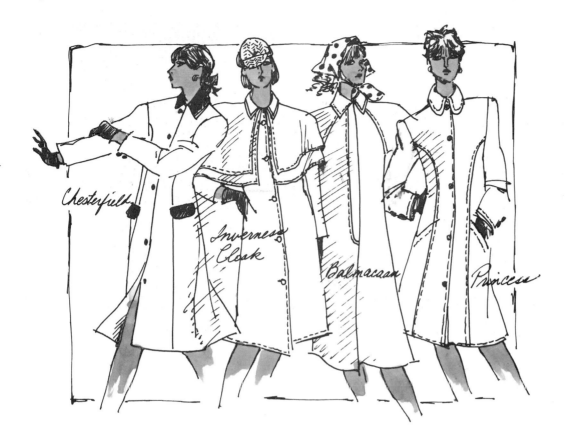

Chesterfield

Inverness Cloak

Balmacaan

Princess

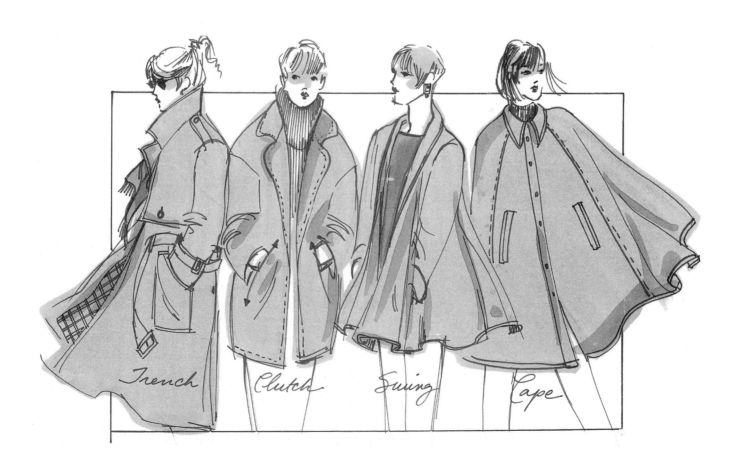

Trench

Clutch

Swing

Cape

in cold weather. The only truly water-repellent fabrics (those that allow no water penetration) are vinyls. These fabrics do not breathe, so vinyl garments are generally constructed with air holes under the arms to allow some air to circulate. Vinyls can be quite stiff, so the designer must add ease to allow for movement.

In outerwear, pockets and collars should be functional. Pockets are used to warm the hands or hold gloves and scarves, so they should be large and conveniently located. Often, hoods are incorporated into collars or extra flaps are added at the neck as a windbreak. Linings and zip-out extra-warm liners are built into cold-weather outerwear. Outerwear should be both functional and fashionable.

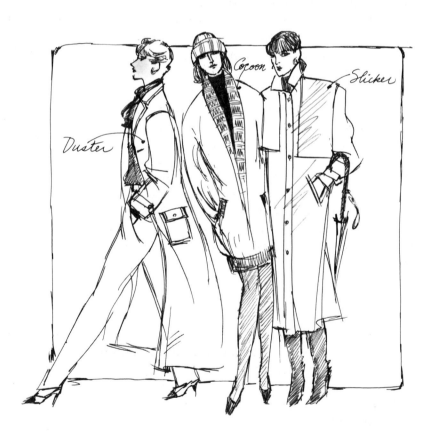

Summary

The basic bodice is the basis for developing all patterns for dress tops, blouses, suits, and coats. Darts, gores, and yokes are combined with ease to style tops.

The fit of a garment is determined by the individual manufacturer according to the standard of fit for each category. The price of a garment reflects how a garment fits. Budget garments usually have less fabric and may have a snugger fit. Designer garments usually have more fabric, and often a person will wear a smaller size in a better-priced garment than in a moderate one.

Set-in sleeves and sleeves that are cut in one piece or incorporate part of the bodice are the two main categories of sleeves. Sleeves are usually drafted. The set-in sleeve is the basic sloper used to create all other novelties. A basic set-in sleeve should fit smoothly and not bind or pucker. The arm should be able to move comfortably.

The set-in sleeve is styled by adding fullness to the cap or the end sleeve or the end of the sleeve. Padded shoulders add visual width to the silhouette, balancing a wide hip and making a person seem taller. The shape of the pad should be appropriate for the style of sleeve; the width is decided by the designer.

Sleeves incorporating part of the bodice are divided into raglan, kimono, and dolman variations. These novelty sleeves have a great variety of shapes. The shape of the armseye seam depends on the style of the sleeve. Gussets may be added to the underarm area to allow for greater movement.

Sleeves are finished with cuffs and novelty details that should be designed to complement the rest of the garment.

Classic styling is repeated over and over with slight differences depending on current fashion trends.

Knit tops are made in several ways. The least expensive is cut and sewn from fabric. Cut-and-sewn sweaters can be made from blocks knitted in a sweater factory in approximately the shape of the sweater pieces. Full-fashion sweaters are knitted on a machine in exactly the shape of the sweater component and then assembled by hand or machine. Hand knitting is the most expensive and time-consuming method of producing sweaters but also allows the greatest design flexibility. Most hand knits are produced by individual knitters in a cottage-industry setup.

Patterned sweaters are produced by jacquard or intarsia methods and can be further embellished with embroidery. Hand embroidery to simulate knitted stitches is another method of producing patterned knits.

Classic styling is appropriate for designing coats. The fashion cycle is slower for coats than for other garments because they are designed to last for several years. Function is important when designing coats because they are worn as protection.

Review

WORD FINDERS

Define the following words and terms from the chapter you have just read:

1. Balmacaan
2. Bandeau
3. Basic sleeve sloper
4. Bishop sleeve
5. Blouson
6. Cut-and-sew knits
7. Dolman sleeve
8. Ease
9. Fisheye dart
10. Full-fashion knit
11. Gusset
12. Handloomed
13. Intarsia
14. Inverness cloak
15. Kimono sleeve
16. Padded sleeve
17. Peplum
18. Set-in sleeve
19. Shadow
20. Smock
21. Water-repellent

DISCUSSION QUESTIONS

1. Discuss the differences between the two methods of constructing cut-and-sew knit garments.
2. What methods of removing excess fabric are used to fit tops?
3. What are some practical considerations to keep in mind when designing coats?
4. Describe and diagram the standard fit of a set-in sleeve. How much ease is added to the cap of a basic set-in sleeve?
5. Name three sleeves cut-in-one with the bodice.

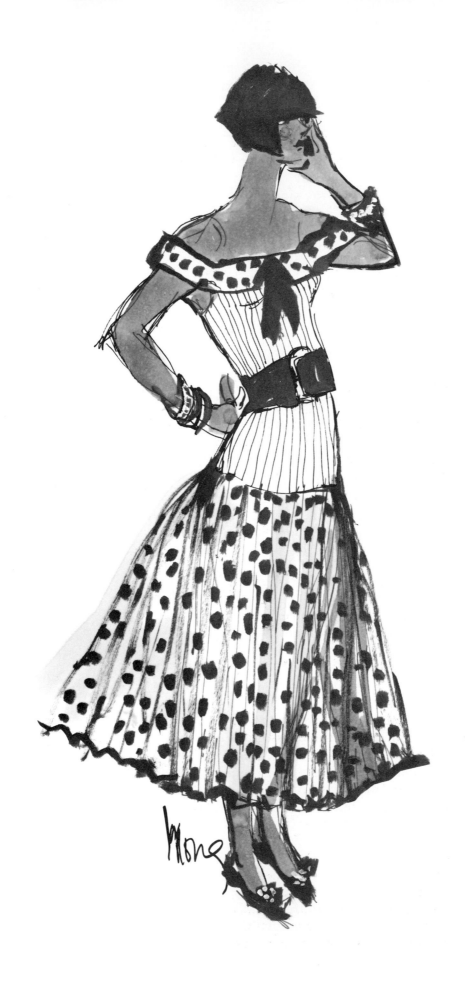

CHAPTER **11**

Skirts

A skirt is a tube of fabric that encircles the body from the waist down. When designing a skirt, the two most important factors to keep in mind are the silhouette and the length. The silhouette refers to the shape of the skirt, which depends on the amount of ease (extra fabric) in the garment and the kind of fabric used. The shape of the pattern pieces will also affect the silhouette. Skirts are styled in four basic shapes: straight, flared (wider at the hem, flaring from a slim waist), circular (very flared), and pegged (tapered at the hem.)

A sheath skirt follows the shape of the body. However, the kind of fabric will greatly alter the shape of the skirt. A full skirt in a crisp fabric will be more flared than a skirt made from the same pattern but in a soft fabric.

Straight Skirt

The side seams of a straight skirt are aligned with the straight grain of the fabric, and the cross grain runs across the hips from side seam to side seam. The drop, or difference between the size of the hip and the waist, is removed with darts or gathers. Variations on the straight skirt include the dirndl, pleated skirt, sheath, and straight-wrap skirt.

Flared or Gored Skirt

The pattern pieces in a flared skirt are wedge shaped. They taper at the waistline and gradually flare over the hips to greater fullness at the hemline. The gored skirt can be made in as few as two pieces,

When you have read this chapter, you will understand:

1. The four basic skirt shapes.

2. Variations in straight skirts.

3. Kinds of pleated skirts.

4. Skirt lengths.

5. Waistband treatments.

6. Novelty skirt styles.

Circular skirt

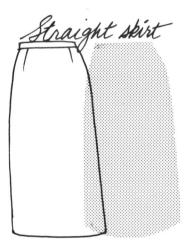

Straight skirt

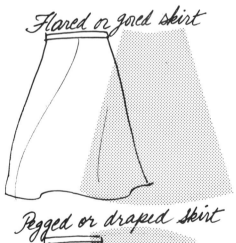

Flared or gored skirt

Pegged or draped skirt

a front and a back. Most fullness will be added to the side seams in this type of flared skirt. A more-attractive flared skirt is made with more gores, which allow fullness to be added at regular intervals. Gored skirts can have from 2 to 16 gores or even more. Inverted pleats and trumpet gores are possible variations.

Pegged or Draped Skirt

A pegged skirt is wider at the waistline, and the excess fabric is gathered or draped into a waistband. The side seams are tapered at the hemline. Variations include the sarong, asymmetrical drape, and hobble skirt.

Circular Skirt

This skirt can be a half-circle, a full circle, or, for the most exaggerated look, several full circles sewn together. Of all skirts, this one is the widest at the hemline. It has a small waist, and the skirt pattern looks like a doughnut.

STRAIGHT SKIRTS
Sheath

The basic sheath pattern has four front darts to reduce the excess fabric between the waist and the fullest part of the hip. This pattern is often used as the basic sloper from which other skirt variations are made. Usually, this skirt has a center back seam, two darts in the back, and a slit or release pleat to make walking easier.

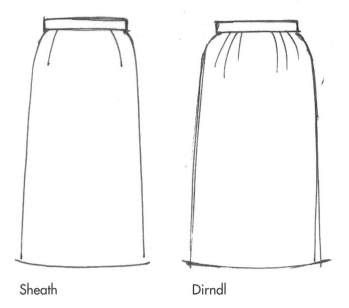

Sheath Dirndl

Dirndl

The dirndl can have a minimum amount of ease, with a slim silhouette where the excess fabric, or drop, is eased into the waistband. This dirndl looks like a sheath, except that the hipline is slightly bulkier. The typical dirndl, however, has much fullness eased into the waistband. The amount of ease depends on prevailing fashion and the kind of fabric used. The more body a particular fabric has, the less fabric should be used for the dirndl because a stiff fabric emphasizes the natural fullness of the hips. This skirt is the traditional style for many ethnic costumes; in fact, the word *dirndl* is taken from the name of the skirt in an Austrian folk costume.

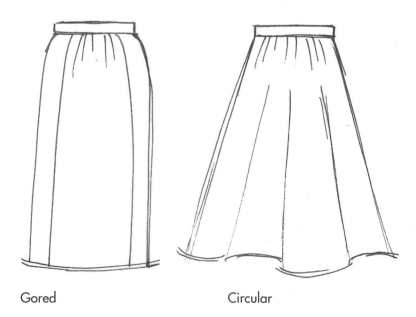

Gored Circular

Gored Sheath

This skirt substitutes seam lines for darts, but the side seams are straight. The seam lines may conceal pockets. This style is very slenderizing. The gores may be arranged in many ways—for example, a plain darted front and three gores in back for smooth fit. Other variations include a style that buttons in front or a skirt that wraps to the side front. More ease can be added if a dirndllike skirt is desired. Inverted pleats or large box pleats can be added to the seam lines. This is a versatile way of making a sheath skirt.

Gathered

The gathered skirt is the simplest kind of skirt to make and, consequently, is often a beginner's first sewing project. Much of this skirt's character is determined by the kind of fabric used to construct it. A stiff fabric will accentuate the hips and hang away from the body. A soft fabric will cling to the body and create a more natural silhouette. This skirt is much fuller than a dirndl.

Pleated

Generally, pleated skirts are straight pieces of heat-sensitive fabric that are pleated commercially. Best for pleating are fabrics made from fibers that do not decompose under high heat, such as polyester, tri-acetate, acrylic, or blends of these fibers. Wool, cotton, and linen can be pleated but not permanently: The pleats will have to be reset every time the garment is cleaned. Both knit and woven fabrics can be pleated.

A special contractor is used for most commercial pleating. Frequently, the skirt will be seamed and hemmed before it is sent to the contractor. Often, inexpensive garments will be pleated with a very small underfold, and the shallow pleat will sit out. This is a way of saving fabric. The designer determines the style and the size of the pleat. Then the contractor makes a manila-paper pattern that is scored in the dimension of the pleat and the underfold. A graduated pleat can be made. From the hip upward, more fabric is taken out of each pleat so that the skirt will fit the curve of the body. When the skirt is sewn into the waistband, it will fit smoothly at the waist; yet it will not strain or spread awkwardly at the hipline.

Pleated skirts can be made from circular-shaped patterns, but the majority are constructed

from straight pieces of fabric. After the skirt length has been placed in a hot oven that sets the pleats, thin strips of masking tape at the hemline and waist hold the pleats in place until the skirt can be sewn to a waistband or bodice. As the pleats are sewn, the tape is removed.

Variations can be made by pleating only the top of the garment (unpressed or released pleats), top-stitching the pleats over the hip and releasing them on the rest of the skirt or setting the pleated skirt on a yoke or a low torso dress.

Kinds of Pleats

Knife, Straight A straight pleat is easily graduated to compensate for the drop between the waist and hips. The pleats may be any size, from a quarter–inch to several inches wide. This pleat will look crisp and tailored in a sporty fabric; yet it can also look dressy in a soft fabric.

Box The box pleat has a sporty look, as does the inverted box pleat. The box pleat is particularly appropriate for plaids because one pleat can emphasize one color of the plaid and the contrast plaid can be used as the underfold. A box pleat is difficult to graduate at the waistline.

Accordion; Crystal The larger version of this style is called an *accordion pleat;* the small, fine version is called a *crystal pleat.* This style has no underlay, but the pleats are gathered into a seam or the waistband. Crystal pleating is effective with sheer fabrics and has a dressy look. This type of pleat is difficult to show on a hanger because the pleat tends to collapse. When the garment is worn, the pleats are held out by the body and drape nicely.

Engineered This kind of pleat is planned for an individual garment. It can be a constructed pleat, built into the pattern and pressed by hand rather than constructed by a contractor. Sometimes, commercially pleated fabric can be combined with straight fabric to simulate the look of an engineered pleat.

FLARED SKIRTS

A flared skirt is wider at the hem than at the waist; this slims the waist and hips. The side seams slant outward from the fullest part of the hip. Because the side seams are not on the straight grain, the skirt is cut partially on the bias, which influences the way it hangs. When bias fabric hangs, it tends to sag. For this reason, flared skirts are often gored so the grain

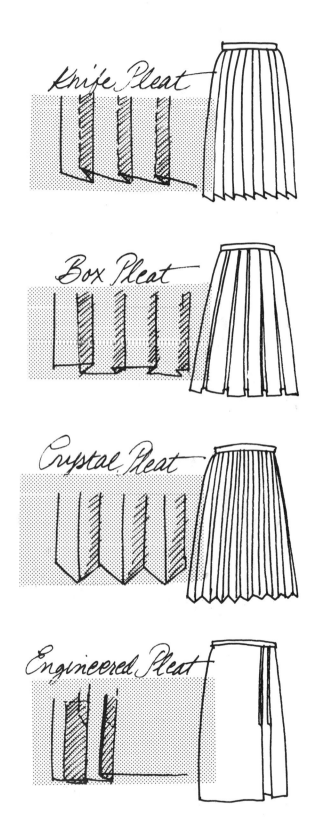

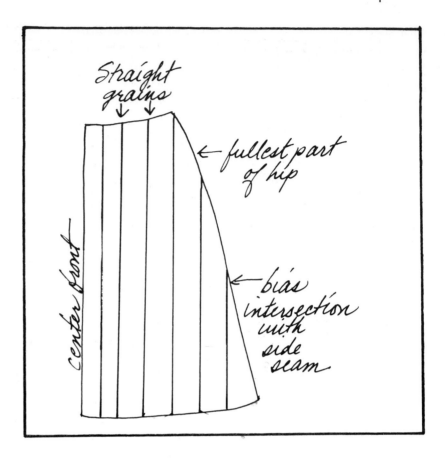

line can be controlled by a seam in the individual segment of the skirt. Multiple gores add body and fullness to the skirt because the seams stabilize the way the skirt drapes. Furthermore, gores can be shaped to add fullness to specific areas of the skirt. For example, the trumpet gore fits smoothly over the hips and thighs and flares at any point thereafter, depending on the designer's preference.

Novelty effects can be achieved by cutting all gores on the true bias. This is particularly effective for stripes and plaids, but the patterns should match exactly when more than four gores are used, and this is difficult to engineer.

A gored skirt often has a center back seam (with a zipper opening) that divides the back into two gores. A single panel in front makes a classical three-gore skirt. A gored skirt is named by counting the number of gores. A gored skirt does not have to be divided equally in front and back. Sometimes, the back is simplified by using two gores, although the front may have more divisions. All gored skirts can be altered by adding more fullness to each panel, or the design can be varied by adding more fullness to the center panel and easing the excess into the waistband. Another common styling device

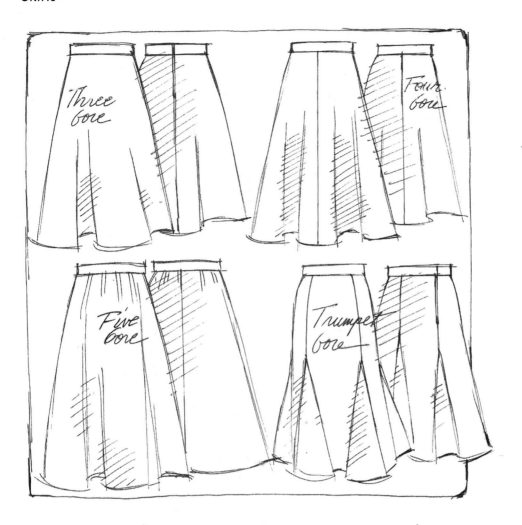

is to put the gored skirt on a hip yoke or a low-torso dress. An inverted pleat can be added to the gores of a flared skirt to give added fullness to the hemline.

PEGGED AND DRAPED SKIRTS

The pegged skirt visually enlarges the hip area because the skirt is tapered at the hemline. This skirt may be coupled with a snugly fitted bodice, a combination that makes the waist seem very small. The first example in the accompanying illustration shows a straight skirt that has been tapered slightly from the fullest part of the hips. If the taper is not too exaggerated, it will slenderize the skirt silhouette. As the skirt becomes tighter at the hemline, it must be slit, or a pleat must be added so that the wearer can walk. The second example is a draped skirt. Concentrating the ease at the center of the waist exaggerates the size of the hips.

During periods when physical movement and active lifestyles are fashionable, this silhouette is

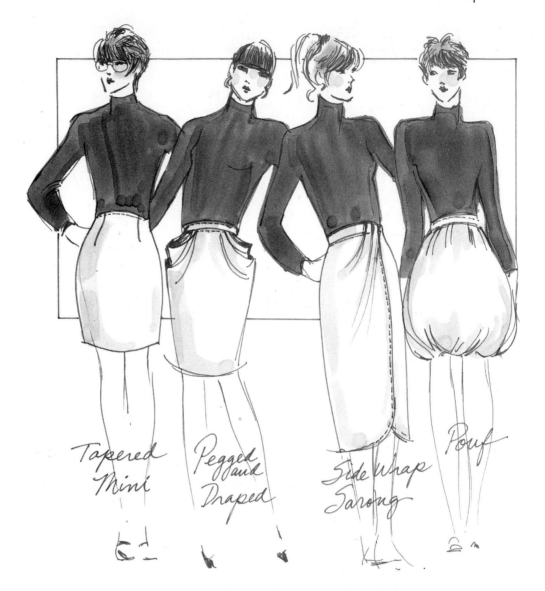

Tapered Mini

Pegged and Draped

Side Wrap Sarong

Pouf

not found in day wear and appears only occasionally in evening wear. When fashion stresses the feminine aspects of womanhood (as it did between 1912 and 1915), this silhouette is popular.

The sarong and other asymmetrically draped skirts were popular during the late 1940s. They were worn for street wear as well as evening wear. The wrap sarong over a bathing suit has become a classic.

The harem skirt, or pouffe (also worn as full, ankle-length, bloomerlike pants), is a novelty that is revived occasionally as lounging apparel.

CIRCULAR SKIRTS

Circular skirts are rarely made commercially because very wide fabric is required if the skirt is to be cut from a single piece of goods. When the fabric is

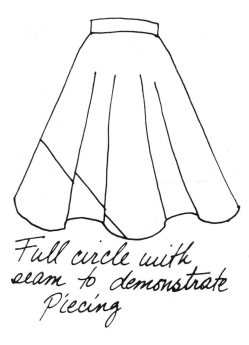

Full circle with seam to demonstrate Piecing

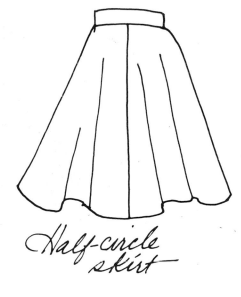

Half-circle skirt

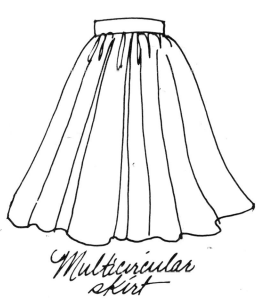

Multicircular skirt

not wide enough for a full circle, the skirt must be pieced or gored. The circular skirt also wastes a great deal of fabric and is difficult to hem because it is mostly on the bias; a very small hem must be used. During the 1950s, circular felt skirts were popular, particularly those trimmed with whimsical appliqués. Felt is the ideal fabric for circular skirts because it has no grain line, is very wide, and does not have to be hemmed because it will not ravel.

When a very full skirt is desired, especially for evening wear, several circular shapes can be put together for a dramatic effect.

Perhaps the half-circle skirt is the most wearable of all the silhouettes. It has a modified and graceful flare that is more easily cut from fabric of average width. Waste fabric (called *fallout*) is still a consideration.

SKIRT YOKES

A *yoke* is a horizontal division in a garment. A skirt yoke can eliminate darts and gores by fitting the fabric over the hips and forming the foundation for the flared or pleated portion of the skirt. This is an effective way to make a skirt fit smoothly under a long overtop. The yoke should end 2 inches above the hem of the top so that the yoke seam is not visible.

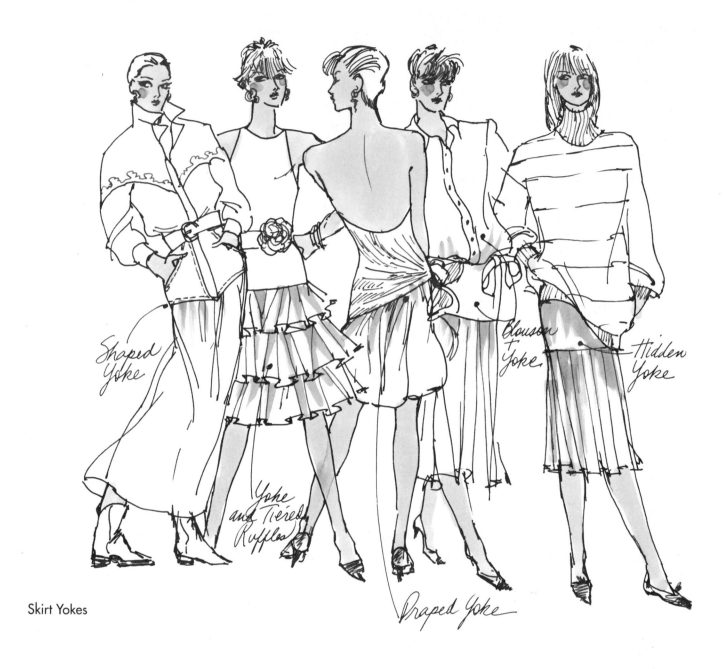

Shaped Yoke

Yoke and Tiered Ruffles

Draped Yoke

Blouson + Yoke

Hidden Yoke

Skirt Yokes

WAISTBAND TREATMENTS

Styled waistbands can add interest to a basic skirt. The designer should plan a styled waistband carefully because too much bulk or detail is uncomfortable and makes the waist seem larger. A classic waistline treatment is belt loops and a tailored belt. Elasticized waistbands add comfort to a garment and are especially appropriate for children's wear, active sportswear, and clothes for mature and large-sized women. Elasticizing the back of a waistband adds comfort to the garment without sacrificing a tailored look.

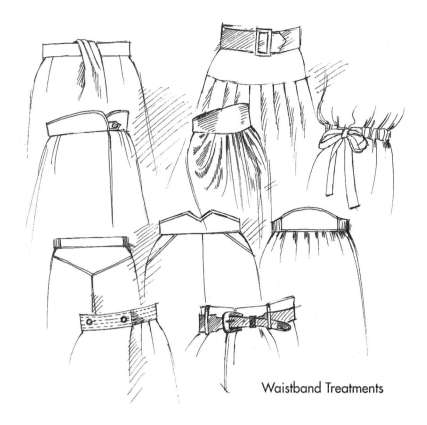

Waistband Treatments

SKIRT LENGTHS

Raising and lowering hemlines has been a major occupation in fashion since the beginning of the twentieth century. The length of skirt affects other components in a costume or dress because any change in hemline, even a few inches, alters the garment's proportion. Greater variety is possible with a skirt that covers the knees because the skirt shape is emphasized by greater length.

When a particular length is the accepted fashion for a period of time, the eye becomes accustomed to the established proportion. A radical change promoted by a few fashion leaders may be necessary to start a more moderate change of hemline. Gradually, designers and a few consumers experiment with the new length, and complementary accessories are developed. Leg coverings and shoes are the accessories most relevant to a change in length. Eventually, the general public begins to recognize the new look as high fashion. More people ask for and buy the newer length. Usually, the consumer does not discard an existing wardrobe but will gradually add new items in the fashionable length.

Fashion magazines reinforce the new look and sometimes give suggestions on how to make older garments look more contemporary. Bit by bit, the

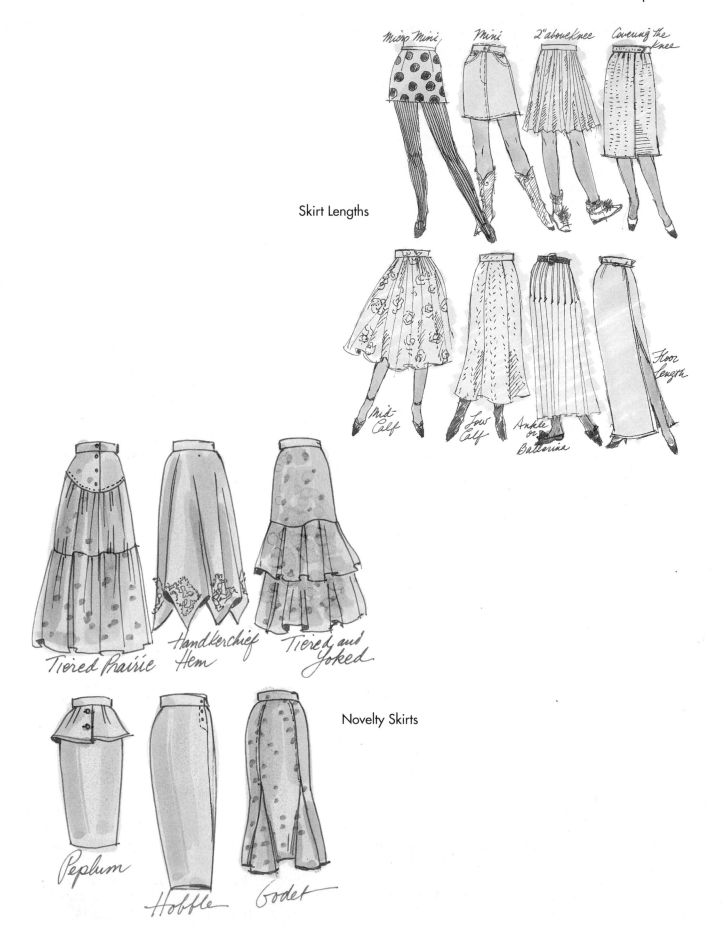

Skirt Lengths

Novelty Skirts

less-radical versions of the newer length are accepted by the general public. Accessories that enhance the new look become available at lower cost and in a greater number of stores. Now the new length is widely accepted. Many variations are designed around the new fashionable proportion, and these variations eventually become more important than the new length itself. As endless variations are designed and the general public regularly wears them, fashion leaders look for something new. Hemlines change once more, giving designers a new proportion to experiment with. The cycle has returned to the starting point, and once again length is the fashion question.

The cycle requires several years, but economic and social factors that alter lifestyles often affect the speed with which the cycle completes itself.

Summary

The four basic skirt shapes are straight, flared or gored, pegged or draped, and circular. Skirts can be styled and fitted by using darts and side seams, gathering, gores, and pleats. Gathered skirts emphasize the hipline, while flared, slim, and gored skirts slim the figure.

Pleated skirts can be machine pleated if they are made in a heat-sensitive fabric. Knife, box, accordion, and crystal pleats are typical patterns. Engineered pleats are constructed when the skirt is made and then sewn and pressed in by the operator.

Gores are usually used for flared skirts because they effectively add more fullness to the hemline. Gores correct the side-seam sag that is typical of a simple flared skirt. They can be cut on the bias or straight. Trumpet gores and godets are two novelty gored styles.

Pegged and draped skirts include sarong and harem skirt novelties. This style adds bulk to the hipline.

Circular skirts are dramatic and are popular when fitted bodices are in fashion. They demand a great deal of fabric and tend to be expensive to make.

Skirts can also be fitted with a hip yoke to replace darts or gores. This is effective styling for a skirt worn with an over-top.

Novelty waistbands are appropriate for skirt styling when they are carefully designed.

Elastic added to waistbands adds comfort and fit to a garment.

Skirt lengths are an important fashion variable. The length of the skirt balances or accents the other elements of a garment's design. A customer should experiment to find her most flattering length in each stage of a fashion cycle.

Review

WORD FINDERS

Briefly define the following terms from the chapter you have just read:

1. Accordion pleat	9. Knife pleat
2. Box pleat	10. Maxiskirt
3. Circular skirt	11. Miniskirt
4. Crystal pleat	12. Pegged skirt
5. Dirndl	13. Sarong
6. Gored skirt	14. Sheath
7. Graduated pleat	15. Straight skirt
8. Harem skirt	

DISCUSSION QUESTIONS

1. Discuss the various types of straight skirts. Which allow more freedom of movement?
2. How do gores affect the styling of a flared skirt?
3. What are the technical difficulties in styling a skirt that is a full circle? What fabric is particularly suitable for circle skirts?

CHAPTER **12**

Dresses

The traditional definition of *a dress* is a single garment that covers the torso and legs. Merchandising policies of department and specialty stores are flexible enough to incorporate a broader range of garments into their dress departments when fashion dictates variety. Dress departments may also include costumes, jumpsuits, and two-piece garments as well as traditional dresses. Merchandising trends today divide dresses by age, use, and price range, based on the theory that the customer will recognize the merchandise that appeals to her and will want to find it conveniently located in one area. Some innovative stores may group better and designer dresses in a specialized department featuring one company or designer. The merchandise has to have significant consumer recognition and be able to sell a large number of units to support an individualized department.

JUNIOR DRESSES

Junior dresses tend to be less expensive than missy dresses, and their prices fall in the moderate-to-budget range. The designer of junior dresses must analyze customers by age, occasion, fit, price points, and hot items.

Age

The average age of the junior dress customer is 14 to 25 years. Some stores have two junior departments, the "bubble-gum" or very young junior department for the 14-to-18-year-old and a regular

When you have read this chapter, you will understand:

1. Dress categories and their customers.

2. Specialty dress categories.

3. Traditional methods of designing a dress.

4. Classic dress styles.

Junior
Dress

junior department. Younger girls purchase their dresses and sportswear in the teen and children's departments. Typically, the junior customer is in junior high, high school, or college. Some young businesswomen are included in this category. The junior dress department boomed in the 1960s and 1970s when the bulk of the baby-boom generation dominated the economy. Dress departments generated less volume in subsequent decades because sportswear began to dominate retail sales during the 1980s.

Occasions

One of the most important factors to consider when designing for this customer is school or work life. Many of these customers are in school, so trends at high school and college campuses are crucial. Dress codes, or the lack of them, influence dress departments. When it was compulsory to wear dresses or skirts to school, many more of these items were sold. When a community has many schools where uniforms are mandatory, the daytime junior dress business will be radically affected. Some businesses maintain a dress code that requires dresses or skirts, but the trend toward more-casual garments has discouraged many customers from wearing dresses during the day.

The junior dress designer should be constantly aware of what the customer is wearing, her lifestyle, and the events she attends. A special category of dresses has emerged in the junior department—the occasion dress. This is a long, fancy dress that is priced from $50 to $200. The junior customer wears this dress to proms, weddings (often as the bride or bridesmaid for casual weddings), sweet-16 parties, and other special occasions. She may buy one or two of these garments per year. Spring and summer are especially popular times to purchase and wear these dresses. In general, the garments are made of delicate cottons, prints that mix and match, and eyelets trimmed with lace and ribbons. More-sophisticated party or dancing club dresses, made of slinky knits or other body-conscious fabrics, are also popular in short versions.

Fit

Fit restrictions for this category are fewer than for missy garments. The more youthful figure tends to have fewer fitting problems than the mature one. The designer should make samples using a typical junior fitting model.

Hot Items

Trends are important in this market. Many items and fads make this a fast-moving, constantly changing classification. Many trends come from junior and contemporary sportswear. For example, when T-shirts became a hot item in junior sportswear, dress manufacturers quickly incorporated them into junior dress departments, teaming the shirts with a skirt and pricing the combination as a unit. Occasionally, a dress item will become an important sportswear item—for example, jumpsuits. Jumpsuits were a hot item in the dress department, and sportswear manufacturers included them in their lines as soon as they checked (sold well).

CONTEMPORARY DRESSES

The contemporary category is relatively new to the department store. This category was developed so the latest fashion could be included in the merchandising mix. The contemporary customer emerged in the 1970s when a large number of young women grew out of traditional junior apparel. More often than previous generations, these women tended to pursue careers and delay marriage and childbearing. This created an audience of fairly affluent women who were figure-conscious because of society's emphasis on diet, active sports, and a more mobile lifestyle. This customer was unable to find fashion merchandise in the missy area unless she paid very high prices for famous designer clothes. The new contemporary division concentrated on moderate-to-better-priced garments that featured forward-looking styles.

A "bridge department" sells merchandise that is not as expensive as the designer department, yet is several price points above moderate. This merchandise is appropriate for the woman who wants more style and better quality and yet is not as fashion forward as a true contemporary customer.

Contemporary Dress

Age

The average age of this customer ranges from the sophisticated 17- or 18-year-old to women in their forties and fifties, if they have the proper figure and frame of mind.

Occasions

The contemporary customer, more than consumers in other categories, tends to put less emphasis on

occasion and more on the flexibility of her wardrobe. The total look of the outfit is more important than its formality. Because the category is new and not traditionally divided among established departments, there is more room for experimentation in the merchandising of contemporary garments.

Many contemporary designers choose the boutique method of grouping garments, disregarding whether the items are dresses or separates. Some stores follow suit by putting similar looks together to give the impression of a contemporary department. They hope to capture the customer's attention with a small, well-defined selection of merchandise. For many years boutiques and specialty shops have concentrated on the look of the merchandise and not tried to be all things to all people. If the boutique approach is successful in the contemporary category, department stores may use that method to merchandise all apparel in the future.

Location

This is an important consideration for the contemporary designer. Generally, the most advanced fashion appeals to the urban dweller, especially the resident of a large city.

Fit

Contemporary garments should be less affected by fit restrictions and concentrate more on pure fashion. If the style is supposed to fit snugly, the contemporary garment should not compromise. Contemporary garments are usually limited to small sizes. Rarely do they go over size 12.

Hot Items

This is the testing ground for new fashions and colors. All other categories look to this area for retail items. Often, a contemporary designer will capture the fashion essence of the most current lifestyle. These designers will be emulated in lower price ranges and will set the pace for many different design areas.

MISSY DRESSES

Missy is a traditional category that is well represented in several price ranges in most department stores. Typically, a department store will have bud-

get or inexpensive, moderate, and better missy dress departments and a designer dress department. Often, a sport dress department, which sells casual dresses, shifts, and pantsuits, will also be included.

Age

The ages covered are 18 through the seventies, but missy fashion tends to be a state of mind and figure more than an age.

Occasions

A great range of activities is covered by this category of dresses, from housework to office work. Occasion dresses, such as short cocktail dresses, long formals, and MOB (mother-of-the-bride) costumes, are traditional in the missy category. Generally, a manufacturer will specialize in dresses in a limited price range and for one type of occasion. The buyer will select from many vendors to stock a variety of garments. Some seasons will place emphasis on different kinds of merchandise. For example, the holiday season will require a larger stock of cocktail and dressy dresses. The knowledgeable buyer will have a selection of formals on hand for conventions and black-tie dinner dances. In the spring and during holiday seasons, the dressy costume suitable for a wedding sells well.

Fit

The missy dress category has many fit restrictions because this customer with a mature figure may have some figure problems to disguise. Forward fashion is distilled and modified so it will fit the customer who wishes to look up-to-date. The missy dress customer wants to look neat, fresh, and fashionable in easy-care garments that pack and travel well. Polyester fabrics, or fabrics blended with polyester, are particularly popular in this category because they are easy to care for.

This missy customer usually wants the upper arm covered because it may be heavy or flabby. Thus, there are few bare and sleeveless looks. Overblouses and tunics are flattering for many figures. Loose dresses that have separate belts are very successful because the dress can be worn by a short- or long-waisted person. The shirtdress, which is styled in a heavy shirting fabric with a crisp collar, front-button placket or zipper, and

Missy
Evening
Dress

casual styling details, is a consistent best-seller. Moderate hemlines are most successful in this area. Changes in skirt length are usually tested in other categories before a change is offered in the missy department.

All these dress categories constitute the bulk of department and specialty store business. Special categories of dresses are also manufactured. Specialties offer the manufacturer a limited market, but there may be less competition within the specialty.

SPECIALTY CATEGORIES

Specialty categories have been created to cater to women who cannot wear junior or missy size ranges. Petite, half-size, large size, tall, and maternity apparel are specialty categories based on size. Other specialty categories reflect styling or the occasion for which the dress will be worn; bridal and soft dresses are examples. Finally, some categories feature very expensive designer garments. Custom designers often specialize in the hard-to-fit woman who cannot find appropriate apparel in retail stores.

Petite

Many retailers have added petite departments for the small adult customer who cannot find clothes that are sophisticated enough for the work world in the junior department, yet needs garments styled for a figure under 5 feet 3 inches. These departments feature contemporary and missy garments and have many loyal patrons.

Large and Half-Sizes

Current census reports estimate that approximately 30 percent of women in the United States wear a size 16 or larger. Specialty stores have catered to these women in the past, and styling has been very conservative, with little fashion appeal. Dark colors and simple silhouettes were typical until the early 1980s. Half-sizes were included in this classification. These garments were sized from 12+ to 20+ and fit the stout, short-waisted woman. Half-sizes are currently a very small segment of this category and have been largely discontinued.

Retailers have realized there is a substantial market segment of large women eager to purchase fashionable, colorful apparel for all types of garments. Department stores are opening departments for this

forgotten woman, and more specialty stores are catering to her. Such magazines as *Big and Beautiful* are also appealing to this customer with specialized fashion information. Dresses flatter the large woman and form a major classification in any large-size department. The heavy woman has fit restrictions that must be taken into consideration when designing. Simply grading or sizing up a pattern made for an average customer will not be sufficient for many large women. Different patterns must be used, and a larger grade (2 inches or more per size instead of the 1 inch typical for average apparel) is typical. Price is a factor because this category of apparel is difficult to manufacture at budget levels. More and more manufacturers are adapting their merchandise to appeal to this growing market segment.

Tall Sizes

Dresses in this category fit women who range in height from 5 feet 8 inches to more than 6 feet. Most often, this apparel is sold in specialty shops that can completely outfit the taller woman.

Maternity

Pregnant women have to buy clothing that will fit their temporarily expanded figures, but they will not wear the garments for long. Thus maternity clothes are moderately priced and easy to care for. Generally, maternity clothes are made in youthful styles because the expectant mother is usually under 35. Dresses are a minor category because separates are more versatile. Specialty stores are most successful with maternity wear, so many department stores are gradually phasing this category out.

Bridal

Bridal departments feature dresses for brides and formal dresses suitable for bridesmaids, proms, graduations, and other formal occasions.

Soft Dressing

This missy dress department sells casual, easy-care dresses or tops and bottoms that are priced separately, such as sportswear, and can be combined to look like a dress. A jacket or soft-shirt look is often included. Lightweight print fabric sells well in this department.

Soft
Dressing

Designer Dresses

Designer dresses feature expensive items by name
designers. Some stores separate foreign and domes-
tic designers. Some designer lines have both sports-
wear items and dresses and are sold together in a
boutique or section housing the designer's apparel.

TRADITIONAL DRESS CONSTRUCTION
Horizontal Divisions

A dress may be divided horizontally at any point on the body. Four typical divisions are illustrated: the low torso, natural waist, empire line, and shoulder yoke. These divisions can be applied to long or short dresses or other one-piece garments.

1. *Low torso or hipline.* This is the proportion of overblouses and jackets, sweaters over skirts, and dresses with a dropped waistline.
2. *Natural waist.* The natural waist is the traditional and most natural division between the bodice and the skirt. This style line may be emphasized with a belt, sash, or jacket that ends at the waist.
3. *Empire line.* This is especially popular for junior dresses because it is a youthful proportion. An

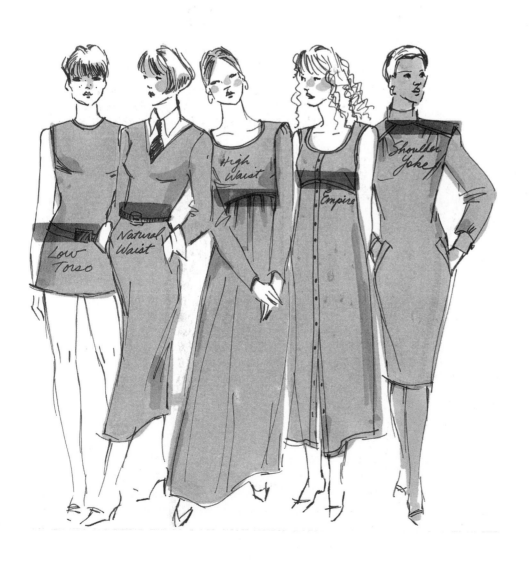

empire line makes the person seem taller, especially when the line is used on a long dress.

4. *Shoulder yoke.* This horizontal seam controls bust ease and is a classic styling device for shirtdresses.

Horizontal Divisions and One-Piece Dresses

Dresses may be styled with no horizontal divisions. This style emphasizes height and may slenderize the figure if the garment is divided into gores. The two typical kinds of dresses without horizontal divisions are the princess-line dress and the shift. The princess line can fit the body very snugly or skim

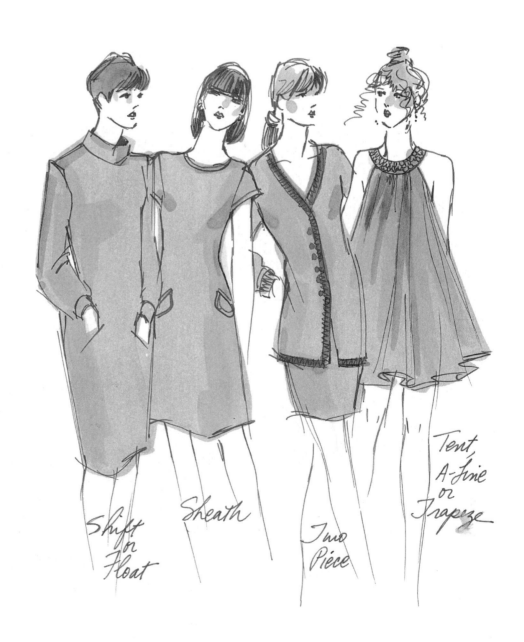

Shift or Float

Sheath

Two Piece

Tent, A-Line or Trapeze

the figure. The shift fits loosely. Like bodices and skirts, dresses are shaped by darts, gores, and ease.

Often, the waist of a loose dress will be defined by a belt. Knit garments are often undarted and ungored. They cling to the body because of the nature of the fabric.

Some traditional gored variations of one-piece dresses and other one-piece dresses are illustrated. These traditional styles have countless variations, but the classics are reinterpreted during various fashion cycles.

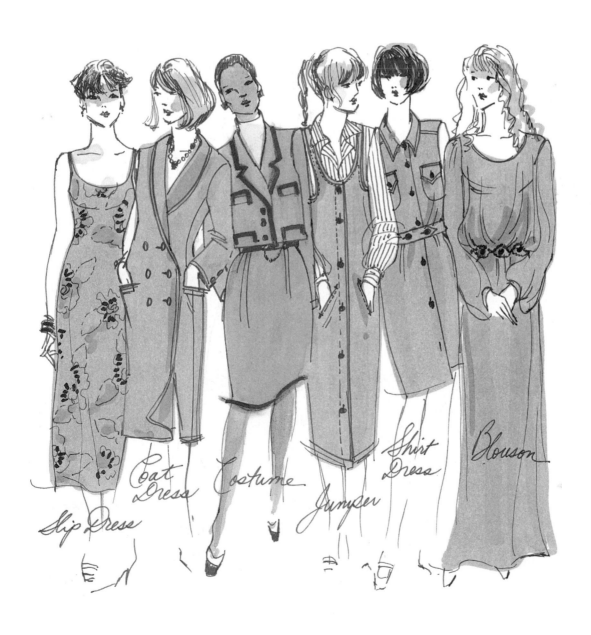

Slip Dress Coat Dress Costume Jumper Shirt Dress Blouson

Summary

A dress is a single garment that covers the torso and legs. Dress departments also sell two-piece dresses and other soft garments as well as the traditional dress. The three primary dress categories are junior, contemporary, and missy.

Junior dresses cater to a youthful customer. Dresses for school and special occasions are designed. This is a classification where fads and hot items are important sellers. Contemporary departments sell updated dresses to women from 18 to 50 if they have youthful figures and are fashion leaders. Contemporary dresses tend to be more expensive than junior or missy styles. The size range is from 2 to 14. Bridge departments offer dresses that are youthful but not as fashion forward as contemporary retailers. Missy departments sell dresses for conservative women for both day and evening wear.

Specialty dress categories are based on size, type of garment, or price. Dresses are offered in petite sizes, half-sizes, large sizes, and for tall women. Maternity departments sell dresses for pregnant women. Soft dressing refers to two- or three-piece dresses, and bridal departments sell specialized dresses for weddings. Specialty departments based on price are the designer dress departments. Some designer boutiques offer both dresses and sportswear.

Dresses can be fit with yokes or seam lines at the waist or hip. Horizontal segments of cloth called gores are also used to style and fit dresses. There are countless popular variations of dresses. Classical styles include the sheath or chemise, float or shift, tent, shirtdress, and jumper.

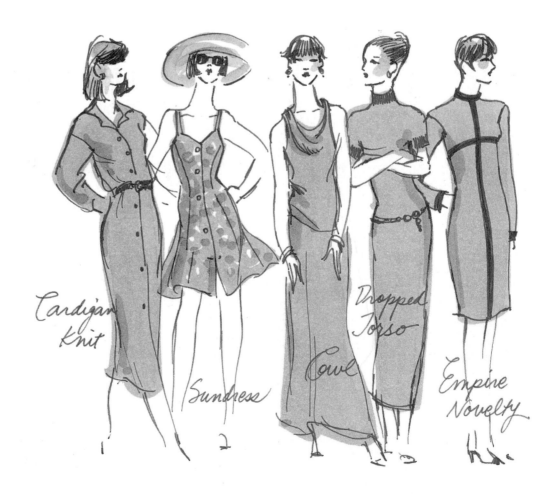

Cardigan Knit

Sundress

Cowl

Dropped Torso

Empire Novelty

Review

WORD FINDERS

Define the following terms from the chapter you have just read:

1. A-line
2. Caftan
3. Dress
4. Empire dress
5. Half-size
6. Junior dresses
7. Large sizes
8. Maternity dress
9. Missy dress
10. MOB
11. Petite dresses
12. Sheath
13. Shift
14. Soft dresses
15. Tall sizes
16. Bridge department

DISCUSSION QUESTIONS

1. What factors affect sales of junior day dresses? Consider the lifestyle of the customer.
2. Characterize the contemporary dress customer.
3. Describe the specialty size categories.

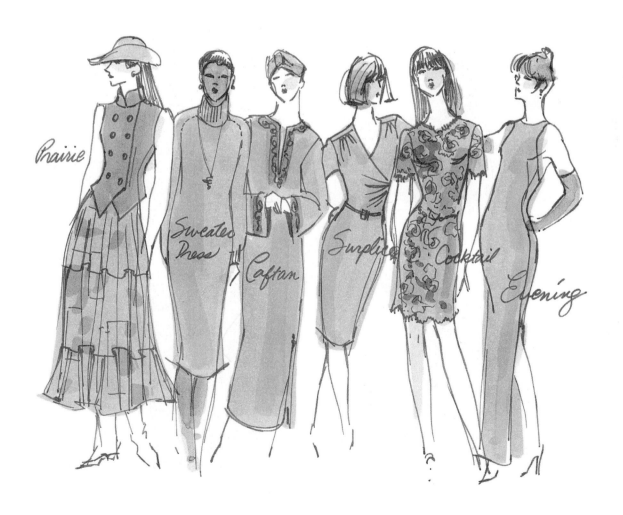

Prairie Sweater Dress Caftan Surplice Cocktail Evening

CHAPTER 13
Sportswear and Pants

Sportswear is a twentieth-century word. The merchandising definition of *sportswear* is separate garments, priced individually, that are worn for casual occasions or participation in active sports.

Active sportswear is worn for playing active sports. Designers of active sportswear are most successful if they participate in and understand the demands of the sport for which they design. Function is the most important aspect of active sportswear, with easy care as the important second requirement. Often, competitive sports set rigid limits on the kinds of apparel and the colors that are acceptable. Active sportswear is less influenced by fashion; yet it frequently influences the styling of spectator sportswear, which are separates worn for informal occasions that are not sports specific. For example, the hacking jacket and jodhpurs of the British equestrian and the denim jeans, riding boots, and cotton shirts of the cowboy have been adopted for casual wear. Jogging suits and sweatshirts have inspired lounge and sportswear. The simple tank suit of the professional swimmer has been adapted into a one-piece suit. Tennis dresses are acceptable as resort wear, and sportswear colors are now accepted on the tennis courts.

Originally, spectator sportswear was designed for attending a sporting event. When a casual lifestyle became common in the United States and working people gained more leisure time, spectator sportswear was adopted for any casual occasion. This evolution was logical because sportswear is colorful, comfortable, and easy to care for.

When you have read this chapter, you will understand:

1. The difference between active and spectator sportswear.

2. How pants developed as acceptable apparel for women.

3. Classic pants styles from the past and present.

4. The difference between items, separates, and coordinated sportswear.

5. Size and style categories of sportswear.

6. Merchandising of outerwear and suits.

7. Various pants lengths.

HISTORY OF PANTS AND SPORTSWEAR

Sportswear for women is a relatively recent development. Amelia Bloomer's attempt to liberate women during the 1850's from the cumbersome and unhealthy corsets and full skirts was a failure. Except for women who occasionally wore men's clothing—Mary Edwards Walker, the first woman to be appointed a surgeon during the Civil War, wore trousers to command professional respect from the soldiers she served, and Calamity Jane often passed as a man in Wild Bill Hickock's Wild West Show—pants for women were forgotten until the beginning of the twentieth century. At that time, active sports became more popular, and women became increasingly interested in them. The sports that first allowed women to wear pants were horseback riding and bicycling. These sports required the legs to be free. The first riding suits had man-tailored jackets, much like the formal riding jackets of today, and

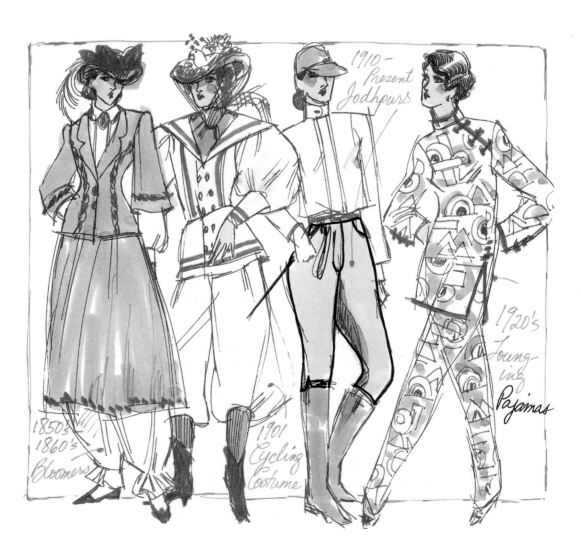

1850's
1860's
Bloomers

1901
Cycling
Costume

1910–
Present
Jodhpurs

1920's
Lounging
Pajamas

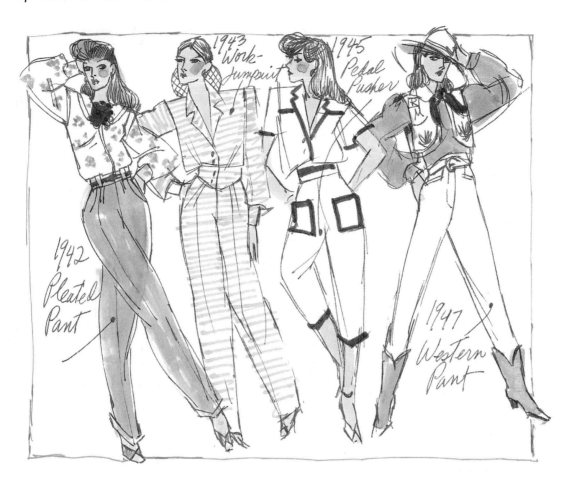

1943 Work-Jumpsuit

1945 Pedal Pusher

1942 Pleated Pant

1947 Western Pant

baggy pants, which allowed the rider to sit astride the horse. Bicycling pants were full bloomers that were styled like the skirt fashions of the times.

French designer Paul Poiret introduced harem pants in 1909, and a few brave fashion leaders made appearances in the radical new style. Separate skirts and blouses became fashionable about this time, and women began to wear elaborately embroidered and trimmed blouses with basic skirts. These garments were more easily mass-produced than dresses because fit was less difficult and the items could be sold at a lower price. Waist shops (blouse shops) were the first to sell separate, ready-made garments.

The first pants and sportswear for women emulated men's wear. This theme is popular in women's sportswear even today. Women borrowed the battle jacket, pleated pants, tailored shirts, blazers, tuxedo jackets, jeans, and cardigan sweaters from men's wear.

World War I stimulated the development of sportswear as trousers became a necessity for wartime work. Pants were worn for spectator sporting events, although the skirt and dress remained dominant. Coco Chanel introduced yachting pants

in 1920, inspired by sailor's bell-bottom pants. The craze for active sports like skiing and equitation stimulated the trend for pants.

During the Depression of the 1930s, women returned to the housedress. This fashion trend reflected the national desire to create jobs for men. The war was over, and the nation's workforce swelled with returning soldiers, so it was back to housework for women. As unemployment became widespread, the housedress was the prevalent look. The long skirt and somber colors further emphasized that times were hard. Marlene Dietrich continued to wear pants and suffer the consequences: Dietrich was ordered off the streets of Paris in 1932 by the chief of police for walking along the Seine wearing a man's jacket and trousers.

Working outside the home became a necessity during the 1940s as World War II drained men from the workforce. Rosie the Riveter, the symbol of the female factory worker, wore no-nonsense pants, overalls, or a jumpsuit to work. Now, pants were here to stay. Women tasted the freedom and flexibility of pants and they became an integral part of their wardrobes, although still worn only for specific activities. Lauren Bacall and Katharine Hepburn personified the casual elegance of a woman wearing pants.

After the war, a nation that was tired of strife looked to its heritage for a simpler, more wholesome lifestyle. Women discovered Western wear, and casual cottons were developed into sportswear.

During the 1960s, the youth movement was in full swing as postwar babies entered young adulthood. Influenced by warfare in Vietnam, military uniforms, battle jackets in the original khaki, denim work clothes, jeans, and long hair became badges of the hippie. Meanwhile, high fashion was engrossed in the future, fascinated by scientific technology and moon walks. Pared-down fashions evolved into the microminiskirt, often made from shiny, structured fabrics and worn with boots.

Hippies disdained mass-produced, stylized fashions. Instead, they wore natural fabrics, wrinkled and faded to a pale indigo blue. These young adults popularized antifashion apparel that minimized the differences between the sexes.

Denim jeans survived the antifashion movement of the sixties to become a basic apparel item worn by almost all categories of consumers. Jeans were first made by Levi Strauss, a German tailor who emigrated to California in the mid-nineteenth century to mine for gold. He was unsuccessful as a

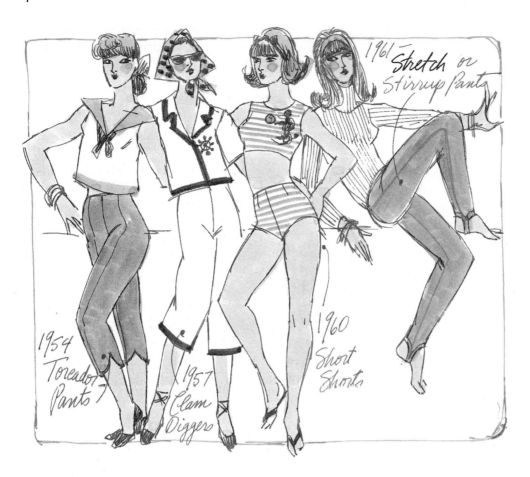

miner and began to manufacture sturdy work pants out of heavy canvas twill, imported from France, called *serge de Nimes*. This was shortened to *denim*. Denim was dyed with indigo dye made from plants imported from India. This dye was duplicated chemically in the twentieth century. The dye bleeds, and denim apparel gradually becomes softer blue with successive washings.

Levi's original pants had double-stitched seams and rivets to secure stress points. Miners prized them for their durability, and this thriving cottage industry grew into the largest apparel-producing firm in the United States by the mid-twentieth century, still bearing the name of its founder, Levi Strauss. For decades the firm concentrated on making sturdy work clothes, but when denim apparel became fashionable in the 1960s, Levi was in a position to capitalize on their famous product with a well-organized manufacturing system that geared up to produce a great variety of fashion apparel for every member of the family while continuing its domination in the work-clothes business.

Pants were also popular with high fashion designers in the 1960s. André Courreges shows pants

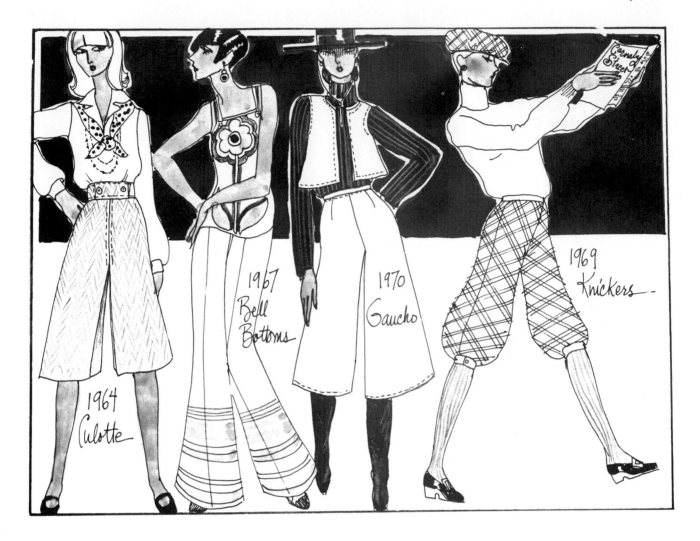

1964
Culotte

1967
Bell
Bottoms

1970
Gaucho

1969
Knickers

for day and evening, and Yves Saint-Laurent tuxedo suits for women. Saint-Laurent shocked the establishment in 1971 by showing hot pants in his spring collection.

Other famous designers from Europe and the United States stepped in to establish the jean as status fashion by affixing their names and logos to the back pockets. Jeans were styled with a great variety of details and versions of the classic shape during the 1970s and 1980s. During the early part of this decade, the customer turned away from wearing novelty jeans and demand increased for the original five-pocket jeans. The moderately priced version could be purchased from the traditional makers Levi, Lee, and Wrangler, but many other manufacturers entered the marketplace to compete for the basic jeans business. Calvin Klein, Ralph Lauren, Jordache, Gloria Vanderbilt for Murjani, Brittania, Cherokee, and Guess? perfected the fit of women's jeans and prewashed them to soften the color and stiffness of the fabric. Fierce competition developed for the

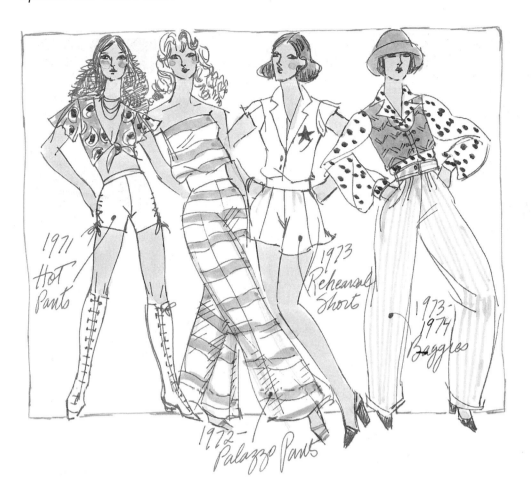

1971
Hot
Pants

1972-
Palazzo Pants

1973
Rehearsal
Shorts

1973-
1974
Baggies

basic jeans customer among all the manufacturers of denim apparel. The most successful carefully wooed the consumer with innovative styling and launched advertising campaigns to glamorize their product line. These days, domestic jeans manufacturers keep a close eye on how Europeans style denim, importing the hottest trends for the U.S. market.

Recycling clothing was an important innovation as youth became increasingly concerned about ecology and commercially induced obsolescence. The casual lifestyle of the 1960s became high fashion during the 1970s. Design from the streets was the catchword of designers, and the casual look invaded all levels of fashion, even the couture collections, thus demonstrating how changing lifestyles can affect fashion radically. The contemporary 1970s fashion emphasized comfortable and flexible clothing dyed with natural colors and spiced with the fantasy of handcrafted ethnic items. Worldwide imports supplemented U.S. clothing production. Sweaters from the Orient, Indian gauze and sheetings, embroidery from the Near East, and African native prints joined the traditional European fashion imports in U.S.

stores. (Imports are generally single items or compo-
nents of an outfit, so they are sold in sportswear de-
partments and boutiques.) These fashions were
particularly popular with the young and avant-garde.
Freedom of choice was the motto for this fashion rev-
olution. Pants broke the occasion barrier, and they
are now acceptable fashion almost everywhere.

The more conservative customer continues to
purchase standard knits and traditional sportswear
components. For this customer, fashion is still dom-
inated by the mass-produced look that emphasizes
easy care and reasonable prices.

What about future apparel trends? This is a
continuing question in the mind of the creative de-
signer. Designers must be sensitive to changes in
lifestyles. They must stay in constant touch with
the particular customer who buys their designs.
Larger social trends often indicate the apparel that
will be popular in the near future. Finally, distribu-
tion of the population in terms of age, career, habi-
tat, and increased leisure time greatly affects
purchasing habits.

The designs of the future have their roots in
the present. Apparel designers must heighten their
awareness of lifestyles and customer demands.

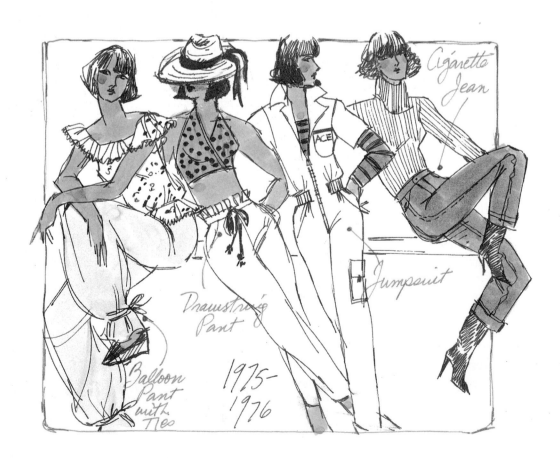

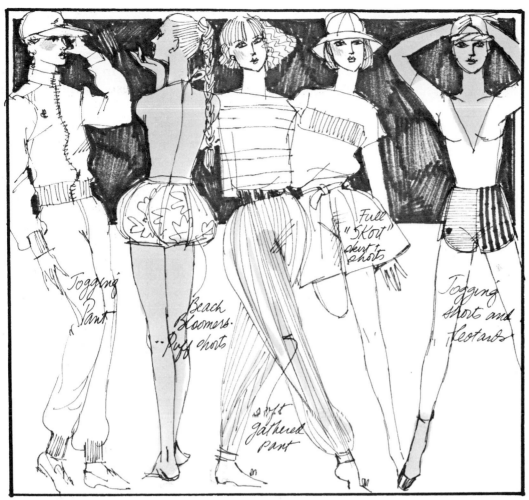

Jogging Pant

Beach Bloomers. Puff shorts

Full "Skort" skirt shorts

soft gathered Pant

Jogging short and Leotards

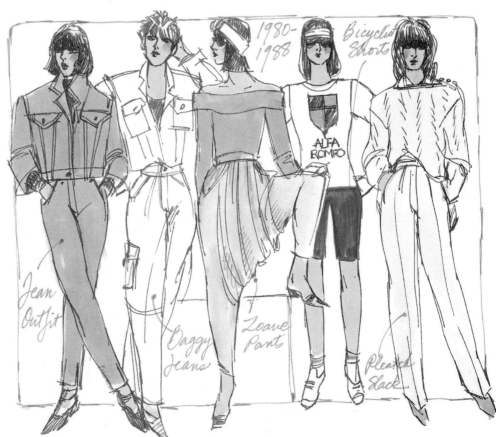

1980-1988

Bicyclist Short

Jean Outfit

Baggy Jeans

Zoave Pant

ALFA ROMEO

Pleated Slack

MERCHANDISING SPORTSWEAR

Commercial sportswear lines are usually organized in one of three ways.

Items

Items are garments sold as separate units. Generally, items are trendy and change constantly as the customer seeks novelty. Price depends on the specific garment, so there is no typical price range. Junior sportswear departments carry many items, most of which are inexpensive. Items are easy for a store buyer to move in and out of—that is, to buy for a limited time. Characteristically, items are more popular during prosperous times and when in-

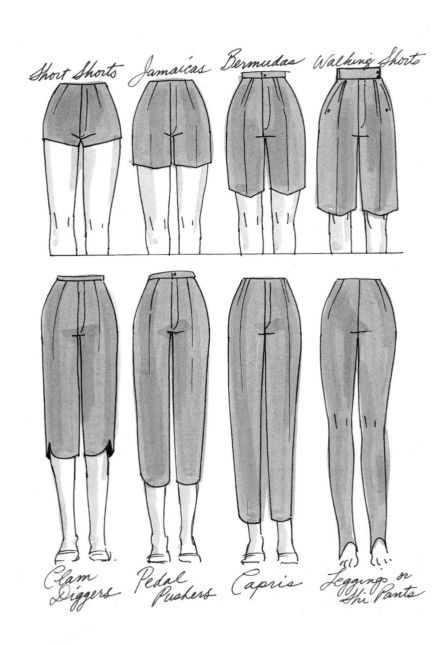

Short Shorts Jamaicas Bermudas Walking Shorts

Clam Diggers Pedal Pushers Capris Leggings or Ski Pants

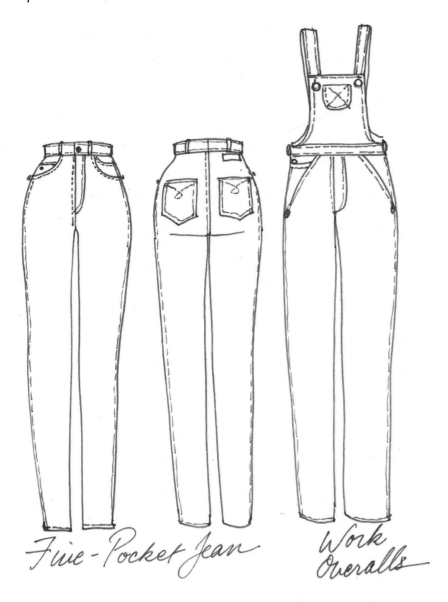

Five-Pocket Jean

Work Overalls

novative fashion is important. Many import lines fall into this category.

Separates

Garments that are unusual enough in design to be purchased singly are called *separates*. Unlike items, separates generally fit into a group of styles that can be worn together and are made of complementary fabrics.

A manufacturer may organize a whole line around separates or offer buyers a separates group. These items may tie in with each other, but each item has such a definite style that it can be sold alone. This is a flexible way to purchase apparel because the store does not have to buy a group of styles in a range of colors and sizes, which would be

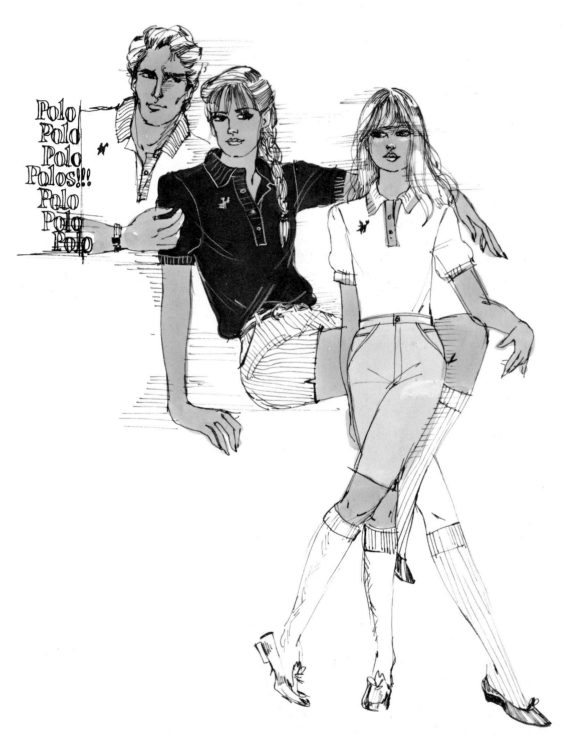

Separates
A popular and typical separates item in most categories of men's, women's, and children's sportswear departments is the classic knit polo shirt, often with an identifying manufacturer's logo or name. Polo shirts are usually offered in many colors, and the item lines have depth in a few basic styles.

a large investment. Instead, the store can buy more garments in the current hot category and fewer garments in the less important categories.

Separates buying is advantageous when layering is popular because the choice of separates gives the customer many options. Selecting separates requires a rather sophisticated customer, able to coordinate an outfit from many optional pieces. She may have to search in other departments or stores for matching components. Generally, the customer who shops in department stores is not this sophisticated. Coordination can be made easier by training salespeople and increasing the displays of coordinated separates. In the end, though, the customer must put together the final look.

Coordinates

A closely developed group of garments, carefully linked by color or detailing, is a typical description of *coordinates*. These garments are designed in an interrelated group to encourage the customer to complete an outfit by buying several pieces. A typical coordinated group usually consist of jackets, with a few accessory sweaters, and blouses, pullover sweaters, and T-shirts. Basic and novelty pants and skirts, accessories, and sometimes dresses complete the mix.

The group can be rounded out by adding shorts, halters, and bandeaus during the summer and pantsuits, long skirts, vests and tunics in the fall. Current hot items will be adapted for the coordinated group. To buy this complete package, the buyer will select many components so that the customer will have several possible outfits from which to choose. Each component will be bought in several colors and in a range of sizes. This will be an expensive purchase that will consume much of the *open to buy*.

The buyer usually purchases coordinated groups from large manufacturers who can ensure delivery and provide cooperative merchandising programs. The buyer saves a small percentage of the budget for items and fashion merchandise. This buying trend encourages large manufacturers to concentrate on safe, coordinated sportswear groups. Small and medium-sized vendors handle the fashion merchandise, items, and separates. One problem with purchasing coordinates is that some odd pieces are left unsold. After most components of a group have been sold, the remainder must be marked down.

SPORTSWEAR CATEGORIES

Sportswear is manufactured for junior, contemporary, designer, and missy customers in the same way that dresses are. Both active and spectator lines are designed for each category.

Junior sportswear is usually more item-oriented and less expensive than missy sportswear. The junior customer is more likely to experiment with her clothing purchases, but staples are still the

Coordinated Groups

Typical coordinated groups are based on a theme and offered in a limited color and fabric range. All the bottoms and tops are coordinated so that the customer is encouraged to purchase several pieces of the group to wear together. The colors of the tops and bottoms must match exactly.

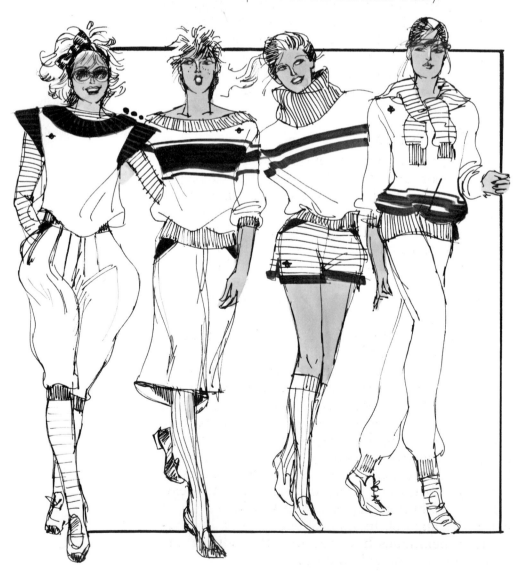

cornerstone of the department. Prices range from budget to moderate. Special active sportswear and swimwear are created for this customer.

Contemporary sportswear (also called *bridge* because it is less expensive than designer and more innovative than moderate sportswear, thus "bridging" the two categories) tends to be the most experimental of all the categories, putting many items that are not traditionally considered sportswear into the merchandising mix. Fashion is the crucial factor in this category. Items are important, and prices range from moderate to high. Typical bridge lines are Ellen Tracy, Anne Klein II, DKNY and so forth. Designer sportswear is more expensive than bridge vendors. Examples of U.S. designer sportswear lines are Donna Karen, Oscar de la Renta, Calvin Klein, and Ralph Lauren. Refer to the list of designer collections in Chapter 3 for additional manufacturers in this category.

Missy sportswear tends to be conservative. It is manufactured in all price ranges, from budget through expensive designer categories. Large manufacturers dominate missy sportswear, and items decrease in importance. Easy-care synthetic staples are emphasized in this category.

COATS AND SUITS

Gradually, this traditional merchandising category is being incorporated into general sportswear, especially the suit. A traditional, tailored suit had a great deal of hand tailoring, which was done by skilled people. Workers who are skilled in hand tailoring are becoming rarer, and handwork in the U.S. market is expensive. Because cost is such an important consideration, many customers select less-structured sportswear components or combine a jacket with a matching skirt or pair of pants for a suit look.

Coats and outerwear jackets still constitute a separate category of merchandise. The contemporary customer may find some outerwear in a sportswear department, but coat manufacturers still sell to junior and missy coat departments. Increasingly, handwork is being eliminated in all coat categories. Fusible interfacings have replaced time-consuming hand padding. Also, expensive fabrics are simulated by bonding inexpensive goods to stiff backings so that the fabrics are bulky enough for outerwear. Handbound buttonholes are reserved for the most expensive apparel. In almost every case, mass-production techniques have replaced the skills of the hand tailor in women's outerwear.

The sportswear jacket or skirt is usually more complicated in construction than the comparable item produced by a dress house. The item must stand on its own and be purchased as a separate unit, so it must be more detailed. The jacket as a dress component depends on companion pieces to sell the whole outfit, so the jacket may be less tailored in its detailing.

The designer must be aware of merchandising trends and social changes. Merchandising trends affect short-term fashion trends, particularly hot items and popular categories of merchandise. Social trends affect the long-term evolution of fashion cycles, including merchandising trends. Buyers and fashion reports for retailers are good sources of merchandising information. Designers in all categories of merchandise should constantly review these sources.

Summary

Contemporary sportswear is a blend of active and spectator trends that are particularly suited to the casual U.S. lifestyle. Sportswear for women began with Amelia Bloomer in the mid-nineteenth century when she introduced pants for women. Several decades later women began to wear pants for such active sports as cycling and jodhpurs for horseback riding. The youthful decade of the 1920s saw more women in pants, stimulated by women working in factories and the rising popularity of a greater variety of such active sports as tennis and golf. Again, World War II required many women to work on the assembly line in place of men, and pants were the most practical apparel to wear. After the 1940s, women in pants became more and more acceptable with each succeeding decade. During the 1960s, denim jeans became a universal apparel item, worn by young and old, men, women, and children for casual occasions. By the mid-seventies, women could wear pants almost anywhere, and a huge variety of styles was available. The popularity of pants will continue into the next century.

Commercial sportswear is organized in three ways: items, separates, and coordinated sportswear. Items are sold as separate units and tend to be novelty garments. Separates are garments that can be worn with other outfits. This category includes basics like sweaters and jeans. Coordinated sportswear manufacturers make all the pieces that can be worn together in one outfit. Colors, designs, and details are all compatible. This is the most difficult category of merchandise to manufacture because several fabrics must be purchased for each group, different factories are usually used for the tailored and soft garments, and the timing of all the manufacturing must be carefully coordinated so that all the pieces in a group ship at the same time.

Sportswear is manufactured for junior, contemporary/bridge, and missy customers and many of the specialty customers that specific dress sizes are made for.

Suits are often incorporated into sportswear lines. Jackets are sold separately from skirts, pants, and coordinating tops. Customers with different-sized tops and bottoms can have their outfits tailormade. Outerwear is usually an item category sold in sportswear departments or in specialized areas.

Styles of pants return to fashion in cycles. It is important for the designer to be aware of past styles and to interpret them with updated details and shapes in adapting them to the present.

Review

WORD FINDERS

Define the following terms from the chapter you have just read:

1. Active sportswear
2. Bell bottoms
3. Bloomers
4. Coordinates
5. Culottes
6. Items
7. Jodhpurs
8. Jumpsuit
9. Leotard
10. Merchandising trends
11. Outerwear
12. Separates
13. Social changes
14. Spectator sportswear
15. Tailored jacket

DISCUSSION QUESTIONS

1. Discuss the three ways a sportswear line can be organized.
2. What items are included in a typical coordinate sportswear group?
3. Name five garments that were designed originally for active sportswear but have been adapted for spectator sportswear.

Index